Degas at the Races

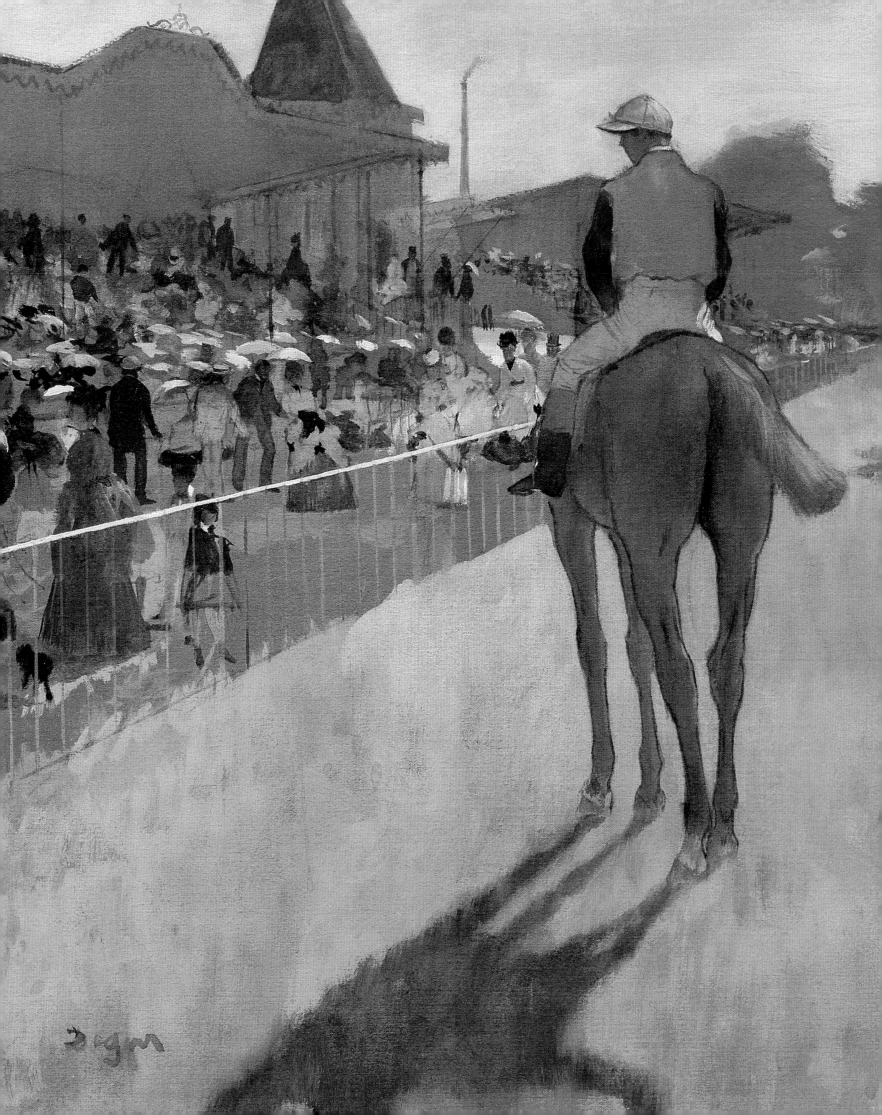

Degas
at the Races

Jean Sutherland Boggs

with contributions by
Shelley G. Sturman and
Daphne S. Barbour
and
Kimberly Jones

National Gallery of Art, Washington
Yale University Press, New Haven and London

On behalf of its employees, First Union National Bank is proud to make this exhibition possible.

United Airlines is the official carrier for the exhibition.

The exhibition was organized by the National Gallery of Art, Washington.

The exhibition is supported by an indemnity from the Federal Council on the Arts and the Humanities.

Exhibition Dates
National Gallery of Art, 12 April–12 July 1998

The book was produced by the Editors Office, National Gallery of Art
Editor-in-chief, Frances P. Smyth
Senior editor, Mary Yakush
Editor, Susan Higman
Designer, Chris Vogel

Typeset in Fournier and Berthold Walbaum by Duke & Company, Devon, Pennsylvania
Printed on Satimat Club by Snoeck, Ducaju & Zoon, Ghent, Belgium
The clothbound edition is distributed by Yale University Press

FRONT COVER: *Scene from the Steeplechase: The Fallen Jockey,* cat. 16 (detail)
BACK COVER: *At the Races: Before the Start,* cat. 94 (detail)
FRONTISPIECE: *The Parade (Racehorses before the Start),* cat. 56 (detail)
pp. 14–15: *At the Races: The Start,* cat. 13 (detail)
pp. 206–207: *Before the Race,* cat. 50 (detail)
pp. 240–241: *The Trainers,* cat. 97 (detail)

Library of Congress Cataloging-in-Publication Data

Boggs, Jean Sutherland.
Degas at the races / Jean Sutherland Boggs ; with contributions by Shelley G. Sturman and Daphne S. Barbour and Kimberly Jones.
p. cm.
Catalog of an exhibition held at the National Gallery of Art, Washington, D.C., Apr. 12–July 12, 1998.
Includes bibliographical references.
ISBN 0–89468–273–3 (paper)
ISBN 0–300–07517–0 (cloth)
1. Degas, Edgar, 1834–1917–Exhibitions.
2. Horses in art–Exhibitions. 3. Horse racing in art–Exhibitions. I. Sturman, Shelley. II. Barbour, Daphne. III. Jones, Kimberly. IV. National Gallery of Art (U.S.) V. Title.

N6853.D33A4 1998
760'.092–DC2197–43580

Contents

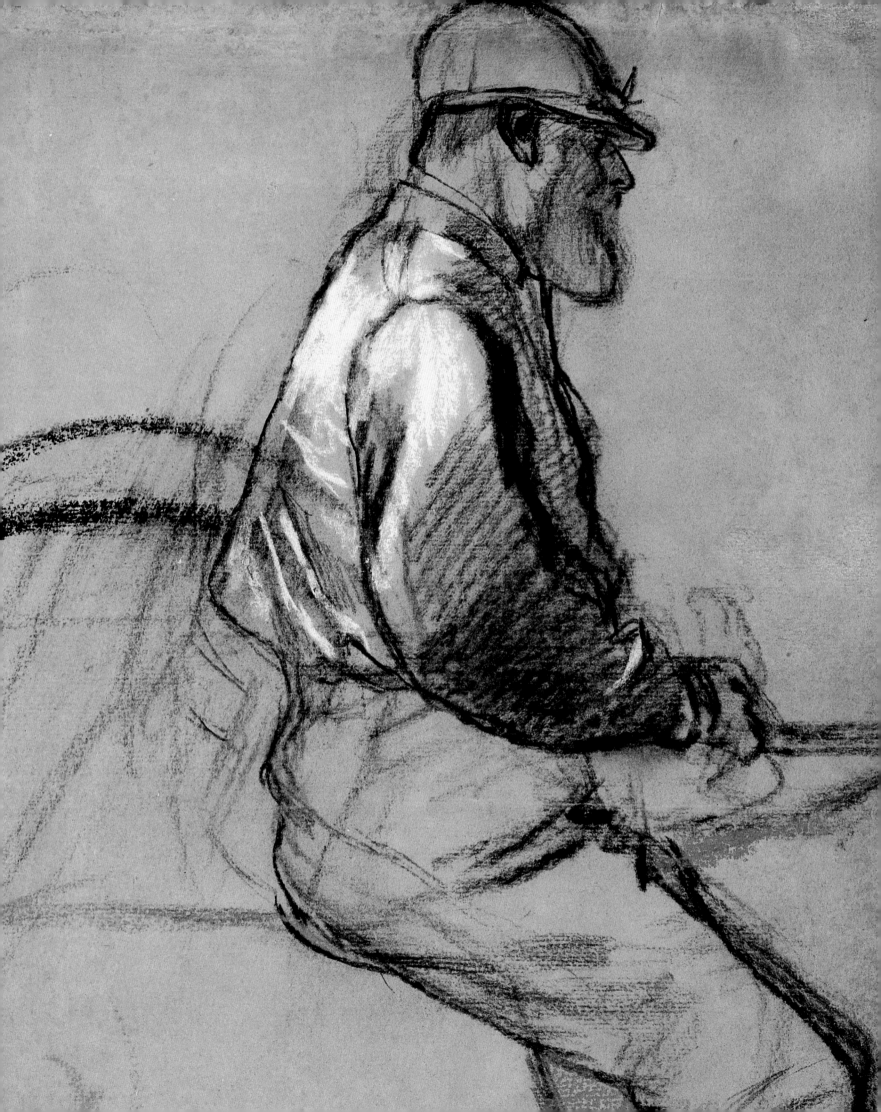

Director's Foreword

Degas at the Races is the first museum exhibition devoted to one of Degas' favorite themes: the horse and the race-track. A passionate observer of Parisian life—its workaday routines, its private domestic moments, the public and the bohemian entertainments of the modern city—Degas was equally fascinated by the recently established racetrack at Longchamp in the Bois de Boulogne, and by the hunting and riding sorties of his friends in the country. He loved the social spectacle of the racecourse, but was also intrigued by the nervous tension, the energy under perfect control, of a feisty thoroughbred ready for the start. His searching eye and creative hand are represented here by more than one hundred paintings, pastels, drawings, and sculpture dedicated to the beauty of the horse.

It is singularly appropriate that we celebrate Degas' horses and riders here at the National Gallery of Art. While the exhibition includes important paintings and sculpture on our theme from the founding Widener and Rosenwald collections, and one acquired with the Dale Fund, Mr. and Mrs. Paul Mellon have been especially generous. In addition to lending the superb series of Degas' wax sculpture of horses and riders—promised gifts to the Gallery on the occasion of the 50th Anniversary in 1991—they have also lent their great early masterpiece *Scene from the Steeplechase: The Fallen Jockey*, exhibited by Degas at the Paris Salon of 1866 and subsequently reworked by the artist. It is seen now in public for the first time in more than thirty years, along with a group of related drawings and paintings. These works, lent by lovers of the horse, the race, and the hunt, as well as by great admirers of Degas' art, form the heart of the exhibition. Of course the exhibition would not have been possible without the generous cooperation of many other lenders from around the world, who are acknowledged individually elsewhere, and whom I thank collectively here.

The idea of organizing *Degas at the Races* was first proposed by Philip Conisbee, curator of French paintings at the Gallery. We were fortunate to engage the scholarly services of Jean Sutherland Boggs, doyenne of Degas studies, as our guest curator, who shaped the exhibition and wrote the principal essay of the catalogue. Kimberly Jones, assistant curator of French paintings, made invaluable contributions, including an essay, chronology, and the catalogue entries. Shelley G. Sturman, head of objects conservation, and Daphne S. Barbour, conservator, have collaborated on an essay on Degas' wax horses.

Patronage is as important to a museum exhibition as it is to an artist, and without the generous support of First Union National Bank, this project would not have been possible. In addition, First Union is supporting educational outreach for the exhibition through its *Excellence in Education* program, which reaches more than one thousand schools throughout the country. I therefore extend our heartfelt thanks to Edward E. Crutchfield, chairman and chief executive officer, and the employees of First Union National Bank.

As always we owe a great debt to the Federal Council on the Arts and the Humanities for their continued and invaluable support of our exhibition program.

Earl A. Powell III
Director

cat. 73 (detail)

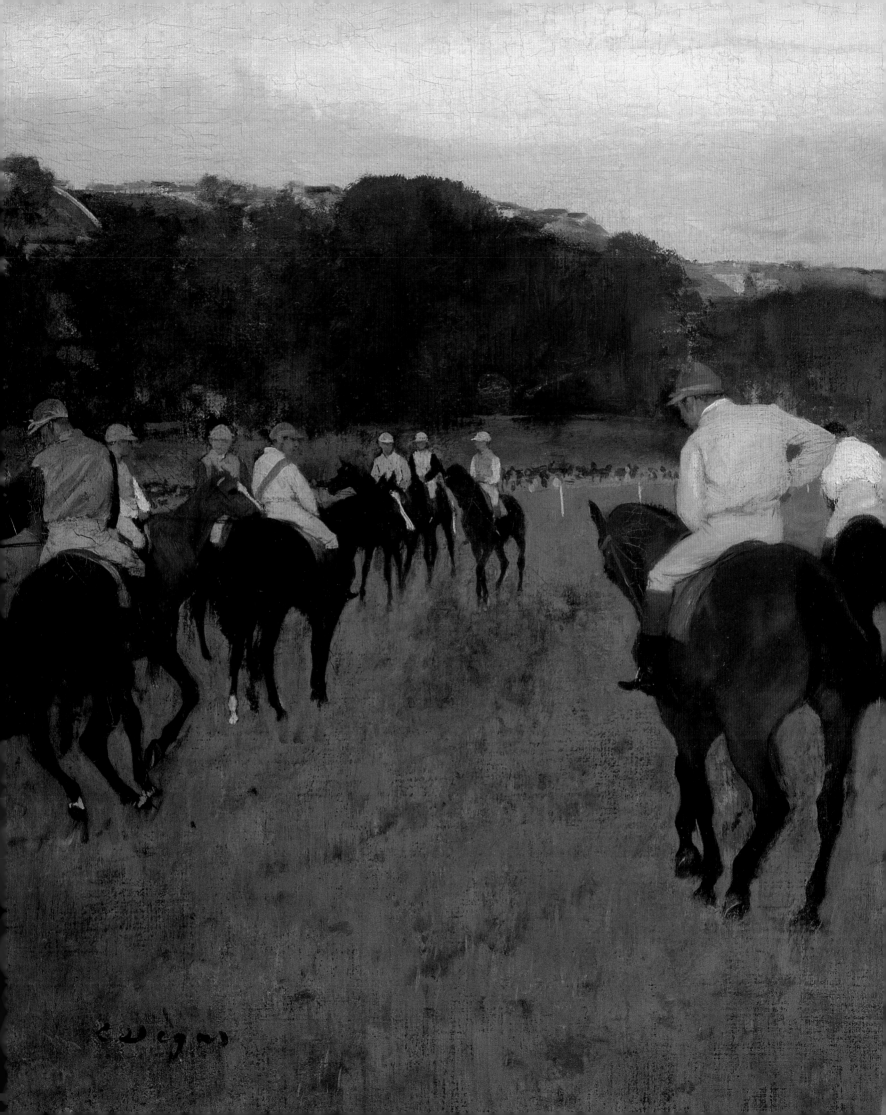

Lenders to the Exhibition

The Art Institute of Chicago

The Art Museum, Princeton University

Ashmolean Museum, Oxford

Ateneum, The Finnish National Gallery, Helsinki

Brooklyn Museum of Art

Denver Art Museum

The Detroit Institute of Arts

Harvard University Art Museums, Cambridge

Mr. and Mrs. J. Tomilson Hill

Hiroshima Museum of Art

The Israel Museum, Jerusalem

Mr. and Mrs. H. Anthony Ittleson

Kunsthaus Zürich

Mr. and Mrs. Paul Mellon, Upperville, Virginia

The Metropolitan Museum of Art

The Minneapolis Institute of Arts

Musée Cantonal des Beaux-Arts, Lausanne

Musée d'Orsay, Paris

Musée du Louvre, Paris

Museum Boijmans Van Beuningen, Rotterdam

Museum of Fine Arts, Boston

Nasjonalgalleriet, Oslo

National Gallery of Art, Washington

National Gallery of Canada, Ottawa

Norton Simon Art Foundation, Pasadena

Öffentliche Kunstsammlung Basel, Kunstmuseum

John D. Reilly, courtesy of The Snite Museum of Art, University of Notre Dame

Rijksmuseum Amsterdam

Mrs. Vincent de Roulet

Sterling and Francine Clark Art Institute, Williamstown

Eugene V. and Clare E. Thaw

Collection Carmen Thyssen-Bornemisza, courtesy of Fundación colección Thyssen-Bornemisza, Madrid

Virginia Museum of Fine Arts, Richmond

The Walters Art Gallery, Baltimore

Mrs. John Hay Whitney

The Wohl Family

Yale University Art Gallery, New Haven

Private collections

cat. 49 (detail)

Acknowledgments

The National Gallery of Art would like to thank Sarah Campbell Abdo; William Acquavella; Colin B. Bailey; Joseph Baillio; Felix A. Baumann; Isabelle Bérès; Christopher Burge; Beverly Carter; Michael Conforti; Helen Cooper; Malcolm Cormack; James Cuno; Chris Dercon; Caroline Durand-Ruel Godefroy; Sarah Faunce; James Ganz; Patricia Garland; Ivan Gaskell; Charlotte Gere; Leonard Gianadda; Paolo Graziadei; Lady Roseline Harvie-Watt; Osamu Hashiguchi; Mr. and Mrs. J. Tomlinson Hill; William Johnston; George Keyes; Geneviève Lacambre; Katharine Lee; Ronald de Leeuw; Arnold Lehman; Nancy Little; Dominique Lobstein; Evan Maurer; Mrs. Eugene McDermott; Mary Jo McGlaughlin; Marc de Montebello; Philippe de Montebello; Christian Neffe; Linda Nochlin; Monique Nonne; Maureen O'Brien; Maurice Parrish; Joachim Pissarro; Dean A. Porter; Michèle Prouté; Paul Prouté; Stephanie Rachum; Richard Rand; Theodore Reff; Malcolm Rogers; Anne Roquebert; Allen Rosenbaum; Samuel Sachs; Katharina Schmidt; Manuel Schmit; Robert Schmit; Kathleen Schrader; Thomas Llorens Serra; George T. M. Shackleford; Lewis I. Sharp; Marjorie Shelley; Robert Singer; Soili Sinisalo; Tone Skedsmo; James Snyder; Saskia van der Spek; Stephen B. Spiro; Harriet Stratis; Michel Strauss; Mr. and Mrs. Eugene V. Thaw; Shirley L.

Thomson; Jacqueline Towbin; Katharine Untch; Gary Vikan; Junko Watanabe; Christopher White; Jon Whitely; Mrs. John Hay Whitney; Guy Wildenstein; Juliet Wilson-Bareau; James N. Wood; and Jorg Zütter.

Many individuals on the National Gallery staff have contributed to this exhibition, and we thank especially D. Dodge Thompson, chief of exhibitions, and Ann Bigley Robertson, exhibition officer; Kate Haw, departmental assistant, French paintings; Ruth Fine, curator of modern prints and drawings; Mark Leithauser, chief of design; Frances P. Smyth, editor-in-chief, and Chris Vogel, designer; Sally Freitag, chief registrar, and Michelle Fondas, registrar; Ross Merrill, chief of conservation, and David Bull, chairman, painting conservation; Shelley Fletcher, head paper conservator; and Sandy Mazur, corporate relations officer, assisted by Diane D. Colaizzi.

Author's Acknowledgments

Although I have worked on Degas on and off for fifty years, I could never have accepted the National Gallery's invitation to be curator of this exhibition if I had not been Kress Professor at the Gallery's Center for Advanced Study in the Visual Arts from 1994 to 1995. My research then, with the assistance of Pauline Maguire and Abby Krain, was directed

toward a catalogue raisonné of the more than thirty-five hundred drawings by Degas. For this I had to address the problems of sorting those works by theme and proposing a chronology, happily including his images of horses, races, hunts, jockeys, trainers, and other riders. I must therefore acknowledge my indebtedness to the Kress Foundation and to CASVA, its director Henry Millon, and his staff.

In the course of my research on the exhibition I discovered another debt to the Kress Foundation, which had deposited in the Gallery's photographic archive the photographs, some of them unpublished, of Degas' notebooks, which Theodore Reff had used for his invaluable catalogue of this material, sponsored by the Kress Foundation. During my year in Washington I was able frequently to discuss Degas' wax sculpture with Shelley Sturman and Daphne Barbour, who were making a detailed study of his technique in the Gallery's conservation laboratory. I have been fortunate to have them as collaborators on this exhibition.

I would especially like to thank Earl A. Powell III, director, and Philip Conisbee, curator of French paintings at the National Gallery, for inviting me to be guest curator. Philip has carefully shaped the concept and size of the exhibition and its catalogue, and has been a judicious adviser, generous with his time and his hospitality. Kimberly Jones, assistant

curator of French paintings, played an important role as liaison between me and the Gallery staff. Susan Higman did sterling work as the editor of my manuscript.

Early discussions of this project were held with Ronald Pickvance, who organized the only preceding exhibition on the theme of *Degas' Racing World* in New York in 1968, and who has remained a friendly spirit behind the present enterprise.

I must also acknowledge other Degas scholars, most of whom are personal friends, including my colleagues in the 1988 exhibition in Paris, Ottawa, and New York—Douglas W. Druick, Henri Loyrette, Michael Pantazzi, and Gary Tinterow—and Marilyn R. Brown, Eugenia Parry Janis, Richard Kendall, Eunice Lipton, Anne Pingeot, Sue Walsh Reed, Barbara Stern Shapiro, and Richard Thomson.

I wish also to thank Harvey Buchanan, Andrew Clark, Colleen Evans, Marianne and Walter Feilchenfeldt, Robert Flynn Johnson, Marianne Karabelnik, Pauline Labelle, Anne Norton, Margaret Ripley, Gyde V. Shepherd, Darrell Sewell, Pierre Théberge, and Patty Ting, who have helped me in indispensable ways with the exhibition or the catalogue.

Jean Sutherland Boggs

Note to the Reader

Catalogue Entries

Degas rarely titled his works. Every attempt has been made to use the artist's own title for a work when it is known, or a title found in contemporary sources, including exhibition catalogues and records of sales. Titles in the atelier sales (the Ventes), in Lemoisne's catalogue raisonné, and posthumous literature have also been considered. Titles have been translated from the French when necessary.

Dates given may be at variance with those inscribed on the works, which were often added at a later date. Research has shown that Degas' dating is sometimes inaccurate.

Dimensions are in centimeters, followed by inches in parentheses, height preceding width.

Vente and atelier stamps, and their location, are recorded. The vente stamp imitates Degas' signature and is normally printed in red; any departures in color are identified. The vente stamp was used on most of the works sold in the atelier sales (see Ventes I-IV below). The atelier stamp, "Atelier Ed. Degas," within an oval, was printed in black or red on the works in the artist's studio after his death.

Works are identified by the number in the standard catalogues: Lemoisne for most of the paintings, pastels, and some drawings, with Brame and Reff for the supplement to it; Pingeot for sculpture; and Reff for the notebooks.

Exhibitions held during the artist's lifetime, monographic exhibitions, and those related to racing and sporting subjects are included in the catalogue entries.

Orthography of the Degas surname

The spelling of the name Degas without the particle is used on both the birth certificate and the tombstone of Hilaire Degas, the artist's grandfather, as well as by his Italian children. The exception is the painter's father, Auguste, who began to use the particle (De Gas) when he moved to Paris. The painter, like his brothers and sisters, also used De Gas, but by the time of the impressionist exhibition of 1874 he had changed the spelling to Degas. The other members of the family in France used De Gas, with the exception of the painter's brother René who changed the form to de Gas. Thus, in the catalogue, Degas is used for the artist and for the Italian members of the family, De Gas for the French members of the family, and de Gas for René.

Abbreviations

BR
Brame, Philippe and Theodore Reff. *Degas et son oeuvre: A Supplement*. New York, 1984

L
Lemoisne, Paul-André. *Degas et son oeuvre*. 4 vols. Paris, [1946–1949]

P
Pingeot, Anne. *Degas, sculptures*. Paris, 1991

Reff Notebook
Reff, Theodore. *The Notebooks of Edgar Degas*. 2 vols. 1st ed., London, 1976. 2d rev. ed, New York, 1985

Vente I–IV
Vente Atelier Degas. Galerie Georges Petit, Paris. Vente I: 6–8 May 1918; Vente II: 11–13 December 1918; Vente III: 7–9 April 1919; Vente IV: 2–4 July 1919

cat. 66 (detail)

SECTION I

Degas at the Races

Jean Sutherland Boggs

The Horse in Art and Legend

Degas and the Horse in Art, 1855–1868

Edgar Degas was born in the 1830s, the decade in which the French first developed the enthusiasm for horse racing that would last throughout the century. In 1834, the year of his birth, the racetrack at Chantilly was opened, and the following year the Prix de Jockey Club was established there. The first race was held the year after that and carried a purse of five thousand francs. Such activity around the year of his birth might explain a predisposition in Degas' later work for subjects of racetracks like Chantilly, if perhaps not Chantilly itself.

No records, however, not even apocryphal legends, mention a horse — even as a toy — in the artist's childhood.[1] In his early years in Paris, when the family moved frequently,[2] largely in the ninth *arrondissement*, just below Montmartre, there would have been little opportunity for companionship with this animal. In the summer, his father, Auguste De Gas, would take his family to the seaside resort of Saint-Valéry-sur-Somme, near the Belgian border, and there was at least one visit to his grandfather, René-Hilaire Degas, in Naples and San Rocco di Capodimonte, when Edgar was six,[3] but there is not even a hint of horses playing a role in those vacations. Nor was the school where Edgar went as a boarder when he was eleven, the eminent if austere Lycée Louis-le-Grand,[4] apt to encourage any

indulgence in riding as a leisure activity. In short, there is no evidence that as a child the painter had had any experience with, or interest in, horses.

Yet during his boyhood and youth, Degas was living in a world in which the horse, particularly the cart horse, was indispensable. Although there were other forms of transportation — including the train, which had just been introduced — horses pulled private carriages or stage coaches and delivered goods in carts. Elegant and highly bred horses were used by the prosperous and by the cavalry for the ceremonial occasions popular in mid-nineteenth-century Paris, and were also casual but inevitable accompaniments to everyday life.

Degas, who was unconventionally trained and not at all precocious, seems to have made his first experiments drawing the horse at the École des Beaux-Arts in Paris, where he registered with Louis Lamothe (1822–1869)[5] on 6 April 1855. There, in a small notebook, Degas sketched horses from plaster casts of the Parthenon. In a rudimentary drawing of the north frieze (fig. 1), Degas depicts some boys walking beside their horse and concentrates on the arched body of the standing youth and the smaller figure beside him; he seems almost indifferent to the animal. Accents of heavy lines, which represent the shadows cast by the relief, enliven the hesitant drawing. To the right, on the same page, he includes a

cat. 6 (detail)

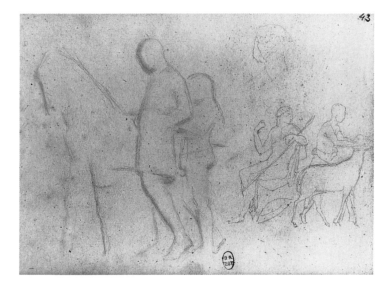

fig. 1. Copy after a plaster cast of the north frieze, Parthenon, April or May 1855, graphite on paper. Bibliothèque Nationale, Paris (*left*)

fig. 2. Copy after a plaster cast of the west frieze, Parthenon, summer 1855, graphite on paper. Bibliothèque Nationale, Paris (*right*)

compositional drawing of some figures, presumably Olympian: a seated god with a staff, who could be Apollo, and a youth, perhaps Pan, who is leading a goatlike animal. Even at this early stage in his career Degas was breaking down the spatial and compositional restrictions of the frieze, a structure that has often been used to explain the organization of his early racing pictures.[6]

Degas had additional opportunities to draw from casts of the Parthenon.[7] In the summer of 1855 he spent two months in Lyons, where Lamothe was working with *his* teacher, Hippolyte Flandrin, on the decoration of Saint Martin d'Ainay. Flandrin, who had studied with Ingres, Degas' idol, was the leading painter in Lyons. At the local school of fine arts, in a notebook somewhat smaller than the one he had used in Paris, Degas sketched a caval-ryman from a cast of the west end frieze (fig. 2). His choice of subject is significant, because the man is riding — indeed, reining in — a spirited horse who has raised its forelegs. The horse may not dominate the composition, but it is at least as important as the rider. As in his earlier drawing, Degas uses heavy lines or hatching, usually at points of motion or resistance, to represent the shadows in the relief. Although livelier than the horse he had copied in Paris, in this rather cursory, generalizing drawing Degas records fewer details of the animals' structure and anatomy than did the Parthenon sculptors.

In addition to notebook sketches, Degas made larger drawings on separate sheets of paper. Where or when these were made is not known, and doubts have been raised about the attribution of some.

One of the more important of these drawings, surely by his hand (cat. 1), prefigures his later work, in particular his *Sémiramis* (fig. 21), in which a standing horse visually unites the assembled courtiers and their queen. The horses in this earlier drawing, based on two from the Parthenon's west frieze (fig. 3), have not achieved the nobility of the horse that dominates the later painting, but they are self-contained and self-assured. Man is even serving the animal as the youth adjusts its bridle. The relatively large size of the drawing allows for the greater suggestion of relief in the modeling of the horse, but Degas works additional variations in the lights and shadows, both within the horses' bodies and beyond their contours. At this point he was becoming increasingly interested in anatomical details, evident in the heads and the mouths, which follow the original almost exactly. The source may be a plaster cast, but the drawing nevertheless hints at lean, sinewy animals that assert their own character and independence.

In September 1855 Degas left Lyons for Paris, and in July 1856 he arrived in Naples by way of Marseilles. (The intervening ten months have never been satisfactorily explained.) His father supported his decision to go to Italy, where the latter had been born and where his son would be near three uncles and his grandfather in the family home, the Palazzo Degas,[8] in the heart of Naples. Two aunts also lived in the city with their children: the impoverished Aunt Rosa, duchessa Morbilli, and the prosperous Aunt Fanny Primicile-Carafa, marchesa di Cicerale e duchessa di Montejasi. Aunt Laure, the baroness Bellelli, of whom Degas was particularly fond, lived in exile with her family in Florence,[9] and an American aunt, his mother's sister, Anne Eugénie Musson, widow of the comte de Rochefort, also lived in that city.[10] After spend-

ing his first three months in Naples making some minor family portraits and indulging himself in the beauty of the landscape and the rich resources of its museums, churches, and ancient sites, Degas left for Rome.

In Rome, his life centered around the French Academy at the Villa Medici, where as a visitor in life classes he made drawings after the nude. He was essentially free to explore Orvieto, Assisi, or the treasures of Rome. Degas in his freedom could choose to discipline himself or to let his imagination roam freely, stimulated by Dante or the Bible or other literature. The work of these Italian years, which is recorded in great detail in seven small notebooks,[11] is so varied that the results are often confusing.[12]

Horses, which embodied this same passion for freedom with discipline, began to appear somewhat more frequently in his works. The annual race of the riderless horses (or Barberi) on the Corso in Rome inspired more than one drawing in a notebook Degas used between October 1856 and July 1857;[13] these drawings

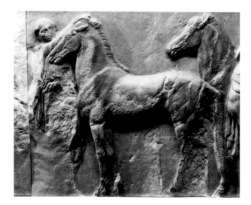

cat. 1. *Sheet of Studies* (after a plaster cast of the west frieze, Parthenon), 1855–1856, graphite on paper. Musée du Louvre, Département des Arts Graphiques, Fonds du Musée d'Orsay, Paris

fig. 3. Plaster cast of the west frieze, Parthenon

fig. 4. *Riderless Horses (Barberi) in Rome*, 1856–1857, ink on paper. The Pierpont Morgan Library, New York

fig. 5. *Head of a Donkey*, 1856–1857, graphite on paper. The Pierpont Morgan Library, New York

fig. 6. *Rider with Trumpet; Horse;* and *Jockey*, August 1858–April 1859, graphite and ink on paper. Bibliothèque Nationale, Paris

were, in turn, often influenced by the responses of earlier French artists like Carle Vernet (1758–1836)[14] and Géricault (1791–1824) to the same event. In one notebook, however, two bands of drawings (fig. 4) seem not only original, but even prophetic of his studies six years later for *Scene from the Steeplechase: The Fallen Jockey* (cats. 16, 18). The upper register depicts men preparing the undisciplined horses before the race begins, the lower shows horses galloping in different directions.[15] Without man's control Degas imagines the animal world in mindless chaos.

In that same notebook Degas turned from the rare spectacle to the most commonplace: a donkey pulling a cart. His drawings of the donkey's humble body are abbreviated and faint but by no means unsympathetic.[16] The most compassionate drawing is a profile of the animal's head (fig. 5), which shows enough of the primitive bridle to underscore its servitude. But the leaflike ears are as perky as antennae, the dark eyes large and soulful, and the mouth and nostrils, by contrast, so old

and resigned, that this donkey is perhaps a poor imitation of a horse but a better reflection of certain human beings.

At this stage Degas was not yet thinking of the horse as a hero of – or even a participant in – the history paintings that he was then undertaking, such as *Saint John the Baptist and the Angel, Dante and Virgil*, or *David and Goliath*,[17] but on occasion he did draw a horse in an imaginary composition. In one page of his notebook, for example, he drew a stallion rearing – not balking in fear, but playing its role in a ceremony as its rider blows a trumpet (fig. 6). The horse, free of saddle or bridle, turns its head toward the rider, the hairs of its mane and tail curling in response to the theatricality of the event. Below, on the same sheet, is a profile of a horse controlled by complicated trappings, including a harness; nevertheless, it stands proudly and even defiantly with its legs thrust outward and its head held high. Degas could not have been unaware of the contrast between the liberty of one horse and the servitude of the other. A clue to the servitude may be given in the

lower right corner with the suggestion of a jockey's profile as well as jodhpurs and a riding boot. Later, Degas would become more reconciled to the domination of the horse by the rider on the racecourse.

Although the previous drawing seems to have been his own invention, Degas was still stimulated by the work of earlier artists. When he arrived in Florence to stay with his aunt Laure Bellelli in August 1858,[18] he found in the Uffizi an equestrian portrait of Charles V by Anthony van Dyck, an artist he much admired.[19] In one drawing (fig. 7) Degas suggests only the monarch's legs, while the horse, with its powerful chest and curving contours, is modeled with bold shadows, its body on an angle to emphasize its sculptural mass. The black patch of shadow over its eye makes its bent head with sensitive nostrils all the more theatrical. Yet as Degas drew him, the horse is awkward, the position of the legs almost splayed, and the horse's left foreleg appears to be disjointed. But copying Van Dyck has made Degas see the horse as romantic, almost capable of the passions the shadows suggest.

Degas' notebooks reveal that he was aware of the potential in the relationship between rider and horse. Early in 1856 he had sketched the pedestal (with a glimpse of the horse's legs and feet) of Verrocchio's equestrian monument to Bartolomeo Colleoni.[20] Degas, who never seems to have traveled to Venice, would have worked from a photograph or print, struck by the dignity provided by this high pedestal for the dynamic *condottiere* and his horse. By then he had realized that the horse alone could perform the same role for the rider, as it did in a shorthand drawing he made on 2 April 1859 after Van Dyck's painting of Marchese Anton Giulio Brignole Sale, in Genoa.[21] In this drawing Degas captured the supreme dignity and gracious condescension of the gentleman in the portrait,

enhanced by the horse bowing deferentially in front of its noble rider.

In a notebook begun in Florence in August 1858 and finished in Paris by June 1859, Degas copied the works of French artists, for example, Géricault's *Five Horses Viewed from the Rear* (fig. 8).[22] Theodore Reff, who catalogued Degas' notebooks, observed that he had made drawings from Géricault's five horses over several pages, including two on a page combined with a horse and the profile of a jockey (fig. 9) from two lithographs by Alfred de Dreux. Degas' copies after de Dreux,[23] such as that of a groom and horse in the same notebook (fig. 10), added to his anatomical knowledge of the horse but were more concerned with recording the relationship between groom and animal. On this level Degas was preparing himself for the stable, the paddock, and the track of France in the second half of the nineteenth century, but on

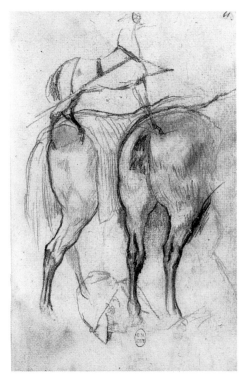

fig. 7. Copy after the horse in Anthony van Dyck, *Charles V*, August 1858–April 1859, graphite on paper. Bibliothèque Nationale, Paris (*top*)

fig. 8. Théodore Géricault, *Five Horses Viewed from the Rear*, 1820–1822, oil on canvas. Musée du Louvre, Paris (*left*)

fig. 9. Copies of horses and a jockey after Géricault and Alfred de Dreux, 1859–1860, graphite on paper. Bibliothèque Nationale, Paris

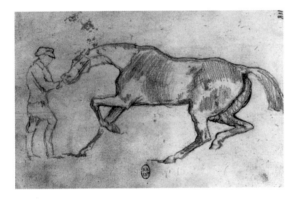

fig. 10. Copy after Alfred de Dreux, *Scènes équestres*, 1859–1860, graphite on paper. Bibliothèque Nationale, Paris

fig. 11. *Two Men in an Open Carriage*, 1859–1860, ink on paper. Bibliothèque Nationale, Paris

quarters bay, front of the head white." Here Degas was analyzing the color of horses he saw on the streets, rather than borrowing them from other works of art.

In Florence[24] Degas made a drawing (cat. 2) after *The Battle of San Romano*, which he inscribed "Florence 1859/Paolo Uccello." Like the original painting in the Uffizi, his composition is dominated by the rearing horse, while its wounded rider is almost rendered incidental. In fact, Uccello's white steed is so buoyant that it has been compared to a rocking horse,[25] while the other horses are in various positions of battle – dying, kicking, charging, retreating (fig. 12). Degas simplified the composition somewhat, eliminating figures in the battlefield, and foliage and trees in the background. Yet he achieves the same respect for the horse that Uccello reveals, as well as the same clarity and response to the decorative, even in battle. Degas admired the sophistication of Uccello's scheme. The surprising vignettes of perspective throughout the whole work – not all of which Degas reproduces – would be something he would apply to very different subject matter later in his life, in particular to his dancing classes, but also to those works in which the horse would play a role in a contemporary setting.

Three other drawings, which Degas dated "Florence 1860,"[26] are copies from frescoes Benozzo Gozzoli[27] had painted about 1459 in a small chapel in the Medici-Riccardi palace. The frescoes show members of the Medici family and their extensive retinue setting out, many on horseback, to worship the newborn Christ child. On the walls of its inner room Benozzo had painted angels singing and praying for the newborn child.[28] The total ensemble – the inner chamber with the angels and the outer chamber with the procession of the magi – is an extraordinarily decorative work with tender colors

another he was still attracted by the interpretation of horses in works of art from the past.

Yet Degas did not ignore the horse on the street. Although very little of the horse itself is revealed, his spirited – if somewhat offhand – ink drawing of two men in top hats on a horse-drawn carriage (fig. 11) has a certain animated charm. He also adds an inscription that relates to the drawing: "Horse reddish or a violet-gray, the legs aside from the articulation more violet. The coat at the neck and the feet is red – the stomach fawn" and "horse a dappled gray brown – fore-

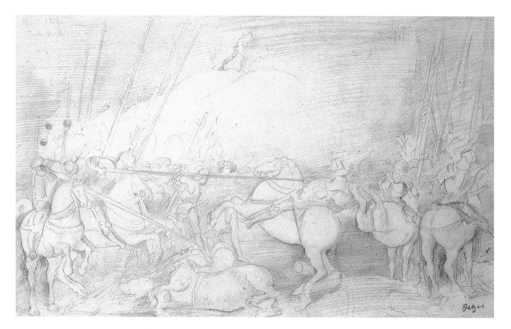

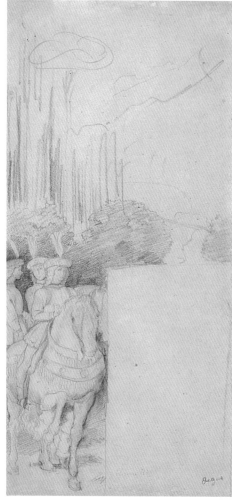

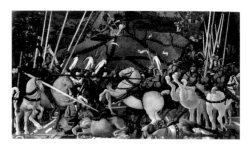

cat. 2. *Battle of San Romano* (after Uccello), 1859, graphite on paper. Private collection (*top left*)

cat. 3. *Three Pages* (after Benozzo Gozzoli, *Journey of the Magi*, Palazzo Medici-Riccardi, Florence), 1860, graphite on paper. Fogg Art Museum, Harvard University Art Museums, Gift of Henry S. Bowers, Class of 1900 (*top right*)

fig. 12. Paolo Uccello, *Battle of San Romano*, 1450s, tempera on panel. Uffizi, Florence

and gold leaf, a stylized landscape, and charming figures. There are no dissonances. Degas worked with graphite on white paper, so the drawings show none of Benozzo's color. He also eliminated more – much of it decorative – than he had in copying Uccello's *Battle of San Romano*. The result is inevitably austere.

Degas was influenced by the Renaissance artist's desire to impose order on the natural world. From one frescoed wall, through which a door had been cut, he depicted three courtiers on horseback, leaving the space for the door untouched on the page (cat. 3). The composition itself is attractive as a vertical panel with the doorway removed. Degas also ignored the beauty and precision of the

recession of tree trunks in the background. Instead, he was fascinated by the exactitude with which Benozzo placed and executed the legs of the animals in space, a particular challenge in representing the horse.[29] His reproduction of those legs is nevertheless dutiful rather than assured. He was more successful in discovering an affinity between the eyes of the diffident, youthful courtiers and those of the bent head of the horse. In fact, in his drawing, he raised its eye on our right to make the animal even more appealing.

A more conventional segment (fig. 13) shows a young magus, Gaspar, with his courtiers moving with gifts to the Christ child. In Degas' drawing (cat. 4), he relishes comparing the pattern of the horses'

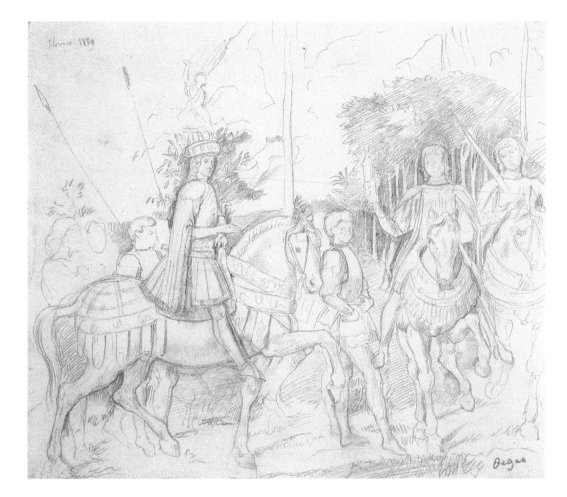

cat. 4. *Lorenzo de Medici and Attendants* (after
Benozzo Gozzoli, *Journey of the Magi*, Palazzo
Medici-Riccardi, Florence), 1860, graphite on paper.
Fogg Art Museum, Harvard University Art
Museums, Gift of Henry S. Bowers, Class of 1900

fig. 13. Benozzo Gozzoli, *Procession of Magus Gaspar*,
1459–1460, fresco. Palazzo Medici-Riccardi, Florence

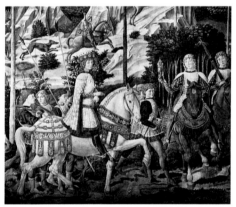

legs with those of the youths. His drawing
may have some of the uncertainty of the
youths themselves, but the painter of
the dance emerges in the movements of
both riders and horses. The page leading
Gaspar's horse and the rider gesturing
above him, offering a gift to the Christ
child, are particularly graceful as turn-
ing points in what is otherwise a proces-
sional frieze. On the hillside, Degas has
attempted to show a figure on a horse
galloping in response to its rider's whip,
but the drawing only faintly acknowl-
edges this element of daring in the fresco.

The drawing (cat. 5) in which Degas
learned most from Benozzo is copied
from a fresco (fig. 14) on the left wall,
where serious, red-capped Florentines
watch the procession. Degas reduced the
accompanying figures from nine men to
six and from six horses to three, suggested
by faint, almost undetectable, lines. He
eliminated all the ornamental foliage but
paid tribute to it in the lower left corner
by the small but spirited clump of cactus.
Only a glimpse of Benozzo's majestic
mounted figure at left remains, repre-
sented by the compliant front of the
horse with the long and contradictorily
disobedient ears of a donkey; in fact, it
resembles the donkey whose head Degas
had drawn two years before (fig. 5). The
central rider and horse are gracious and
pivotal; much fainter is the outline of the
young courtier and horse who are moving
to the right. The arrangement seems un-
planned and informal, as if in anticipation
of the groupings of jockeys Degas later
would record at the races. In the concen-
tration upon the essential figures and
the variation in the weight of the pencil
from left to right, Degas indicates an
atmosphere of light and air between and
around the horses and riders. There is
nothing here of a hermetic relief. Al-
though he could have learned most from
Benozzo from this wall, it is obvious he

was also more selective and more arbitrary in changing its relationships in space. In his drawing that sense of a formal ritual of such fundamental importance to Benozzo has broken down.

By this time – 1860 – Degas had almost completed his exploration of the horse through the work of other artists. He would not forget what he had learned from the Parthenon sculptors, or from Van Dyck, Uccello, and Benozzo Gozzoli, but he would not copy their works again. His break with the French painters of this animal, like Vernet, Géricault, and de Dreux, was not as complete. He was still consulting their works when he painted horses from life about 1862, but during the sixties that dependence was severed. He would find himself on his own with horses as he was with human beings.

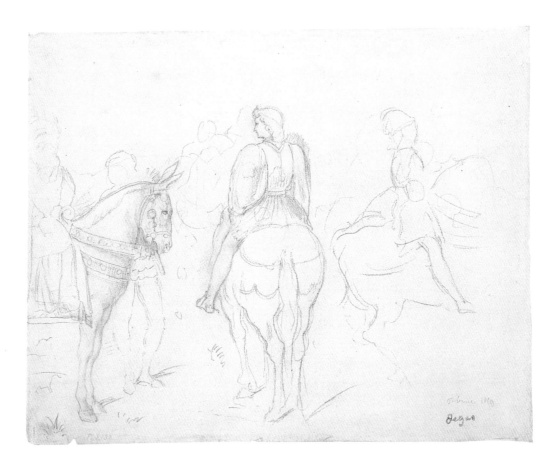

The "Impeccable and Superb Horses" of Legend, 1856–1868

Much as Degas enjoyed recording the world he knew and the very different worlds artists like Uccello and Van Dyck had created, he was also challenged to work from his own imagination, which had been cultivated in his classical education at the Lycée Louis-le-Grand. In Italy he experimented with themes from Dante[30] and the Bible, but the paintings, as opposed to the drawings, were never resolved. When faced with the prospect of returning to France, he must have felt particularly ambitious about producing history paintings that would establish his reputation at the official Salon in Paris. As a result, his famous, large Notebook 18[31] may be full of landscapes, studies, and even caricatures of the people he met in his travels, as well as occasional portraits, sketches for the largest portrait he would ever paint – *The Bellelli Family* – copies, even tracings of illustrations in

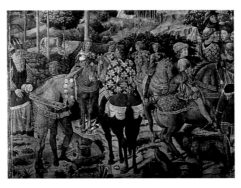

cat. 5. *Attendants of the Patriarch Joseph of Constantinople* (after Benozzo Gozzoli, *Journey of the Magi*, Palazzo Medici-Riccardi, Florence), 1860, graphite on paper. Rijksprentenkabinet, Rijksmuseum Amsterdam

fig. 14. Benozzo Gozzoli, *Procession of Magus Melchior*, 1459–1460, fresco. Palazzo Medici-Riccardi, Florence

archaeological books, but above all it contains explorations for history paintings that he also pursued in smaller notebooks between 1859 and 1862.[32]

In Italy, many of Degas' friends were artists, most of them French but a few of other nationalities. Among these companions the most important was undoubtedly Gustave Moreau (1826–1898),[33] who was eight years older than Degas. They had met in Rome at the *académies du soir* (or evening classes with models) at the Villa Medici, probably early in 1858. Moreau, a natural and tolerant teacher, probably gave Degas the most encouragement in undertaking history paintings himself. Since Degas was living at a time when artists like Eugène Delacroix (1798–1863) and, very differently, Ernest Meissonier (1815–1891) were using horses as a significant part of their history paintings, he almost inevitably contemplated producing works himself in which horses would play both starring and supporting roles.

Alexander and Bucephalus (cat. 6) was the earliest history painting in which Degas cast a horse as a protagonist. According to Plutarch, when Alexander was a youth at the court of his father, Philip, in Macedonia, he was shocked that his father's trainers were unable to break in a large, wild steed. Against all advice, Alexander took up the challenge himself, and succeeded after realizing that the horse was afraid of its shadow. Degas depicts the moment when Alexander masters the great stallion by protecting its eyes from the sun. It was an uneven victory, and the horse is surprisingly docile in the probably unfinished painting. An independent drawing (fig. 15) reveals the struggle that has taken place through the awkward but vigorous contours of the leg and chest, the unresolved but energetic bristling strokes through the mane, and the passion expressed in the mobility and darkness of the eyes, nostril, and opened mouth. Degas uses the horse as a witness to Alexander's future greatness. In the painting, this is also expressed in the amazement of the men who look toward the prince who has conquered this valiant horse as he would a great empire.

It is instructive to study the few extant drawings for *Alexander and Bucephalus* and the other versions, one in oil and one in gouache,[34] of the composition. The drawings of draped figures for Philip and his court are solid and substantial,[35] as clearly defined sculpturally as figures by Masaccio or Raphael, whereas in the paintings only Alexander seems complete. In the same way the studies of the mountainous countryside have a clarity that is absent in the painting.

Something else compensates for this loss of clarity and completeness, however, and that is the evocative power of color. This was inspired by the examples of Moreau and also Delacroix, whose work he had come to appreciate and imitate. And from one note on *Alexander and Bucephalus*, it is clear that Degas was thinking in terms of color, if of the most discreet kind, "The building is in the tones of fresco – green walls and columns of marble or granite – The city frees itself imperceptibly from the grayish pink mountains – silvery sky – the city is of a dark milky tone like Veronese – with touches of green growth – everything closely bound together."[36] This is closer to the gouache version; the colors are warmer and made more opaque in the two oils. But all three are remarkable for Degas' sensitive and dramatic use of color. In some ways *Alexander and Bucephalus* is as close as Degas was to come to the history paintings of Moreau, who nevertheless did teach Degas about how evocative the unfinished, the unformed, the unrealized, and even the unarticulated could be in painting.

fig. 15. Study for *Alexander and Bucephalus*, c. 1859–1860, graphite on paper. Private collection

cat. 6. *Alexander and Bucephalus*, 1859–1861, oil on canvas. National Gallery of Art, Washington, Bequest of Lore Heinemann in memory of her husband, Dr. Rudolf J. Heinemann, 1997.57.1

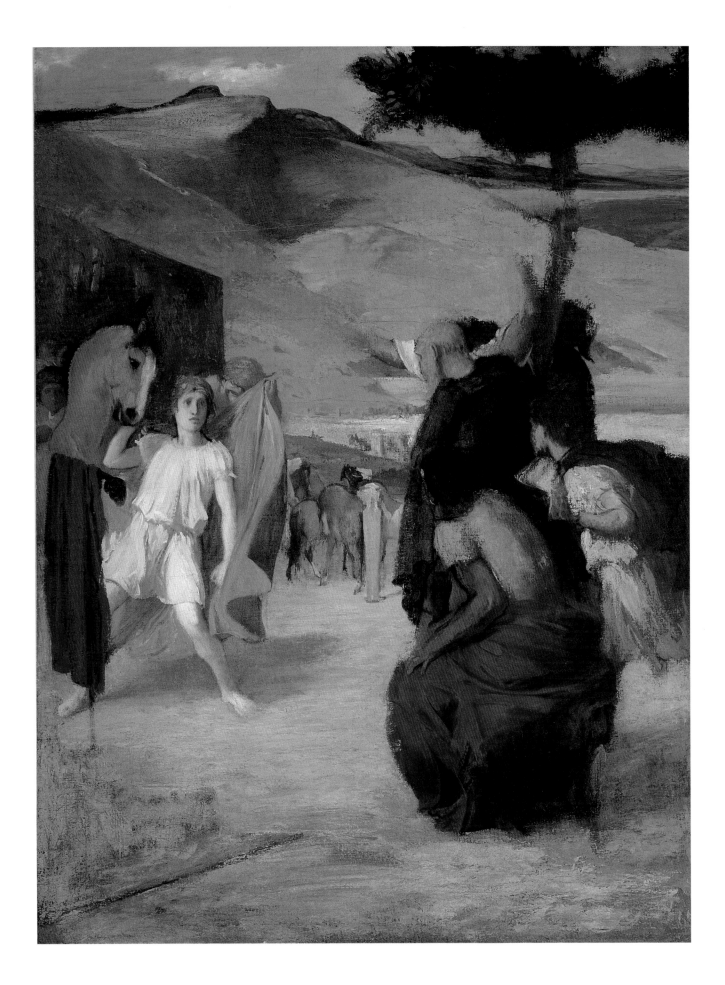

In his other history paintings, the horse plays only a supporting role. For *The Daughter of Jephthah* (fig. 16),[37] Degas chose an enormous canvas – the largest he ever attempted – an indication of his ambitions for the work, through which human beings and horses move or stand as if they are on a vast operatic stage. Degas also made a number of studies for the work, and on some he added notes, occasionally on color. In this biblical story, Jephthah, a mercenary, returns from a battle he has won after pledging to the Lord that he will sacrifice "whatsoever cometh forth of the doors of my house to meet me."[38] This turns out to be his beloved daughter, who is celebrating her upcoming marriage with her maidens on the hillside. The conjunction of the triumphant army returning and those at home ready to celebrate that victory as well as the nuptials of Jephthah's daughter – both groups ignorant of the imminent tragedy – is full of dramatic possibilities. But it is also severely hampered by the limitations that the unities of space and time impose on a painting. In the moment Degas chose to represent Jephthah, the warrior is the only one aware of the tragedy, which consumes and humbles him.

The horse is a link between the battle and the homecoming. In one study (fig. 17) the steed seems to have been caught as it prances proudly, but just as it begins to sense the agony of its master, who twists away from the sight of his child and clenches his left fist in a pose that is almost operatic. With its head thrust suddenly back, its eyes frighteningly blank, and its nostrils and opened mouth alert, the horse responds sympathetically and actively, helping him establish an acceptance of the tragedy. In another drawing (fig. 18), the horse is dignified and undisturbed, not as yet aware that his master has just realized who the victim will be

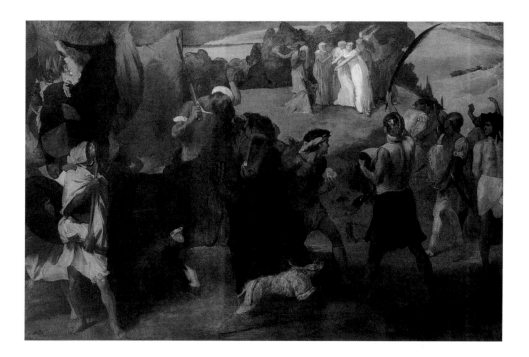

as he stretches out his arm toward his daughter. The head of the horse is reminiscent of one from the east pediment of the Parthenon. Degas made a small oil painting from this head, which he may have painted while working on *The Daughter of Jephthah*.[39] During these years Degas also made a single drawing of Jephthah's horse (fig. 19) with a glimpse of a man behind. Holding its head upward, as if in pained disbelief, this steed prances but does not move forward. Its shock is expressed in inaction but also by the quivering lines with which it is drawn. It is further evidence of Jephthah's tragedy.

Ultimately Degas decided to change both rider and horse in the painting. In

fig. 16. *The Daughter of Jephthah*, c. 1859–1861, oil on canvas. Smith College Museum of Art, Northampton, Massachusetts, Purchased, Drayton Hillyer Fund, 1933

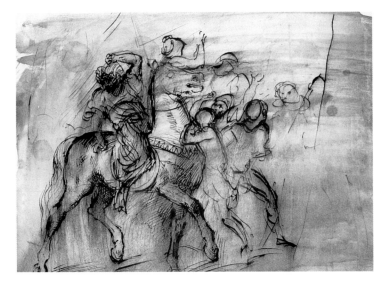

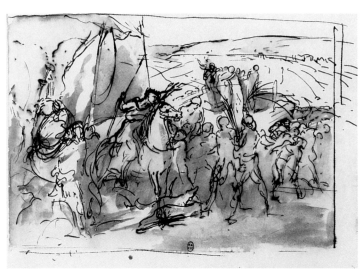

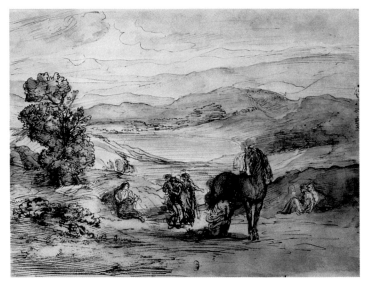

the final version their heads are bowed in their full knowledge of the event. It has been suggested that Degas' decision to paint the moment as one of passive resignation rather than defiance was influenced by Delacroix.[40] Degas had copied the older artist's painting *Ovid among the Scythians*,[41] perhaps when it was exhibited in the Salon of 1859 after his return from Italy, although the copy (fig. 20) seems to have been made from memory since he changed some of the details.[42] It took a full page in his large notebook and was exquisitely executed in pen and brush with brown ink. In the painting, the horse – a very large mare – is being milked for the legendary sustenance of the Scythi-

ans. It is quite reasonable that this horse should have influenced the horse in the *Daughter of Jephthah* on which Degas was working when he was copying the Delacroix. Degas made his horse more resigned, not unlike his Bucephalus. In the end Degas was never satisfied and he repainted *Jephthah* more than once, but apparently made no attempt to exhibit it, publish it, or sell it during his lifetime.[43]

Studies for another history painting, *Sémiramis Building a City* (fig. 21), are also found in Notebook 18. Significantly, however, most of Degas' preparatory drawings – among the most exquisite he ever made – are on separate sheets of paper. Having returned to France and

fig. 17. Study for *The Daughter of Jephthah*, c. 1859–1860, ink with wash on paper. Bibliothèque Nationale, Paris (*top left*)

fig. 18. Study for *The Daughter of Jephthah*, c. 1859–1860, ink with wash on paper. Bibliothèque Nationale, Paris (*top right*)

fig. 19. Study for *The Daughter of Jephthah*, c. 1859–1862, graphite on paper. Private collection (*bottom left*)

fig. 20. Copy after Eugène Delacroix, *Ovid among the Scythians*, April–June 1859, ink with wash on paper. Bibliothèque Nationale, Paris (*bottom right*)

found stability and space living with his father and renting a large studio for his work, Degas was no longer as dependent upon portable notebooks for his first explorations of works of art. Nevertheless, Notebook 18 contains, as Reff points out, another form of study for *Sémiramis*: his lists of "important publications of archaeological material," his copies of "almost every type of exotic art available to him in Paris, including Assyrian reliefs in the Louvre, Mughal School miniatures and Greek coins in the Bibliothèque Nationale, reproductions of Assyrian and Persian wall paintings," among other more contemporary material.[44] While exploiting the variety of his sources in conceiving *Sémiramis*[45] — and there were others — Degas wanted to paint a generic rather than specific Near Eastern subject around this mythical queen who is said to have built the great city of Babylon.

In Notebook 18, in the middle of drawings Degas made at the Salon in Paris between April and June 1859, is a sketch in black ink (fig. 22). The sketch could be one of the artist's first proposals for *Sémiramis,* except that unfortunately, from the point of view of establishing the

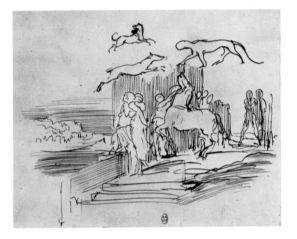

fig. 21. *Sémiramis Building a City*, c. 1860–1862, oil on canvas. Musée d'Orsay, Paris

fig. 22. Compositional study for *Sémiramis*, c. 1859, ink on paper. Bibliothèque Nationale, Paris

fig. 23. *Study of a Horse* (study for *Sémiramis*), c. 1860–1862, graphite on paper. Musée du Louvre, Département des Arts Graphiques, Fonds du Musée d'Orsay, Paris

date, it has been pasted in, perhaps at a later time. The queen, overlooking the valley where the city would be built, does not dominate this study. Another figure attempts to rein in a balking horse. This stallion is uncontrolled compared with the principal horse in the painting, but it is as assertive, its silhouette almost as pure. And it looks upward to a small horse galloping, a large dog bounding, and a panther prowling in the sky.

Although Sémiramis assumes her queenly place with her courtiers as she surveys Babylon in the final painting, she is essentially balanced by the protective horse that stands with such dignity behind her. The steed, placed in a horizontal, friezelike composition, derives from the drawing Degas had made about four years earlier from a plaster cast of the Parthenon (cat. 1). Whether Degas kept that early drawing with his studies for *Sémiramis* is not known, but when the Louvre acquired the painting and most of the preparatory drawings at the sale after the artist's death, it numbered this drawing as a study for this work rather than as an early copy.[46] On another piece of paper about the same size as his early copy, from about 1860, Degas worked with pencil, producing a more sophisticated drawing of the horse (fig. 23). He ignored the head but emphasized its hindquarters. The gradation of light to shadow is so delicate and precise that it indicates both the anatomical observation and respect for the surface of the coat he was learning to reproduce from copying the works of Géricault, although the effect of the horse in this drawing is not nearly as robust. Degas was distilling his earlier drawing from the Parthenon frieze, a form of purification, rather than working directly from the horse. To add the final touch to this refinement he lifted the tail as an elegant brush. When it came to what was presumably the last drawing

of the horse before the painting (cat. 7), Degas retained more of the substance of the Parthenon horse and, using the gradations possible with *estompe*, he imitated what Géricault did in oil paint to suggest both the musculature and the gloss of the animal's coat. The tail, although as much a gesture of self-confidence as in his intermediary drawing, is at the same time longer and more natural. By closing the mouth of the horse and darkening its eyes he made it less menacing than the one on the Parthenon.

In order to make the horse prominent against the panorama of the city and the courtiers Degas gave it a shining "white muzzle" on its nostrils and mouth and an even greater flourish to its tail. Two other horses are visible – the back of one behind the first, the nose of another appearing above the chariot at the right – but Degas had been indecisive about both in all of his studies, and something of that indecision has remained. One drawing (fig. 24) that illustrates an intermediary state shows an obsession with the ornamentation of the horse that might have been derived from Assyrian art and perhaps encouraged by Moreau – the combing of the mane, the weaving of a tie around the full tail, and in particular the tassels, which only survive in a much simplified and bulky bridle in the finished painting. Degas' solution in this drawing for the second horse as a curious and impudent spectator, who raises its head to see above the attendants, reveals that he was able to conceive this animal as an antidote to the staid court of the Babylonian queen. *Sémiramis Building a City* is a serene and serious painting, but there is almost no communication among the participants. The horse seems the most spirited figure in the composition.

For his last traditional history painting, *Scene of War in the Middle Ages* (fig. 25), which he exhibited as his first submis-

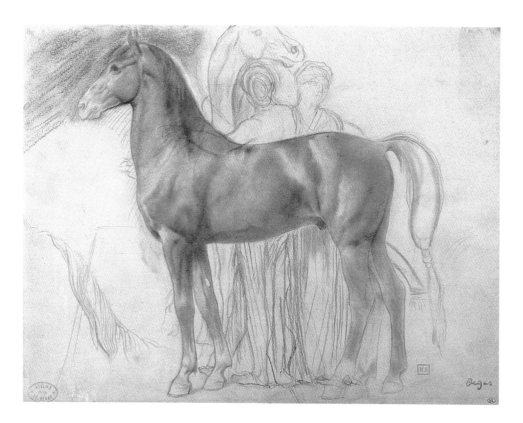

sion to the Salon in 1865, Degas chose stallions as imposing and noncommunicative as the horse in *Sémiramis*, and also painted them in profile. But there the similarities end. This harrowing subject, with the nude women who have been violated by the men on horseback, painted against a background of flames and smoke that rise into a cloudy sky and struggle with any glimmer of sunlight on the fields, has never been satisfactorily explained.[47] The costumes suggest the late Middle Ages. A preparatory drawing for the archer at the left is of a female, perhaps Jeanne d'Arc, the Maid of Orléans, which would confuse its meaning further.[48] The name "Orléans" has some association with the work,[49] and Degas' paternal grandfather was from Orléans and his mother from New Orleans. Four years before this painting was exhibited at the Salon, during the Civil War, Union soldiers, in capturing the city of New Orleans, where part of the artist's mother's family was still living, treated the women of the city barbarically; and

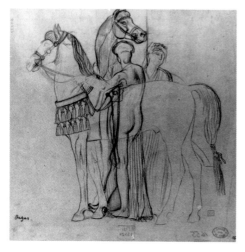

cat. 7. *Study of a Horse and a Group of Attendants* (study for *Sémiramis*), 1860–1863, graphite and chalk with *estompe*, with crayon on paper. Musée du Louvre, Département des Arts Graphiques, Fonds du Musée d'Orsay, Paris (*top*)

fig. 24. *Two Women Restraining Two Horses* (study for *Sémiramis*), c. 1860–1862, graphite on tracing paper. Musée du Louvre, Département des Arts Graphiques, Fonds du Musée d'Orsay, Paris

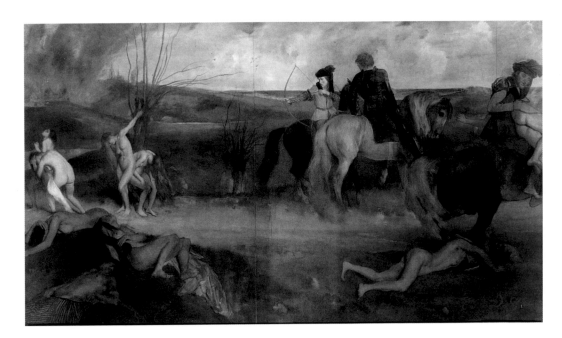

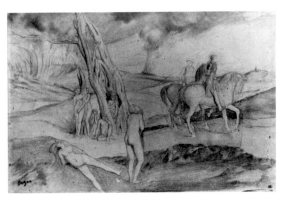

fig. 25. *Scene of War in the Middle Ages*, 1863–1865, *essence* on paper, mounted on canvas. Musée d'Orsay, Paris

fig. 26. Compositional study for *Scene of War in the Middle Ages*, c. 1863, graphite and wash on paper. Musée du Louvre, Département des Arts Graphiques, Fonds du Musée d'Orsay, Paris

it has been suggested that this painting was Degas' interpretation of that event in medieval dress.[50] It remains a bewildering, though deeply moving, picture.

The stallions do not share in the ignominy; they are merely the handsome bearers of the archers. Among the many beautiful independent drawings for the painting none survives for the horses. The only place where the principal two horses appear is in a pencil compositional drawing (fig. 26), which is otherwise almost completely changed in the finished painting. Curiously it is the horses – and not their riders – who survive most nearly intact. This part of the drawing, however, was pasted on later (but certainly not as late as the finished painting), as a correction to what lay underneath. From this

drawing, and even more from the painting, it seems probable that Degas had worked from the animals themselves. It is clear that Degas wanted strong horses with broad and rounded croups, generous tails and manes – but in the painting he made them even more powerful. He enlarged the animals in proportion to their riders, simplified their legs, and painted their tails and manes to cascade even more extravagantly. In particular, he colored the most conspicuous horse a pale gold with a strong light falling upon its haunches. The horses have the proportions and manes of the Austrian Lipizzaner and presumably possessed its strength and agility. But even such a splendid animal as the golden horse can, with its sorrowful large black eyes, the hair of its mane flowing softly, and the bent head, give some hint of shame.

Two years after the artist's death, one of his friends, Paul Lafond, wrote a book on his work, in which he notes that in these different compositions – *Sémiramis Building a City*, *Scene of War in the Middle Ages*, *Alexander and Bucephalus*, and *The Daughter of Jephthah* – there are "impeccable and superb horses like the one we will find in the painting of *Mlle Fiocre (ballet de la Source)*."[51] Degas exhibited *Mlle Fiocre in the Ballet "La Source"* (cat. 8) as his fourth submission to the Salon, in 1868, and the painting has always been difficult to classify. Degas called it a portrait, but "à propos du ballet 'La Source.'" The caveat is necessary because, although the dancer, Eugénie Fiocre, sat for him,[52] her position of almost complete lassitude in the painting, as she supports her head on her hand, does not reveal her character, temperament, or even her appearance. It has also been called his first painting of the ballet, but Degas has not painted the performance itself but a break in rehearsal, which is indicated by the pink ballet slip-

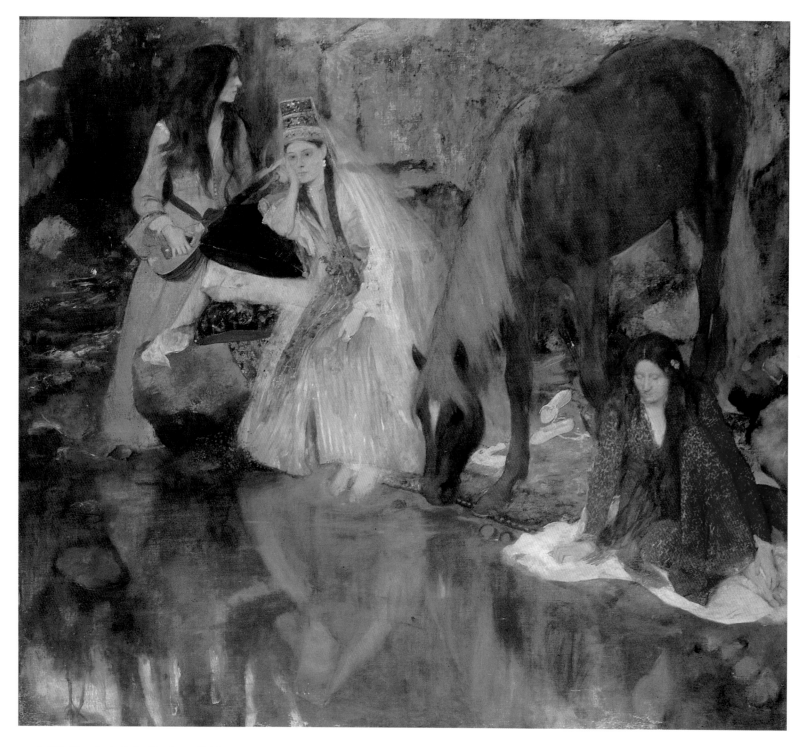

cat. 8. *Mlle Fiocre in the Ballet "La Source,"* 1867–
1868, oil on canvas. The Brooklyn Museum of Art,
Gift of James H. Post, John T. Underwood, and
A. Augustus Healy, 21.111

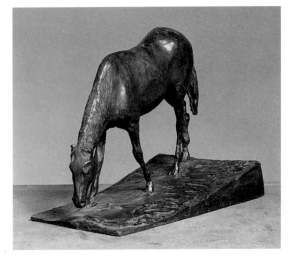

fig. 27. *Horse at a Trough*, c. 1867–1868, bronze. The Metropolitan Museum of Art, New York. Bequest of Mrs. H. O. Havemeyer. The H. O. Havemeyer Collection

cat. 9. *Study of a Horse*, 1867–1868, graphite on paper. Museum Boijmans Van Beuningen, Rotterdam

pers cast aside on the floor. As a depiction of a theatrical event in the France of Napoléon III, it could be considered a history painting. Eugénie Fiocre was sufficiently renowned and the ballet itself, which had been performed for the first time in November 1866, was considered such a distinguished event that Ingres and Verdi were at the dress rehearsal. The critics at the Salon of 1868 were also bewildered as to the classification of the painting. The three women beside the pool reminded the caricaturist Bertall of washerwomen doing their laundry in the Seine, and he gave them as companions two enormous horses like enlarged toys, all stupefied because they had forgotten the laundry itself. But, in considering Degas' later paintings and pastels of dancers resting between performances, *Mlle Fiocre* seems a natural prelude to his later work.

Regardless of its classification, the presence of the horse is problematic. It was justified by the performance itself, because in the first act the heroine and her entourage entered on horseback. Degas depicts only one horse, as he chose only three dancers, to represent the ballet. In *L'Événement illustré*, Émile Zola commented that, "Three women are grouped along a bank, a horse drinks beside them. The horse's coat is magnificent."[53] Fortunately most of the painted animal seems to have survived the artist's difficulties with varnish, both before and after he submitted the painting to the Salon. Degas attempted to have this remedied in the early 1890s when a restorer removed the varnish and Degas repainted some of the work.[54]

The horse must have been a challenge for Degas. He presents it from an angle, from a three-quarters view, and perhaps

more significantly, from above. From its wobbly legs, its full flaxen mane, which is much lighter in color than its chestnut coat, and its slightly swayed back, it could be a pony, which would be practical from the point of view of the weight upon the stage. Although sharing with the dancers the moment of respite, it does not share in their lethargic, contemplative spell; instead, the horse, sensibly, drinks water from the pool.

It must have been while Degas was working on the painting that he made an exquisite pencil drawing of a similar horse, though reversed, with its head held upward (cat. 9); in the background, with a fainter touch, he lowered the head as if the animal were drinking from a pool. He also produced a work of sculpture, *Horse at a Trough* (fig. 27; cat. 111), which shows his interest in this horse from various angles. Because the painting is large, it is a surprise to discover that the wax or bronze cast is so small – about six-and-a-half-inches high. But visitors to Degas' studio frequently mentioned that he would pick up a wax in his hands and turn it around against a light to show its modeling. Walter Sickert described one such incident on his last visit to Degas in his obituary for the artist: "it was night – he held a candle up, and turned the statuette to show me the succession of shadows cast by his silhouette upon a white sheet."[55]

John Rewald was the first to propose that the *Horse at the Trough* was related to *Mlle Fiocre*.[56] By now it is generally con-ceded that it is one of the earliest works of sculpture, but there is still some disagreement about which came first – the sculpture or the painting.[57] It is not impossible that Degas began the painting, had some difficulty with the horse, and modeled one in wax in order to study it more easily from above. As was characteristic of his early work in sculpture, Degas' armature was tidy and intricate, and his modeling of the wax relatively smooth.[58]

In *Mlle Fiocre in the Ballet "La Source,"* the dance and the world of horses came together, but the beginning of their relationship was also its end. Both the ballerinas and the horses would flourish separately in their own natural environments in the later work of Degas.

1. The most definitive biography on Degas is Henri Loyrette, *Degas* (Paris, 1991). Roy McMullen's *Degas, His Life, Times and Work* (Boston and New York, 1985) is in English and, although not as detailed, is very good. Only information of particular interest to "Degas at the Races" will be footnoted.

2. From the records of the births of the painter and his siblings and from the painter's school records we know that the family moved at least twelve times in the eighteen years between 1834 and 1852. See Loyrette 1991, 680, n. 31.

3. His sister Thérèse was born on that visit.

4. Paul Valéry in relation to Degas wrote of the lycées of the 1850s as "an incredible system, conceived as it was to exclude carefully anything to do with the body, the senses, the sky, the arts, or social life" (Valéry 1960, 22).

5. Louis Lamothe was from Lyons, where he had studied with Hippolyte Flandrin. Degas may have worked in Lamothe's studio before entering the École des Beaux-Arts. Among other artists who studied with Lamothe were Henri Regnault and James Tissot.

6. Among many others, Lipton 1986, 30–32; Richard Thomson in exh. cat. Manchester 1987, 93–99.

7. Reff Notebook 3, 28.

8. Jean Sutherland Boggs, "Edgar Degas and Naples," *Burlington Magazine* 105, no. 723 (June 1963), 273–276; Riccardo Raimondi, *Degas e la sua famiglia in Napoli, 1793–1917* (Naples, 1958); Loyrette 1991, 143–148. The Palazzo Degas was next to the Gesù Nuovo on the calatà Trinità Maggiore.

9. Loyrette 1991, 145–147.

10. Loyrette 1991, 15–16, 679, n. 24.

11. Reff Notebooks 7–13. Notebook 7 is in the Musée du Louvre, Paris, Département des Arts Graphiques, Fonds du Musée d'Orsay. Notebook 8 is in the Pierpont Morgan Library, New York. The others are in the Bibliothèque Nationale, Paris.

12. See Henri Loyrette, *Degas e l'Italia* [exh. cat., Villa Medici] (Rome, 1984–1985).

13. Reff Notebook 8, fols. 24v (fig. 4), 26v, 27. The races were probably held the last five days of the Carnival before Lent in 1857.

14. Carle Vernet was a member of a distinguished family of painters, who specialized in battle scenes (for Napoléon), races, and hunts. Fol. 27 in Reff Notebook 8 was after Carle Vernet.

15. Although there are also two bands of notes, these apply to a history composition upon which Degas was working during these years and which did not involve a horse, *Saint John the Baptist and the Angel*, based on the Apocalypse.

The vision of the riderless horses is, however, almost apocalyptic in itself.

16. Reff Notebook 8, fols. 78v, 79, 79v show the whole donkey.

17. Saint John the Baptist: L 20, 21 (locations unknown); L 22 (Niarchos collection). Dante and Virgil: L 34, 36 (locations unknown), L 35 (City Art Museum, Saint Louis). David and Goliath: L 114 (Fitzwilliam Museum, Cambridge).

18. When Degas arrived in Florence by 4 August 1858, his aunt and two cousins were in Naples, where his grandfather was dying, and did not return until early November. His purpose for being there was the preparation of the family portrait, *The Bellelli Family* (L 79, Musée d'Orsay), which he probably painted later in Paris. He did not leave for France until early April.

19. Reff Notebook 12, fols. 11, 72; Notebook 13, fols. 41–45 (with notes) provides the evidence for his admiration for Anthony van Dyck (Flemish, 1599–1641).

20. Reff Notebook 5, fol. 35.

21. Reff Notebook 13, fol. 45.

22. The painting entered the Luxembourg in 1849 (4891). Degas could have used Géricault's lithograph of the painting; the Musée du Louvre, Paris, Département des Arts Graphiques, Fonds du Musée d'Orsay, Fonds Fevre Degas, contains a heavily inked impression of it.

23. De Dreux copies are Reff Notebook 13, fols. 60, 61, 65, 66, 68, 98, 118, 120.

24. He was delayed twice in Florence, when he was still learning how other artists used the horse. His first visit lasted about eight months. The second stay was only for about a month, during which time he made two drawings of his uncle for the family portrait and made some copies in the Medici Chapel, which he dated "1860" (cats. 3–5).

25. Peter and Linda Murray, *The Age of the Renaissance* (New York and Washington, 1974), 118.

26. Reff, who has argued that Degas inscribed the dates on many of his drawings in Italy later and made errors through lapses of memory (Theodore Reff, "Degas's Copies of Older Art," *Burlington Magazine* 105, no. 723 [June 1973], 150–151), has never questioned the dates on these drawings after Benozzo Gozzoli in the Medici-Riccardi palace.

27. Before leaving for Italy Degas had made a copy after Benozzo Gozzoli's *Triumph of Saint Thomas Aquinas* in the Louvre (Vente IV: 101.a). In Italy he made studies after the other artist's fresco series in the Campo Santo, Pisa (L 52, Vente IV: 65.c), two inscribed "Pisa 1859" in the Kunsthalle, Bremen, and one in a notebook, Reff Notebook 3, fol. 35, which Reff believes is after an engraving, and the following drawings in notebooks: Reff Notebook 2, fol. 8; Notebook 8, fol. 12; Notebook 9, fols. 27, 31, 32, 35, 37; Notebook 15, fol. 13.

28. Degas made drawings of the angels: Vente IV: 81.d and IV: 93.a, both identified as after Benozzo Gozzoli by John Walker, the first director of the National Gallery of Art (Walker 1933, 184, 185).

29. It can remind us of the comments of Gisela Richter on the Parthenon frieze, which Degas, after all, had studied in making his copies. Of the Parthenon sculptor she wrote, "he is able to accomplish astounding things. In the cavalry procession, for instance, he represents as many as eight horsemen abreast in a relief of only about two inches in depth, and the effect is convincing" (*The Sculpture and Sculptors of the Greeks* [New Haven, 1950], 170).

30. Three compositions of Dante and Virgil were more or less finished (L 34, 36, locations unknown; L 35, City Art Museum, Saint Louis).

31. Notebook 18, the richest of Degas' notebooks, was actually taken apart and exhibited in *Degas: Form and Space* [exh. cat., Centre Culturel du Marais] (Paris, 1984–1985). In the unconventional catalogue for this unconventional exhibition, most of Notebook 18 is reproduced (with Reff's notes), much of it in color. (The notebook has been bound since.)

32. Reff Notebooks 12–16, all in the Bibliothèque Nationale in Paris.

33. For the fullest account of his life and work, see P. L. Mathieu, *Gustave Moreau, with a Catalogue of the Finished Paintings, Watercolors and Drawings* (Boston and New York, 1976).

34. L 92 (oil) and L 93 (gouache).

35. For examples of draped figures see National Museum Stockholm, NM 38/1977; Reff Notebook 19, fols. 40, 46, 63.

36. Reff Notebook 19, fol. 38.

37. See Loyrette in exh. cat. Paris 1988–1989, no. 26, 85–87.

38. Judg. 11:30–35.

39. Lemoisne gave the study of the head a number – 98 – that followed the other painted studies for *Jephthah*, although he did not comment on it.

40. For the influence of Delacroix see, among others: Reff 1976, 19, 24; Loyrette in exh. cat. Paris 1988–1989, 86, 87; Kendall in exh. cat. New York 1993, 44–45.

41. For the history of *Ovid among the Scythians* by Delacroix, see Martin Davies, *National Gallery Catalogues: French School* (London, 1957), 77–79.

42. Reff Notebook 18, fol. 127.

43. The only mention of *Jephthah* in a publication before the artist's death seems to be a passing reference in Lemoisne 1912, 30. The mystery is how he knew about it, although he had arranged to meet Degas in 1895 (author).

44. Reff Notebook 18, 19.

45. Although Lillian Browse, a former dancer and

author of *Degas Dancers* (London, 1949), observes that Degas, who was a theater- and opera-goer, may have been influenced by the new production of *Sémiramis* by Rossini (1792–1858) on 9 July 1860, Henri Loyrette, who has pursued the evidence of Degas' actual attendance at opera performances, denies this because the paintings and the studies of *Sémiramis* are such a contradiction of the character of that production. Nevertheless, that presentation of Rossini's opera, which also introduced a ballet which Degas would have appreciated even this early, could have challenged him to paint his own *Sémiramis* so coolly that Loyrette is reminded of *Salammbô*, the archaeologically and meticulously correct but nevertheless romantic novel of ancient Carthage by Gustave Flaubert (1821–1880), which was published in September 1862, probably too late to have influenced *Sémiramis* (in exh. cat. Paris 1988–1989, no. 29, 90).

46. For the history of this drawing see exh. cat. Paris 1969, no. 101, although it is not identified specifically as a study after the Parthenon frieze.

47. Loyrette in exh. cat. Paris 1988–1989, 105–107, gives the fullest coverage of the research, including some that had not been published.

48. (RF 15522) See exh. cat. Saint Louis 1967, 70 and no. 40.

49. As Loyrette points out in exh. cat. Paris 1988–1989, 105, the title "The Misfortunes of the City of Orléans" was given the painting on 1 May 1918, shortly after Degas' death, at an exhibition at the Petit Palais and at the first sale of the contents of his studio (Vente I:13). No explanation has ever been given.

50. Hélène Adhémar, "Edgar Degas et 'La Scène de guerre au moyen âge,'" *Gazette des Beaux-Arts* 70 (November 1967), 295–298.

51. Lafond 1918–1919, 2: 2.

52. The evidence is given by Loyrette in exh. cat. Paris 1988–1989, no. 77, 134.

53. Émile Zola, *Salons*, ed. F. W. J. Hemmings and Robert J. Niess (Geneva, 1959), 138, as printed in *L'Événement illustré*, 9 June 1868.

54. Rouart 1937; published in Denis Rouart, *Degas in Search of His Technique*, trans. Pia C. DeSantis, Sarah L. Fisher, and Shelley Fletcher (New York, 1988), 16. In her indispensable monograph on the painting, Ann Dumas (*Degas's Mlle Fiocre in Context* [Brooklyn, 1988], 45, n. 42) reports that when it was examined in the laboratory of the Brooklyn Museum in 1985, "X-rays revealed a faint pentimento along the line of the horse's neck and mane, suggesting that their position may have been slightly shifted." The "magnificent" coat seems, however, to have survived.

55. Sickert 1917, 185.

56. Rewald 1956, 15, 141.

57. Pingeot 1991, no. 42. Her catalogue of the sculpture of Degas is the best documented and most up-to-date. Barbour and Sturman (this volume) present a case for the horse preceding the painting.

58. Millard 1976, 97. Although Millard places the work later than we do, in the seventies, he bases his case on "the smooth and careful finish that Degas sought at the time."

Racing and the Steeplechase, 1861–1866

Ménil-Hubert and the Valpinçons

In September and October 1861, Degas took a trip to a remote part of Normandy to visit his friend Paul Valpinçon (1834–1894), an amateur painter, and his new wife at their family estate.[1] In 1823[2] the Valpinçons had acquired Ménil-Hubert, a château in the Norman countryside, which was not far from the great national horse-breeding establishment, Haras-le-Pin, and the minor racetrack at Argentan. It has been customary to think that the Valpinçons had horses, that they rode, they hunted, and that they permitted races and steeplechases over their land, but horses never seem to have been mentioned in later interviews with members of the family.[3] Yet it was undoubtedly his visits to Ménil-Hubert that introduced Degas to the horse in the stable, the paddock, and on the track.

Degas chronicled this trip to Ménil-Hubert in the large notebook in which he had made drawings for *Jephthah* and *Sémiramis.* His notebook included some text but largely handsome drawings, reminiscent of the landscapes of Claude Lorrain (1600–1682), whose etchings he had admired in Rome.[4] Degas began his text, "promenade to Haras-le-Pin . . . left the road at Argentan and took with Paul the strait route for Exmes. Exactly like England with small and large pastures enclosed with hedgerows, wet paths, some ponds, green and umber."[5]

The green, the dampness, and the shadows of the countryside around Ménil-Hubert were unlike the landscape Degas had left in Italy. In studying Degas' landscapes, Richard Kendall identifies the site of *Promenade beside the Sea* (cat. 10) as the Bay of Naples[6] and proposes that it must have been executed after his return to France, if not necessarily after his visit to Ménil-Hubert. The very grayness of the sky, the coldness of the waves breaking against the shore, and the general melancholy could be an expression of his discovery of Normandy and his identification of its countryside, people, and weather with what he knew of England from literature, and paintings and prints.[7] The riders might have been taken from some of his own drawings or paintings to be made in Normandy before the decade was over. The fact that the horses and riders are leaving the scene, so that only their backs are in view, and the fact that the figures are a couple makes the painting quietly romantic.[8] The horses are barely visible but the touches of light paint on their legs and, in particular, on the rump of the right horse, along with a glimpse of a shaggy mane, make them seem poetic, faintly reminiscent of works by Delacroix.

In this same Notebook 18, Degas also drew a landscape with a carriage (fig. 28), bearing two passengers with a whip, making its way on a curving road to Exmes. A bent old man walks beside them, two

cat. 16 (detail)

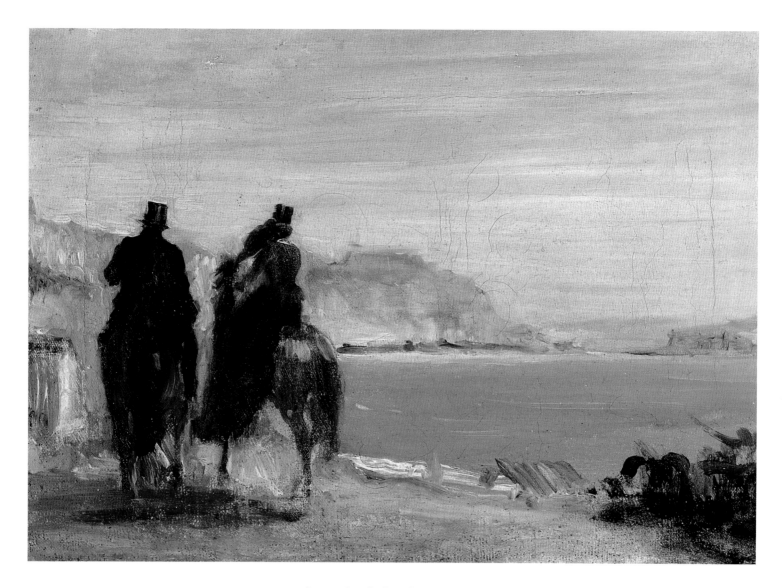

cat. 10. *Promenade beside the Sea*, c. 1860, oil on canvas. Private collection

casual stragglers before them, and a rather elegant lady with a parasol follows between two men, one clearly a gentleman, the other perhaps not. The landscape is bosky, full of entwined underbrush. The town of Exmes is revealed on the left at the top of a hill in the mid-distance. Degas describes it as "indeed a clean town with its church and brick houses." He goes on, "across hilly and wooded roads in a half hour we find ourselves in a large allée in a park with fences. Beginning of autumn."[9] On the next page there are inscriptions above and below a drawing of great trees on either side of a wide path and a view over a low fence to the formal château at Haras-le-Pin (fig. 29). Above he wrote, "The dead leaves cry out underfoot. One expects to see the horses breaking forth. Suddenly we are in a great allée which leads us to the château. It is the allée of Maisons-Laffitte." At the bottom, he added "The Haras is from the time of Louis XV. In front are two pavilions like the stables at Versailles."

Considering that it is generally believed that this trip marked the beginning of Degas' interest in equestrian things, there is surprisingly little evidence of horses in his notes or his drawings.[10] Although from the château of Haras-le-Pin, he did make a drawing of the landscape he saw and wrote, "From the terrace behind the château view on a countryside absolutely like those of the races and

to think that the society within the house drew in more rustic members of the surrounding community. In 1862 Degas dated heads he drew of these citizens – a justice of the peace at Gacé, a teacher, a parish priest, a doctor – which come close to the caricature in the English art he admired.

The future doyens of the household were, of course, Paul and his wife, who had married in January 1861. Although the collection of Paul Valpinçon does not seem to have been distinguished, his father had owned Ingres' *Valpinçon Bather* (now in the Louvre). M. Valpinçon was, in fact, persuaded to introduce the young Degas to Ingres, one of the great events of the artist's life.

Ménil-Hubert would turn out to be a very hospitable house where Degas would be welcomed for almost fifty years, until the artist was too infirm to make the journey any longer. He was known to say he was coming for two weeks and then stay for six.[13] Ménil-Hubert provided unexpected entertainment as well as a kindness he always respected and enjoyed.

The Racetrack

In the five years between his first visit to Ménil-Hubert and his exhibition of *Scene from the Steeplechase: The Fallen Jockey* (cat. 16) at the Salon of 1866, Degas was developing his portraits and history paintings, but he was also becoming more familiar with the racetrack. He continued this interest when he returned to Paris in October 1861. October was the month for the track at neighboring Argentan and Le-Pin, so he may have already seen an actual race before he left Normandy; *On the Racecourse* (fig. 30) makes this seem likely. Within a basin of wet green land, a small crowd of gentlemen and some women riders with top

fig. 28. *Pedestrians and a Carriage on the Road to Exmes*, 1861, ink with wash, heightened with white, on paper. Bibliothèque Nationale, Paris (*top left*)

fig. 29. *View toward the Château of Haras-le-Pin*, 1861, pen and ink, reworked with wash, on paper. Bibliothèque Nationale, Paris (*top right*)

fig. 30. *On the Racecourse*, 1861–1862, oil on canvas. Öffentliche Kunstsammlung, Basel

hunts in English colored prints."[11] He had never been in England, but its art and its fiction – he was reading Tom Jones in translation – had prepared him for this new world he was exploring in France.

Degas and Paul Valpinçon walked on to Ménil-Hubert. A wash drawing, largely gray, in the same notebook, is probably of the estate.[12] (The surrounding landscape is spare as if it were reduced as he tried to recreate it.) There is reason

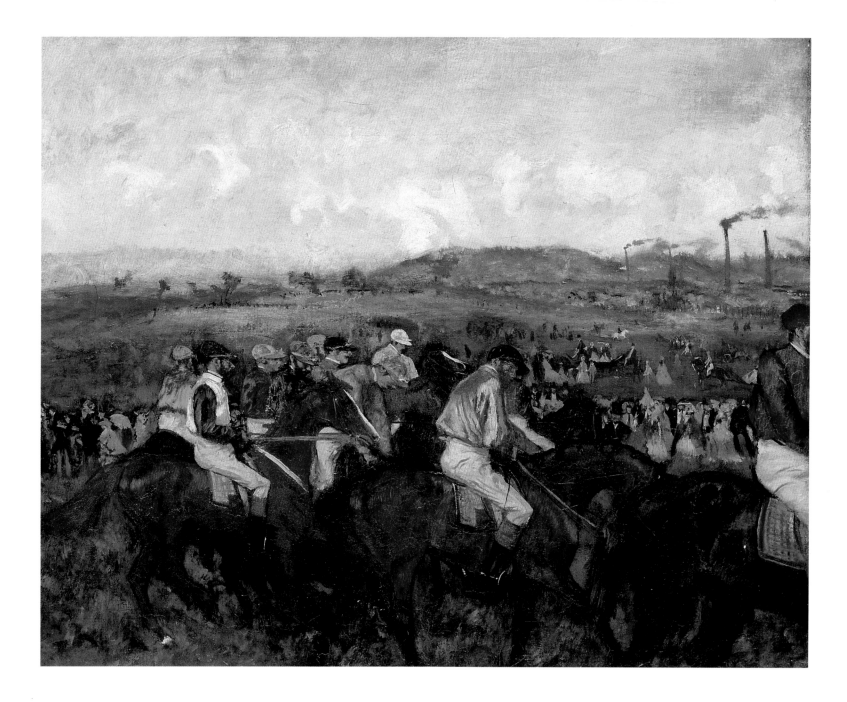

hats, other women with lighter bonnets and capes, and a few boys with soft caps look down at a sunlit patch of grass where gentlemen riders prepare their horses for the steeplechase.

It is difficult to know what drew Degas to the track. Gambling could not have been the attraction. In fact, Paul Valéry relates an anecdote Degas liked to tell:

He had set off in the train for a suburban racecourse, in order to do drawings of horses' legs. In the same compartment were a number of dubious-looking individuals who started playing three-card monte, and naturally asked him to take part. Degas declined, saying he never played. "What are you going to the races for, if you don't play?" they countered, in a menacing manner. Degas, not very pleased with the turn things were taking, decided to make boldness pay, and said, with a smile full of dangerous innuendo: "You would be mighty surprised if I told you what I am going for!" Thinking he must be a police agent, they said not another word, and vanished hurriedly at the next stop.[14]

Degas did inscribe a painting of the track "1862," but perhaps two decades later. It was called *The Gentlemen's Race* (cat. 11) when Durand-Ruel, Degas' dealer, bought it from the artist on 14 February 1883.[15] By then it was also acknowledged that the artist had repainted it. When he began the work in 1862 it would have been of a race near Ménil-Hubert, presumably at Argentan. What has survived of the 1862 canvas is generally believed to be the landscape with the figures against it in the distance and its atmosphere of dampness and general gloom. It suggests Degas' letter to Henri Rouart twenty-three years after that orig-

inal visit to the Valpinçons, "water which rises everywhere from under your feet. There are some pastures where it is like walking on sponges."[16] X-rays of the painting reveal the reworking of the riders and the addition of the central hill and the smokestacks.[17] The artist was fascinated with smoke; in one notebook he used between 1877 and 1883, and therefore probably contemporary with the repainting, Degas listed possible subjects, "On smoke, the smoke of smokers . . . of tall chimneys, of factories, of steamships, etc."[18] And certainly *The Gentlemen's Race* is often remembered for those smokestacks, an indication that the race Degas used for the repainting took place in suburbs against the background of an increasingly industrialized Paris, rather than in the country.

Fortunately, two paintings survive which must be very close to what *The Gentlemen's Race* would have been in 1862: *Jockeys at Epsom* (cat. 12) and *At the Races: The Start* (cat. 13). Although the title given the first very small painting might have pleased Degas because of his success in equating the Norman and English countryside, both were undoubtedly based upon a race in Normandy, whether observed or remembered or assembled by artifice. That wet countryside, even producing an unlikely lake or bay in *At the Races: The Start,* is almost indisputably near Ménil-Hubert, probably at Argentan.

In the foreground of *Jockeys at Epsom,* perhaps the earliest of Degas' racetrack paintings, is the brown earth of the track — rough and irregular — with some scumbled brushstrokes of paint, which could record hay as well as mud. Beyond the jockeys is rich, sodden, green earth with a rain-filled sky, such an abrupt change in color, scale, and tonality that it seems to be a screen or a theater curtain. The landscape with figures is vintage

cat. 11. *The Gentlemen's Race: Before the Start,* 1862; reworked c. 1882; finished by 1883, oil on canvas. Musée d'Orsay, Paris, Bequest of the comte Isaac de Camondo, 1911

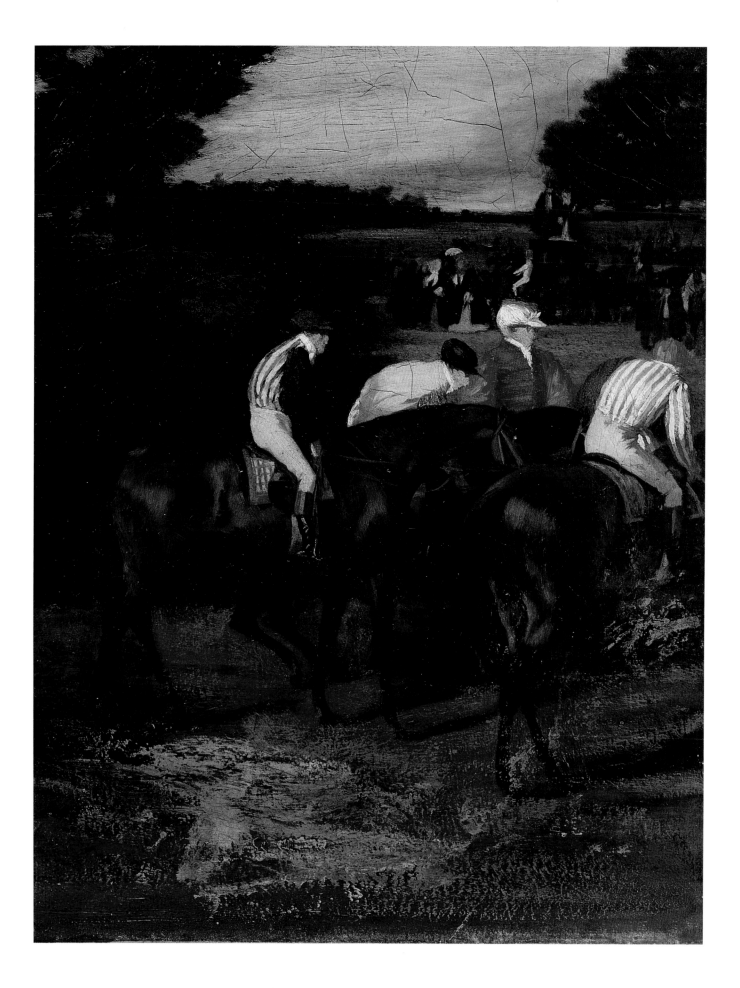

Ménil-Hubert, as confirmed by the notebook drawings and *On the Racecourse* (fig. 30). The people in these landscapes wear black attire and the men also sport top hats. Both men and women have scarves that relieve the otherwise sober color with touches of pink and white and pale blue. Twice in *Jockeys at Epsom* the light skirts of dresses spill out under the coats, in one case where the woman holds up a pink parasol. As Zola would describe spectators doing in *Nana*, one couple stands on top of their carriage for a better view.[19] It is a bourgeois crowd in spacious surroundings with a gap of green grass to separate them from the horses and riders, which only good behavior or self-protectiveness would explain.

The band of horses and riders, however, appears to be in a different realm. Such a distinction is common in race paintings and prints, but it is startling when compared with other canvases on which Degas was working, perhaps even simultaneously, such as *Daughter of Jephthah* (fig. 16), *Sémiramis Building a City* (fig. 21), *Alexander and Bucephalus* (cat. 6), and *The Bellelli Family*. In all of these there was an effort, even when the space was shallow, to unify the image back from the picture plane. Here the disruption could have been out of respect for an existing tradition, which may not be improbable, or more likely awkwardness as Degas was mastering a new genre. Even more curious to those not immersed in sporting prints, the jockeys are handled very differently in paint from the horses, but at least in the cursory way they are painted they establish a link with the spectators.

The horses in *Jockeys at Epsom*, based upon the paintings and prints of Géricault, appear to be anatomically convincing, solid and silken. The horse to the right, viewed from behind, is borrowed from Géricault's *Five Horses Viewed from the Rear* (fig. 8), although the concealing blanket has been removed. The one behind is less certainly adapted from Géricault; rather, standing in profile, its position is one of the conventions of the genre. Nevertheless, the two horses in the painting are cause for pride in life or in a work of art. Behind them are two others who, with their colorfully clad jockeys, are inserted without consideration of the rational order shown in the representation of multiple legs in the Parthenon frieze or the frescoes of Benozzo Gozzoli, which Degas had copied. The artist still has something to learn although he tries to clarify the relationship of the four horses to shadows on the ground.

Almost no studies of racehorses appear in the early notebooks of Degas, and even fewer of jockeys. One such drawing, in a notebook of 1859–1860, when Degas was thinking of *Jephthah*, shows a spirited horse and a shaken rider (fig. 31). By contrast, the riders in *Jockeys at Epsom* are more stereotyped, with three bent into a habitual curve and the fourth, in a red jacket, sitting back with a cultivated aplomb. Nevertheless, the lively colors of their jodhpurs, jackets (two handsomely striped), and puffed caps with small bows, animate the work, making their horses seem splendidly solid and shining, despite the sodden world in which they are about to race.

At the Races: The Start (cat. 13) is twice as wide and barely higher than *Jockeys at Epsom*, and the ground provides more consistent and gradual spatial transitions. In the background Degas became more ambitious, introducing many more figures. Degas' crowd is untidy and undisciplined, aside from a ring of well-dressed spectators closest to the race itself. The horizontal shape of this painting, instead of giving a concentrated image of enforced idleness before the race begins, as *Jockeys at Epsom* does, presents an

fig. 31. *Mounted Jockey*, 1859–1860, graphite on paper. Bibliothèque Nationale, Paris

cat. 12. *Jockeys at Epsom*, 1861–1862, oil on canvas. Mr. and Mrs. H. Anthony Ittleson

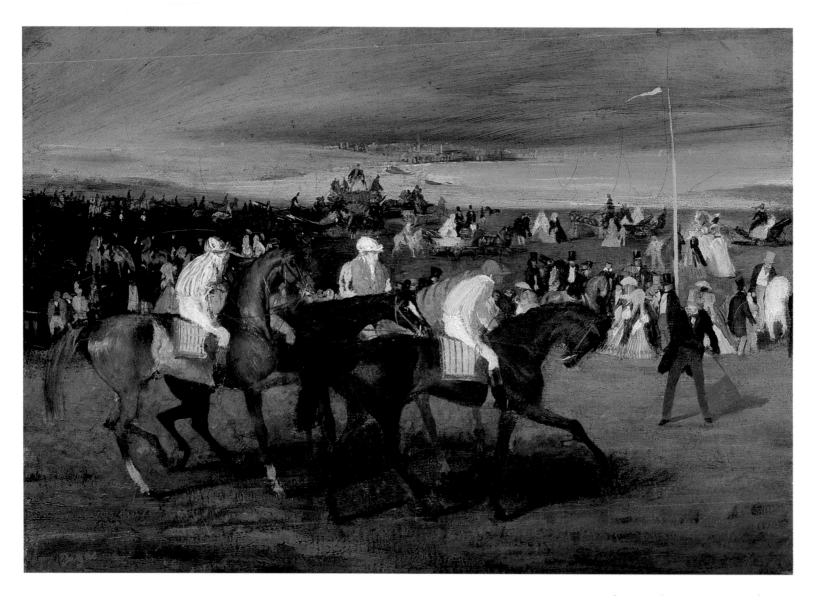

cat. 13. *At the Races: The Start*, 1861–1862, oil on canvas. Fogg Art Museum, Harvard University Art Museums, Bequest of Annie Swan Coburn

expectation of the horizontal experience of the race itself. The viewer is there, as its title implies, ready for the start.

The horses have changed most in the horizontal painting. Even something as seemingly simple as rendering them in four different hues – a light brown, a black, a reddish roan, a chestnut – gives greater individuality. Degas also restrains the luster of their coats and the demonstration of their anatomy, but the horses in themselves are more exhibitionist, showing off their limber bodies, their bent legs elegantly placed as in dressage, and their heads in positions that show their readiness to race.

Although Degas' notebooks contain surprisingly few studies of horses and jockeys, he did make independent drawings that show his concern with the positions and structure of the horse at the left and the horse at the right. The drawings that he made were on sheets of paper almost the same size as *Jockeys at Epsom*, but placed horizontally (cat. 14).[20] Although the artist had probably looked at actual horses, he was remembering works by Géricault like *Mounted Jockey* (fig. 32). Admittedly, the horses are reversed, which to Degas, the printmaker, was a natural process he often initiated. Degas is still showing how much he had learned from Géricault about musculature and the sheen of the horse's coat; his horse is also, like Géricault's, a proud animal. Degas asserts himself, modifying Géricault's influence slightly. In this case Degas has shortened and subdued the curve of the neck. The tail is more reticent, and the head is more reflective. The horse seems to step delicately as if it were measuring the tread. On the whole, Degas' horse is not as fiery an animal. As it turns its head very slightly, it is wistful and gentle. Lean and nervous, proud and cautious, it is a Degas horse in the making.

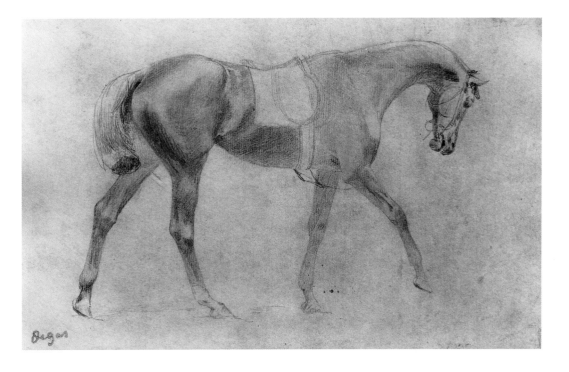

cat. 14. *Horse with a Saddle*, 1861–1862, graphite on paper. Private collection, courtesy of Galerie Schmit, Paris

fig. 32. Théodore Géricault, *Mounted Jockey*, 1820–1822, oil on canvas. Virginia Museum of Fine Arts

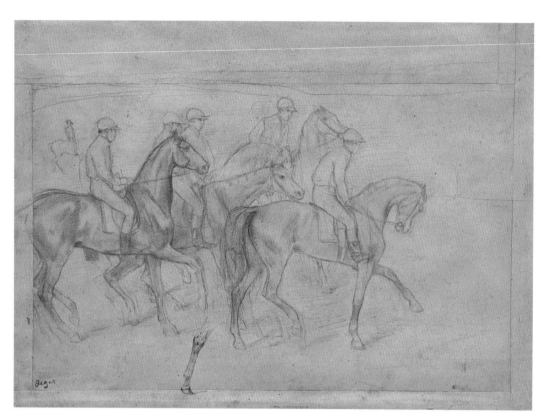

cat. 15. *At the Races*, c. 1865, graphite on paper. Sterling and Francine Clark Art Institute, Williamstown, Massachusetts

fig. 33. Gustave Moreau, *The Start*, c. 1865?, pen and ink on paper. Musée Gustave Moreau, Paris

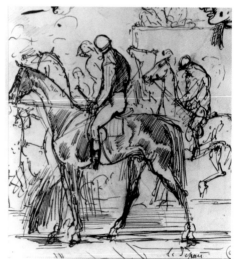

Degas had still not learned the lessons of the Parthenon frieze and Benozzo Gozzoli about the arrangement of rows of horses on a plane. The left and right horses of *At the Races: The Start* are clearly outlined (and complete) on the frontal plane. The black horse with the outstretched neck seems to have lost one of its legs, and the legs of the red horse are absent. Yet Degas again uses the shadows on the ground to pull the four horses and riders together. Kendall senses "the use of a set of conventions, rather than first-hand observation" and concludes that "Degas may well have put together these experimental canvases without visiting the racetrack,"[21] although perhaps *re*visiting the racetrack would be more accurate. A great deal of the work would have been done in Degas' studio.

Another drawing, clearly related to *At the Races: The Start*, is almost the same size but the horses and riders are larger (cat. 15). The three front horses are already familiar, even in personality, but the fourth and an additional fifth are also visible, raised slightly above the others, while a sixth tiny horse and rider is added toward the upper left, perhaps as a reminder that this is a sketch and not a finished work. In this exploratory drawing the efforts of Degas to clarify the positions of the twenty legs are visible. The horses and riders are pulled together as an active mass in the left three-quarters of the sheet, so that the blank quarter at the right is ready to receive them, a composition with an ingenuity unexpected for Degas in 1862. In fact, he has added strips of paper on all four sides for this purpose.[22] The drawing's greatest difference is in the description of the jockeys. Their bodies are more naturally articulated and relaxed. The rider at the left sits upright but at ease as he reins in his horse. Degas has obviously tried to sustain the anonymity or lack of individuality or charac-

ter in the faces of the original jockeys, but something escapes (with the exception of the rider at the left). The jockey at right is obviously young, the profile of the youth next to him angular and serious, the glimpse of the next somewhat cocky. It is as if Degas had come to know the jockeys and could not deny their individuality. Inevitably it suggests the possibility of Degas making this as a study to prepare to repaint *The Gentlemen's Race* (cat. 11), which he dated 1862. It is unlikely, nevertheless, that the drawing is as late as 1883, when he sold the painting to Durand-Ruel. Certainly it does not achieve the naturalness and the portraiture of the jockeys in the final version of the painting, so the drawing is more probably from the mid-sixties.

This drawing can be compared with one by Moreau (fig. 33), who may have encouraged Degas to find subjects at the track. Unfortunately, like Degas', it is undated. He handles the pen and ink with great bravura, much more apparently confident than Degas as he stresses the confusion before "Le Départ" (or *The Start*), which he writes on the bottom of the drawing. But the result seems superficial, lacking the thought that has gone into Degas' interpretations of his horses and jockeys. Moreau may have led Degas to the theme but he did not influence either Degas' conception of the racetrack or his execution of it.

The works from 1861–1862 were a tentative and modest beginning for Degas as a racetrack painter. Lemoisne realistically assesses them, "these first canvases do not yet reveal that research into movement, that immediacy of Degas's later paintings of the racetrack. He was still embarrassed by the anatomy of the horse."[23] After these brief efforts, inspired by his first visit to Ménil-Hubert, there was an apparent hiatus in Degas' drawing and painting of horses and races

from 1862 to 1866, when he most ambitiously took it up again for a large painting to be submitted to the Salon in 1866, *Scene from the Steeplechase: The Fallen Jockey* (cat. 16).

The Steeplechase

Although Degas was relatively unworried about money in the 1860s, he had already been warned by his father when he was in Italy that someday he would have to support himself.[24] Degas was as unprepared to make money as the rest of his family, but he did recognize the steps that must be taken to win renown as an artist, exhibiting at the annual Salon, as he had with *Scene of War* in 1865 and would do with *Mlle Fiocre* in 1868 (cat. 8), works which were unexpected and original in subject matter and therefore presumably eye-catching. The problem was that the critics did not respond, perhaps because his vocabulary was too discreet. It was with this challenge in mind that Degas exhibited *Scene from the Steeplechase: The Fallen Jockey* (cat. 16) in 1866. He had chosen a fashionable subject; it had been only three years since the Société des Steeple-chases was founded to regularize and encourage the sport. One of the attractions of the steeplechase, at least among those socially inclined, was that the riders were not professional jockeys, but "gentlemen." Another attraction was the danger of the race itself, in which horses and jockeys competed against each other, jumping over barriers and galloping across open fields or a course. Degas had not misjudged the potential interest in the subject, because one of the successes of the Salon was, if not a steeplechase, a professional race with jockeys: the *Grand Prix de Paris* by Olivier Pichat, which Emperor Napoléon III owned.[25] Pichat's canvas, however, was composed conventionally, based upon the tradition of En-

glish sporting prints and, unlike Degas' entry, was reassuring in its photographic clarity.

Degas must have wanted to cause his own sensation, even to rival what Manet had accomplished with his *Déjeuner sur l'herbe* (Musée d'Orsay) at the *Salon des Réfusés* three years before. It is unlikely that he cared about the kind of official and imperial recognition that Pichat had achieved at the Salon of 1866, but he would have enjoyed shocking the most discriminating collectors and critics and the artists he respected with something adventurous and new. To make certain that his painting would not be overlooked he selected a large canvas – 180 by 152 centimeters – and he chose to represent the drama of the steeplechase on this large surface with only two figures and two horses (one was essentially invisible). It was a bold conception for a relatively mundane event, with the visible horse galloping to freedom, having thrown the jockey, who seems inert on the ground. The other rider, as depicted in a cartoon by Cham (fig. 34) and Degas' squared preparatory drawing (cat. 17), was impassive. All the other aspects that would have surrounded such an event – spectators, horses and riders, stewards – are eliminated and we are left with what has been called "a contemporary mishap"[26] and the puzzle about whether the fallen jockey is alive or dead. It was probably too obscure as a concept to have invited even the criticism of any detractors then.

There seems to have been very little public response to the *Scene from the Steeplechase: The Fallen Jockey*. The cartoonist Cham[27] drew a very lively fallen jockey looking up open-mouthed at the large, ungainly horse moving diagonally across the canvas; the shoulder of a mounted jockey emerges from behind a cloud (fig. 34). Underneath the text reads, "M. De Gas. You cannot go there on

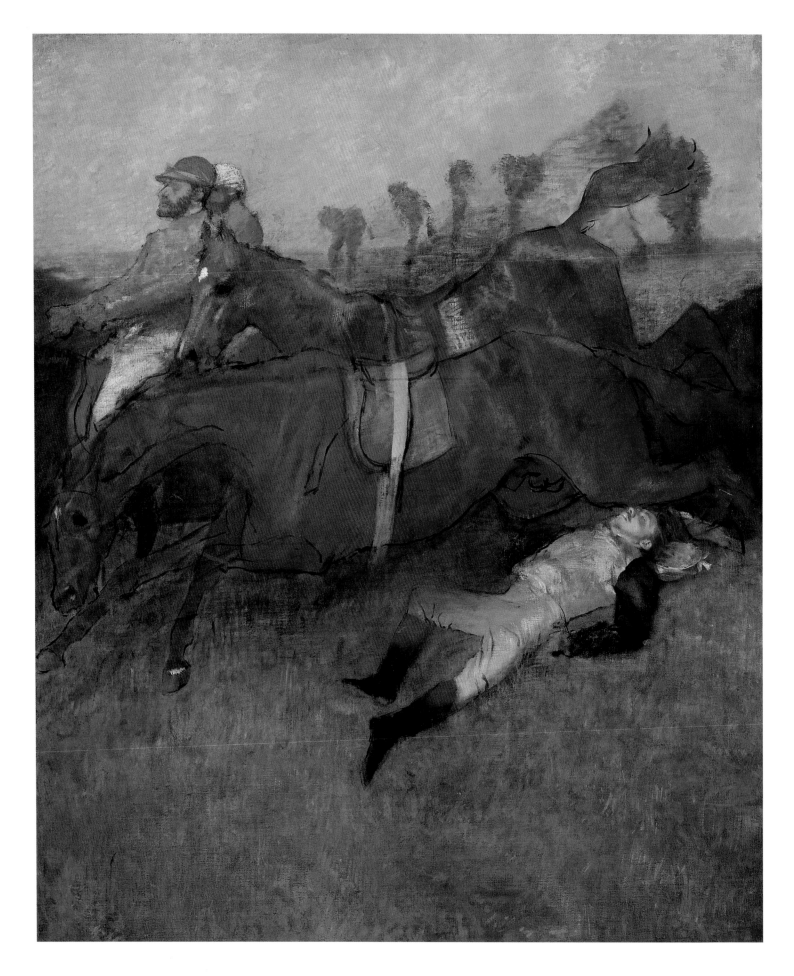

horses of wood!" One critic praised "this brisk and lively composition."[28] Another anonymously wrote of "the clarity and delicacy of tone . . . somewhat in the English style," but added, "Like the jockey, this painter is not yet entirely familiar with the horse."[29]

Thirty-one years later Degas agreed. In talking to the journalist Thiébault-Sisson, Degas revealed that the submission of the *Steeplechase* to the Salon was an important event in his career: "You are doubtless not aware that, about the year 1866, I perpetuated a *Scène de* Steeple-*chase*, the first, and for long after the only scene of mine to have been inspired by a racecourse." It was in this conversation that Degas boasted that in 1866 he had been "reasonably well acquainted" with the horse but he essentially admitted that the anonymous critic had been right when he told Thiébault-Sisson, "I was totally ignorant of the mechanism that regulates a horse's movements. I knew infinitely less on the subject than a non-commissioned officer whose lengthy and attentive practice enables him to visualize the animal's reactions and reflexes."[30] Whatever the reasons, Degas became dissatisfied with his *Scene from the Steeple-*

cat. 16. *Scene from the Steeplechase: The Fallen Jockey,* 1866; reworked, 1880–1881 and c. 1897, oil on canvas. Collection of Mr. and Mrs. Paul Mellon, Upperville, Virginia

cat. 17. *Jockey* (study for *Scene from the Steeplechase: The Fallen Jockey*), c. 1865–1866, graphite and chalk heightened with white on paper. The Snite Museum of Art, University of Notre Dame, Notre Dame, Indiana, on extended loan as a promised gift from Mr. John D. Reilly, Class of 1963

fig. 34. Cham, "M. De Gas. You cannot go there…on horses of wood!," from *Le Salon de 1866, photographié par Cham,* 1866

M. DE GAS.

Fallait pas qu'il y aille .. aux chevaux de bois!

cat. 18. *The Wounded Jockey* and *Studies of Horses*
(compositional study for *Scene from the Steeplechase:*
The Fallen Jockey), c. 1866, graphite and charcoal on
paper. Private collection

fig. 35. X-radiograph of *Scene from the Steeplechase:*
The Fallen Jockey

chase: The Fallen Jockey and repainted
it at least twice, once in the early eighties
and again in the nineties.[31]

An X-radiograph of the *Steeplechase*
(fig. 35) reveals not only the possibility of
three layers of work but the scraping off
of earlier paint, which makes reconstruc-
tion difficult. There is no question, how-
ever, that in front of a mounted jockey
was a leaping horse with a raised, com-
pact tail, which is now covered by trees
and a cloud. The fallen jockey was in
the same position but his left leg was
straighter and further from his right, and
his left arm must have been more fore-
shortened and closer to the body. Fortu-
nately, the head of the fallen jockey seems
to have been untouched so that it is con-
firmed as being from phase one – that
is, 1866 – as is a preparatory drawing
(cat. 23).

With unbound sheets of drawings it is
more difficult to determine the sequence
of execution than for those in notebooks.
One vertical sheet (cat. 18), drawn with
both pencil and charcoal, seems to be an
exploration of the subject itself in a man-
ner that is reminiscent of the page Degas
sketched in one of his notebooks on the
race of the Barberi in Rome (fig. 4). The
notebook sketch is not one-seventh the

size of the drawing related to the *Steeple-chase* and was obviously, some eight years earlier in Rome, dashed off *con brio*, but it shares with the *Steeplechase* study a sense of the desire of the horses for liberation and a wonder at their capacity to enjoy any unexpected freedom. Both drawings have ribbons of activity that could be described as friezelike, but which in their animation anticipate film even more. Whereas in the earlier study there are two ribbons alternating with two lines of script, unrelated to the subject, in the later drawing the filmlike band is light and sketched at the bottom, like the predella of an altar. It shows all the horses with riders, except for one at the left galloping off to the liberation he has seized. Degas also permits himself to imagine two rider-less horses bounding in the sky, indiffer-ent to the smaller and fainter horse and rider moving toward us. It is as if the artist, although already conceiving a large painting devoted to one horse, one mounted jockey, and one fallen rider had, on the one hand, to grapple with under-standing the instinct of the horses to es-cape and achieve freedom like the two horses in the sky and, on the other, to suggest the scale and complexity of the steeplechase itself, from which they have fled, at the bottom of the drawing. But between the two is the nugget of the painting he intended to exhibit at the Salon — the relationship of the fleeing horse and the inert jockey.

In contrast with this drawing, the large painting is very selective in its com-position of the mounted jockey and the runaway horse. The horse in the painting seems to have been developed from the horses in the sky, which are flatter, more graceful, but not as powerful. There are two drawings related to it, one a delicate pencil drawing on blue paper in the British Museum (fig. 36), which is still so vague that the primary emphasis is on the

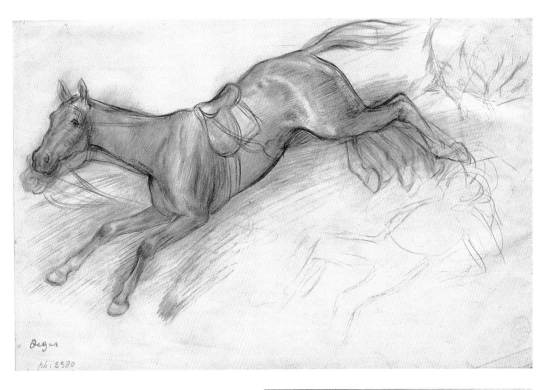

curves underneath the horse's belly and over its back. Much more sculptural is a charcoal drawing (cat. 19), which has been described as Degas "boldly display-ing his anatomical absurdities,"[32] in which the horse gains in vigor and in pathos. It is unclear whether Degas drew so many alternative rear legs from indecision or to create a sense of movement, as the futur-ists would do fifty years later. Neverthe-less, the strong definition of the raised hind leg is picked up both in Cham's cartoon and in the X-ray. The head of the horse in this drawing, with its solemn dark eyes and perky ears, may not suggest great intelligence, but it declares the innocence of the horse as a possible protagonist.

Drawings of the fallen jockey are also extant. One of the earliest may be one which was kept in the collection of the artist's younger brother, René de Gas, and his family, perhaps because René might have posed for it (cat. 20). The round head and snub nose are closer to his fea-tures than to those of the other brother, Achille, who is traditionally supposed

cat. 19. *The Bolting Horse* (study for *Scene from the Steeplechase: The Fallen Jockey*), c. 1866, graphite and charcoal on paper. Sterling and Francine Clark Art Institute, Williamstown, Massachusetts *(top)*

fig. 36. *Horse Leaping*, c. 1865–1866, graphite on paper. The British Museum

to have posed for the other versions of this figure.[33] In Degas' exploratory compositional drawing (cat. 18) the fallen jockey is like a rag doll, flat and unarticulated. In the drawing after René or some other model, Degas saw his torso in space, using the weight of his pencil to clarify its position. Although the legs are barely suggested, the bent left arm is convincing and the fingers of the hand folded under the palm believably. The head is somewhere between loutishness and youthful innocence, the brows making it clear that the boy is resisting consciousness.

In another drawing that until recently remained in the artist's family, Degas' principal interest was in the jockey's jacket, working out the play of light on

cat. 20. *Fallen Jockey* (study for *Scene from the Steeplechase: The Fallen Jockey*), c. 1866, graphite on paper. Collection of Mr. and Mrs. Paul Mellon, Upperville, Virginia

cat. 21. *The Fallen Jockey* (study for *Scene from the Steeplechase: The Fallen Jockey*), 1866, chalk heightened with white on paper. Sterling and Francine Clark Art Institute, Williamstown, Massachusetts

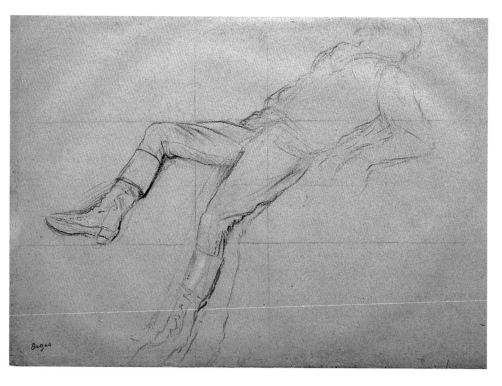

the silk.³⁴ He carried it further on another sheet, to a point that he was so nearly satisfied with the figure that he squared it for transfer (cat. 21). In that drawing there is a hint of the beard worn by the model thought to be Achille. The emphasis here is upon the jodhpurs and boots drawn with a certain unsentimental angularity. From this he may have moved to another drawing (cat. 22) in which the head with goatee and sideburns seems to be Achille, but Degas explored the jacket and jodhpurs in greater detail; the buttons and buttonholes are particularly convincing, as is the transition from the jacket to the sleeve. The head with the opened mouth and partly closed eye appears detached but not lifeless. Finally there is the drawing of the head (cat. 23) with the

cat. 22. *Fallen Jockey* (study for *Scene from the Steeplechase: The Fallen Jockey*), c. 1866, charcoal and chalk on paper. Collection of Mr. and Mrs. Paul Mellon, Upperville, Virginia

cat. 23. *Head of the Fallen Jockey* (study for *Scene from the Steeplechase: The Fallen Jockey*), c. 1866, crayon heightened with white on paper. Collection of Mr. and Mrs. Paul Mellon, Upperville, Virginia

magnificently executed sparse beard and dank locks of hair. The jockey does seem to breathe but not without suggesting the possibility of death.

In the *Steeplechase* as it was submitted to the 1866 Salon, Degas apparently only painted one horse and one rider in inevitable apposition; the mounted jockey must have been indifferent. Ideally they should not have been opponents; the jockey should have been riding the horse toward victory. An accident or character flaw gave the horse his freedom and left the jockey frozen on the ground. Cham, in making his cartoon of the original version of this painting, must have inevitably thought back to the one (fig. 37) he had made of Manet's *The Dead Toreador* (fig. 38) at the Salon two years earlier, in which the bull is both absurd and vile and the toreador heroic but dead, almost like a gingerbread man. The Degas, perhaps in itself originally inspired by the challenge of the Manet, is not nearly as simple. In fact it must have seemed incomprehensible and bewildering. The horse cannot be held responsible, frightening as its large body appears looming over the fallen jockey. The blame is probably with fate, but a fate courted by the very weakness of the jockey himself, who may or may not be dead.

The tradition that Achille De Gas, the older of Degas' two brothers, both younger than he, posed for the fallen jockey may provide some clue to the meaning of the painting. Achille was always something of a failure. He did poorly at the Lycée Louis-le-Grand. When he joined the Merchant Navy he was at least once threatened with expulsion, which his father was able to prevent by using influence in the appropriate ministry.[35] When he left the Merchant Navy, during which time Degas painted him in the uniform of a cadet,[36] to return to Paris in 1864, he was uncertain about which direction he should take – but always where family protection would be provided – in Naples, Paris, or New Orleans. He assumed the manners and habits of a *boulevardier*, jauntily dressed but fundamentally indolent as Degas describes him in *Portraits in an Office (New Orleans)*, of 1873, or the winter before at the races as he appears in *Achille De Gas* (cat. 52). He traveled a good deal between Paris and New Orleans, ostensibly helping sort out the family's finances. In 1875 he caused something of a sensation in Paris by shooting the husband of his former mistress and spending a month in jail for the crime. In the early eighties he married Emma W. Hermann,

fig. 37. Cham, caricature of Édouard Manet, *The Dead Toreador*, in *Le Charivari*, 22 May 1864

fig. 38. Édouard Manet, *The Dead Toreador*, 1864, oil on canvas. National Gallery of Art, Washington, Widener Collection

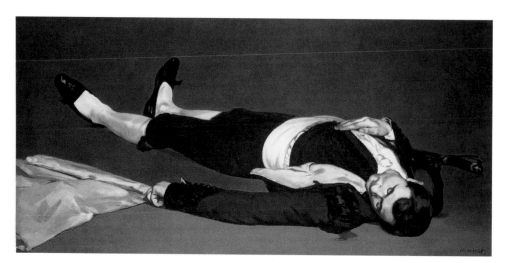

an American from New Orleans, and retired to Geneva, became an invalid, and returned to Paris to die in 1893. Degas seems to have considered him with a certain affectionate tolerance and to have traveled with him on occasion, for example to Brussels in 1869 and to Naples in 1876. When Achille died Edgar wrote to a friend, Mme Camus,

You haven't forgotten my poor Achille. You were hospitable and good to him in bad times. And remember how your husband went out at six in the morning to wait for him to be released from prison that time he fired the revolver. In 1889 he had a slight stroke two years after another which left him half-paralyzed. He had to stay in bed for two years, losing his speech and perhaps some of his reason. He has just died here after being back for two weeks.[37]

As a victim of his own irresponsibility and an unkind fate, Achille had been an appropriate model for the fallen jockey.

A little more than a quarter of a century before Achille died, Degas must already have recognized his vulnerability in using him as the model for the work he hoped would make his reputation at the Salon. That vulnerability was expressed most effectively in the head of the fallen jockey, which, against all odds, Degas seems to have left untouched in his future reworkings of the painting. In some ways it must have been particularly precious to him, partly because it was such a refined painting, but perhaps also because it symbolized so exquisitely the risks to which his brother would expose himself so often.

Robert Herbert points to parallels between *The Steeplechase* and the Goncourts' play, *Henriette Maréchal,* which was first performed at the Comédie

cat. 24. *Studies of Horses,* c. 1866, chalk on paper. Sterling and Francine Clark Art Institute, Williamstown, Massachusetts

Française on 5 December 1865 and considered so shocking that it was only performed six times.[38] A young man, who is in the process of changing his affections from his mistress to her daughter, is watching his brother race in a steeplechase at Caen when, "He fell . . . at the first barrier and remained for a moment without moving; we thought he was dead."[39] Since the Salon opened on 1 May 1866, not quite five months after the opening of the play, one can understand Herbert's reluctance to claim too much for this discovery and to suggest that "It is a coincidence that Degas' fallen jockey is dated the same year as the play."[40] It is less the rather prosaic accident of the fallen jockey than its effect on the ties between brothers, not as close in the play as between the Goncourt brothers themselves but probably comparable to the relationship of the painter to his two brothers René and Achille, that makes one feel that a visit to the theater may have helped Degas formulate the sense of the risk of meaningless loss of life behind his *Scene from the Steeplechase:*

The Fallen Jockey. The execution of the painting could have absorbed all his time for those five months, which seems to have been otherwise free.

In preparation for the head of this jockey (or brother) who could be dying, Degas made a drawing (cat. 24) in which, with charcoal and white chalk, he modeled the skull strongly, but muting it slightly. He was meticulously observant of the jockey's hair – the thin wiry strokes of a new beard, the heavier weaving of the mustache, the soft brush of the generous eyebrows, and the weight of the locks receding from his forehead. Degas emphasized the orifices in the head – the soft ear, the eye that is slightly opened, the nostrils, and the mouth that opens to reveal white teeth. The jockey appears to be alive (as if he were resting or posing). Some of that life is conveyed by the brilliant light between and below his brows.

In painting this same head – and undoubtedly using the drawing – Degas worked with even greater refinement, as in the ear as it recedes into space. Although the hair is brilliantly executed in the drawing, it is painted with even greater variety and subtlety. An ordinary light brown with highlights of greenish gold, it is, as in the drawing, thinning about his forehead. The brows are heavy and bushy with some hairs growing down on his nose, the mustache strangely dark and dense, the beard full of life, as indicated by touches of gold paint and vibrant cross-hatching, but thin over the jaw where the growth must be new. His head of hair is not as tangible as in the preparatory drawing; it seems to be only an aura between the head and the green lining of the pink cap. Degas uses light and shadow somewhat differently on the face in the painting, shadows, for example, where there had been strong light between the brows. These changes seem directed toward muting and refining the realism of

the work without destroying it. The eyes are closed serenely but the nostrils and mouth are open in a disturbing manner. The teeth are even whiter and, as they project more, are perhaps a reminder of the skeleton and an intimation of the possibility of death. But a faint blush of pink, with its expectations of life, appears on the cheeks and in the lips. Degas does not reveal whether the jockey is dead or alive, expiring or reviving, but he makes us aware of the risk and he expresses great tenderness for the victim. The head is only one small part of a very large painting but it does convey the delicacy of the balance of the jockey's chances of survival.

In all of this, the mounted jockey is the most enigmatic figure. From the X-radiographs, his position was essentially the same as the principal mounted jockey in the finished work, but his mount seems to have disappeared into the mists of time or, as Cham indicated, drawing him at a somewhat different angle, into the clouds. One preparatory drawing has survived of the jockey who sits convincingly on his horse, his hands held out for the reins (cat. 17). In this pencil drawing, squared for transfer and originally heightened with white, there is a certain spareness, hardness, and even meanness, which may be a commentary by Degas on the rider's indifference. Although the angular drawing style is not too different from the other drawing squared for the final painting, of the fallen jockey (cat. 21), Degas never allowed its softening into tenderness and helplessness in the upper part of the body to intrude into his interpretation of the rider who survives.

Degas was more compassionate to an unknown horse that presumably did not survive the dangers of the steeplechase (cat. 24). He drew the horse four times, from different angles and in different sizes, so that the effect across the page is

almost that of an *abattoir*. It may have been just a poignant reminder of the price the animal could pay for such a race, but it is not impossible that Degas had considered painting a fallen horse in the dark area behind the other horses and above the fallen jockey, which is sometimes described as a hedge.

Undoubtedly the large painting, as it was shown at the Salon of 1866, was of a contemporary subject, but it also must have seemed, in this austere version limited to the horse and the fallen jockey, something of an allegory. But it is an allegory pointing to a truth rather than to a moral. There is no heroism in either the jockey or the horse, just as there is no blame. Degas may have still been within the tradition of history painting, but it was essentially his farewell until he was to revive the subject some fifteen years later.

A Postscript to *The Steeplechase: Sulking*

Aside from the later revisions to the *Steeplechase*, there was a more immediate postscript to the painting in a canvas that Degas and his dealer Paul Durand-Ruel (1831–1922) called *Bouderie* or *Sulking* (cat. 25).[41] Serious efforts have been made to find clues to the meaning of the painting,[42] but nothing has been resolved except agreement that it was painted between 1869 and 1872, that friends posed for the two figures, that the woman was definitely the model Emma Dobigny,[43] and that there is probably no literary source. *Sulking* comes from the period in which Degas was painting some of his finest genre subjects, including *The Rape*, which is now generally called *The Interior*.[44] He was a friend of two other master genre painters among his contemporaries, James Tissot (1836–1902), who was French but lived in London, and the Belgian Alfred Stevens (1823–1906), and it

cat. 25. *Sulking*, c. 1869, oil on canvas. The
Metropolitan Museum of Art, H. O. Havemeyer
Collection, Bequest of Mrs. H. O. Havemeyer, 1929

was quite clear from his correspondence with Tissot[45] that he was painting genre or narrative paintings with the English market quite deliberately in mind. His passing enthusiasm for this kind of painting probably made him particularly responsive to English art as he found it at the World's Fair of 1867 in Paris,[46] and it probably also encouraged him to paint equestrian subjects for English buyers.

On the wall in *Sulking* hangs a color engraving called *Steeplechase Cracks* by an English artist, J. H. Herring.[47] The excited and essentially dangerous movement depicted in Herring's scene establishes a tension and anxiety that is not resolved between the heads of the man and the woman. It also shows the attractions, temptations, and allure of the race in the convention developed for its representation by English artists. A careful study of the room reveals something less refined than the pretty dress of the young woman would suggest. The papers on the table are in disarray. The wooden walls seem to be of the crudest carpentry.

The two figures are disturbing in their estrangement. She is perhaps only defensive as she looks up, but his hunched figure is decidedly furtive. There may be something after all to the description of the work by Degas' friend Paul Lafond. "Let us consider a picture representing a man seated in an office, his arms crossed on a table, covered in part by papers, a bookmaker, or at least an habitué of the racetrack." He continues about "a young woman dressed for a visit, her expression anxious, her eyes vague, leaning at an angle on the desk, continuing to talk to someone who does not even look at her. Is it a scene of a separation, of a request for money? We do not know."[48] And we may never know. But it does not seem impossible that it transfers the dangers of the racetrack to the more sedentary setting of an office.

Notes

1. The importance of this trip to Degas' equestrian works has been emphasized, among others, by Lemoisne 1946–1949, 1: 39–40; Loyrette in exh. cat. Paris 1988–1989, 101, and Loyrette 1991, 199; Kendall in exh. cat. New York 1993, 68.

2. Pierre-Jean Penault, "Monsieur Degas à la campagne," *Le Pays d'Auge* (June 1990), no. 6, 5.

3. Suzanne Barazzetti, "Degas et ses amis Valpinçon," *Beaux-Arts* 190 (20 August 1936), 1, 3; 191 (24 August 1936), 1, 4; 192 (4 September 1936), 1–2.

4. Reff Notebook 10, 50.

5. Reff Notebook 18, 161.

6. Kendall in exh. cat. New York 1993, 61, 64. Reff Notebook 18, 55 is related to cat. 10.

7. There is no record of Degas having visited England before the fall of 1871. Loyrette 1991, 22; Reff Notebook 23, 48–49.

8. One of the few references to a horse in Italy in all the literature on Degas turned up provocatively in an article by Christopher Benfey, "Degas and the 'Black World,'" *The New Republic* (21 October 1996). Duncan Kenner, a patron of Norbert Rillieux, a distinguished mulatto chemical engineer who had revolutionized sugar refining throughout the world and who was a cousin of the painter's mother, visited Naples and went riding with the painter's uncle Henri Degas, perhaps against a landscape such as Degas painted here.

9. Reff Notebook 18, 161.

10. Loyrette (in exh. cat. Paris 1988–1989, 101) observes that the drawings were "not, curiously, of the horses."

11. Reff Notebook 18, 163.

12. Reff Notebook 18, 195.

13. Barazzetti 1936 (4 September). Barazzetti had interviewed Hortense Valpinçon Fourchy.

14. Valéry 1960, 72.

15. Loyrette in exh. cat. Paris 1988–1989, 102.

16. *Letters,* 66, 84, 22 August 1884.

17. Loyrette in exh. cat. Paris 1988–1989, 102.

18. Reff Notebook 30, 200.

19. Émile Zola, *Nana,* trans. N. R. Teitel (New York, 1970), 326.

20. In addition to cat. 14, Vente IV: 226.a and Vente IV: 228.c (locations unknown). Only one drawing, beautifully executed in red chalk, is known (private collection). It is for the tan horse at the left, where it holds its head high. Vente IV: 237.b.

21. Kendall in exh. cat. New York 1993, 67.

22. Standish D. Lawder in Haverkamp-Begemann 1964, 1: no. 152, 76.

23. Lemoisne 1946–1949, 1: 30.

24. Letter of 11 November 1858 from Auguste De Gas to his painter son in which he reminds him that, "La question du pot-au-feu, dans ce monde, est tellement grave, impérieuse, écrasante même, que les fous seuls peuvent la perdre de vue ou la dédaigner."

25. Anne Roquebert, *Edgar Degas* (Paris, 1988), 21 and repr., 20, fig. 19.

26. McMullen 1984, 132.

27. Cham was Amédée, comte de Noé. His grandson would marry a niece of Paul Valpinçon. Kimberly Jones has found a cartoon of the *Steeplechase* when it was exhibited at the Salon by Bertall (Charles-Albert d'Arnoux, 1830–1882) in *Le Journal Amusant* 541, 12 May 1866; it has a second mounted rider.

28. Edmond About, *Salon de 1866* (Paris, 1867), 229.

29. Anonymous, *Salon de 1866* (Paris, 1866).

30. Thiébault-Sisson 1921.

31. When John Rewald published the pioneering *History of Impressionism* in 1946, his only reference to the *Steeplechase* was under 1866 in the chronology for Degas as "exhibited a race scene at the Salon." One reason for this was probably because the work had not then been exhibited since the Ventes in 1918 and 1919 and only published in the first of the catalogues of those sales of the contents of Degas' studio after his death. In the revised and enlarged edition of his book, published in 1961, Rewald reproduced a color plate of the *Steeplechase* and clearly had some difficulties in explaining the style of the painting with its exhibition in 1866. As he astutely put it, "Whereas the head of the jockey is very delicately painted and shows similarities with the artist's previous work, the rest of the composition startles us by an extreme freedom of execution." He went on, "it does appear astonishing that he should have submitted to the jury a work so freely brushed (and that it should have been accepted)." By the fourth revised edition in 1973, Rewald had the answer, "The fact is that at a much later date the artist reworked parts of the painting, and this explains the more freely brushed sections."

32. Loyrette in exh. cat. Paris 1988–1989, 123.

33. Lemoisne 1946–1949, 1: 40.

34. For the drawing see Sale Ader Tajan, Hôtel Georges V, Paris, 19 December 1994, no. 9, repr. in color but cropped.

35. Loyrette in exh. cat. Paris 1988–1989, no. 4, 64.

36. *Achille de Gas in the Uniform of a Cadet,* 1856/1857 (National Gallery of Art, Washington).

37. In exh. cat. Paris 1988–1989, 488, as to an anonymous woman, who has since been identified as Mme Camus. Degas painted a wonderful portrait of her in red: *Madame Camus,* 1869/1870 (National Gallery of Art, Washington).

38. Herbert 1988, 169.

39. Edmond and Jules de Goncourt, *Théâtre. Henriette Maréchal, La Patrie en danger* (Paris, 1885), act III, scene 5, 129.

40. Herbert 1988, 169.

41. Durand-Ruel Archives (8848) as deposited 27 December 1895 from Loyrette in exh. cat. Paris 1988–1989, no. 85, Provenance, 148.

42. Reff 1976, 116–120; Loyrette in exh. cat. Paris 1988–1989, no. 85, 146–148.

43. Dobigny had posed for a painting of her head by Degas (L 198, private collection, Zurich), which he inscribed "Degas / 69," and which seems very close to her head in *Sulking.*

44. L 348, c. 1868–1869 (Philadelphia Museum of Art).

45. *Letters,* 1, to Tissot from Paris, 30 September 1871; 3, to Tissot from New Orleans, 19 November 1872; 6, to Tissot from New Orleans, 18 February 1873; 7, to Tissot from Paris, Saturday 1873; 8, to Tissot, no date.

46. Reff Notebook 21, fols. 30, 31, 31v.

47. Identified by Reff 1976, 117.

48. Lafond 1918–1919, 2: 5, describes it as a "toilette de visite." Loyrette in exh. cat. Paris 1994–1995, no. 67, 378, also assumes that she is "visiting." But surely in the 1870s this would have meant wearing a hat.

3

Family Outings and the Hunt

Family Outings, 1866–1868

Degas made his last official gestures to the horse in his submissions to the Salons — *Scene of War in the Middle Ages* in 1865 (fig. 26), *Scene from the Steeplechase: The Fallen Jockey* in 1866 (cat. 16), and *Mlle Fiocre in the Ballet, "La Source"* in 1868 (cat. 8). All were fairly large canvases, all to some degree enigmatic, and the first two at least related to the tradition of history painting. But over this same period Degas was coming to know and to represent the horse in its more natural environment as a source for more domestic pleasures. He did not free himself completely from the influence of Géricault and de Dreux, but he sought a new informality that was consistent with the domesticity he was enjoying with the Valpinçons in Normandy and with the circle of Manet and Berthe Morisot in Paris.[1]

In the tiny memorandum book — about four by two inches — in which he had made drawings for *Mlle Fiocre*,[2] Degas made a study for a painting known as *The Morning Ride* (cat. 26). The surprising thing about the sketch is that it could suggest a jaunt into the countryside, whereas the other pages in the book, with the possible exception of drawings of horses on the first four, must have been produced in Paris. Although Manet was painting racetrack scenes then, it was essentially within Paris at Longchamp. For Degas the best place to study horses

was still with the Valpinçons in Normandy. It has been suggested that it was on a visit to their estate that Degas went to the nearby coast to paint the cliffs and the sea as a background for *The Morning Ride*,[3] if not necessarily the riders themselves, whom he might have found in the Bois de Boulogne.

Degas chose a fairly large canvas for the painting and placed four riders against a background that suggests a vacation spot. He included boats and some masts in a bay under a white cliff, as well as white houses snuggled against the hill. Only the ominous beige (actually the underpainting) of the darkening sky hints at something less than an idyllic ride. Degas not very characteristically began this painting with a brown foundation, drew the contours with thin black paint, and worked into the shadows with transparent paint and into the lights with thick, matte paint.[4] The opaque white of the cliff and houses is picked up with equal brilliance in the white trousers worn by the intruder, the rider who enters from the left bouncing on a galloping pony. He is surveyed with both curiosity and a suggestion of superiority by the two women riders on either side of an indistinct figure, who also wears white trousers. Degas was obviously amused by the chance encounter of the intruder and the established trio and set it off against brilliant yellow-green grass. The canvas was never finished and undoubtedly appeals to

cat. 38 (detail)

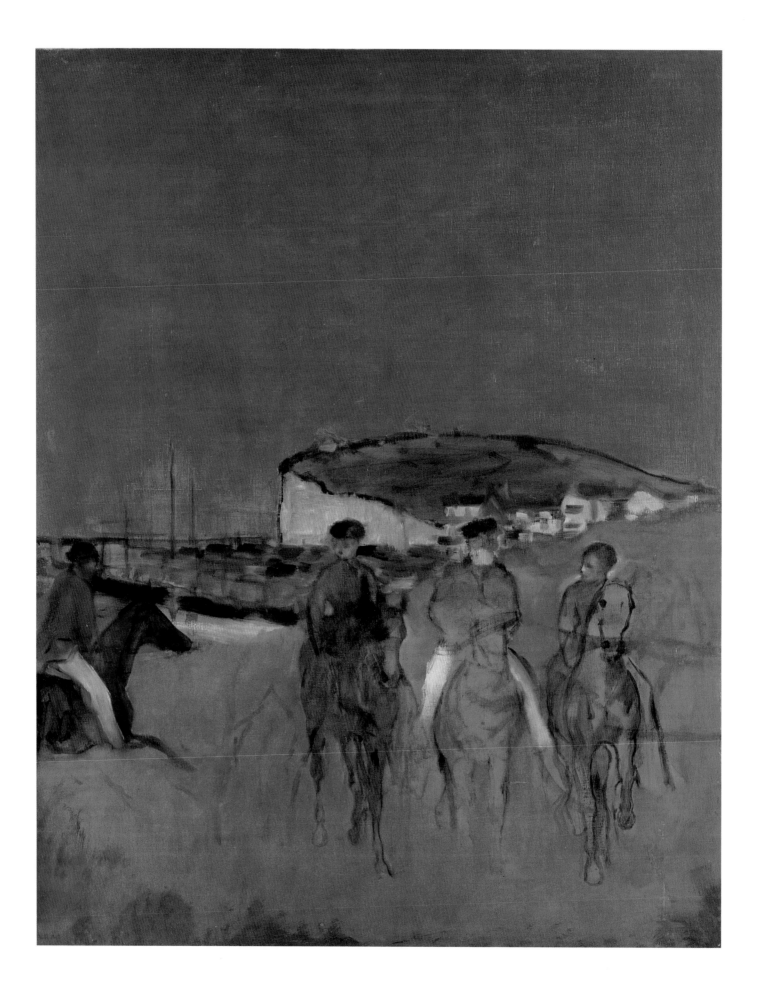

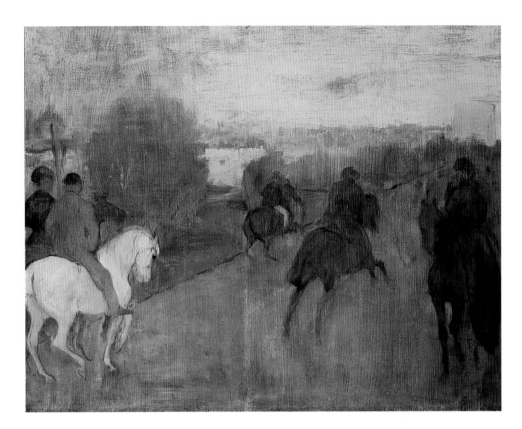

cat. 26. *The Morning Ride*, 1867–1868, oil on canvas. The Detroit Institute of Arts, Founders Society Purchase, Ralph Harman Booth Bequest Fund *(facing page)*

cat. 27. *Horses and Riders on a Road*, 1867–1868, oil on panel. Private collection

modern taste for how much of the process – the hesitations, the corrections, even the underpainting (or pentimenti) – is revealed. It anticipates impressionism in subject matter, if not in technique.

A comparison with *Promenade beside the Sea* (cat. 10), painted eight years earlier, points up the degree to which *The Morning Ride* is deliberately unimaginative, without an ounce of romance. The pairing of riders is missing, and instead of a couple provocatively riding away, the trio approaches with absolute indifference. Though reminiscent of figures in Manet's racetrack paintings of the mid-

sixties, especially in the frontal arrangement of the riders, the three in the Degas painting are much closer to the picture plane. As it is, the legs of the horses seem somewhat shattered, and the intruder with the bowler hat on the pony destroys any harmony the trio might possess, if only in upsetting the balance as the cynosure of their eyes. The landscape is much more solid than in the earlier work. It is also inhabited – by houses and boats as well as horses and riders – whereas the lyricism of the earlier Neapolitan background was not disrupted by other occupants. Although *The Morning Ride* is

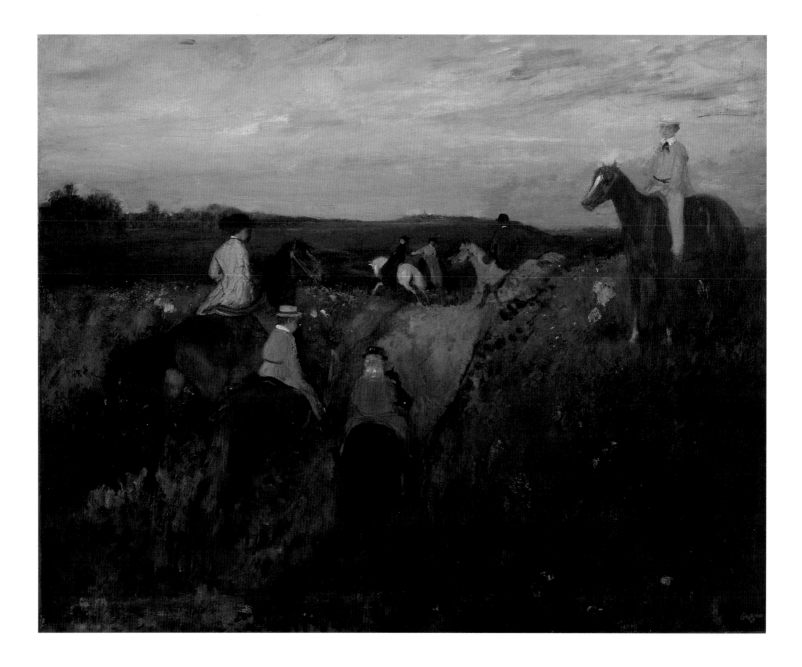

cat. 28. *The Promenade on Horseback*, 1867–1868, oil
on canvas. Hiroshima Museum of Art

unfinished and the cavaliers essentially
unrealized, Degas does suggest, with
sure, bold, and energetic strokes, four
different characters, as well as different
responses of the trio to the interloper
who is just missing them on the canvas.
The precise social backgrounds of the
figures are not known, but two different
worlds are represented – the two women
from the bourgeois gentry and the escort
or trainer from the world of the stable, to
which the outsider on the pony at the left
also belongs.

A possible source for the frontality
of the three figures can be found in the
frescoes Degas had copied in the Medici-
Riccardi palace in Florence (cat. 3),[5]
which Benozzo Gozzoli had painted al-
most four hundred years earlier. The
Renaissance frontal horses and riders are
as close to the picture plane as that of
Degas, and they provide precedents for
the way – with thin black paint – he drew
the positions of the legs and the tilt of the
heads of his horses. Although Degas had
copied the fresco at least five years earlier,

it was characteristic that he would use it as the foundation for another work that much later.

Another canvas, as wide as *The Morning Ride* but only half the height and therefore horizontal, is *Horses and Riders on a Road* (cat. 27), in which humbly dressed, bowler-hatted riders, possibly trainers or "lads," exercise their horses on a public road beside a body of water, perhaps a river. They move independently, at varying paces. A senior horseman stops at the right to survey them. The canvas throbs with life but of an awkward, uncoordinated, though highly convincing kind.

On a canvas as large as *The Morning Ride*, but horizontal, Degas invented another equestrian outing, *The Promenade on Horseback* (cat. 28). In this painting he increases the riders in the foreground to seven, and makes the figures smaller and the landscape more expansive. About six years earlier Degas had painted *On the Racecourse* (fig. 30), which this painting suggests; both were probably based on the countryside around Ménil-Hubert or nearby. Against landscapes of breadth and a somewhat ominous darkness, with high horizons but with drops toward land where races could take place, Degas had gathered men, women, and children together to ride or to watch horses. In the later work, however, the artist is more selective and at ease. A compositional drawing (fig. 39), which Degas presumably made before beginning the later work, acts as a link between *On the Racecourse* and *The Promenade on Horseback*. This drawing has two characters from the latter painting, two children riding ponies back from the picture plane. But it has a horse, which is less like any horse in the later work than like the one sunk into the shadows in the lower right-hand corner of *On the Racecourse*, although it is reversed. In the drawing it is given an even more

imposing place. In its pride as it dominates the gathering by its silhouette, it is reminiscent of the stallion in *Sémiramis*, although its head is held even higher in its self-confidence. This cart horse appears supreme over the restless youthful riders.

Compared with the drawing, Degas was somewhat more diffident in his interpretation in the later painting. Nevertheless, he did establish relationships that, without destroying the informality, seem to indicate social rituals as formalized and inevitable as those he would discover in the rehearsals and performances of the dance. The setting may be an open countryside, but a grassy incline with rather ominous rocks crosses the painting, isolating the male rider perched on a horse. Although it is almost as prominent as the horse in the drawing, it is neither as large nor as strong nor as austere as that Percheron. Toward the front at the left, a trio of young riders prepares to descend the bank. The girl further to the left is presumably just emerging from adolescence and sits sidesaddle on her horse with perfect ease, wearing an exquisite costume, and revealing a pretty profile (cat. 29).[6] In the front row of the painting she anchors the left side — and to some degree is played off against the male rider in the upper right, perhaps an instructor or a tutor. To her right is a young boy, with a belted tunic and a straw hat, who sits on a pony. The little girl is probably Hortense Valpinçon, born in 1862, who also appears on her pony in another drawing

cat. 29. *Woman Rider Viewed from Behind*, 1867–1868, graphite and *estompe* on paper. Musée du Louvre, Département des Arts Graphiques, Fonds du Musée d'Orsay, Paris

fig. 39. *Horses and Riders* (compositional study for *The Promenade on Horseback*), 1867–1868, graphite on paper. Private collection

fig. 40. *Mounted Girl* (study for *The Promenade on Horseback*), 1867–1868, graphite on paper. Bibliothèque Nationale, Paris *(left)*

fig. 41. *Woman Rider* (study for *The Promenade on Horseback*), 1867–1868, graphite on paper. Location unknown *(center)*

fig. 42. *Horsewoman* (study for *The Promenade on Horseback*), 1867–1868, graphite on paper. Location unknown

(fig. 40). All three look toward the two *amazones,* as the French call women who ride sidesaddle, and a male "suitor" who dashes down the bank toward them. Based on the drawings (figs. 41, 42) Degas had made, the two women are an enchanting inducement for his ardor. The two scenes of flirtation – between the rider and the two *amazones,* and the girl on horse at the left and the rider high on his horse at right – are amusing. The most discreetly stated possibility of an attachment between the two children is also apparent. The suggestions, restrained though they may be, unite this panorama of riders against a landscape almost as if they were dancers on a stage.

Another important element of this work is the emphasis on the physical aspect of riding. The viewer is invited to sit on the horses with the children and to move into the landscape, which supports the idea that Degas actually had experienced the height of a horse and its movement forward while sitting on the animal. Kendall sees that experience with each rider in the painting as an important part of its structure, "Lurching from group to group, our eyes follow their unequal progress, while the rise and fall of the landscape evokes the horses' motion."[7]

The man at the right, raised high on horseback, becomes more acceptable with an analogy to the dance. This mounted figure, so conspicuously placed, could seem a parody of the great equestrian figures of the past like Niccolò da Tolentino by Castagno or the Colleoni by Verrocchio, both of which Degas had in some parts copied,[8] or the engraving *Knight, Death, and the Devil* by Dürer, which he must have known. Degas' horseman is placed particularly high because the animal has remarkably long and seemingly wobbly legs. This chestnut steed is glamorized somewhat by the white stripe between his eyes and his nostrils, but nothing seems to make the strategically placed rider anything but inconsequential. His pale yellow (or beige) suit with the matching straw hat is not the normal attire of men for riding, although it is related to the suits that the children wear. Clothing an inadequate body, it could be the dress of an actor or a clown. The difficulty is that he has black eyes of great intensity and what looks like the vestige of a mustache in an elderly

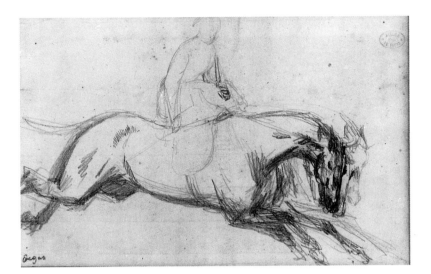

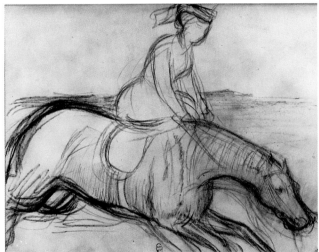

fig. 43. *Galloping Horse with Woman Rider*, 1867–1868, graphite on paper. Location unknown *(left)*

fig. 44. *Woman on Horseback*, 1867–1868, graphite on paper. Bibliothèque Nationale, Paris

face, framed by wind-blown hair. His position on the horse assumes a curious sense of responsibility, like that of a *maître de ballet*. That Degas painted this work not long after the *Steeplechase* may have made him sensitive to the possibility of dangers for this strange and vulnerable figure.

It was probably out of his interest in recording (or creating) these family outings on horseback that Degas was attracted by women riders in motion. On one separate sheet of paper he made a pencil drawing (fig. 43) of a horse in full gallop. Both rear and forelegs stretch out, but none touches the ground. Perhaps to enhance the motion – or from genuine indecision – Degas did repeat lines in the drawing. For example, there are three profiles for the horse's head, an extra pair of forelegs, and the repetition of contours

under its abdomen, above and below its neck, and around the hind legs and rump of the horse. The pattern of the strokes has a calligraphic variety, which contributes almost abstractly to a suggestion of urgency. The rider, seated sidesaddle, is almost faint, but the lines become stronger and more decisive in the fingers of her left hand, which holds the reins. In one of his largest notebooks,[9] Degas drew the same horse and rider again (fig. 44) but with greater assurance. There is less hesitation in the contours, which describe the movement of the horse with energy and continuity, its neck now stretched in a curve in its desire for speed. The rider is more clearly defined and she sits with the upper part of her body further forward as she pulls on the reins. Degas may have shown his admiration for a woman rider in these drawings, but he may never have

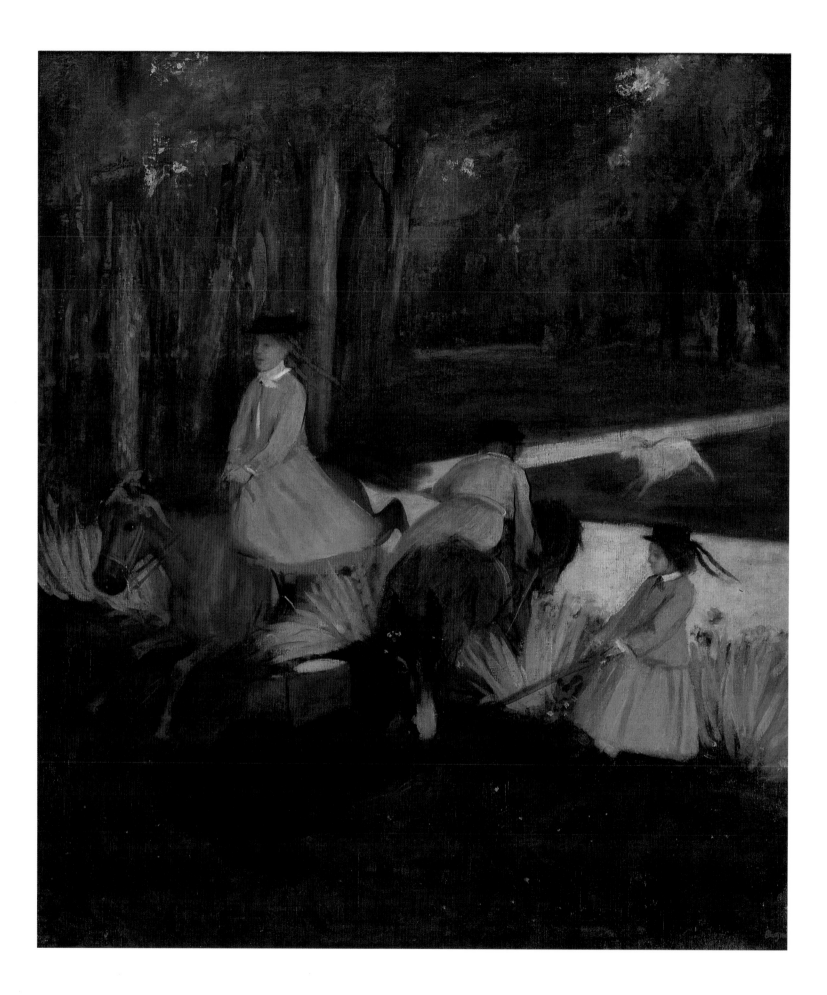

found the physical charm to warrant a painted portrait of her. (Later he would know an *amazone* of real distinction, Mary Cassatt, but that would not be for almost ten years, and he was never to paint her portrait on a horse.)

In the largest canvas in this series, *Children and Ponies in a Park* (cat. 30), Degas painted three young girls with their mounts on a heavily wooded estate not unlike Ménil-Hubert. In fact, the youngest child may be Hortense Valpinçon, who would have been six when this was painted. In subject – the enjoyment of playing with unruly animals out-of-doors – it seems a protoimpressionist work. The woods in the background could have origins in the Barbizon school, but the three pleasure-loving girls could not. The two outer (and older) girls are dressed in pretty attire, and certainly some effort has been made to make the youngest conform. The children are, however, more conformist than the animals with which they play. The eldest sits primly on her pony, which is galloping like a rocking horse. The smallest child puts a great deal of effort into making her tiny horse move, but it is balking, its forelegs planted firmly in a bed of irises. The girl at the right pulls at the reins of a donkey that sits on the grass, completely indifferent and unmovable, while in the background a goat bounds toward them. In spite of minor frustrations, *Children*

and Ponies in a Park records a happy afternoon. But it may have been the last time that Degas painted amateurs with any form of mount.

The Hunt, c. 1859–1873

Leaving for the Hunt (cat. 33), Degas' lone painting of the sport, exists in some isolation in his work, much as it belongs to the groups of horsemen against landscapes he had painted in such early work as *At the Races: The Start* (cat. 13), *The Morning Ride* (cat. 26), and *The Promenade on Horseback* (cat. 28). Anticipations of this hunt are to be found in an etching (cat. 31) of a gentleman with a very high top hat mounting his horse (inevitably reversed), possibly preparing to join a hunt, and a drawing in Notebook 18 (fig. 45) with several similarly attired riders, but shivering, in the foreground. Both the etching and the notebook page must have been sketched before Degas left Italy for Paris in 1859, and both are conscious of the contrast between the sartorial elegance of the riders and a rough and picturesque landscape background. In the same notebook, but later, about 1861, Degas drew a more plebeian rider (fig. 46) making his way up a road as he follows his hound in what must have been at least a poacher's hunt. But besides this etching, these drawings, and the final painting with its preparatory studies, the only other evidence of any interest in the subject comes from copies Degas made in the Louvre of two enormous royal hunts.

The first (fig. 47) is most of the composition of a tapestry, over four meters high and seven meters wide, woven at Brussels from one of the cartoons designed by Bernaert van Orley after 1521 for the series of the scenes of the months known as "Le chasses de Maximilian."[10] The month is March and the scene a stag hunt. Although drawings and prints ex-

cat. 30. *Children and Ponies in a Park*, 1867–1868, oil on canvas. From the Collection of Joan Whitney Payson

cat. 31. *The Sportsman Mounting His Horse*, 1859, etching on paper. Sterling and Francine Clark Art Institute, Williamstown, Massachusetts *(top)*

fig. 45. *Riders on Horseback*, 1859, ink on paper. Bibliothèque Nationale, Paris

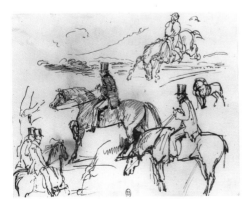

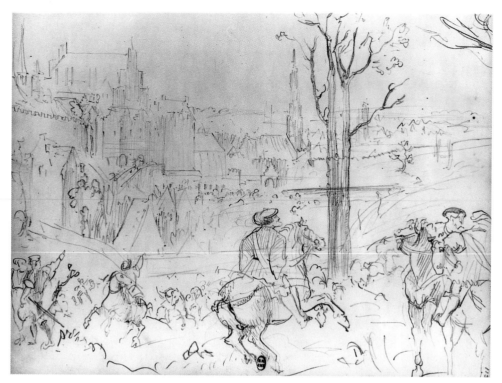

fig. 46. *Rider on a Road*, c. 1861, ink with wash on paper. Bibliothèque Nationale, Paris

fig. 47. Copy after tapestry designed by Bernaert van Orley, c. 1861, graphite on paper. Bibliothèque Nationale, Paris *(top right)*

fig. 48. Carle Vernet, *Deer Hunt on Saint-Hubert's Day in 1818*, by 1827, oil on canvas. Musée du Louvre, Paris

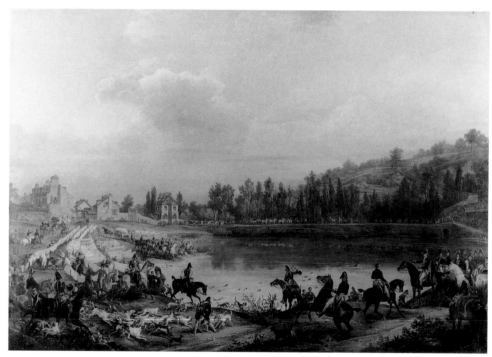

isted of Van Orley's composition and were available at the Louvre and the Bibliothèque Nationale, Degas worked from the original tapestry, which, with four others from the series, was hanging in the Louvre between 1853 and 1900.[11] Degas sketched the tapestry in Notebook 18, in which he had drawn hunters as well as many of his studies of *Jephthah* and the record of his first trip to Ménil-Hubert. Although he outlined the picturesque silhouettes of the medieval town of Brussels and its lake behind the tree, his particular emphasis is on the flurry of the hunters climbing the bank as against the relative insouciance of the emperor – a true Renaissance prince – on a rearing horse. It is a glimpse of the emperor's profile with the Hapsburg chin that makes it certain that Degas worked from the tapestry rather than the drawing and engraving, which had eliminated this profile. The emperor is believed to be the grandson of Maximilian I (r. 1493–1519), Charles V (r. 1516–1556),[12] whose horse Degas had already drawn from a painting by Van Dyck in the Uffizi (fig. 7). The two courtiers on the right are like courtiers everywhere and in every time, watchful and conspiratorial. The sliver of the tree at their right is the point where Degas cut off some of the tapestry in his drawing. With lines like threads of silk or wool, always of the same intensity and breadth, occasionally broken to change emphasis, Degas made a drawing that has the flatness of a tapestry. In spite of the deliberately primitive draftsmanship, it nevertheless captures the pageantry of a Renaissance hunt.

His copies from a second large work in the Louvre is of a painting by Carle Vernet, more than two meters high and three meters wide, commissioned by Charles X (1757–1836) in 1825, exhibited at the Salon of 1827 and showing "a deer hunt of 1818 for Saint Hubert in the forest

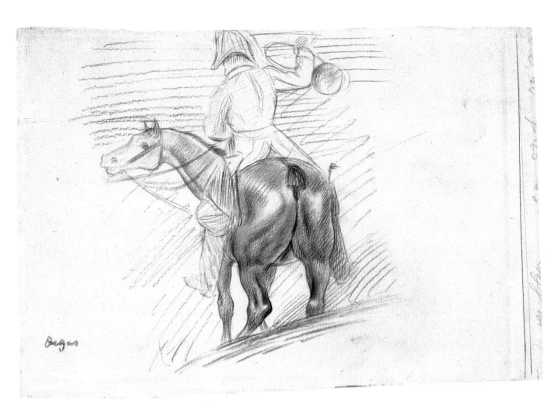

of Meudon . . . in the presence of the comte d'Artois (the future Charles X) and of the duc de Berry" (fig. 48). The duc de Berry (1778–1820) was the son of Charles X and had been assassinated in 1820. In addition to being a memorial to his son, this painting was commissioned by Charles X the year after he became king, succeeding his unfortunate brother Louis XVIII (1755–1824), as an *apologia* for a Bourbon monarchy, considerably less entrenched than Maximilian's creation, the Hapsburg or Holy Roman Empire. The hunting scene was painted by Vernet with considerably more restraint and bourgeois decorum than Van Orley's "chasses de Maximilian."

The horizontal painting shows a background of houses, hill, trees, and a lake of great clarity, with mounted horsemen everywhere. From what have been identified as copies by Degas (cat. 32; fig. 49), it is apparent that he was not interested in the whole panorama but rather in the details. Three of his drawings have

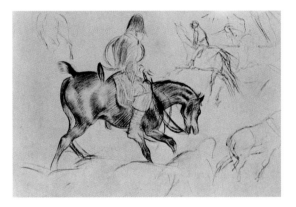

cat. 32. *Huntsman Blowing His Horn* (after Carle Vernet, *Deer Hunt on Saint Hubert's Day in 1818*, detail), 1865–1870, graphite and charcoal on paper. Virginia Museum of the Fine Arts, Collection of Mr. and Mrs. Paul Mellon

fig. 49. *The Whipper-In* (after Carle Vernet, *Deer Hunt on Saint Hubert's Day in 1818*, detail), c. 1865, graphite on paper. Location unknown

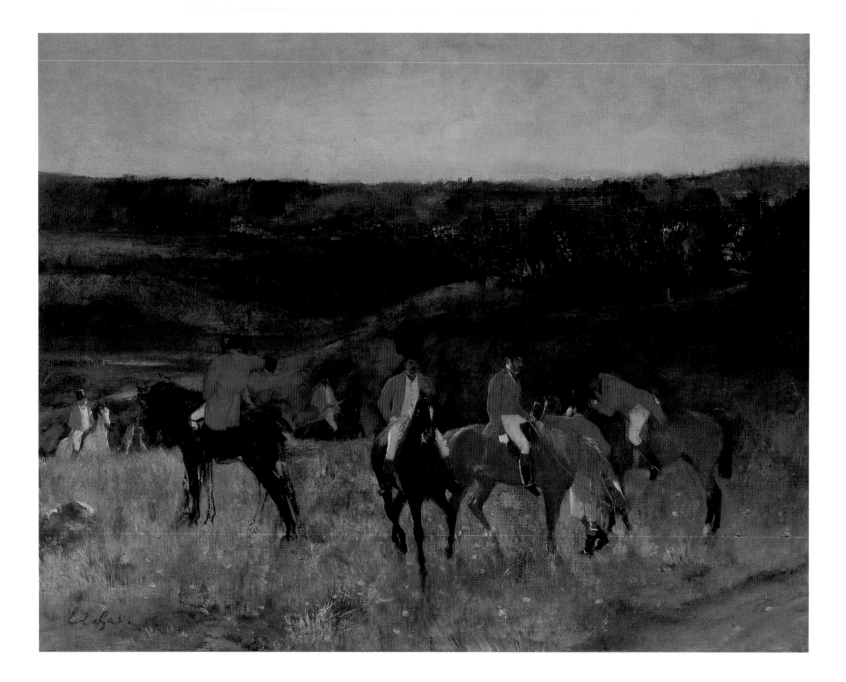

sources in figures in the painting boldly silhouetted against the lake, and all three have been catalogued, two in the Ventes and one in an auction sale, as "piqueurs" or the whippers-in who control the dogs. The use of the watercolor for the third drawing should have indicated that he had a more exalted position. Whereas the other two figures Degas copied are pursued or surrounded by a multitude of lively hounds, this figure has no dogs around him. And indeed, he is placed, appropriately low and bare-headed, his horse's head bowed in deference, before the future Charles X. The elegantly dressed and mounted figure Degas had chosen here is presumably the ill-fated duc de Berry.

Degas drew the whippers-in with pencil, making them stocky and solid, mounted on strong horses, bearing the emblems of their positions, the bicorn hat and the horn, with a certain familiarity. The foreshortening of the horse of the central figure (cat. 32) is undoubtedly based on the Vernet, but the physicality of the croup and hind legs is exaggerated, if only because of the addition of charcoal to the pencil of the rest of the drawing. Degas' concern for the details rather than the total ensemble that had interested him before the tapestry of Maximilian would seem to substantiate the convictions of some that it was from such details, not usually borrowed from another artist's work, that Degas additively created his total compositions. Interestingly, however, he does not seem to have used these segments of the Vernet in another painting.

The drawing of the whipper-in at the left of Vernet's painting (fig. 49) was not, like the other two, among the works sold in the four sales of the contents of the artist's own paintings and drawings after his death, but appeared in a sale of part of the collection of his nephew Jean

Nepveu-Degas (and perhaps other members of the family) at the Hôtel Drouot in Paris in 1976.[13] On the verso it has a stamp of the atelier, which means it was inventoried with the things that were prepared for the posthumous sale but were either kept for a fifth sale that was never held or for members of the family. It belongs to a group of drawings with a similar provenance that have sketches of horses with or without riders, which move with considerable speed,[14] unlike the static positions that Degas had chosen in the Vernet. In this drawing of the whipper-in, there is no relationship between the sketches behind and to the right of the figure to anything in Vernet's painting. They must have been made rapidly before moving horses and riders. Often the very lightness of these lines makes them difficult to reproduce, which may be one reason they were not chosen for the sales. But they do show that although Degas might concentrate upon a restrained horse and rider, he imagined them in a world of greater activity. For Degas there were two levels of perception – one of abandonment to the movement of a hunt or race, which was subordinated but represented in such sketches, and one of controlled observation leading to the definition of a still moment of rest and reflection, as in Degas' sole painting of the hunt (cat. 33).

Even if Degas had never accompanied an actual fox hunt at Ménil-Hubert or nearby Haras-le-Pin, he could have known the subject from French artists like de Dreux, who had, for example, painted Emperor Napoléon III, Empress Eugénie, and their court on a hunt at Fontainebleau on a large canvas that is now at the Virginia Museum of Fine Arts. It was also a favorite subject with those English artists Degas had admired.[15] It has even been suggested that the hunt in *Leaving for the Hunt,* because of the top hats worn by the

cat. 33. *Leaving for the Hunt,* c. 1866 and c. 1873, oil on canvas. Private collection, courtesy of Galerie Schmit, Paris

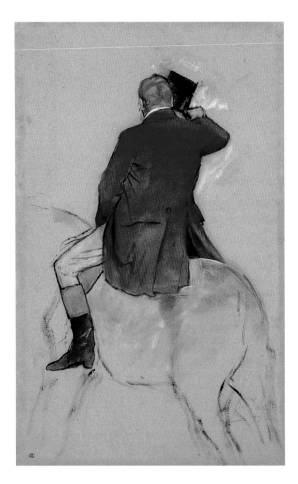

cat. 34. *Rider in a Red Coat Viewed from Behind*, 1873, *essence*, ink, and gouache on paper. Musée du Louvre, Département des Arts Graphiques, Fonds du Musée d'Orsay, Paris

hunters, was in actuality an English hunt, which Degas might have seen when he traveled to Liverpool in the fall of 1872 to catch a steamship for America or when he returned in 1873.[16] In general, it is now accepted that *Leaving for the Hunt* was painted in two stages.[17] It may have begun as a French hunt painted against a landscape like that of Ménil-Hubert in the second half of the sixties but, probably inspired by a visit to England, Degas changed it to an English hunt in 1873, making expressive use of the English top hats. A link in the argument is the date "73" inscribed on a drawing (cat. 34), which is signed with the more pretentious form he had otherwise given up, "De Gas," as a probable effort to make it more appealing to the English market.[18]

The earlier landscape, no matter what its date, provides a mellow and fertile background – great distances, rolling hills, a bank up which the horses and riders climb, and a field in the foreground dotted with delicate flowers and weeds.[19] That rosy sky, either dawn or sunset, derives from his work of the sixties.[20] The hunters in their red coats and top hats were probably painted in 1873 over figures from the first phase, perhaps a little like adding a suit to a paper doll. At the same time Degas left the earlier painting of nature and the horses intact.

The hunters are dressed identically in the English fashion, wearing shining black top hats, scarlet (or as the English would call them, pink) coats, gleaming white vests and jodhpurs, and immaculately polished high boots. Physically they are also close to the stereotypes of hunters in English prints – of a certain age, somewhat portly, with generous mustaches, and inclined to be convivial among themselves. The same generously built, mustached model or friend, a type only too easy to caricature, might have posed for all the figures in the painting,

like Degas' dancers in their uniformity of attire and their informal camaraderie before the hunt (as before the dance) begins. The only isolated figure, the one with his back toward us (cat. 34), is undoubtedly the Master of the Hunt, who raises his hat to the approaching riders. The painting depicts an idyllic society of gentlemen against a rich natural setting in which the light from the presumably rising sun gently and accidentally illuminates parts of their bodies. Touched by this light, the red of their coats has a particular glow against the complementary green. The painting is consequently so beautiful that it comes close to being nostalgic and sentimental.

It is difficult to know Degas' attitude toward the hunt. First of all, it may have been a completely French hunt clad in English clothes and some English mannerisms. Although the figures in the painting are quiet, there are those other more casual drawings, which are difficult to reproduce, that make it clear that, although he chose these tranquil moments for the canvas, Degas was not unaware of both the heightened activity and the real danger of the hunt, as seen in one of the drawings he made after Vernet (fig. 49). Two drawings for *The Hunt* (cats. 35, 36) show Degas treating those figures much more cruelly than he did in the painting. The figure nearest the center is, in its drawing, more portly, more complacent, and, as expressed by the angles of his eyebrows, mustache, and hat, more predatory. The figure at the right is something of a pompous ass. Even the huntmaster (cat. 34), with his hair parted at the back and the folds of the coat stretched over his back, suggests a conceit that is absent in the painting. In spite of the keenness and fundamental cruelty of his observations, as conveyed in the drawings, Degas still manages to make the painting a nostalgic, innocent memory.

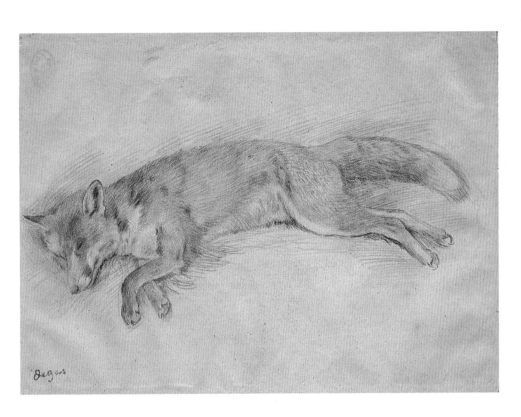

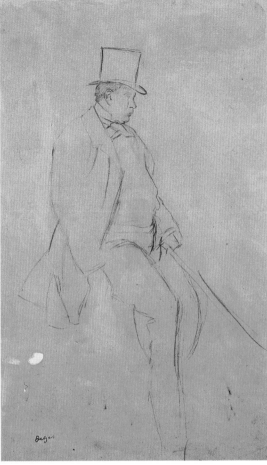

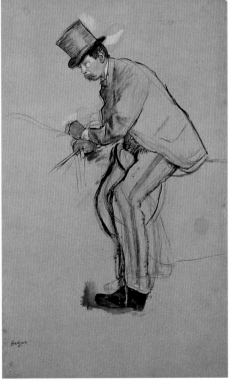

cat. 35. *Gentleman Rider*, c. 1873, brush with gouache and oil over graphite on paper. The Art Institute of Chicago, Gift of Mrs. Josephine Albright *(top right)*

cat. 36. *Gentleman Rider*, c. 1873, graphite with brush and gouache on paper. The Art Institute of Chicago, Charles Deering Collection

cat. 37. *Dead Fox*, c. 1864–1868, graphite and pencil on paper. Sterling and Francine Clark Art Institute, Williamstown, Massachusetts

Agreeable as Degas made this gathering before the hunt began, he was not unaware of its purpose. He did think about the ultimate goal of the hunt, the fox, and made a painting of the dead animal in a wood (L 120, Rouen) and an even more exquisite drawing in red and black chalk (cat. 37) that is as refined as a Pisanello in its absolute expression of waste and pain.

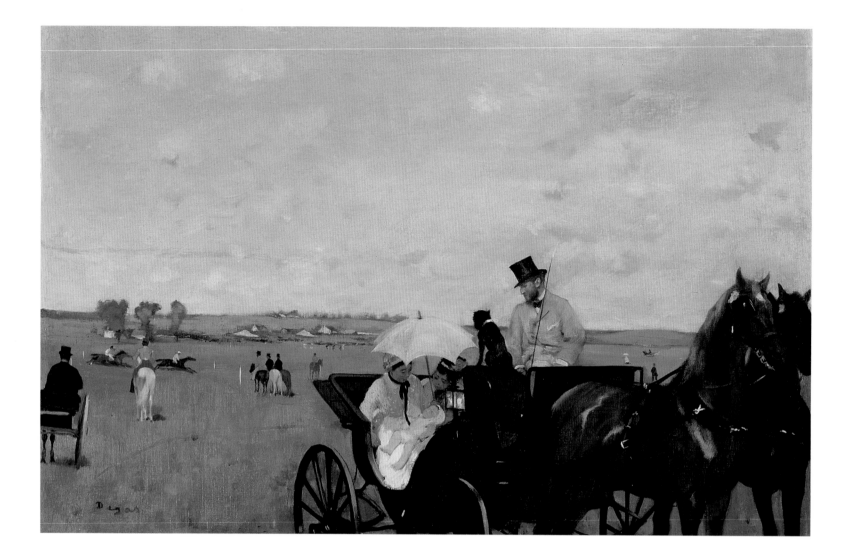

The Carriage Leaving the Races in the Countryside

On 17 September 1872, Durand-Ruel, Degas' dealer, bought from the artist the sublimely beautiful, small painting *The Carriage Leaving the Races in the Countryside* (cat. 38).[21] Degas sold it less than a month before sailing for America to visit his relatives in New Orleans. The painting nevertheless remained very much on his mind. On 19 November he wrote to Tissot in London to ask about the impression his "dance picture," which was for sale in London, was making. He also inquired, "And the one of the family at the races, what is happening to that?"[22] What would happen to it was that it was to be bought by the singer and collector Jean-Baptiste Faure, not long after Degas returned to Paris from his American visit.[23] If Degas had not already himself sold the work when he wrote to Tissot, we might have concluded that his inquiry was only mercenary, but it seems rather to have been based upon a particular attachment to this painting.

The title upon which Degas and Durand-Ruel must have agreed, *The Carriage Leaving the Races*, was typical of Degas' desire for anonymity, since it identified neither the people nor the place. (Horses were rarely identified.) Domesticity and the countryside, however, almost inevitably suggest the Valpinçons. The fact that the countryside is not as dark, damp, nor as oppressive as his earlier paintings around Ménil-Hubert can be explained by the suggestion that it was painted at the racetrack at Argentan,[24] which is an extended green plain with only a few houses and trees. The family is seated in the foreground in the carriage. The young Norman woman in a bonnet appears in another painting, *Henri Valpinçon as a Baby*,[25] where she crouches in the foreground beside the plump son of the Valpinçons, born on 11 January

1869;[26] Mme Valpinçon and Hortense are indistinct figures in the background. A drawing of this nursemaid also exists in Notebook 22, dated by Reff 1867–1874, which is full of other reminiscences of the Valpinçons. The profile of the father, who gazes attentively at the baby, resembles the cameolike image of Paul Valpinçon that Degas had painted in the early sixties,[27] but the mother is less like other known portraits of Mme Valpinçon, perhaps because of the veil and the shadow cast by the parasol.[28] Degas may have composed this family outing artificially rather than as a portrait, although undoubtedly it is improbable that it could have been painted before the birth of Henri Valpinçon. The dog perhaps also belonged to the family.[29] Other suggestions for the mother and father include Degas' friends Ludovic Lepic and Charles Jeanniot and their wives. But as charmingly intimate as these figures are, *The Carriage Leaving the Races* is not a group portrait, and the identification of the sitters is not essential for its appreciation or understanding.

The Carriage Leaving the Races is an apparently casual record of an informal day of racing in a provincial town. The carriage with its well-dressed and engrossed passengers and its handsome driver is about to move away from the course, pulled by two proud brown horses. Behind, bisected by the edge of the canvas at the left, is another carriage with the back of a gentleman in a black coat and hat, who holds up his whip as his vehicle (with another passenger and an unseen horse) moves toward the track. Over the hills are white refreshment tents. Two jockeys ride as if for a steeplechase, but the reactions of the mounted spectators are without tension. In fact, this is one of the characteristics that makes this small painting so precious and endearing. It is a flawlessly beautiful day. Despite

cat. 38. *The Carriage Leaving the Races in the Countryside (Carriage at the Races)*, 1869–1872, oil on canvas. Museum of Fine Arts, Boston, 1931 Purchase Fund

clouds in the sky, the air seems limpid. The low horizon gives a sense of endless space, and the grass and the figures, particularly those in the carriage with their delicate lavenders and pinks and creamy yellows, are caressed by the light. The back of one white horse, ridden by a man with red jodhpurs, seems to glow, directing attention back from the carriage to the green field. The man in the carriage at the left further enlivens the scene without straining it. The painting is essentially of a blissful day in the countryside, animated by horses and riders. The horse becomes the quintessential symbol of leisure, for man if not the animal.

The sense of space in this painting was undoubtedly influenced by the few weeks Degas spent during the summer of 1869 at the shore at Étretat and Villers-sur-mer, which he devoted to landscape painting.[30] The lower horizon and the emphasis upon the sky suggest it. The painting also shows him less cut off from his contemporaries – Monet, Renoir, Cézanne, Morisot – than one might have expected and makes it seem quite natural that he should have enthusiastically supported the organization of their first independent exhibition, which was to lead to their being called impressionists.

Notes

1. For the chattiest account of this circle of friends see *The Correspondence of Berthe Morisot*, ed. Denis Rouart, trans. Betty W. Hubbard (London, 1957).

2. Reff Notebook 21, fol. 12.

3. Kendall in exh. cat. New York 1993, 74.

4. Theodore Reff, "Works by Degas in the Detroit Institute of Arts," *Bulletin of the Detroit Institute of Arts* 53, no. 1 (1974), 31.

5. Reff 1974, 31.

6. A single model probably posed for the three young women riders. Victorine Meurent and Emma Dobigny were favorite models in the sixties, Meurent primarily for Manet, including the *Olympia* and the *Déjeuner sur l'herbe*, Dobigny for several works by Degas, including possibly this one.

7. Kendall in exh. cat. New York 1993, 74.

8. For a copy of the Castagno, see Reff Notebook 3, fol. 3; for a copy of the Verrocchio see Reff Notebook 5, fol. 35.

9. Reff Notebook 22 has 220 pages (127 used), 23.6 x 19 cm.

10. Arnout Balis et al., *Les chasses de Maximilian* (Paris, 1991).

11. Balis et al. 1991, 52, 53.

12. Balis et al. 1991, 14.

13. Hôtel Drouot, Rive Gauche, Paris, 6 May 1976, *Important Ensemble de Dessins par Edgar Degas provenant de l'Atelier de l'artiste et d'une partie de la collection Nepveu-Degas*, no. 17, repr.

14. Among other examples of this dualism found in drawings that were not in the four original sales are these drawings of a moving Master of the Hunt: *Chasseur au chapeau haut de forme* (atelier stamp verso; ex-collection Hector Brame, Paris; sold Christie's, London, 30 November 1982, no. 114); *Deux études de cavaliers* (atelier stamp lower left; not sold Christie's, London, 25 June 1976, no. 29); and one only known from a photocopy in the Documentation at the Musée d'Orsay, with a Nepveu-Degas stamp lower right.

15. Kendall (in exh. cat. New York 1993, 73) mentions *The Field Arriving at the Meet* by Henry Alken as a possible source.

16. Loyrette in exh. cat. Paris 1988–1989, no. 121, 193. Kimberly Jones proposes that the red-coated figures could be gentlemen riders rather than hunters on the basis of an entry in Albert de Saint-Alban, *Les Courses de chevaux* (Paris, 1890), 44, under "Red-coat, Habit rouge": "Dans certaines épreuves réservés aux gentlemen, les conditions stipulent qu'ils doivent monter en tenue de chasses, habits rouge ou red-coat."

17. Loyrette in exh. cat. Paris 1988–1989, no. 121, 193, proposes the date of 1873 for the whole work. Lemoisne 1946–1949, 1: 118 proposed a date of 1864–1868, ignoring the Louvre drawing. Brame-Reff in the Supplement to Lemoisne, no. 66, propose 1866–1868, believing the signature and date were added by another hand. Kendall (in exh. cat. New York 1993, 71–73) proposes two phases and in 281, note 44, proposes that drawings for the earlier phase are "consistent with the early 1860s." The drawings he selects are Vente IV: 78.a, convincingly a study for the rider at the left coming up the bank. His choice of Vente IV: 223.a is less convincing.

18. Loyrette in exh. cat. Paris 1988–1989, no. 121, 193. Degas' interest in the English market is also further demonstrated in his letters. See *Letters*, 1, 12, to Tissot, 30 September 1871; 6, 29–31, to Tissot, 18 February 1873; 6, 33, to Tissot, from Paris, 1873. For letters from Degas to Charles Deschamps in London see *Degas inédit* 1989, 436, letter D1, 25 October 1874; 436–437, letter D2, 1 June 1876; 437, letter D3, 16 June 1876 (from Naples).

19. Kendall (in exh. cat. New York 1993, 281, note 44) states that many trees painted earlier were removed about 1873.

20. Kendall (in exh. cat. New York 1993, 281, note 44) says his examination of the painting at the Galerie Schmit suggested that the sky was painted later, presumably 1873.

21. Loyrette in exh. cat. Paris 1988–1989, no. 95, 158 as Durand-Ruel stock no. 1910.

22. *Letters*, 3, 17.

23. Loyrette in exh. cat. Paris 1988–1989, no. 95, 158.

24. Loyrette in exh. cat. Paris 1988–1989, no. 95, 157.

25. L 270, *Henri Valpinçon Enfant*, private collection.

26. Loyrette in exh. cat. Paris 1988–1989, no. 95, 158, note 8.

27. Suzanne Barazzetti, "Degas et ses amis Valpinçon," *Beaux-Arts* 190 (21 August 1936), 1, records that it was kept by the Valpinçons.

28. Her features in fact resemble most closely those "monkey features" of the Princess Metternich, which Degas had copied in a painting from a detail of a photograph of her (L 89, National Gallery, London).

29. There is a shaky drawing of a dog, probably not in Degas' hand, in the same notebook as the head of the nurse (Reff Notebook 22, fol. 82, which Reff does not question); Degas turned it into a firmer drawing in another notebook (Reff Notebook 23, fol. 73), although even this version does not look down with the proprietary interest of the dog in the painting.

30. See Loyrette in exh. cat. Paris 1988–1989, on "The Landscapes of 1869," 153–155; Kendall in exh. cat. New York 1993, chap. 4, "The 1969 Pastels," 85–107.

The Horse, the Jockey, and the Track, 1868–1874

In the late 1860s Edgar Degas was finding his way to the races. It is true that he had dallied at provincial racetracks in 1861 and 1862, when he had painted *Jockeys at Epsom* (cat. 12) and *At the Races: The Start* (cat. 13), and had later ambitiously devoted himself to *Scene from the Steeplechase: The Fallen Jockey* (cat. 16) for exhibition at the Salon in 1866. But for much of the middle of the decade he had been distracted by private equestrian occasions – family outings or the hunt, which were also country events and probably painted (or at least conceived) near Ménil-Hubert. Before the end of the decade he was attending the popular gatherings at racetracks like Longchamp on the edge of Paris. This interest in a public urban life was consistent with his increasing attachment to the theater, particularly the ballet. In considering the spectacles at the opera he never forgot the individual dancers or singers, including their training and rehearsals. In the same way, at the racecourse he never dismissed the individuality of horses and jockeys nor his admiration for the discipline it took to bring them to the track.

The Horse, 1860–1872

Degas made many studies of horses without their riders. He was serious about learning their anatomy, and as early as 1859 he had made drawings after the *écorché*,[1] or sculptor's model, of a horse by Géricault.[2] Sometime in the mid-1860s he produced a drawing, as well as a counterproof, of a saddled but riderless horse (fig. 50) in which the muscles, tendons, and joints are conspicuous. From a contemporary photograph by Louis-Jean Delton (fig. 51), it appears that Degas' drawing of the muscles crossed above the forelegs, are, for example, by no means exaggerated. Although the neck of Degas' horse is not nearly as arched, there is enough similarity between his horse and Delton's to arouse speculation about whether the painter might not have turned to photographs to learn more about the horse. Delton had been a member of the Jockey Club since 1855 and, as Eugenia Janis writes, "from 1860 on he used photography to record the forms and movement of prize winners, producing a pictorial equivalent of the Stud Book."[3] The albums Delton published, including the *Album hippique* in 1866–1867, may have been an important source for the artist. Degas, nevertheless, seems to have suggested a greater personality in his horse than the photographer was able to do. In spite of his harsh rendering of its forms, the cocky ears, pleading eyes, and sense of helplessness with which the horse chews on its reins give this animal a melancholy charm. From Delton Degas could have learned not just about the horse's anatomy but perhaps even more significantly about the drama possible in the shadows cast by the animal.

cat. 46 (detail)

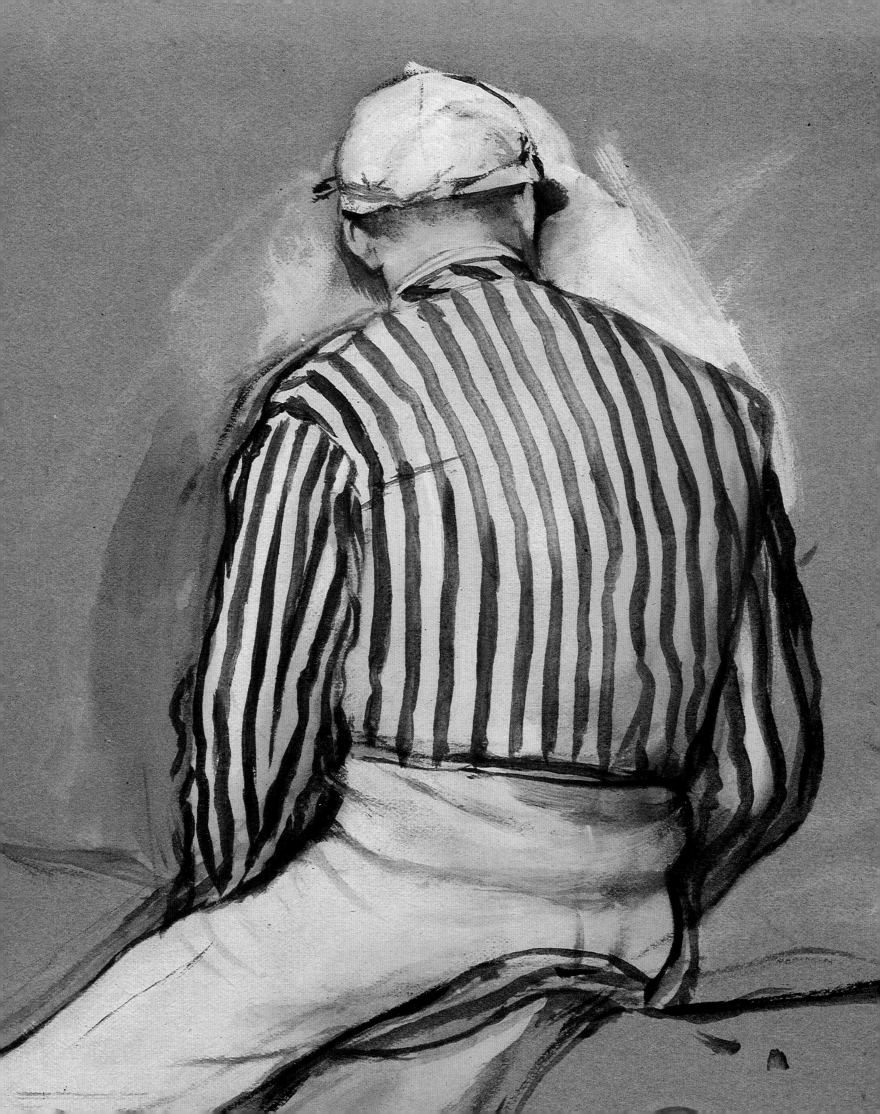

Degas never painted a horse in the isolation of the drawing *Horse with Saddle and Bridle* (fig. 50), but he did draw many others. He also made statues of single horses, mixing his wax with other materials to produce the substance he modeled over armatures, which were largely his own inventions. The first "wax" by Degas to be X-rayed (fig. 52) is close to the black chalk drawing in stance, but is lighter and more animated. The armature for the wax (fig. 53) is surprisingly open and imaginative. Undoubtedly this assurance on the part of Degas suggests that it was made a little later than the drawing, even if, without other information, the date can only be estimated. Although the wax horse must on occasion have borne a saddle and a rider, Degas does not labor this point.

Compared with the drawing, it is obvious that he refined its body, reduced the belly, attenuated the neck, lengthened the legs, raised the tail, and lifted and turned its head so that it looks directly ahead (as is fitting for a good racehorse). Consequently, its proportions are closer to the ideals expressed for a racehorse at the Jockey Club in Paris than those of the aging if appealing nag of the drawing. One statement read, "The solid frame . . . [is] capable of enduring all strain; there is almost no belly so as not to overburden the legs with unnecessary weight. In a word, a perfect machine to attain the purpose in view: strength and speed."[4]

The surface of the sculpture is as abstract and unconventional as the armature. The irregularities of that surface

fig. 50. *Horse with Saddle and Bridle*, c. 1868–1870, chalk on paper. Fogg Art Museum, Harvard University Art Museums, Bequest of Grenville L. Winthrop

fig. 51. Louis-Jean Delton, *Thoroughbred English Stallion Belonging to Count Aguado*, c. 1867, albumen print. The J. Paul Getty Museum, Los Angeles, California

fig. 52. *Standing Horse*, c. 1870, wax and pigment. Musée d'Orsay, Paris. Gift of Paul Mellon, 1956

fig. 53. X-ray of Standing Horse

catch the light and indicate that, although well-behaved, this is a spirited animal.

Degas was moving into the period when he would only use one horse, the lean, disciplined, highly strung, and highly bred racehorse. But there were times that he relished drawing and painting massive and persistent cart horses and silly and undisciplined colts and ponies. There were other occasions when in his notebooks he enjoyed capturing conventional horses at ease when they were not on parade. In one of his most remarkable notebooks of about 1868,[5] he drew a horse stretching out its head and neck as far as it could without hinting as to whether the motive was exercise or curiosity (fig. 54). Degas' own amusement is quite clear. In another drawing in this notebook (fig. 55), the horse, perhaps the same one, crouches comfortably on the ground. The recalcitrant pony in *Children and Ponies in a Park* (cat. 30) comes to mind, but with the blanket over its back and its unfocused eye, this horse is like a tired but attentive grandmother. On the whole, however, Degas saw the behavior of animals as a thing in itself, seldom mimicking or reflecting human behavior.

Degas could romanticize a horse as he did with one he drew with pencil on pink paper (fig. 56), using white so generously it could hardly be described as heightening. Against the background of the tender pink a horse is modeled so strongly and smoothly that it must come from a tradition of classical sculpture. The light falls in pools from above as if its source were

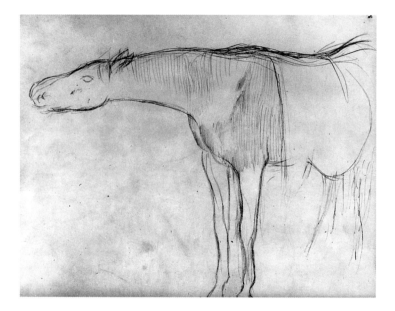

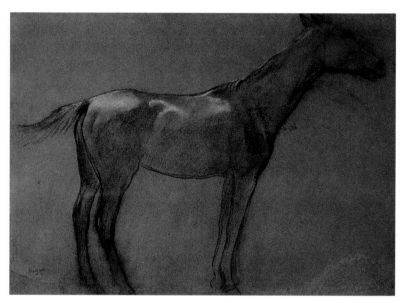

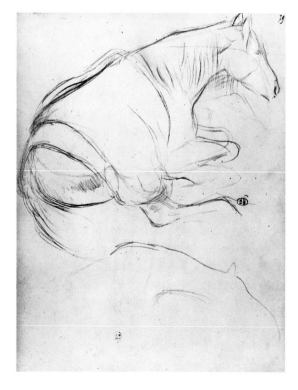

the moon. In those passages of illumination on the cocky tail, or the croup, or down into its back, and barely touching its mane, there are elements of the unexpected and of a poetic beauty. A line running from its legs through its neck reveals the horse's wonder and anticipation.

Heirs to that horse, one black and one white, appear in *Horses in a Meadow* (cat. 39), which is dated 1871. The beautifully painted landscape, with open fields surrounding the smokestacks of a small factory, absorbs any tensions. The two horses are seen in an intimate position, but only one horse's head is revealed. Any expression is conveyed in the solid bodies and in their relationship to each other. They seem to represent nature as tender and enduring, but these are not the horses of the track.

fig. 54. *Horse with Neck Stretched Out*, 1868—1869, graphite on paper. Bibliothèque Nationale, Paris *(top left)*

fig. 55. *Horse Lying Down*, 1868–1869, graphite on paper. Bibliothèque Nationale, Paris *(bottom left)*

fig. 56. *Horse*, c. 1870, graphite heightened with white on paper. Isabella Stewart Gardner Museum

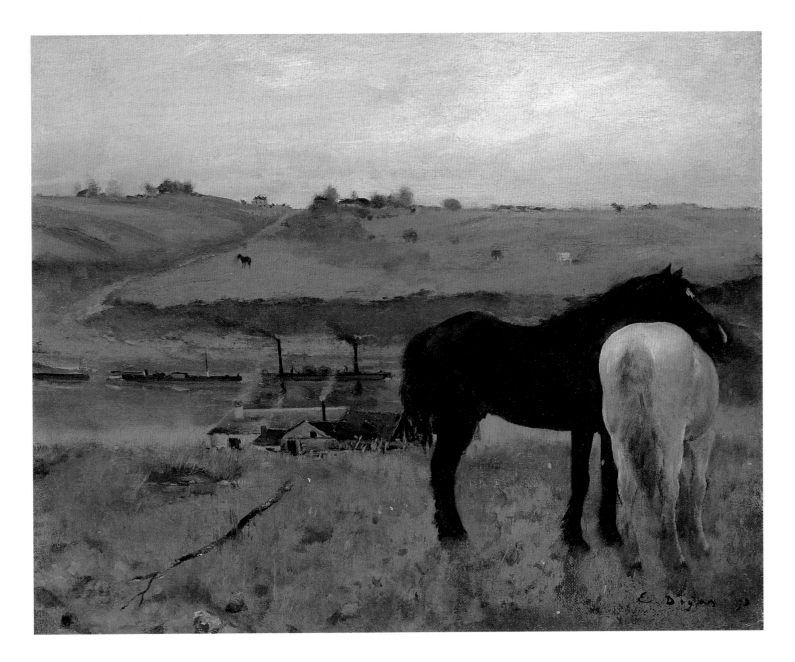

cat. 39. *Horses in a Meadow*, 1871, oil on canvas. National Gallery of Art, Washington, Chester Dale Fund, 1995.11.1

Jockeys

Degas' relationship to the jockeys who rode some of the horses in his works is almost as equivocal as his relationship to the horses themselves. Little is known about these riders except that there was a distinction between the "gentlemen" or amateurs who rode for their own pleasure in the steeplechase and the professional jockeys who rode for money. Far less information exists about the life of the professional jockeys than there is about the dancers, laundresses, and prostitutes of the Second Empire.[6] More can be as-

sumed about the "gentlemen" from the very fact that they had the leisure to indulge in the sport. Achille De Gas, who is often claimed to have been a gentleman rider,[7] was the kind of adventurer who would have been attracted by the excitement and danger of the races themselves. On the two occasions when Degas identified a jockey by a name, Lepic and Broutelles, it has turned out that both were artists. The Viscount Lepic, the son and grandson of Napoleonic generals, was a man who exercised his sometimes limited talents in many occupations – printmak-

cat. 40. *Study of a Jockey*, c. 1865–1868, graphite on paper. Private collection, The Netherlands

fig. 57. *Two Views of a Jockey*, c. 1868, graphite on paper. Bibliothèque Nationale, Paris

ing, stage and costume design, the decoration of ceramics for Sèvres, the creation of anthropological museums, and the breeding of dogs rather than horses.[8] Undoubtedly he rode, but there is some doubt about whether he ever raced. He was, however, ready to pose for Degas as a father and lover of dogs, and apparently occasionally as a jockey as well. A "marquis de" Broutelles may have had as little right to the particle "de" as the painter himself;[9] the only record of him aside from Degas' inscription on one of the two drawings for which he must have posed is that he was a painter born in Dieppe who did exhibit in the Salons. Deflating as the histories of Lepic and Broutelles are in terms of establishing any intimacy on the part of Degas with the world of the racetrack, they do make it clear that he must have used friends or models for his jockeys as he did for his portraits.

One drawing, *Study of a Jockey* (cat. 40), is important because it has links which can help establish a chronology to the drawing *At the Races* (cat. 15), certainly after 1862, and a drawing in Notebook 22 (fig. 57),[10] which is fairly certainly about 1868. In his strictly profile position, facing right, this jockey falls naturally into the pattern of Degas' earliest racecourse paintings: *Jockeys at Epsom* (cat. 12) and *At the Races: The Start* (cat. 13), both of which can be dated 1861–1862, and *The Gentlemen's Race: Before the Start* (cat. 11), which was begun in 1862 but perhaps not finished until 1883. But if this drawing is compared with a detail of the Clark's drawing, also in pencil, it is clear how much Degas had matured. The jockey seems much more relaxed as he sits (with equal propriety but greater natural authority) upon his horse, his hands more at ease as they hold the reins with a certain delicacy. The lines defining the body – angular, very light, and sure – are executed with a form of shorthand; Degas

felt no need to link them as a continuous contour around the body. But the greatest difference is in the head, even in the easier suggestion of the roundness of the cap. In this later drawing Degas does not exactly make a portrait of the bearded jockey, but he certainly has given up the absolute blankness and anonymity of the earlier one. The features are distinct; Degas may even have chosen the beard to give the head more character. The hair of that beard bristles with the strokes of his pencil to a point that it seems almost artificial.

Although the same model appears in Notebook 22[11] and in a somewhat similar position, this jockey is positively expansive as he sits on his horse, his broader shoulders hunched, his forceful head accented more, the nose emphasized, and the beard made more natural. Degas redraws the hands holding the reins where he seems to have left space to balance the energy of the rider. Those hands may not, however, have the same easy assurance as those in the first drawing. But in both Degas was using a model, capturing something of his individuality, and conveying his character with great economy and energy.

Degas made two sketches of another jockey (fig. 57), as if he were two jockeys side by side, in Notebook 22. This jockey is clean shaven except for a somewhat generous mustache. The position of his body, even the protection of his jaunty cap, makes him appear calculating, which his small, light eyes appear to confirm. The drawing is heavily accented, most strongly in the folds of the sleeves of his jacket and the shadow under his arm, which make the face of the figure at right more evasive. But he is that rare thing with Degas, a jockey with a personality.

This drawing, almost certainly about 1868, is significant in its relationship to a group of drawings Degas made of jock-

eys in mixed media. The most eccentric of
these is essentially a painting within a
drawing, *Two Jockeys and Woman with
Field Glasses* (cat. 41). The painting hangs
diagonally on a dark wall that reveals
nothing else. In the lower right corner is
the dramatic figure of a woman in black,
with a black hat lowered over her fore-
head, looking out through field glasses.[12]
She is conspicuously larger than the two
jockeys behind her, as if they were in
another painting before which she is
standing. These jockeys bear a close rela-
tionship to the pair in the notebook, ex-
cept that the right figure now is in back
view and the left figure turns his head
toward the mysterious woman. In some
ways his features and expression are a
cross between the two in the drawing as
he appraises the woman. This is the same
period as *The Interior*[13] and should, with
it, provide an answer to the criticism of
feminist art historians who see Degas
as an unrepentant misogynist.[14] In both
works Degas has expressed his distaste,
though with some humor, for the male's
calculations. In terms of his drawings of
jockeys, however, this issue is tangential.
It is more important as an introduction
to the group of drawings of jockeys made
in the late sixties and provides a date of
1868 for them, uncommon in the work
of Degas.

When Degas' friend Michel Manzi
(1849–1915) decided to reproduce twenty
of the artist's drawings in color in 1897
or 1898,[15] he made the choice in collabo-
ration with Degas. One they selected is
Four Studies of a Jockey (cat. 42), which
was dated 1866 in the album's caption.
It must be remembered, however, that
this was some thirty years later and that
Degas has a reputation for having been
somewhat unreliable in his later dating
of his own works.[16] When Paul-André
Lemoisne wrote a pioneering book on the
work of Degas in 1912, he reproduced

this same drawing and also dated it 1866,
the year Degas exhibited *Scene from the
Steeplechase* at the Salon.[17] Some thirty-
five years later in his catalogue raisonné
he extended the date to 1866–1872, but
gave no reasons for the adjustment. There
has been no general reconsideration of
their dates but their connections to Note-
book 22 makes 1868 the probable year
they were painted.[18]

cat. 41. *Two Jockeys and a Woman with Field Glasses*,
c. 1868–1870, *essence* on paper. Private collection,
Paris, courtesy of Fondation Pierre Gianadda,
Martigny, Switzerland

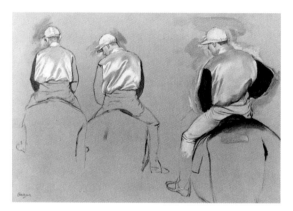

cat. 42. *Four Studies of a Jockey*, c. 1868–1870, brush and gouache with oil on card. The Art Institute of Chicago, Mr. and Mrs. Lewis L. Coburn Memorial Collection

fig. 58. *Three Jockeys*, c. 1868, *essence* on paper. Private collection

Four Studies of a Jockey is useful for other reasons. One is that its complex technique, upon which there has never been general agreement, has been analyzed and described by Harriet Stratis, paper conservator at the Art Institute of Chicago, as "brush and black gouache, with white and brown oil paint, on brown wove paper discolored with *essence*, laid down on cream card."[19] An important part of this technique is the irregular staining of the paper with the thinned oil paint called *essence*. The irregularity of its borders is a reminder by Degas, perhaps somewhat hypocritically, that this is a sketch. The matte darkness from which the sheen of the jockey's silks glow had a particular (if fading) interest to Degas at this time. Degas is so sure with the lines he made with brush and black gouache and the textures and forms he created with oil paint that it hardly seems a simple sketch. It has also been pointed out, again in Chicago, that there is reason to suspect some hypocrisy on Degas' part: "This confidence is explained in part by the presence of graphite and black chalk under the ink and gouache (that is, gouache and oil paint), suggesting that Degas first defined the forms, and then, when these were firmly secured on the page, turned to the brush to make a few unchangeable, perfectly placed strokes."[20] The effect is both informal and flawless, its composition so controlled that it has often been compared with the drawings of Antoine Watteau (1684–1721).

In *Four Studies of a Jockey*, views of the back of the rider are presented; in fact, the indifference toward the viewer in each of the positions is absolute. It also ensures the anonymity of the jockey and prevents Degas from falling into the trap of the teasingly suggestive narrative. He seems to have had three principal interests. The primary one is probably the seat of the jockey, combined with the position

of his shoulders. In the lower right-hand corner he twists and shifts on his horse, placing pressure on his black-clad right arm; this pose is closest to the *contrapposto* of the *Belvedere Torso*, which Degas could have remembered from the Vatican in Rome or from countless casts everywhere. At the lower left the jockey raises himself considerably from the back of the horse with his shoulders thrust forward and hunched downward. Above, he settles back on his mount, and, in the upper right, turns somewhat listlessly, while he looks down, the backs of his ears picked out by white oil paint. In fact, in all the poses of the jockey except the more confident figure in the lower right, the neck seems particularly vulnerable and the jockey very young. In all four poses, however, his balance is assured. Degas' second interest was in the clothing. He used white paint to help describe the tight-fitting jodhpurs, the neat caps, and particularly the shine and the fullness of the silks. And third, he was interested in directing the movement of the viewer's eyes from one jockey to another, to project ourselves into the four positions of his body.

In *Three Jockeys* (fig. 58), another drawing shown from the back, the two men on the left are very close (but not identical) to the two placed vertically on the left in *Four Studies of a Jockey*. They are, however, arranged on a horizontal page as if on a racetrack. Degas seems to have enjoyed the white paint here, using it more generously on their caps and jackets, which he makes even more lavishly silken. He also uses vibrating strokes of white around the figure at the right, emphasizing him in the composition but also giving that jockey a greater sense of physical energy, which an examination of the necks of all three reinforces. Of the thirteen drawings Degas made of jockeys in this series, this is the only one which he

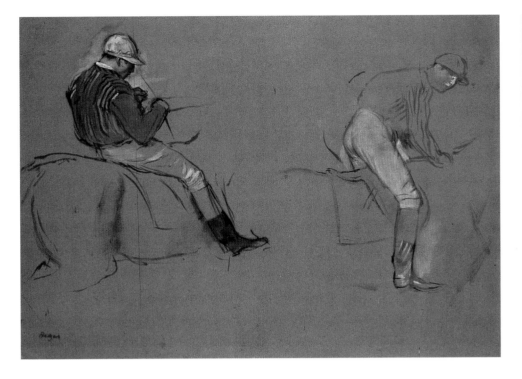

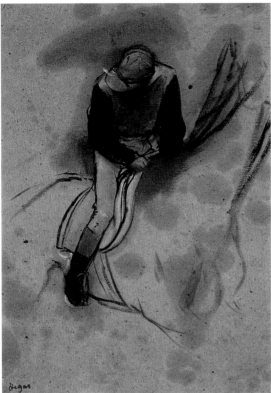

cat. 43. *Jockey Leaning Forward in His Saddle*, 1868–1870, *essence* and gouache on paper. Private collection *(right)*

cat. 44. *Studies of a Jockey*, c. 1868–1870, brush and gouache with oil on paper. Private collection *(left)*

seems to have mined for a later painting, *Racehorses at Longchamp* (cat. 49).

Unusual among these thirteen sheets of drawings is *Jockey* (cat. 43), with a single rider who is moving in our direction but lowers his head so that his face is hidden. The staining with brown *essence* is reduced to a cloud behind the upper part of the figure and some faint dappling of the body of the horse. The predominant tonality is light, the result of the artist's use of an irregular pink wove paper with imperfections, which has faded. Nevertheless, at the core of the work there is a dark shadow on the horse's back, behind the jockey's rump and beneath his arms, in addition to the cloud. With his black-clad arms and his head lowered so that the visor of his cap casts a shadow on his jacket, the jockey is expressively suggested by Degas to be troubled in an otherwise light and sunny world. The handling of the horse shows how arbitrary and bold Degas could be when he subordinated the animal to the jockey,

but the repetition of lines in its neck conveys action. From the pose of the rider it is clear that this action is combined with defeat.

Studies of a Jockey (cat. 44) is completely light filled without any staining. As in other drawings, it could be one jockey from two points of view. The drawing on the left is brusque and assured as the jockey pulls in the reins, whereas in the cursory drawing at the right he raises himself off his horse and lowers his head as he rides forward. The jockeys are almost subordinated to the untouched page. The left jockey, so beautifully and lightly created out of a few apt strokes of paint, draws back on the page as well as on the horse. The rest is dependent upon seemingly casual but effective lines. In another drawing, *Two Jockeys* (cat. 45), the light is so luminous that it seems to dissolve the substance of the body of the second jockey so that all that is left are rudimentary but highly graphic lines. Even in the front jockey at the left Degas works freely

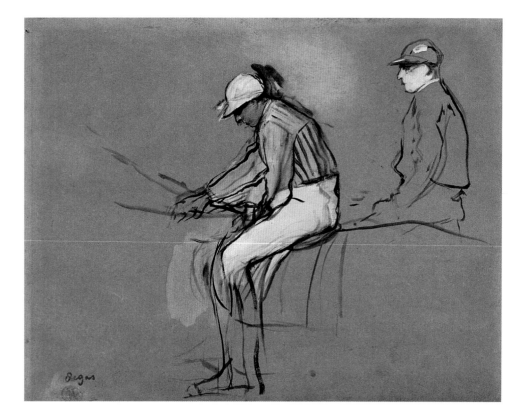

with line, changing his mind and leaving the evidence of it generously, as if the lines were the body of the jockey vibrating in space. There is also almost an irritation in the graphic style. The two jockeys seem in one case crankily distraught, in the other drained of will.

Study of Two Jockeys (cat. 46) is very different from the two pairs of riders just considered. These two are very naturally at ease and self-confident as they wait, presumably before the race. The solidity of their bodies is emphasized by the casual way they turn in space, confident that they have a special relationship with gravity. In *Four Studies of Jockeys* (cat. 47), the same ease is combined with an openness in the frontality of the figures, almost the reverse in every respect of Chicago's drawing (cat. 42). It is as if Degas had worked his way from dark to sunlight, from concealment to exposure, although the relative diffidence of the jockeys and the assurance of the artist remain.

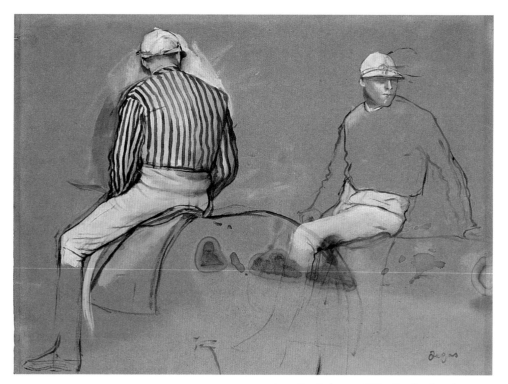

cat. 45. *Two Jockeys*, c. 1868–1870, brush and gouache with oil on paper. Private collection *(top)*

cat. 46. *Study of Two Jockeys*, c. 1868–1870, brush and gouache with oil on paper. Private collection

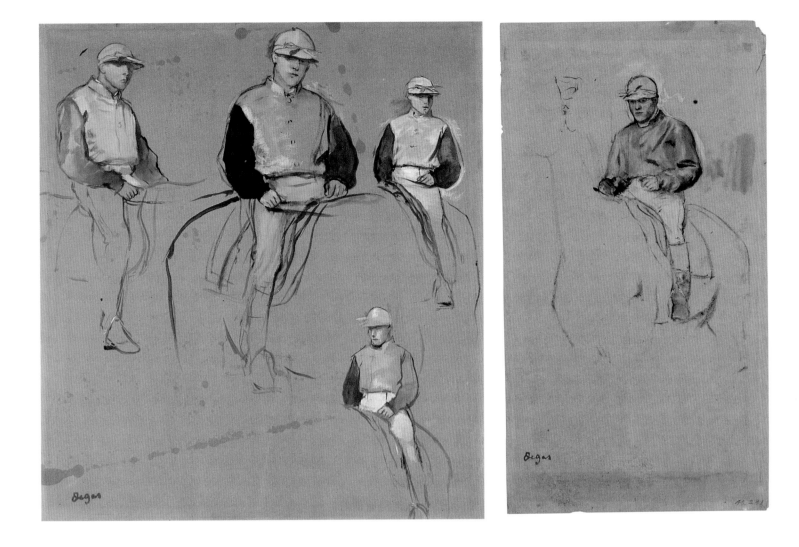

cat. 47. *Four Studies of a Jockey*, c. 1868–1870, brush and gouache with oil on paper. Private collection

cat. 48. *A Jockey on His Horse*, c. 1868–1870, oil and graphite on paper. The Metropolitan Museum of Art, Bequest of Walter C. Baker, 1971

In a drawing of a single jockey (cat. 48), the rider sits on his almost invisible horse confidently, his stocky body strong, determined, and mature. His face expresses nothing but seriousness and confidence. Degas was equally serious and self-confident as an artist. When he was dissatisfied with his execution of the jockey's right hand he crossed it out with dark paint. The drawing is the kind Degas might have used later as a starting point for development and even transformation for later paintings.

It is natural to ask questions about Degas' intention for this series, which does seem to subdivide itself, without stretching much further chronologically, between the first works here (cats. 41–43; fig. 58), which are furtive; the two pairs of jockeys against a light ground summarily and expressively rendered (cats. 44–45); and the mature jockeys (cats. 46–47), to which the single rider could be added (cat. 48). Whether it was because he was thinking of using them in the future as stock figures, as has frequently been suggested,[21] or not, it is interesting that Degas did not sell any of them. Probably they were unknown to the public until Chicago's *Four Views of a Jockey* was reproduced. These jockeys are remarkable examples of Degas' draftsmanship with paint and highly sympathetic records of the jockeys themselves, if as a type rather than as individuals. And they were undoubtedly indispensable to his paintings of racecourse scenes, at which we have finally arrived.

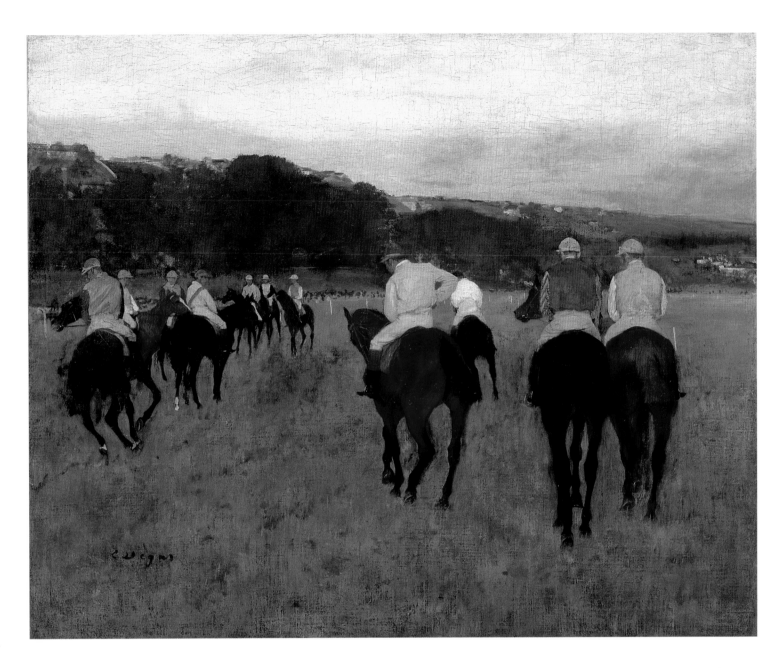

cat. 49. *Racehorses at Longchamp*, 1871; reworked in 1874?, oil on canvas. Museum of Fine Arts, Boston, S. A. Denio Collection

At the Races, 1866–1872

Few works by Degas lack problems of dating, and this is true of a small painting called *Racehorses at Longchamp* (cat. 49), which seems to be the first equestrian work by Degas to have been bought by a museum (the Museum of Fine Arts in Boston in 1903). It is also not improbable that there should be some question as to whether this is actually Longchamp, a busy track on the edge of Paris in the Bois de Boulogne. But the fact that a Parisian site was chosen indicates that the work was considered more sophisticated than

Degas' earlier pictures in Normandy. Beyond the rough grass and above the dark trees are buildings like the outcroppings of a cliff, perhaps Paris itself. The horses and riders, like most of those Degas painted, are not depicted in a race, but at a time before or after the race. They gather in a rather desultory manner, not unlike the hunters in the presumably contemporary *Leaving for the Hunt* (cat. 33). These figures, however, unlike the hunters, do not communicate with each other and, like the drawings of jockeys of 1868, remain resolutely indifferent. The

jockeys that are closest to the picture plane show only their backs, and those further removed, who do look in our direction, have faces that are deliberately blank. The transition to those who do look toward the picture plane is indicated by the tiny jockey in the vermilion cap and diagonal ribbon, fourth from the left, who slumps back on his horse. The horses and riders are in two groups – one in a roughly diagonal formation at the left, the other fanning out from the three riders on the right – and appear to have been choreographed with that strong sense of the ground that Paul Valéry describes.[22]

Degas used wooden horses or chessmen to plan his equestrian compositions. Ambroise Vollard describes a visit to Degas' studio, when "Degas picked up a little wooden horse from his work table, and examined it thoughtfully. 'When I come back from the races, I use these as models. I could not get along without them. You can't turn live horses around to get the proper effects of light.'"[23] Vollard also tells us that Degas bought toys frequently, largely for the children of friends but by implication for his own purposes as well.[24] Obviously the artist liked to work with smaller objects to replace the horses he had seen at the track, and he used his own waxes frequently as models. In his studio he was the skillful choreographer plotting the movements of his mounted horses across the grass or paddock.[25]

The drawing *Three Jockeys* (fig. 58) provided positions for three of the figures in the painting, but they are in different relationships on the canvas. The largest in the drawing at the right becomes the central figure with the red cap. The drawing's central jockey in a blue jacket and cap has been moved to the left, where he attempts to control a recalcitrant horse. The jockey at the left of the drawing is at the right of the painting, having lost the strokes

of white paint on his ears. In general the youths of the painting do not seem as vulnerable as in the drawings. One obvious difference between the drawings and the painting is that in *Racehorses at Longchamp* the horses as well as the jockeys appear. These horses are rather loosely painted in dark colors, but give a sense of the restlessness over which the young jockeys must exert control.

The artist also had to remain in control of eleven horses and riders – forty-four equine legs and twenty-two human – against a landscape on the small surface of the canvas, less than two square feet. In doing this on a small scale he must have thought of the considerably larger mounted figures by Benozzo Gozzoli he had copied in Florence (cats. 3–5). The position of the horse's legs in his central figure is not unlike the black horse bearing a page, in the section of the fresco just to the right of the Magus Melchior (fig. 14); this Renaissance youth is at the center of one of his own copies (cat. 5). Recalling his drawings from Benozzo, Degas also remembered the exactitude of Benozzo's placement of the legs of both horses and men in the frescoes, even if he did not choose to remember the stylized pattern of his cast shadows or the monumental shoes of his horses. It must have been with those Renaissance frescoes in mind that Degas made a pencil drawing of the backs of three horses and jockeys (fig. 59), obviously preparing for *Racehorses at Longchamp*. The drawing is somewhat labored, the contours surprisingly continuous but particularly forceful in the description of the horses, as if their location in space both in this drawing and in the ultimate painting was a serious responsibility for Degas.

The lethargy detected in *Racehorses at Longchamp*, along with the color in the sky, suggest that this is the weary end of the day. This accentuates the fact that the

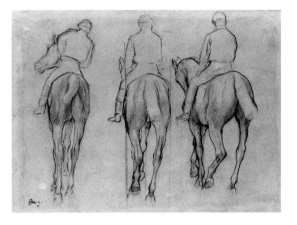

fig. 59. *Three Mounted Jockeys*, c. 1868–1870, graphite on paper. Fogg Art Museum, Harvard University Art Museums, Bequest of Grenville L. Winthrop

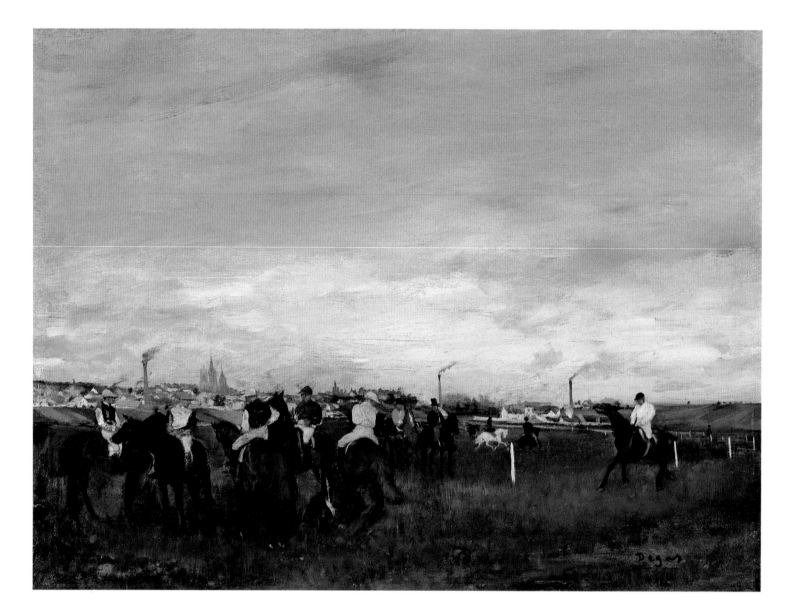

jockeys are barely adult. The tender colors Degas uses for their caps and silks, as pretty as spring flowers against the rough green grass and darker trees, add to this sense of an unstructured, unplanned, and dreamlike gathering of youths, and are reminiscent of the delicate colors of the Medici-Riccardi frescoes. At no point in *Racehorses at Longchamp* is there the activity of the steeplechase horses and riders, or even the clouds in the sky, of his contemporary *The Carriage Leaving the Races in the Countryside* (cat. 38).

The *Racehorses at Longchamp* is particularly appealing because it is so small. *Before the Race* (cat. 50) is even smaller,

its width only as great as the height in the other painting. Degas, many of whose works from the sixties are on a scale appropriate for the Salon, was just before and just after 1870 working on an almost miniature scale, whether he was painting dancers, landscapes, or jockeys. He was also discovering in showing portraits at the Salons of 1869 and 1870 that, small as these paintings were, they were more popular, if not more sensational, than his earlier large history paintings had been.[26] On a visit to France after the Franco-Prussian War, in which Degas had fought and which may have damaged his eyesight, his younger brother René wrote to

cat. 50. *Before the Race*, 1871–1872, oil on wood. National Gallery of Art, Washington, Widener Collection, 1942.9.18

his wife in New Orleans in 1872, "His eyes are better, but he must take care of them, and you know how that is. At this very moment he is painting tiny paintings, that is to say those that would tire his eyes most."[27] Degas had been painting small pictures before the war but René might have been seeing them for the first time. In any case, the effect of *Before the Race* is almost telescopic.

The jockeys in the painting come from the same vocabulary as the *Racehorses at Longchamp*, but there is no awareness of a choreographer at work. Horses and riders are gathering together with a certain nervousness for a reason: the race that is about to begin. This is made clear by the presence of two mounted officials in top hats as well as the convincing confusion of the jockeys themselves, strung along the left half of the picture. The background of buildings with smokestacks is certainly industrial as Paris must have been, and the church on the distant hill could be a neo-Byzantine church under construction. The track is on the edge of the city separated from its dynamism, which is suppressed, in any case, by the lowered horizon. But, telescopic though *Before the Race* may be, it is closer to the energy of the racetrack than *Racehorses at Longchamp*.

The low horizon and the extent of sky in *Before the Race* are not unlike the work of a painter who was being discovered in the 1860s[28] – the painting, *View of Delft* in the Mauritshuis, the Hague, and the painter, Jan Vermeer. Whether Degas actually went to the Hague is not known, but it would not have been impossible. His admiration for Vermeer would have been natural. And here, it is almost as if he had replaced the buildings of Delft by the rank of horses and riders in a painting very much smaller than that of Vermeer.

Degas' concept of the racetrack was expanding. Although he never painted the crowds who supported it with the social variety and enthusiasm of Émile Zola in *Nana* or even Gustave Flaubert in *L'Éducation Sentimental,* he nevertheless began to include the spectators. One such spectator was, of course, the painter Manet, who was drawn to the track because of the visual stimulation of the races themselves that he had already recorded in a few paintings. Since Manet was also essentially gregarious he easily adapted himself to the mores of the track. Degas drew his stocky, energetic, restless figure in a rumpled suit, but wearing an immaculate hat, as he puts one hand in a pocket and holds up a monocle to view a very faintly drawn young woman with a lorgnette (cat. 51). Watching pretty women was one of the pleasures of the track that Manet enjoyed. The woman with the lorgnette is related to the seductress in the drawing with jockeys (cat. 41), but she was undoubtedly closer to the more delicately drawn and diffident *Young Woman with Field Glasses* in the British Museum (fig. 60), who may have been Degas' pregnant sister Marguerite Fevre.[29] Degas was fascinated by the extension of any visitor's experience through binoculars. Another spectator was possibly the painter's brother Achille (cat. 52) posing as another of those *flâneurs,* the nattily dressed men who relished the spectacles Paris provided. At the track Degas was interested in the spectators as well as the performers. This *flâneur* stands with a certain self-conscious ease as he leans on his furled umbrella. Although this identification has been questioned,[30] he has very much the same appearance and manner as Achille in Degas' painting of *Portraits in an Office (New Orleans).* In any case, this man and Manet, as Degas drew them, were part of the prosperous racetrack crowd.

Degas also looked at the female spectators at the races, even if they did not

cat. 51. *Manet at the Races*, 1868–1870, graphite on paper. The Metropolitan Museum of Art, Rogers Fund, 1919 *(left)*

cat. 52. *Achille De Gas*, c. 1872–1873, oil on parchment. The Minneapolis Institute of Arts, Bequest of Putnam Dana McMillan

fig. 60. *Young Woman with Field Glasses*, c. 1866–1868, brush with *essence* on paper. The British Museum

shield their eyes with binoculars. Inspired undoubtedly by charming remnants of Manet's *View of the Race in the Bois de Boulogne*, of 1865, Degas used *essence* and gouache to study the behavior of young women together in the stands (cat. 53). Whereas Manet showed his women standing behind the barrier in front of carriages and even one great spoked wheel, in different dresses, Degas used only one model in one dress to pose in the vertical drawing for a dozen different positions. Her activities are natural – reading, looking, waiting, gossiping, possibly eating – performed with considerable economy, wit, and charm. Degas' usual love of dress for its cut, rather than Manet's en-

joyment of the sumptuous, is apparent in the shaping of her hair, the band over it that keeps her tilted hat in place, the effect of the hoops under her overskirt, the neat pleats of the skirt underneath, even the black of her shoes and the white of her stockings. Degas has come to see that the races are, like the theater and the dance, spectator sports in which much can be enjoyed from those who share the stands. Admittedly he was always selective, seeing the crowd in terms of those who interested (and in this case also delighted) him. The effect is more animated than the Manet but little more interested in individual characteristics. Manet is content to make his black-eyed women as solemn and charming as dolls. Degas sees his young woman as independent and self-willed, not a toy.

Degas even made an essentially architectural drawing of the stand itself (cat. 54), which Loyrette argues is not the one at Longchamp but might be that of Saint-Ouen instead.[31] Degas nevertheless acknowledges its symbolic usefulness in addition to its provision of protection from the elements. The roof of the stadium, if it is Longchamp, seems larger than the building, but it looms over the crowd protectively.

The spectators and the stand were important in two racetrack scenes Degas painted before 1872: *The False Start* (cat. 55) and *The Parade* (cat. 56). In *The False Start*, the stands and the barrier between the track and the crowds are parallel to the surface of the painting. To the right of the stands are luxuriant trees, and within the stands and behind the barriers is a garden of pretty colors of hats, parasols, and dresses. In actuality the crowd is somewhat spare; there are spaces between the visitors. And the handling of the people who make it up is freer and more flattering than Degas' painting of similar

cat. 53. *At the Racecourse*, 1868–1872, *essence* and wash heightened with gouache on paper. Musée du Louvre, Département des Arts Graphiques, Fonds du Musée d'Orsay, Paris

cat. 54. *The Grandstand* (study for *The False Start*), 1869–1872, graphite on paper. Collection of Mrs. John Hay Whitney

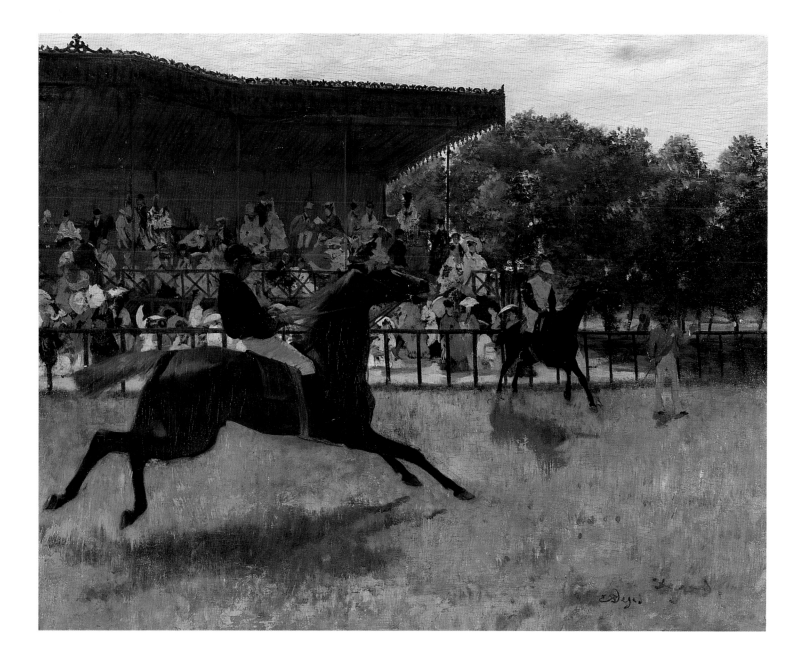

crowds almost a decade before near Ménil-Hubert.[32]

In spite of the charms of the crowd, the stands, and the trees, *The False Start* (cat. 55) is a painting about a horse. While another jockey controls his eager mount, a much larger stallion with its jockey has escaped from the starting post and begins to gallop down the track. His gallop is a classic case of the misconceptions of the movement of the horse that the photographer Eadweard Muybridge would rectify, a fact Degas remembered when he had his historic interview with Thiébault-Sisson

in 1897: "I was totally ignorant of the mechanism that regulated a horse's movements. . . . Marey had not yet invented the device which made it possible to decompose the movements – imperceptible to the human eye – . . . of a galloping . . . horse."[33] But this horse in an improbable movement, rather like an enlarged and westernized Tang horse, commands the left half of the painting through its picturesque silhouette and its energy as it struggles against the jockey who reins it in. It is the boldness of that image framed above by the roof of the stands and kept

cat. 55. *The False Start*, 1869–1872, oil on panel. Yale University Art Gallery, John Hay Whitney, B.A. 1926, Hon. M.A. 1956, Collection

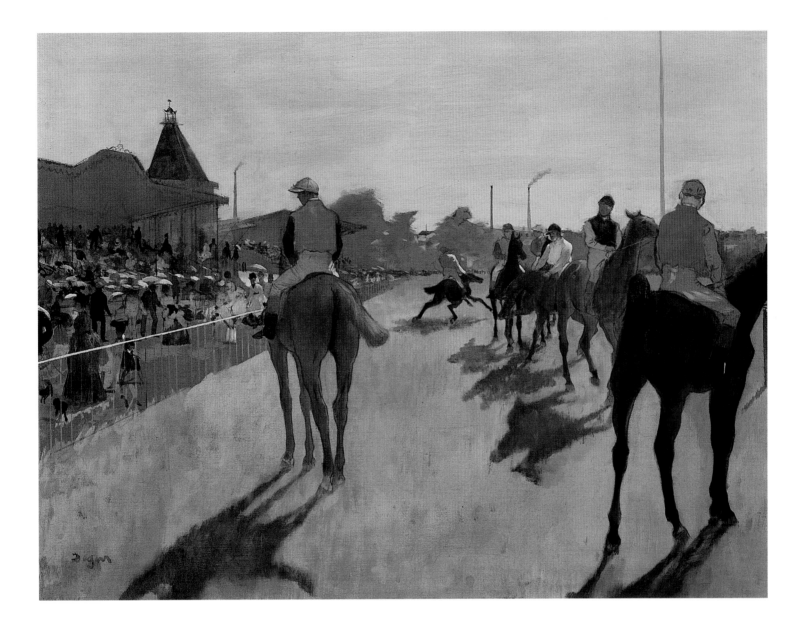

cat. 56. *The Parade (Racehorses before the Stands)*, 1866–1872, *essence* on paper, mounted on canvas. Musée d'Orsay, Paris, Bequest of the comte Isaac de Camondo, 1911

in the left side of the painting that dramatically dominates the panel. Equally evocative are the shadows of both horses and riders, perhaps encouraged by the shadows Delton was finding in photography. The horse may have escaped its bounds but Degas has welcomed this to give us an image of the racetrack it would be difficult to forget.

The False Start is small and without apparent pretensions. *The Parade* is clearly related to it with the same grandstand, the same matte thinness of the paint, and essentially the same palette.

In this painting, Degas even sought the same dramatic shadows from his horses and riders. But it is otherwise more ambitious with seven horses and riders before the stands. Instead of a composition quietly parallel to the picture plane, this is organized on two diagonals receding into space.

The problem of the natural relationship of mounted jockeys to each other in an unstructured space bothered Degas. It was probably for that reason that he made drawings in Notebook 22 (figs. 61, 62) from the *Battle of Solferino* by Meis-

sonier, which was shown, as Reff points out,[34] at the Salon of 1864 and at the Luxembourg Museum from that year. He was copying the work of an artist of whom he would say to Thiébault-Sisson, "this bad painter was one of the best-informed on horses that I have ever met."[35] Degas was humble enough to use one of Meissonier's figures of a mounted officer (fig. 61) as the basis for the horse and jockey at the right of this painting, but he gave the silhouette of the horse's legs more character. He probably learned even more about the relationship of knots of horses and riders in a large gathering, for example, in one study he made of a group at the far left of Meissonier's painting (fig. 62). This may have encouraged him to go further and base the total composition of *The Parade* back on diagonals into space.

Meissonier was inevitably a more conventional artist. In *The Parade* Degas

was subtle, as he was with the smokestacks on the horizon or the suggestion of people in the stands. He was the director, placing his horses and riders adroitly so that we are led back to the bolting horse in the distance and so that he can exploit the dramatic shadows horses and riders cast on the track. He restrained the color and yet could make the jackets of the two jockeys closest to us sing – the one at the left with a light amber, the one on the right with a faint vermilion. He may have even used the racing colors of certain stables to enliven the scene.[36] The suggestion of a racetrack is convincing but far from photographic. Every shape, every color was distilled so that the painting has the refinement and the creative integrity of the Japanese art he was increasingly admiring. Degas had come to the races and found much to excite his visual imagination.

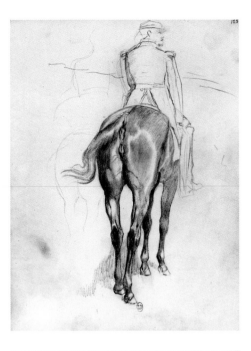

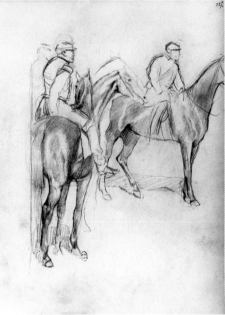

fig. 61. *Cavalryman* (after Ernest Meissonier, *Napoléon III at the Battle of Solferino*), 1868–1869, graphite on paper. Bibliothèque Nationale, Paris

fig. 62. *Two Cavalrymen* (after Ernest Meissonier, *Napoléon III at the Battle of Solferino*), 1868–1869, graphite on paper. Bibliothèque Nationale, Paris

Notes

1. An *écorché* is a sculptor's model, made as if it were flayed of skin and flesh so that the bones and muscles can be seen more easily.

2. Reff Notebook 18, fols. 5, 9, 93–94.

3. Eugenia P. Janis, "Louis-Jean Delton," in *The Second Empire 1852–1870: Art in France under Napoleon III* [exh. cat., Philadelphia Museum of Art; Detroit Institute of Arts; Grand Palais] (Philadelphia, 1978–1979), 410–411. Lipton 1986, 32–33, illustrates fig. 22, a photograph by Delton of c. 1867, *Adam-Saloman and His Daughter*, in a horse-drawn carriage against a backdrop in Delton's studio because, as in the racing pictures of Degas as she sees them, "No attempt was made to actually, dynamically, relate the figures to the backdrops."

4. Janis (in exh. cat. Philadelphia 1978–1979, 410) quotes M. L. Enault as quoted in "Courses" in Larousse 1886–1890, 5: 379, about the ideal race-horse.

5. Reff Notebook 22, Bibliothèque Nationale, Paris (327d réserve, cat. 8) of 111 fols., 23.6 x .19 cm, dated by Reff as Paris and Normandy 1867–1874, is nevertheless predominantly 1867–1869.

6. It is a particular pity that Lipton (1986), who in her first chapter rather surprisingly began with "The Racing Paintings," did not study the social background of jockeys, as she did of working-class women.

7. Achille's interest in racing may have been apocryphal; no written record has been found by this author to substantiate it.

8. We await the publication on the life and work of Lepic by Harvey Buchanan.

9. The "marquis de" Broutelles was a neighbor of the Halévys in their summers at Dieppe. He painted marine subjects.

10. Reff Notebook 22, 15.

11. Reff Notebook 22, 102.

12. Degas did a series on a woman with a lorgnette: L 179 (British Museum); L 184 (Weil Brothers Cotton, Inc., Montgomery, Alabama); Lemoisne 268 (Glasgow); L 269 (private collection, Switzerland); L 431 (Dresden).

13. L 348. For a serious recent assessment of the work see Susan Sidlauskas, "Resisting Narrative: The Problem of Edgar Degas' *Interior*," *Art Bulletin* 74, no. 4 (December 1993), 671–696.

14. See Richard Kendall and Griselda Pollock, eds., *Dealing with Degas, Representations of Women and the Politics of Vision* (London, 1992).

15. *Degas, vingt dessins, 1861–1896* (Paris, 1896–1898), no. 7.

16. Reff 1964, 251: "It is probable then that Degas dated many early drawings near the end of his life, when his memory was no longer accurate."

17. Lemoisne 1912, no. X, pl. X (lower half), 36.

18. This contradicts what the author wrote herself in exh. cat. Saint Louis 1967, no. 46, p. 80, "In Degas' lifetime the gouache drawings, which Lemoisne numbers 151–162, were dated 1866, a date which we have no reason to doubt."

19. As recorded, if not attributed, in Jean Sutherland Boggs, *Degas* (Chicago, 1996), 108, no. 7. This is important because the media of these drawings of jockeys has been described in various (and sometimes contradictory) ways.

20. Richard R. Brettell in Brettell and Suzanne Folds McCullagh, *Degas in The Art Institute of Chicago* (Chicago, 1984), no. 17, 49.

21. Ronald Pickvance in exh. cat. Martigny 1993, 34: "Degas built up an enormous repertoire of contrasting poses that formed an invaluable lexicon which he plundered at will in the making of several race-course scenes."

22. Valéry 1960, 42.

23. Ambroise Vollard, *Degas: An Intimate Portrait*, trans. Randolph T. Weaver (New York, 1986), 56.

24. Vollard 1986, 22.

25. Sickert 1917, 185.

26. In the Salon of 1869 Degas exhibited the *Portrait of Madame Gaujelin* (L 165, Isabella Stewart Gardner Museum, Boston), and in 1870 *Madame Camus* (L 271, The National Gallery of Art, Washington).

27. Letter of René de Gas to his wife Estelle, 18 July 1872, in Brown 1990, 122.

28. Jules and Edmond de Goncourt had written in their *Journal* on a trip to Holland on 13 September 1861 from the Hague, "Encore ici un tableau de cet étonnant Van der Meer, un grand prospect de quai esquissée Un des plus grands maîtres de la Hollande." Edmond and Jules Goncourt, *Journal: Mémoires de la vie littéraire*, ed. Robert Ricatte (Paris, 1851–1865), 1: 728–729. In 1866 W. Bürger published his studies, "Van der Meer de Delft," in three articles in the *Gazette des Beaux-Arts*. In his first article, 21 (1866), 297–330, he reproduced an engraving of the *View of Delft* by Maxime Lalanne and wrote of his reactions over time to the painting which he began by calling, 298, "un paysage superbe et très-singulier," and admitted, 299, "pour obtenir une photographie de tell van der Meer, j'ai fait des folies." Such enthusiasm could have encouraged Degas to go to the Hague to see the painting when he visited neighboring Belgium in 1869.

29. Boggs (in exh. cat. Paris 1988–1989, 129, no. 74) argues that this is Marguerite Fevre.

30. Pickvance in exh. cat. Martigny 1993, 34.

31. Loyrette in exh. cat. Paris 1988–1989, no. 69, 124.

32. The greater ease and lightness of touch could easily be the result of the influence upon him of the crowds Manet had painted at a musical occasion in the Tuileries Gardens or at the entrance to the World's Fair in Paris in 1867.

33. Exh. cat. Paris 1984, 179.

34. Reff Notebook 22, comment, 123.

35. Exh. cat. Paris 1984, 179.

36. Sutton 1986, 146, identifies the colors of the jockey at the right (red jacket, yellow cap and sleeves) as those of Comte Louis de Turenne and of the jockey just behind him (blue jacket and cap, white sleeves) as those of Comte d'Espous-de-Paul. Loyrette in exh. cat. Paris 1988–1989, no. 68, 124–125, identifies two in the background, each under a smokestack: in yellow jacket with red cap and sleeves, the colors of Captain Saint-Hubert; in blue with a yellow cap, Baron de Rothschild. It is probable, however, that Degas produced his own color combinations without regard for the rights of the owners.

5

Distractions from the Horse, 1874–1880

Between 1874 and 1880, Degas was unbelievably productive and imaginative, although this must have been the most painful period of his life. On 12 February 1874, eleven days before Degas' father was to die, the writer Edmond de Goncourt visited him in his studio. He later wrote: "This Degas is a strange youth [he would be forty the following July], a sickly, neurotic person, suffering from ophthalmia to such an extent that he fears to lose his sight, but extremely sensitive and able to seize the character of things at once. He is up to the present the man who has most capably caught the soul of our modern life, in copying it." And then he adds, "But will he ever achieve anything quite complete? I do not know. His mind seems so restless."[1] The tribulations the restless Degas was about to face may have given his work a greater focus, but not in any predictable form.

From the fall of 1870 to the spring of 1871, Degas had served in the infantry during the Franco-Prussian War. This was followed by a trip to New Orleans in 1872–1873 to see his mother's birthplace and to visit his younger brother René, his wife (their blind cousin Estelle Musson Balfour), and their children; his other brother Achille, who was in business with René on both sides of the Atlantic; his uncle Michel Musson, who was "in cotton"; and other relatives. Degas wrote that he had discovered himself to be al-

most a child of Louisiana[2] and described the trip as an agreeable adventure. At the same time, although apologies and explanations have been produced for the obvious indolence of both his brothers in the most famous of his paintings from that visit, *Portraits in an Office (New Orleans)*,[3] as its artist he clearly saw the limitations of Achille and René as businessmen. He was less frank in writing to his old school and lifelong friend Henri Rouart, "De Gas Brothers are respected here and I am quite tickled to see it. They will make their fortunes."[4] This was written two or three months before the uncle's firm went bankrupt, when Degas was still in New Orleans.[5]

When Degas returned to France in the spring of 1873, he was committed to the organization of an exhibition of independent artists who, after their first showing in April and May 1874, would be known as impressionists. It was early in that spring of 1874 that he wrote Tissot, "Look here, my dear Tissot, no hesitations, no escape. You positively must exhibit at the Boulevard. . . . The realist movement no longer needs to fight with the others, it already *is*, it *exists*, it must show itself as *something distinct*, there must be a *salon of realists*."[6] It may have been because of his suspicions about the financial state of his uncle and brothers in New Orleans that Degas was building another kind of support, more moral

cat. 60 (detail)

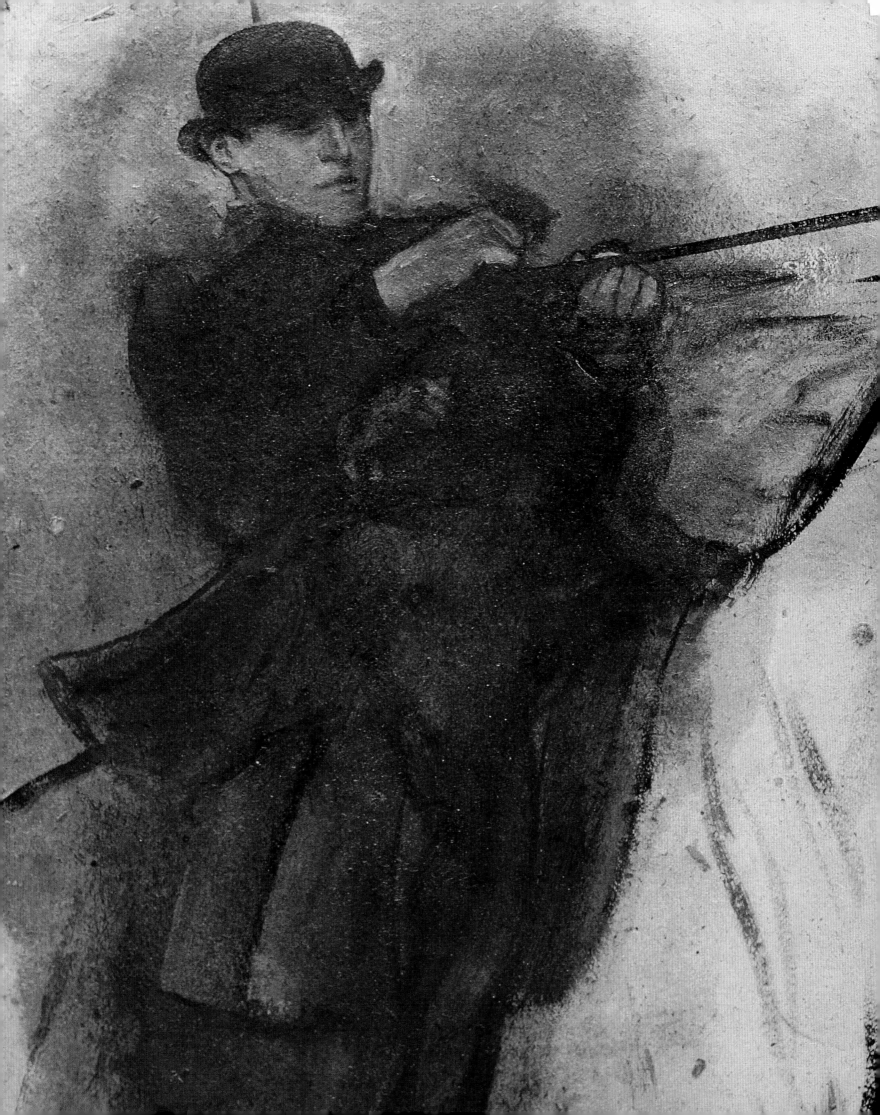

than financial, in his participation with artist friends and acquaintances in the organization of these exhibitions.

About two months before the opening of the first impressionist exhibition, on 15 April, Degas' father, Auguste, died in Naples, leaving his family bankrupt. Only the year after the painter was born, his Neapolitan grandfather had worried that the Mussons were making unrealistic demands of the painter's father to invest in America: "they would avoid work and become Rothschilds at one blow."[7] When almost forty years later that bankruptcy finally occurred, although Auguste had sold all his property in Naples to try to prevent it,[8] even the family admitted that it was because Achille, to some degree, and René, in particular, had overextended their father's bank in borrowing for their ventures in New Orleans.[9] Nevertheless, it was the painter and their brother-in-law, the architect Henri Fevre, husband of their sister Marguerite, who borrowed 40,000 francs to repay the debts, resulting in near penury for the Fevres and Degas. A Musson uncle wrote from France to New Orleans, "In Paris I see Edgar denying himself everything, living just as cheaply as possible. The seven Fevre children are clothed in rags. They eat only what is necessary."[10] Daniel Halévy remembers the difference in the painter's circumstances: "His way of life changed completely. He had been living in the rue Blanche, in a modest but very pleasant house. He disposed of it. He gave up everything he owned and rented a studio at the foot of an alley off the rue Pigalle. . . . I went there one morning with my father; the new dwelling repelled me and I felt our friend had been in some way degraded."[11]

Poverty was not Degas' only embarrassment. On 10 August 1875, his brother Achille shot the husband of his mistress in front of the stock exchange in Paris;

Degas would refer to it as "that time he fired the revolver."[12] In February of 1876, Degas and his uncle Henri Musson had to have another Musson uncle, Eugène, committed as incurably insane at Charenton.[13] Two years later, on 13 April 1878, René de Gas deserted his blind wife and children and eloped with a neighbor to Cleveland, where they were married, both bigamously, on 3 May.[14] It was to be 1887 before the painter was ready to see René again.

Degas and Faure and the Races, 1874–1887

In the seventies and into the eighties Degas also experienced professional worries. His dealer Durand-Ruel was not able to buy his works for a decade because of a recession. But more of an irritant was the fact that just a week before his father died, Degas had persuaded the singer and collector, Jean-Baptiste Faure (1820–1914), to buy from Durand-Ruel six of Degas' pictures that he wanted off the market. In return, the artist agreed to paint four large canvases, one of them the *The Racecourse, Amateur Jockeys* (fig. 63), and accepted an additional 1,500 francs, an arrangement he could no longer afford when faced with earning money to pay off the family's debts. This arrangement has been described as a "difficult relationship in which Degas apparently behaved with less than customary rectitude. From that moment, and for a period that extended over several years, Faure became his most persistent patron and the bane of his existence."[15]

Countering and perhaps even battling these irritations was Degas' increasing creativity as an artist. Some of this was his ingenuity with materials and techniques — the simplification of the armatures of his waxes, the use of monotype and other more generous, if more traditional, forms

of printmaking, and the exploitation of pastel and the thinned oil painting known as *essence,* sometimes in combination with each other. There was also his daring with subject matter, not only of the theater or the dance within an opera house but the theater of the boulevards, the café concerts, as well as the underworld of brothels. And then there were the remarkable portraits of his friends such as Ludovic Halévy and Albert Cavé on a stage, Edmond Duranty in his study, and Diego Martelli in a rented room.[16] Most of his imaginative strength was shown in the impressionist exhibitions from 1874 to 1879. But almost none of this — the technical ingenuity, the worldly subject matter, the imaginative portraits — involved a horse.

Of the four impressionist exhibitions held in the 1870s — 1874, 1876, 1877, and 1879[17] — Degas is listed with only four works with a horse, out of the 143 he planned to exhibit. Three of the four were shown in 1874, and two of those three — *The Carriage Leaving the Races in the Countryside* and *The False Start* — had been painted before 1872. Degas seldom inscribed dates on his works, and there is not a single painting, pastel, drawing, print, or work of sculpture with a horse that is dated by the artist between 1874 and 1879. On the whole, such negative evidence suggests that in this period of financial and family difficulties, Degas seldom turned to the racetrack for escape or consolation.

One of Degas' few racing paintings from the seventies is *Racehorses*, originally called *Out of the Paddock* (cat. 57).[18] It was probably first painted not long after *Racehorses at Longchamp* (cat. 49), and the landscape and the jockeys' silks and positions are similar. Originally Degas was disappointed with *Out of the Paddock*, since it was one of the five paintings he had asked Faure to buy back for him from

decided to "pan in" on the figures. This would increase the illusion of their size, emphasize their density and weight, and reduce the panoramic extent of the landscape background. He also cut their numbers from eleven to six. There may not have been a faster reduction of the size of the figures back from the picture plane but, since the figures are closer, the foreshortening is more apparent.[19]

It is difficult to determine when the jockeys were painted. The rider controlling a balking horse at the far left and a more sedentary jockey putting his weight on his hand at the far right became stock figures in Degas' works and, although somewhat amorphous here, may have been painted either before 1872 or after 1874. The same is true of the more subdued jockeys in the background. The two jockeys closest to the picture plane were likely there from the beginning. The profile is a reminder of Degas' continuing efforts since *The Gentlemen's Race* of 1862 (cat. 11). The back of the jockey echoes his studies from about 1868 (cat. 42; fig. 58) and, in particular, of the jockey in *Racehorses at Longchamp* (cat. 49). Their relationship to each other[20] is based on the drawings Degas had made of the procession of the Magi in the Palazzo Medici-Riccardi in Florence.

The landscape resembles Normandy; perhaps it is the area near the track at Argentan. In tilting upward to such a high horizon, it establishes a play with planes that is also to be found in the relationship of horses and jockeys to each other. The two principal jockeys – the one in profile with pale yellow jodhpurs and a black jacket, the other seen from behind with a pink jacket and black sleeves – are more definite and more tangible. The profile figure has developed in assurance and in clarity since the appearance of other similar jockeys in paintings and drawings like *At the Races: The Start* (cat. 13). After the

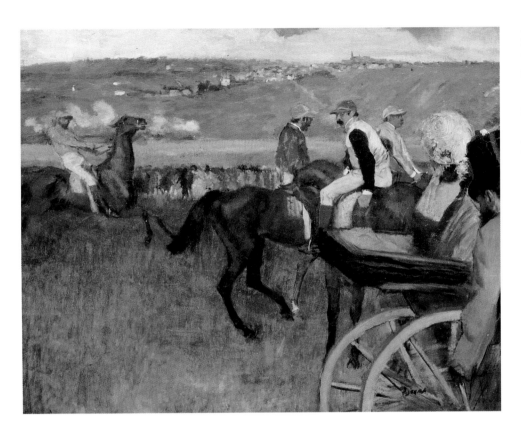

fig. 63. *Racecourse, Amateur Jockeys,* 1874–1887, oil on canvas. Musée d'Orsay, Paris

Durand-Ruel in 1874. Although he did not sell it again until 1891, Degas was able to make the changes in it as he wished. Most of these probably occurred not long after the painting was returned.

The initial layer must have been executed at the same time as the National Gallery's telescopic and considerably smaller *Before the Race* (cat. 50) and *Racehorses at Longchamp,* which is almost the same size. Having produced a sensational miniature and an exquisitely balanced small canvas, in which riders, horses, and landscape exist in perfect harmony, Degas

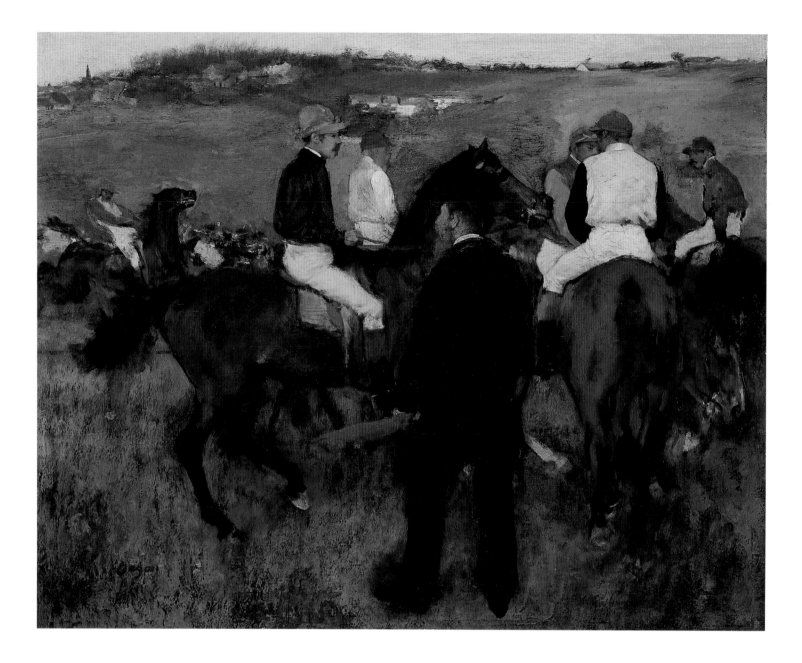

painting was returned in 1874, Degas was
easily able to strengthen and enliven the
horses and riders and to paint the grass in
a manner that suggests his handling of
1878–1879 in *Jockeys before the Start* (fig.
74). Yet he may have had more difficulty
inserting the back of the enormous stew-
ard, so suggestive of certain figures in the
theater, but he placed him so adroitly that
he anchors the painting physically and
psychologically. It has been suggested
that his looking toward the jockey with
red sleeves and cap, who is struggling

with his horse, gives the painting "a
narrative element – the false start – typi-
cal of the 1870s but which Degas later
renounced."[21] And it must have been in
the seventies that Degas finished *Out of
the Paddock*.

Faure was demanding the four large
canvases that he had commissioned.
The one racetrack subject of the four,
The Racecourse, Amateur Jockeys (fig. 63),
is not exactly a large painting, but it is
almost four times the size of *Out of the
Paddock* (cat. 57), which was undoubtedly

cat. 57. *Out of the Paddock (Racehorses)*, 1868–1872;
reworked 1874–1878, oil on panel. Private collection.
not in exhibition

its prototype, and twice the size of *The Carriage Leaving the Races in the Country-side* (cat. 38), which Faure had bought in 1873.[22]

In the thirteen years it took Degas to complete Faure's commission, he was often worried about the execution of the canvas both he and Faure called his *Courses*. In 1876 it seemed particularly on his mind. In an otherwise undated letter the painter wrote the singer: "I am going to return to *Les Courses* on Tuesday. I had to earn my dog's life in order to devote a little time to you; in spite of my daily fear of your return."[23] On 16 June, he wrote again: "I receive your friendly summons and am going to start right away at your *Courses*. Will you come here towards the end of next week to see how it is progressing?" And he adds, "The unfortunate thing is that I shall have to go and see some real racing again and I do not know if there will be any after the Grand Prix. . . . In any case you will be able to see something of your own next Saturday, 24 June, between 5 and 6 o'clock."[24] On 14 March 1877, Degas wrote Faure, "I received your letter with great sadness. I prefer writing to seeing you. . . . You cannot imagine the burdens of all kinds which overwhelm me. . . . I shall devote this fortnight almost entirely to you. Please be good enough to wait until then."[25] On 31 October 1877, he wrote: "You will have *Les Courses* on Monday. I have been at it for two days and it is going better than I thought. What is the use of dragging out the chapter of reasons which makes me so behind?"[26] On 2 July 1886 he wrote: "I shall need a few more days to finish your big picture of the Races. I have taken it up again and am working on it."[27] On 2 January 1887, it was, "This summer I set to work again on your pictures, particularly the one of the horses, and I had hoped to bring it to an end rapidly. . . . I could enter into longer

explanations. The ones I give you are the simplest and most irrefutable."[28] These quotations help clarify the very real reasons for Faure's irritations and frustration and the humiliation behind Degas' excuses; they also give an indication of when the actual painting could have taken place.

There is no evidence that Degas had worked upon the canvas before June 1876. On 16 June, although he admitted he needed to see "some real racing again," he did invite Faure to come in a week to see "how it is progressing," but the painting is not referred to again for almost a year, when Degas does promise to devote almost two weeks to the work. Six months later he was writing that the singer could have the painting the following Monday although it was *nine years later* that he would write that he would finish it rapidly. But the fact remains that it was only finished when Faure threatened him with a lawsuit in 1887.

Undoubtedly the composition must have taken some form in the summer of 1876 and the spring of 1877, when he invited Faure to see it. It was probably then that he conceived it as an enlargement of *Out of the Paddock*, the setting a similar Norman countryside, the ribbon of barely visible spectators between the hillside and the grass of the paddock, the jockeys gathered untidily before the race begins. Although he borrowed the jockey controlling a balking horse from the left of the earlier work and slightly enlarged and strengthened it by freeing it in space, the arrangement of three other riders is new. The jockey in profile, which had been part of most of Degas' racing pictures since 1861 or 1862, is now pushed back and given a subordinate role, whereas the jockey in the outer right of the earlier work, now in a pink jacket and red cap, is brought in front of him where he twists in his saddle. The third is to

their right and not particularly conspicuous, although he wears a distinctive blue, as he sits and waits behind them. The break in the diagonal between the balking horse and the others provides an ease and expansiveness the earlier work does not possess, which is consistent with the relative largeness and the greater breadth of the canvas. That diagonal is stabilized in the lower right corner by the carriage, particularly the dashing repetition of the light spokes of its wheels, based, it has been suggested, upon a woodcut by Hiroshige (1797–1858),[29] and the figure of the bearded, top-hatted man who looks into the cab. A study of the X-radiographs shows that Degas had originally planned a symmetrical composition with a man and woman centered against a railing, but they were eliminated and the composition was changed to be asymmetrical.[30] The jockeys were fairly constant, but the carriage and bearded, top-hatted figure were added later.

It is difficult to be certain what was done to the painting in the eighties, although it is probable that Degas also adjusted the tonality of the work to make it more mellow and more harmonious.[31] Faure kept the painting for five years before selling it for a considerable profit on 2 January 1893 for 10,000 francs.

In the meantime, Faure had acquired the last of Manet's racetrack scenes, *Races in the Bois de Boulogne*.[32] Manet painted one of his romantic landscapes of the suburbs of Paris, with disembodied shadows of horses and carriages, men and women with parasols, and the racetrack crowds behind a barrier of flimsy white posts, while in the foreground the race is taking place, with the horses and jockeys quite clearly derived from Géricault's *Races at Epsom*. This was painted as Degas was working on his first version of *Out of the Paddock* (cat. 57). Although Manet and Degas were friends, they did

conceive their racetrack pictures very differently, and there is almost no evidence of influence of one upon the other. It is believed, however, that Manet did insert the back of the top-hatted figure of Degas into the lower right corner of his painting.[33] And it might not have been inconceivable that Degas was thinking of Manet when he introduced the gentleman with a much shinier top hat than the one Manet painted Degas wearing, looking into the carriage in *The Racecourse, Amateur Jockeys*, perhaps as a tribute after Manet's death in 1883. The intrusion of the woman with the fluffy white hat between this gentleman and the jockeys and riders would have reflected Manet's priorities at the track.

cat. 58. *Man Riding*, c. 1878, brush and ink with gouache and chalk on paper. Sterling and Francine Clark Art Institute, Williamstown, Massachusetts

The Lads, c. 1876

To move from the complications of *Out of the Paddock* (cat. 57) and *Amateur Jockeys* (fig. 63) to three drawings of bowler-hatted trainers or grooms is refreshing. There are evasions in the sitters, who avoid our eyes, but the artist, himself, can conceal very little and, as a matter of fact, does not choose to do so. These drawings (cats. 58–60) recall Degas' series of jockeys from about 1868, which places a single rider (or model) in different poses, all nevertheless concerned with the assured seating and competent balancing on the back of a horse. In both series the hands of the riders are adroit and even the soles of their boots in the stirrups are convincing. Degas also prized both series of drawings enough never to sell one or give it away; he kept both series – the jockeys and the grooms – for himself.

Degas used fundamentally the same technique in these three drawings that he had used in the drawings of the jockeys from the sixties – oiling the paper to give a dark ground, drawing with brush and ink, and using brush and *essence*, largely

a bluish gray, for modeling. One great difference, however, is in the riders themselves. These are not young, lean, taut jockeys in decorative silks, but what the French call "lads," men who service the horses. As in *Horse and Riders on a Road* (cat. 27), a painting from the sixties, they are middle-aged, experienced, hardy, and they wear drab serviceable clothes, aside from the jaunty bowler hats that indicate their roles at the track. Degas depicts the grooms in trousers, not jodhpurs, and jackets and vests (or sweaters) that fasten with one or two buttons and have a rolled down collar. This costume of rather rough materials conceals the body rather than showing it off, as the jockeys' silks do. And the very brown they wear gives a more sober effect. These are serious, competent men, with experience, self-discipline, and a strong sense of the dignity of their labor, whom Degas must have respected when he saw them working with horses outside (as well as within) the track.

Another curious difference between the two groups of drawings, about a decade apart, is that these older riders are largely depicted in movement, whereas the jockeys idle away their time in fixed positions on the horse. In one drawing (cat. 58), a single groom is galloping with purpose, although the horse is barely visible. The angular features of his profile indicate that purposefulness as he presses on his stirrups. The balance of the diagonal position of his body was sufficiently important to Degas that he drew a white chalk vertical as a plumb line on the sheet, just behind the rider's neck and slightly right of the center as if to reinforce the rider's movement in that direction. We can see how self-willed Degas was as a draftsman in leaving the horse almost entirely up to our imagination, in using a few strong strokes of brush and ink for the trousers, but permitting himself a greater range in lights to darks in the upper part of the rider's body. This change in emphasis is one of the reasons that the drawing seems to come into existence before our eyes.

Four Studies of a Groom (cat. 59), compared with either of the two drawings from the sixties of four studies of a single jockey (cats. 42, 47), is much more disciplined. It is on an irregularly cut sheet of paper,[34] but there is nothing disturbing in its shape. Degas also varies the extent of his draftsmanship: the pose of the figure at upper left is suggested by the starkest lines, but the others are drawn with the same elaborate strokes, although the lower left figure is subordinated by shadow. It is the riders on the right, the upper one reining in his horse, the other turning to listen, who seem most compelling. Degas stops short, however, of portraiture.

Two Studies of a Groom (cat. 60) presents two views of the rider. The figure at right, drawn with a few serviceable lines,

cat. 59. *Four Studies of a Groom*, c. 1878, brush, ink, and *essence* on paper. Private collection

cat. 60. *Two Studies of a Groom*, c. 1878, *essence* heightened with gouache on paper. Musée du Louvre, Département des Arts Graphiques, Fonds du Musée d'Orsay, Paris *(top)*

cat. 61. *Studies of a Horse and Rider*, c. 1878, charcoal on paper. Nasjonalgalleriet, Oslo

seems to be sitting sidesaddle as he twirls his whip, surely the ultimate in leisure for a groom. At the left there is more drama, as the figure draws back in his saddle while pulling the reins of an ugly, leathery, bolting horse. The drama is increased by the amount of dark in and around the groom in contrast to the horse, which is light except for the dark head. Degas – who as a student had sketched from casts of the Parthenon frieze, fascinated by the grotesque formation of the horses' jaws – proves in this drawing how much the teeth of the animal could express, in this case, will over pain. The horse's determination is to pull against the reins so that its neck and chest would form a true diagonal, making escape possible, whereas the protagonist, the groom, pulls the reins so that the horse's throat is more nearly vertical. The conflict between man and horse is dynamic, with the restraint of the man and the inherent wildness of the animal emphasized. The second man sits unknowing and indifferent, possibly in reflection.

Degas is often quoted as saying, "No art is less spontaneous than mine," and it is true that he liked to explore more than one aspect of any subject he chose. *Studies of a Horse and Rider* (cat. 61) shows two men and a horse in positions similar to *Two Studies of a Groom*, one rider drawn cursorily in black pen and ink, and the other developed more expressively in charcoal. While the figure in pen and ink is self-contained, the horse and rider struggle as the animal balks. This could be the same scene depicted in *Two Studies of a Groom*, but the figure in ink wears a jockey's cap rather than the bowler hat of a lad, and Degas seems undecided about the outline of the head or hat of the other man. This may have been Degas' first exploration of the idea of a man and a horse as protagonists beside another man who is indifferent to their struggle. In its

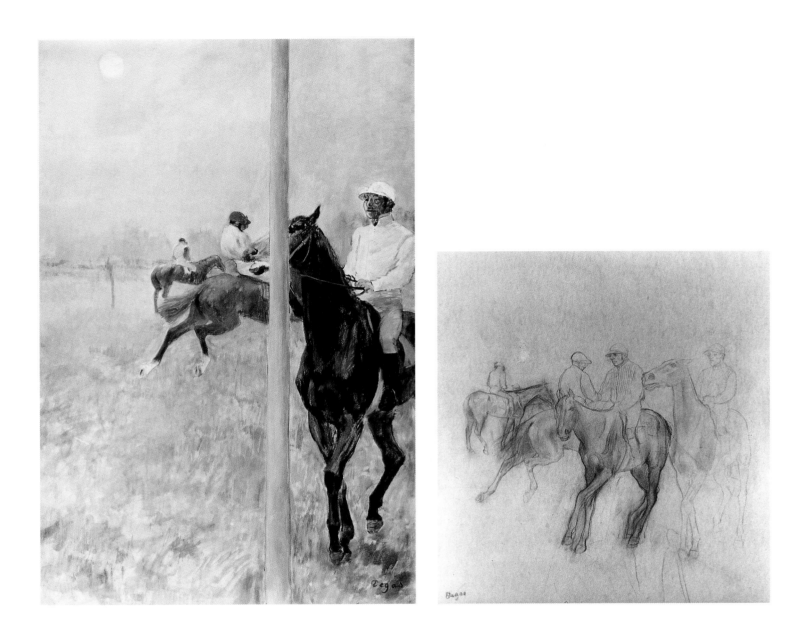

realization, Degas shows the horse as awkward and ungainly, if not as positively grotesque as it is in the drawing with *essence*. He ignores the clothing of the rider to a point that he seems almost nude, clad in clumsy rags. This is a sculptor's way of understanding actions in space from more than one point of view.

Jockeys before the Start at the Impressionist Exhibition of 1879

In the seventies, Degas' only new painting with horses that can be dated securely is *Jockeys before the Start* (fig. 64). In the catalogue for the exhibition *Degas 1879*, Ronald Pickvance pointed out, on the basis of a contemporary review by Armand Silvestre, that this painting was in the 1879 impressionist exhibition; Silvestre had written about the half moonlight on the racetrack.[35] Recently this has been confirmed with other references to moonlight in the exhibition reviews and

fig. 64. *Jockeys before the Start*, 1878–1879, oil, *essence*, and pastel on paper. The Barber Institute of Fine Arts, University of Birmingham *(left)*

fig. 65. *Group of Jockeys*, c. 1868 and c. 1878, graphite on tracing paper. Thaw Collection, The Pierpont Morgan Library, New York

cat. 62. *Horse Walking*, c. 1878, charcoal on paper.
Thaw Collection, The Pierpont Morgan Library,
New York *(top left)*

cat. 63. *Head of a Horse*, c. 1878, graphite on paper.
The Metropolitan Museum of Art, Gift of A. E.
Gallatin, 1923

fig. 66. *Horse and Rider*, c. 1878, graphite on paper.
Location unknown

one to the starting pole in the painting.[36] *Jockeys before the Start*, therefore, was almost certainly painted the year of or the year prior to the exhibition.

Jockeys before the Start is as memorable as any of Degas' surprising pictures at the 1879 exhibition, including the sensational pastel of *The Singer with a Glove* or the dizzying *Mlle Lala at the Cirque Fernando*.[37] One reason is that Degas simplified its elements by reducing the landscape to a flat field with a few trees on the horizon, the sky to a gray wash with a white full moon (or a sun) appearing through the mist, and the riders on horseback to three placed on a diagonal. He then slashed through the composition on the right with the severe vertical of a starting pole. In addition to this daring simplicity, he painted the white canvas with the thinned oil paint he described as *essence*. He applied this *essence* so freely, particularly in the grass, that it seems like watercolor, but with white canvas rather than white paper revealed. There could be a fundamental contradiction between the apparent spontaneity and freedom of the handling and the obvious contrivance in the arrangement of the horses and riders and the placing of the pole. Nevertheless, sufficiently captivated by the lunar light which is at its whitest, almost translucent, in the jacket and cap of the nearest jockey, and seduced by the soft orange-red cap of the jockey in the middle of the painting, it is possible to accept this apparent inconsistency.

Degas took *Group of Jockeys* (fig. 65)[38] – a drawing he had made before or after another painting of the track, *Racecourse Scene*[39] – and altered it almost a decade later with *Jockeys before the Start* in mind. Although the position of the horse and rider at the back of the canvas had already been resolved and the position of the next horse had also been settled (except that its tail seems fuller in the painting), its rider has not yet pulled back to rein in his horse as he would in paint. In the front of the drawing there is another rather conventional rider on a horse, which is gentler and more subdued than the principal horse in the 1879 painting but very close to the 1868 *Racecourse Scene*. At the right are faint pencil outlines of the prouder horse and jockey who will replace them. The final dominant horse and jockey must have emerged as Degas drew on the sheet he would have thought he had finished almost a decade earlier.

Within *Jockeys before the Start*, the rider behind the pole bends back to control the horse and is so coolly dressed in his light red hat, pink shirt, and white jodhpurs that he settles into space rather than competing with the horse and rider now in front. Degas worked his way through four drawings of the horses (cat. 62; fig. 66)[40] before arriving at the principal horse in the final painting. Basic to each study is the concept of a horse holding its head up proudly as it stares directly ahead. In a working drawing for the final painting (fig. 66) Degas draws two vertical lines, faintly, to test the position of the pole against the horse's body. He also opens the horse's jaw to reveal uneven and ominous upper teeth, and he even makes a drawing in the right-hand margin toward the bottom, of its mouth opened but with the lower teeth (instead of the upper) visible. Because Degas wanted the horse to be dignified but with the inherent savagery that needed training and the jockey's control, he expressed its possible willfulness through its somewhat mean, strained head. (The patch of brown over the eye is a wash or stain through which the eye can be seen in the original.) A drawing of such a head (cat. 63), with great sculptural force, may have been one of the studies leading to the painting.

cat. 64. *Jockey*, c. 1868, graphite with *estompe* on paper. The Art Institute of Chicago, Gift of Robert Allerton

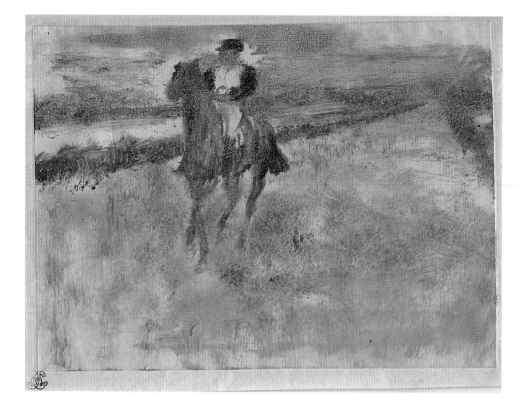

cat. 65. *The Jockey*, c. 1878, monotype on paper. Sterling and Francine Clark Art Institute, Williamstown, Massachusetts

In the painting, the vertical of the post reduces some of its suggestion of inherent violence.

The rider had to be civilized and disciplined enough to work with this horse, to explain and justify the animal's pride as well as its control. Degas used an earlier drawing (cat. 64) of a mustached jockey in a similar position as the basis for the rider in the painting, but his jacket is not so wrinkled and utilitarian, his mustache not so generous, and his legs not stretched out beyond the body of the horse. He nevertheless shows the same relaxed discipline, control, and intelligence. As one critic at the exhibition in 1879 put it, he is one of those jockeys who is full of the importance of his mission.[41] By dressing this gentlemanly jockey in a luminous

white, Degas makes the figure anything but pedestrian. He sits with such supreme self-confidence, his features sharp and keen, his body handled with such inherent dignity and refinement, that he recalls the sketches that Degas had made after Van Dyck's portraits of kings and aristocrats on horseback (fig. 7). Mounted on a stallion in this rarefied crepuscular world, this gentleman rider appears to be a modern prince, a legitimate heir of Van Dyck's Charles V.

A tiny monotype (cat. 65), about six inches across, of a single horse and rider shares the dignity and the purposefulness of the mounted gentleman jockey in *Jockeys before the Start,* even if they are only about one-tenth the size. On that scale and with monotype as the medium, which does not permit the refined description of such details as features, the rider does not have the individuality of the "prince" in the other work. He is in complete isolation as he gallops down an empty road, where the rich black ink of the monotype against the white paper evokes a lonely, moonlit scene. An aura of white almost seems to surround the rider and, in particular, the horse's legs. He may not be a prince, but he could be a knight on a mission. In spite of the apparently crude technique of monotype, the freedom and atmospheric quality of the print's handling equals the free and expressive handling of the grass in *essence* in *Jockeys before the Start.* The painting and the monotype must have been made almost at the same time when Degas was prepared, if only very briefly, to romanticize the single horse and rider.

Notes

1. *The Journal of the De Goncourts*, ed. Julius West (London, n.d.), 212, entry of 13 February 1874 for 12 February.

2. *Letters*, 5, 27, to Henri Rouart, 5 December 1872.

3. L 320, Pau. See Brown 1994, 33.

4. *Letters*, 5, 28, to Henri Rouart, 5 December 1872.

5. Brown 1994, 32.

6. *Letters*, 12, 38–39, to Tissot, Friday 1874.

7. Riccardo Raimondi, *Degas et la sua famiglia in Napoli, 1793–1917* (Naples, 1958), 107, letter of René-Hilaire de Gas to his wife in Paris, 19 December 1835.

8. Jean Sutherland Boggs, "Edgar Degas and Naples," *Burlington Magazine* 105, no. 723 (June 1963), 274. He sold his patrimony for 131,976.36 lire: Archivio Notarile, Naples; notary, L. Cortelli, 1873, fol. 61.

9. Brown 1994, 60, letter of Achille De Gas to Michel Musson, 31 August 1876.

10. Brown 1994, 60, letter of Henri Musson to Michel Musson, 17 January 1877.

11. Daniel Halévy, *My Friend Degas*, ed. and trans. Mina Curtiss (Middletown, 1964), 23.

12. Exh. cat. Paris 1988–1989, 488, from an unpublished and undated letter, probably written to Mme Camus, Archives of the History of Art, The Getty Center for the History of Art and the Humanities, Los Angeles (no. 860070).

13. Brown 1990, 129.

14. In 1989 Professor Harvey Buchanan of Case Western Reserve University found in the archives of Cayuga County, Ohio, the marriage record of F. B. René de Gas ("he has no wife living") and America Durrive ("she has no husband living"), dated 3 May 1878.

15. Pantazzi, "Degas and Faure," in exh. cat. Paris 1988–1989, 221–223, gives the clearest summary of the transactions between Degas and Faure.

16. L 526, *Portrait of Friends in the Wings (Ludovic Halévy and Albert Cavé)* (Musée d'Orsay, Paris); L 517, *Edmond Duranty*, 1879 (The Burrell Collection, Glasgow); L 519, *Diego Martelli*, 1879 (The National Gallery of Scotland, Edinburgh).

17. See *The New Painting: Impressionism 1874–1886* [exh. cat., National Gallery of Art, Washington; San Francisco Museum of Art] (San Francisco, 1986).

18. Durand-Ruel, Paris (1367), title used when bought in April 1872 from its first owner, Ferdinand Bishoffsheim.

19. Professor Richard Thomson of Edinburgh University in exh. cat. Manchester 1987, 99, describes the changes Degas made in this painting.

20. Thomson in exh. cat. Manchester 1987, 99; Pantazzi in exh. cat. Paris 1988–1989, 268.

21. Thomson in exh. cat. Manchester 1987, 99.

22. It could have been Faure who suggested that a carriage like that in *Carriage Leaving the Races in the Countryside* should be grafted onto this commissioned painting. Faure as a bravura performer himself would have wanted it to be a bolder, more energetic statement of *Out of the Paddock*. Appropriately, even the crowd becomes more conspicuous.

23. *Letters*, 19, 45, to Faure, 1876.

24. *Letters*, 104, 120, to Faure, Thursday, 16 June 1876 (redated by Pantazzi).

25. *Letters*, 20, 45, to Faure, 14 March 1877 (date amended by Pantazzi).

26. *Letters*, 21, 46, to Faure, Wednesday, 31 October 1877.

27. *Letters*, 105, 120, to Faure, 2 July 1886.

28. *Letters*, 107, 121–122, to Faure, 2 January 1887.

29. Pantazzi in exh. cat. Paris 1988–1989, 267, with reference to Siegfried Wichtmann, *Japonisme* (New York, 1985), 249–250.

30. See Charles de Couëssin, "Techniques, transformations, dans les toiles de Degas des collections du musée d'Orsay," *Degas inédit* 1989, 156, 157, and Pantazzi in exh. cat. Paris 1988–1989, 266. The presence of a couple suggests a connection with another overpainted picture, L 184, *Racecourse Scene* (Weil Brothers Cotton, Inc., Montgomery, Alabama).

31. Pantazzi sums up its total character most effectively, "As it stands, the composition is among the most monumental — and most original — racecourse scenes Degas ever conceived, with order and whimsy fused in almost perfect unison. Though set in the country, this is not a leisurely day at the races of the sort depicted in *Carriage Leaving the Races in the Countryside* (III: 13) but a full-scale event, with a wall of spectators somewhat incongruously assembled on the outskirts of a village where fields and trains coexist with an optimism characteristic of the machine age. The speeding jockey at the left, wittily echoing the movement of the train, counteracts the stately frieze of jockeys at the right." Pantazzi in exh. cat. Paris 1988–1989, 266.

32. For the most recent summation of the history and literature on *Races in the Bois de Boulogne* by Manet, see Charles S. Moffett in exh. cat. Paris 1983, no. 132, 338–339.

33. Étienne Moreau-Nélaton, *Manet raconté par lui-même*, 2 vols. (Paris, 1926), 1: 139; John Richardson, *Édouard Manet: Paintings and Drawings* (London, 1958), 124, believe it to be Degas.

34. It is not impossible that Degas could have been unhappy with his drawing as a composition on a perfect rectangle and tore off the right part to achieve the balance he required. On the other hand, he was inventive enough to have been amused at the idea of working within an irregular piece of paper he had found somewhere.

35. Ronald Pickvance in exh. cat. Edinburgh 1979, no. 11, 14, referring to Armand Silvestre, "Le Monde des arts: Les indépendants," *La Vie Moderne*, 24 April 1879, 38.

36. Berson (1996, 1: 243) publishes in addition to Silvestre, F.-D. Syène, "Salon de 1879," *L'Artiste*, 1 May 1879, 22, on the crepuscular light (1996, 1: 238); Athureaux Rolland, "Beaux-Arts . . . Les Aquarellistes, les indépendants," *L'Ordre*, 9 May 1879, 3, on the starting pole that divides the composition.

37. L 478bis, *Singer with a Glove*, pastel (Harvard University Art Museums); L 522, *Mlle Lala at the Cirque Fernando* (National Gallery, London).

38. In assembling a remarkable group of studies around two curiously related paintings, painted almost ten years apart, L 184, *Racecourse Scene* (Weil Brothers Cotton, Inc., Montgomery, Alabama), and *Jockeys before the Start* (fig. 64), Ronald Pickvance (in exh. cat. Edinburgh 1979, nos. 9, 13) did show this compositional drawing but did not relate it to *Jockeys before the Start*.

39. L 184, *Racecourse Scene*, 1868–1872 (Weil Brothers Cotton, Inc., Montgomery, Alabama).

40. The four drawings of horses are *Horse Walking* (cat. 62); *Jockey on a Horse* (Vente IV: 231.c, location unknown); *Rider on Horseback* (fig. 66); *Horse Turned Three-Quarters Left* (Art Institute of Chicago 1945.30).

41. Syène 1879, 292. See Berson 1996, 1: 243.

"Not Enough Horses," 1880–1890

The 1880s were happier and more pro-
ductive for Degas – on the paddock or
even in a pasture – than the 1870s had
been. In 1888 he wrote to his friend Paul
Bartholomé, with what was probably a
polite expression of hypocritical envy, in
arranging to go to see the figure of Christ
his friend had carved for the tomb of his
first wife, "Happy sculptor! I too should
like . . . [to do what you have done] . . .
but I have not done enough horses."[1]
In fact, by 1888 Degas had made a great
many horses. At the beginning of the
decade, at a dinner at the home of Alexis
Rouart,[2] brother of Henri, Degas painted
a plate (fig. 67). On its white porcelain
surface he arranged the familiar backs
of three jockeys fanning into space until
the smallest is almost in a profile. In front
he places a larger, insouciant rider, who
turns his profile away. Another rider leans
over in front of him, his face hidden but
not his white jacket with red polka dots.[3]
All of this appears to be painted with
cheerful good humor.

The small panel painting *Jockeys*
(cat. 66) seems to be the last in a sequence
from *Before the Race* (cat. 50), in which
the jockeys are viewed from an enormous
distance, to *Racehorses at Longchamp*
(cat. 49), in which they are still far away,
to *Racecourse, Amateur Jockeys* (fig. 63),
where the horses and riders are closer to
the picture plane. In *Jockeys*, the viewer is
close enough to touch the animals. It is a
genuinely sensational effect, the chinless

but solidly built young jockeys painted in
faded, warm colors beside the enormous
heads of two chestnut horses, the more
conspicuous one a vulgarization of the
head of a horse from the Parthenon's
pediment.[4]

An important figure in the life of
Degas about 1879 and sporadically until
his death in 1917 was the American
painter Mary Cassatt (1845–1926). It is
improbable that they were lovers but they
did share an enthusiasm for the visual
arts. At that time they were particularly
attracted to Japanese art and, as practi-
tioners, to printmaking. With other artists
they had planned to publish prints for
subscribers in a "journal" or portfolio
of prints they called *Le Jour et la Nuit*.[5]
This journal never came into being, how-
ever, perhaps because, as Cassatt's family
believed, "Degas is never ready for any-
thing,"[6] but both artists continued to
produce some of the greatest prints of the
nineteenth century. Degas had intended
one of his etchings of Cassatt as she vis-
ited the Louvre to be his first contribution
to *Le Jour et la Nuit*.

The two artists shared two other
interests. One was that Cassatt was a
passionate horsewoman, one of those
elegantly dressed *amazones* who rode
in the Bois de Boulogne whom Louis-
Jean Delton enjoyed photographing.
Although Degas was presumably only a
spectator, he was nevertheless in a posi-
tion to learn certain fine points of horse-

fig. 67. *Plate with the Racetrack*, c. 1880–1885, paint
on porcelain. Location unknown

cat. 78 (detail)

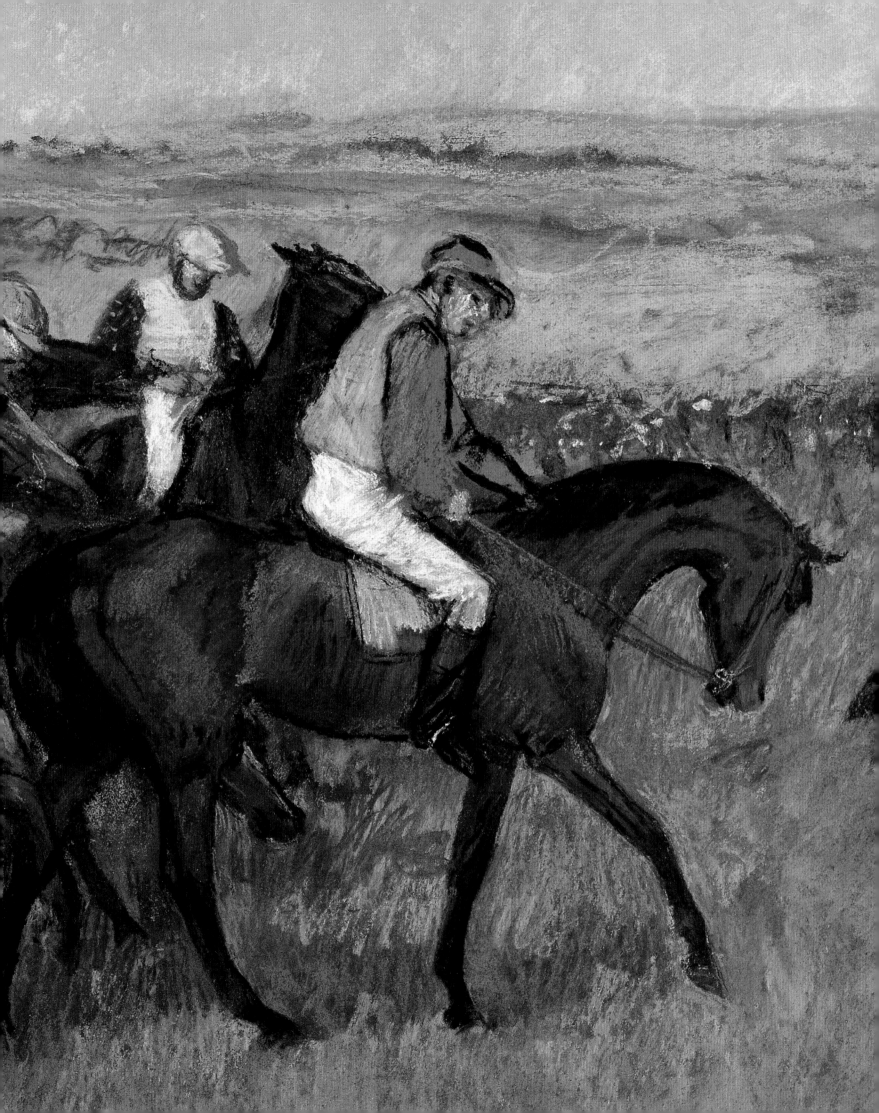

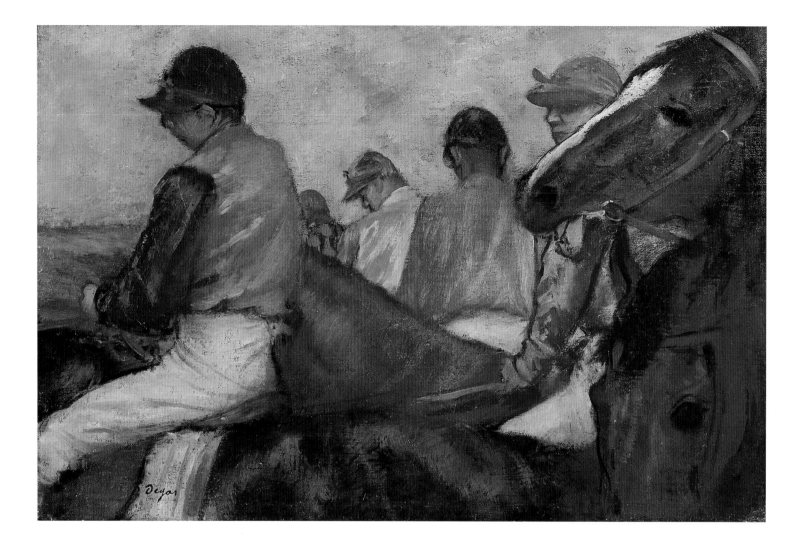

cat. 66. *Jockeys*, c. 1882, oil on canvas, mounted on cardboard. Yale University Art Gallery, Gift of J. Watson Webb, B.A. 1907 and Electra Havemeyer Webb

manship from her that might contribute to his work. The other was that Cassatt was a proselytizer who enjoyed persuading her rich American friends to collect works of art. Degas benefitted from this directly, particularly in the case of her young friend Louisine Elder and her husband, H. O. Havemeyer, who were to buy so many of his works. He also enjoyed sharing in Cassatt's enthusiastic encouragement of her friends to make other kinds of acquisitions, such as the paintings of El Greco and Goya. Sometimes the interest in horses and art coincided as when Cassatt's brother, Alexander, presumably as much a lover of horses and riding as his sister, wanted to buy Degas' *Scene from the Steeplechase: The Fallen Jockey* (cat. 16). Although it was more than ten years

since he had painted it, Degas decided, and Mary Cassatt seems to have agreed, that he needed to retouch it. She may have been thinking of restoration, which was often necessary after a work had been exhibited too soon at the Salon before the paint and the varnish had had a chance to stabilize, as had been true of *Mlle Fiocre in the Ballet "La Source"* (cat. 8) in 1868. But Degas soon began to think in terms of transformation. As Mrs. Cassatt from Paris tried to explain to her son in Philadelphia, "as it is unfinished or rather as part of it has been washed out & Degas imagines he cannot retouch it without painting the whole over again & he can't make up his mind to do that I doubt if he ever sells it – he says it is one of those works which are sold after a man's death

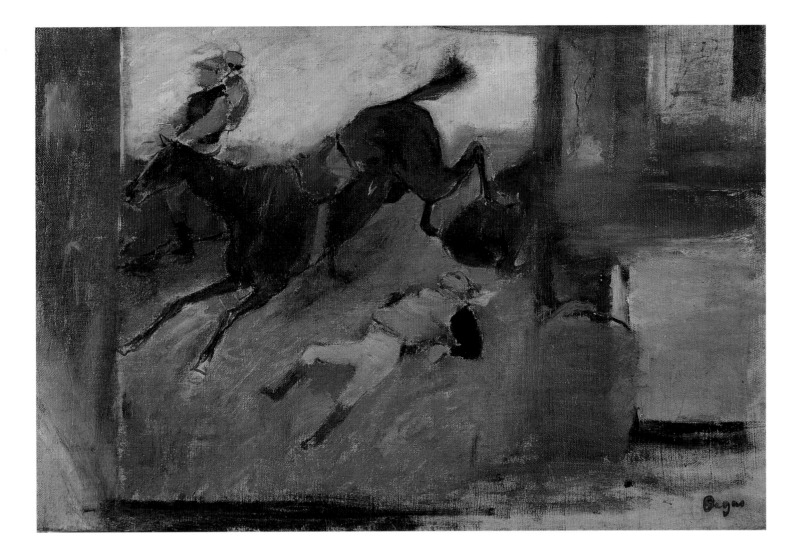

cat. 67. *Studio Interior with "The Steeplechase,"* c. 1881, oil on canvas, on board. The Israel Museum, Jerusalem, Sam Spiegel Collection

& artists buy them not caring whether they are finished or not."[7]

A document of Degas' reconsideration of the work, which in casual conversation he referred to as *The Steeplechase*, has survived. It is *Studio Interior with "The Steeplechase"* (cat. 67), which has rarely been reproduced or exhibited. This canvas is small, not two feet wide, and obviously an oil sketch Degas did not choose to finish. It shows a version of Degas' painting of the steeplechase hanging on the wall of a gallery, house, or studio, with the back of a standing spectator barely suggested toward the right.[8] Using the spectator as some indication of scale, it seems that the painting within the painting is essentially the same width as the canvas Degas exhibited at the Salon

in 1866 but truncated in both the sky and the grass to give it a squarer format. Only one horse is fully visible, and it has fragile legs and an exuberant tail like "the horses in the sky" in an early compositional drawing (cat. 18) or the drawing of a single horse on blue paper in the British Museum (fig. 36). The back legs of this horse are shown above a dark form, which can be interpreted as either horses lying wounded or dying on the ground like the drawing from the Clark (cat. 24), or some obstacle like a hedge in the actual steeplechase. (The same quandary exists in the final painting.) Degas worked some variations on the fallen jockey by spreading his legs farther apart and swelling his chest more defiantly. The greatest change, however, is behind the horse, in the ad-

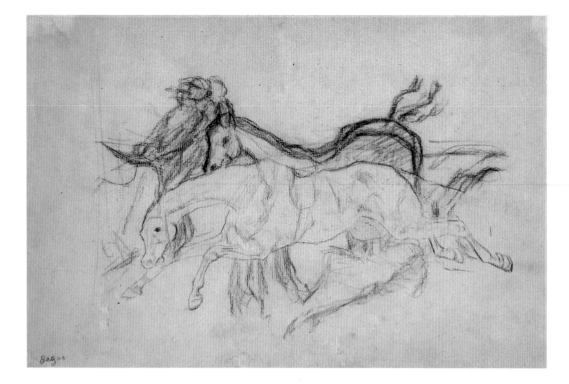

cat. 68. *Racehorses* (study for *Scene from the Steeplechase: The Fallen Jockey*), c. 1881, charcoal on paper. Collection of Mr. and Mrs. Paul Mellon, Upperville, Virginia

painting spectators in galleries on square canvases, such as *The Visit to the Museum*, dated about 1885.[11]

The charcoal drawing *Racehorses* (cat. 68), a study for *The Steeplechase*, seems to be Degas' response to the interest shown by Robert Cassatt. The greatest departure is in the emphasis upon action in the movement of two riderless horses and two mounted riders behind them. The sense of motion is so strong in the drawing, some of it through repetition of lines, that the two to three riders seem positively cinematographic and difficult to distinguish from each other. The composition bounces on the backs of the horses. The front horse seems a reversal of an earlier drawing (fig. 68) Degas had made of a horse galloping. Later, at a time when his draftsmanship was more economic and sure, Degas must have looked at the same drawing and turned it into another (fig. 69) of two horses. He didn't worry about the rider. The rather pathetic lowered head of the horse in the earlier drawing is now placed in the background behind the principal steed, which is at a slight angle and seems considerably fleeter, and the dark emphasis in the broken contours adds to the suggestion of motion. Its expression is somewhat more eager, the head is elongated in an exaggerated fashion. In the compositional drawing (cat. 68) both horses are combined into one to make a gentler, more affectionate steed, which is like a mirror image of the earlier studies. Degas was increasingly fascinated as the years went by with a proof and counterproof, an image and the equivalent of a mirror reflection.

The same procedure took place with drawings for the other horse. Even in the compositional drawing, Degas treated the animal more gently, finishing it with a flaming tail. A charcoal drawing of it, in reverse, shows it with a kindly expres-

dition of two jockeys on almost invisible mounts.

Studio Interior with "The Steeplechase" is quietly beautiful in tonality and color. The warm coral pink of one rider's cap, which is also used for the jacket of the fallen jockey, and the soft melon green of the front rider's sleeves survive – almost as caresses – in the final version of the painting (cat. 16). Although the grass is painted freely, like that in *Jockeys before the Start* (fig. 64), and does soften to bushes or trees on the horizon, the landscape on the whole is very flat. Two possible clues to the dating of this small work are its square format and the representation of someone looking at a work of art. *Studio Interior* has been dated 1866 – with the assumption that it was a study for the painting and that the work was not changed after its exhibition in the Salon that year[9] – and the 1870s,[10] which could explain its inventiveness. It is not impossible, however, that it was painted when Mr. Cassatt decided he wanted to buy the Salon painting. At that time Degas was

sion, bounding dutifully at a slight angle. The counterproof (cat. 69) is even more endearing.[12]

Infrared photographs of the painting reveal the process by which Degas increased the action and the excitement of the painting. This is largely the result of his having painted out the earliest (and higher) horse, which is now hidden behind sky and trees, and having introduced these two horses that have been racing against each other, and both of which have succeeded in throwing their riders.

Although there is still only a single fallen jockey, and not two, he is the epitome of the victim of the steeplechase and was probably not too much changed after Degas had been stimulated to rework the painting. But two and possibly three mounted jockeys were inserted above and behind the riderless horses, their own mounts almost invisible. Two drawings exist for these riders as well as another one that is reversed but is also a possible study.[13] A pencil drawing (fig. 70) shows a pair of jockeys farther apart than in the compositional study, dressed the same and with rather harsh features but different beards. In another drawing (fig. 71) Degas used gouache highlights to pick out the gloss of the silks of one jockey, drawn twice, but he shows him slumping more

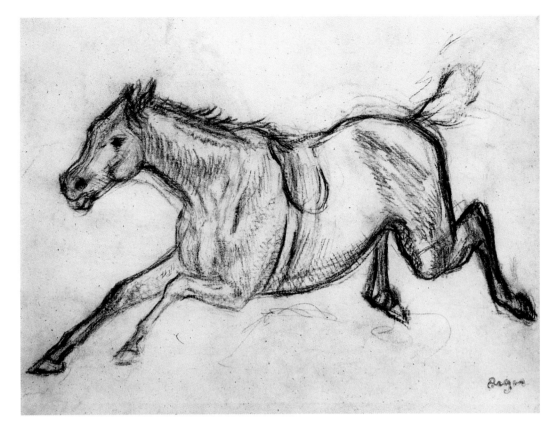

than in the final painting. These drawings are evidence that Degas was thinking about the painting and presumably working upon it, but in the end neither he nor Mary Cassatt were satisfied with what he had accomplished about 1881. Nevertheless, his preoccupation may have brought Degas back to the subject of the races then and would pull him back to *The Steeplechase* about 1897.

cat. 69. *Horse Escaping* (study for *Scene from the Steeplechase: The Fallen Jockey*), c. 1881, graphite and charcoal on paper. Private collection

fig. 68. *Horse with Rider* (study for *Scene from the Steeplechase: The Fallen Jockey*), c. 1866, graphite on paper. Private collection *(bottom left)*

fig. 69. *Horse Galloping* (study for *Scene from the Steeplechase: The Fallen Jockey*), c. 1881, graphite on paper. Private collection

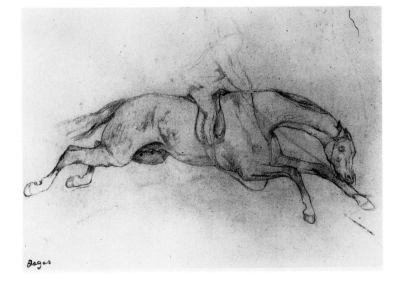

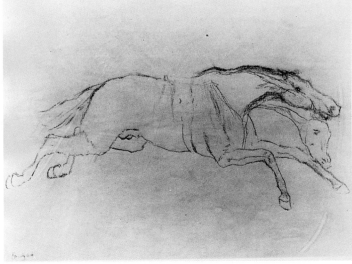

Degas made another friend at the beginning of the eighties, Henry Lerolle (1852–1929), who was also a painter. Lerolle bought works by Renoir and, in January 1883, *Before the Race* (cat. 70) by Degas, which Durand-Ruel had only bought from the artist the month before. Degas wrote to the first wife of Bartholomé:

Something surprising has happened. A painter Henry Lerolle . . . whom I know to be quite well off, has just invited me to dinner. The right he has is still recent, but fairly weighty. In agreement with his wife, who is said to manage him, he has just, at a moment like this, bought a little picture of mine of horses belonging to Durand-Ruel. And he writes admiringly of it to me (style Saint-Simon), and wishes to entertain me with his friends and although most of the legs of the horses in his fine picture (mine) are rather badly placed, yet, in my modesty, I should very much enjoy a little esteem at dinner.[14]

His vanity was probably further assured when in 1897 Renoir painted the two Lerolle daughters, Yvonne and Christine, at the piano in their parents' apartment,[15] with two works by Degas in the background, a pastel of dancers[16] and *Before the Race*. The sale of this painting of horses may have encouraged Degas to take up the subject of the racetrack more enthusiastically in the eighties.

The painting Durand-Ruel sold Lerolle was to be, if it was not already, one of three Degas made of the subject, mounted jockeys in an improbably empty field, with similar diagonal compositions but each with a different palette; the other two have the same title, one in the Walters Art Gallery in Baltimore (cat. 71), the other in the collection of Mrs. John Hay Whitney (cat. 72). Since the one Lerolle owned, which is now in the Clark Art Institute in Williamstown, was sold by Degas in 1882, and Mrs. Whitney's to Vincent van Gogh's brother Theo, a dealer, in June 1888, it is assumed that the Clark's version is the earlier, which an analysis of the two paintings substantiates. In their supplement to Lemoisne's catalogue, Brame and Reff indicate that the Walters panel was sold by the artist to Durand-Ruel in 1884,[17] which could place it between the others, but this relationship still remains somewhat problem-

fig. 70. *Two Jockeys*, c. 1881, graphite on paper. Location unknown *(left)*

fig. 71. *Studies of a Jockey*, c. 1881, charcoal and graphite, heightened with gouache on paper. Location unknown

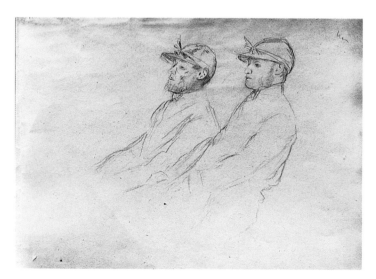

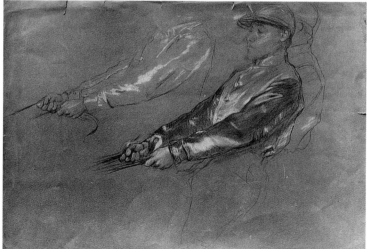

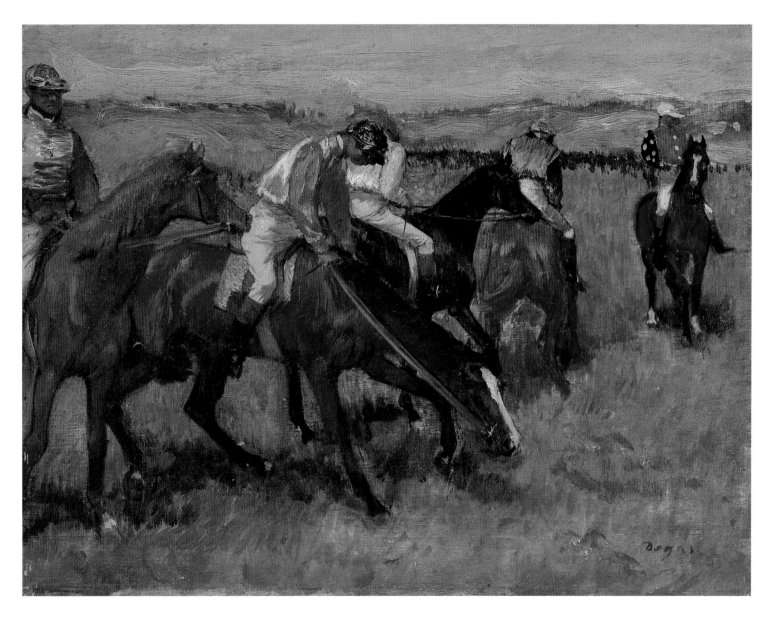

cat. 70. *Before the Race*, 1882, oil on panel. Sterling and Francine Clark Art Institute, Williamstown, Massachusetts

atic. There is also evidence that Degas worked variations upon this theme into the nineties.[18]

The Clark's panel is identical in size to the National Gallery's *Before the Race* (cat. 50). Its horses and jockeys are, however, fewer in number and much larger in relation to the picture area. Only five jockeys are on horseback, although the variety of their activities makes it seem more. In their arrangement as a diagonal wedge back into space, the horses and their riders can suggest the undisciplined *corps de ballet* Degas was drawing and painting almost simultaneously, the rough grass paddock replacing the floorboards

of the stage. In both arenas he was attracted to the accidental juxtapositions to be found in the moments of rest just before the entertainment takes place. Although all the jockeys are not young, which was often also true with the *corps de ballet,* in this painting Degas did suggest a certain youthful vulnerability in the jockey with the yellow jacket, red sleeves, and blue cap, whose mount is stretching downward as if directed by the white stripe on its head. The young jockey leans over to watch as if to prevent any damage. Two of the riders are seen from the back and reveal nothing of their age or their temperament. The jockey at left

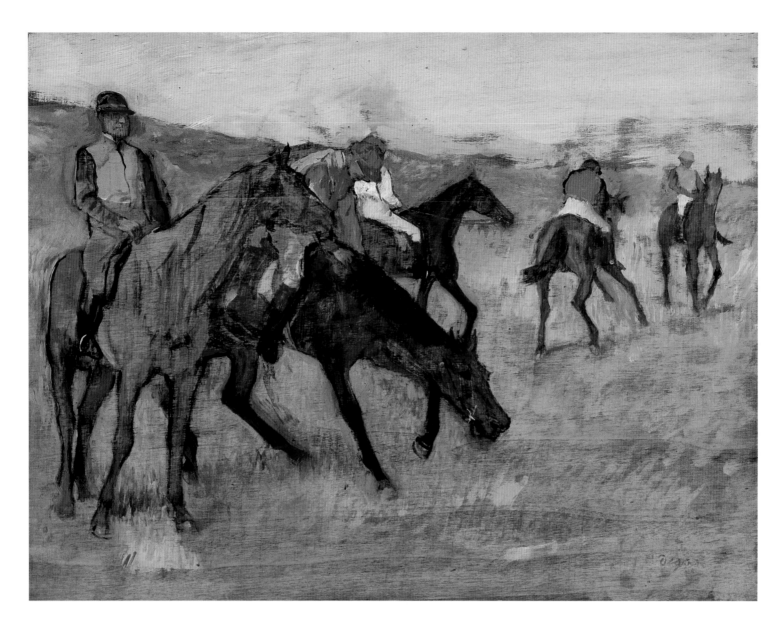

seems severe and middle-aged, although his horse does reveal an amiable curiosity. On the right a jockey with a white cap and polka-dotted silks looks composed, dignified, but interested in what is happening to the right of the painting, while his horse bends its head while looking in another direction. No strong characterizations or tensions are evident, only a restrained variety of actions among the horses and riders brought together on a beautiful day. The coats of the horses are silken and vary in color from red roan and black to the predominant chestnut, but the painting is animated most by the variety of the jockeys' silks. The intensity

of those touches of color, when combined with the liveliness of the strokes of paint, makes this vibrant work a small gem.

When Degas confided in Mme Bartholomé about Lerolle's purchase of this painting he was probably not just joking when he wrote, "most of the legs of the horses . . . are rather badly placed."[19] In this small work he had five pairs of human legs as well as twenty of the horses to consider, to make them convincing but also expressive. Two interests of his would help with the eventual resolution of the problem. One was his curiosity about photography. This was, after all, a critical moment in the history of this new

cat. 71. *Before the Race*, 1882–1884, oil on laminated panels. The Walters Art Gallery, Baltimore, Maryland

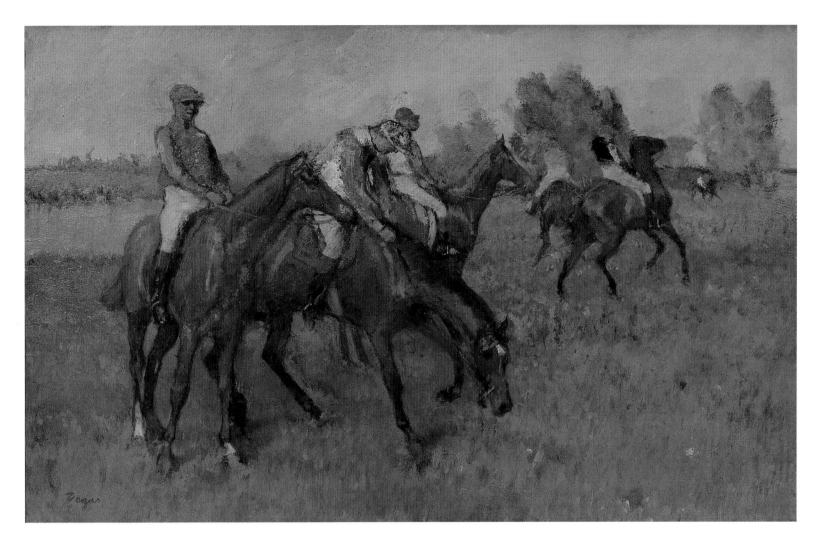

cat. 72. *Before the Race*, 1882–1888, oil on paper, mounted on panel. Collection of Mrs. John Hay Whitney

medium. In 1878 Dr. Étienne Jules Marey (1830–1904) had written his theories about the movement of the horse in the 15 October issue of *La Nature*, a publication Degas knew,[20] and in the 14 December issue Gaston Tissandier discussed the work of Eadweard Muybridge (1830–1904), illustrating his article with single photographs of a horse walking, trotting, cantering, and galloping, thus confirming Marey's theories. Three years later, on 26 November 1881, Muybridge gave a demonstration of instant photography of animals in Meissonier's studio. Although Degas was not present, he would have heard about the event. In artistic circles in France there was considerable interest in the question of how animals actually moved. Louis-Jean Delton, in his annual publication of equestrian photographs,

explained in his 1882 edition of *Le Tour de Bois*:

For a long time I refused to believe, I swear it, that it would be possible to obtain a photograph of a horse in movement. I often told my sons of my regret at not being able to fix on paper those natural movements, careless and unposed, of those elegant women riders and brilliant horsemen I see pass each day in the two allées on either side of our office. My sons resolutely rose to the challenge; and their patience and their obstinate work were crowned with complete success.[21]

Although Degas did not copy photographs by Muybridge until the photog-

fig. 72. *Jockey on Horseback*, c. 1882, graphite and charcoal on paper. Private collection

rapher published *Animal Locomotion* in 1887, he was aware that he could learn from this other medium and was probably examining photographs of horses in movement with considerable curiosity by 1882.

Degas' other interest that would help him create convincing horses was sculpture. By 16 April 1881, after many previous promises, he finally succeeded in exhibiting his *Little Dancer Fourteen Years Old*, made of wax and other materials, at the sixth impressionist exhibition. By then he must have been modeling horses, the very process of which brought him closer to understanding their anatomy. The horse in the Clark painting in back view, with a glossy rump and a swinging tail, could almost have been modeled in wax and, in fact, resembles two of his works of sculpture, *Rearing Horse* (cat. 117) and *Horse with Jockey* (cat. 115) in the firmness of the execution of the croup and in the spreading of the hind legs to support its rearing. These were the beginnings of Degas' understanding of the horse, particularly in motion, that would reach fruition before the 1880s were over. It is not impossible that he occasionally gave a thought back to Uccello's *Battle of San Romano* (fig. 12), which he had copied in 1859, and where fallen lances on the ground measure the diagonal recession of horses.

Before the Race (cat. 70) is covered with oil paint so that the colors are intensified and the jockeys' silks appear to glisten. Using another panel of exactly the same size for the painting now in the Walters collection, Degas proceeded very differently. He coated the panel so thinly with paint that the grain and the texture of the wood are visible. Degas' approach to the handling of the medium was more linear and raw, as is most obvious in the almost expressionistically linear description of the horse in the fore-

ground. Although Degas did not change the proportions of the panel, he did arrange the five horses and riders differently than he had in the Clark's version. He brought the stately, older rider on the left, a figure that is wooden and severe, out in front of the bending youth so that the younger jockey would not attract the same attention. He detached the fourth rider from the main pack and shows him moving to join the formerly isolated jockey on the right. In general his approach is more immediate and more forceful, in contrast to the understated elegance of the Clark's painting. At the same time, the subdued color of the Walters panel is not lacking in subtlety.

These paintings are clearly variations on a theme, just as Degas probably appreciated such variations in those other arts that were important to him, music and the dance. For the third version of the subject he used a panel somewhat wider than the other two and obviously relished the space it gave him on both sides of the group of riders. He emphasized this further by adding the tiny figure of a horse and rider in the distance at the right as the apex of the wedge of horses and jockeys in motion. Degas made several drawings of this mounted jockey, adjusting its position on the sheet of paper. One is a drawing on pink paper in a greenish gray graphite for the horse and a black charcoal for the rider, called *Jockey on Horseback* (fig. 72). In the other two panels the suggestion of a landscape background is rather minimal except for the roughness of the turf and, in the Clark's painting, the pink on the hillock in the background. In the Whitney painting, on the other hand, the ground changes color, and there are trees of different sizes and configurations on the horizon. Around and behind these trees are a few hints, a smokestack or roofs, of human habitation. Although Degas' letters are sometimes bewildering

out of context, one to Lerolle on 2 March 1887 rather suggests that the other artist had been trying to persuade him to give more importance to landscape or "nature" in his work. Although Degas responds, "In loving nature we can never be quite sure whether she requites it,"[22] he does here seem to permit nature to be the unifying element with its tender colors, its gentle light, and the space he permits to liberate the horses and riders. Another reason for the harmony is the muted colors and textures that were encouraged by his painting on paper that had been laid on a panel. Degas could not paint with the bravura of the Clark painting. On the other hand, with the liberation in space he could clarify the drawing of the horses' picturesque legs, as he did most adroitly.

In February 1883 Degas finally sold *The Gentlemen's Race: Before the Start* (cat. 11), which he had first dated 1862. It would be consistent with his procrastination over it if he had just finished it before Durand-Ruel bought it. Its composition — jockeys on horseback lined up along the picture plane, readying themselves into position for the race that is about to begin — was very much on his mind. Degas, therefore, must have decided to make a more modern version in pastel. This is *Before the Race* (fig. 73) in the Rhode Island School of Design museum. In working in pastel, Degas was using a medium that he was finding increasingly attractive for scenes of the dance, for portraits, and for his nudes or bathers. Aside from the advantage of being able to work directly — and more rapidly — with the sticks of pastel, the medium would have appealed to him for the freshness and intensity of the colors available and because the movements of his hand (and occasionally the print of a finger or thumb) were recorded on its surface. In front of the horses and jockeys in the pastel, Degas placed the white board of

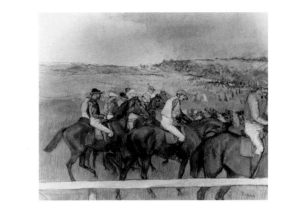

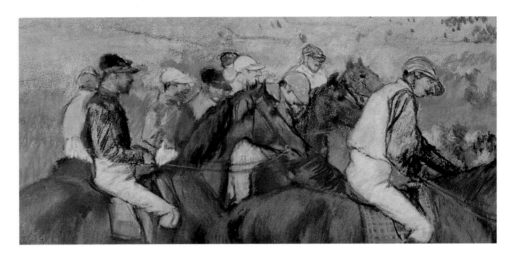

a fence, with an emphasis rather like the vertical starting post in *Jockeys before the Start* (fig. 64). Obviously it was closer to the horizontal fence originally planned for, but later removed from *The Racecourse, Amateur Jockeys* (fig. 63), over which he was still suffering because he had not finished it for Faure. In any case, the fence helped distinguish this pastel from similar compositions. Degas, on the whole, simplified the landscape and did not repeat the smokestacks of Paris, which he had probably only recently added to the *Gentlemen's Race*. His suggestions of crowds in the background are so abbreviated that they could easily be flower beds or bushes. But he went further in making the jockeys' faces more visible and their features more distinctive than any in his other racetrack scenes (fig. 74). It is not only that the jockeys in the pastel are individuals but that

fig. 73. *Before the Race*, 1880–1884, pastel. Museum of Art, Rhode Island School of Design *(top)*

fig. 74. Detail of fig. 73

Degas at that time, presumably the mid-eighties, seems to have made a great many drawings of men or youths in the same positions but with very different physiognomies, whether seeking the most pertinent or amusing to be used in this pastel, or working out variations as an exercise.

Two such drawings, whether preparatory or afterthoughts, are those inscribed with names assumed to be the sitter's. One is a pencil sketch of a jockey (fig. 75), related to the figure in the front at the left, who sits upright, his head in a perfect cameo, both his hands held out to touch the reins with the greatest delicacy. In the upper left corner Degas inscribed "Lepic," surname of his multitalented friend the vicomte Ludovic-Napoléon Lepic, who came from a family that had distinguished itself in the service of both the First and Second Empires. This friend and fellow artist, who co-signed Degas' first monotype,[23] must have agreed to pose for a jockey. (There does not seem any other reason that Degas would have written Lepic's name on the drawing.)

In using the drawing of Lepic for the pastel, however, Degas modified his beard and made him seem shiftier, if only because some of the sideburns are removed, the chest is frailer and the wrists are limper; he is no longer a "gentleman rider." His companions are no more forthcoming and reassuring. The central jockey has sly slits for eyes, a petty mustache, and no chin. The jockey on the right has a generous mustache but an expression of malevolence. Perhaps, fed up with the amateurs, who were claiming his time in the other two paintings upon which he had been working for so long, Degas decided to draw lower-class scoundrels instead. He made these jockeys appropriate companions for the male visitors to the brothels in his monotypes from the seventies. They even suggest his drawings of criminals from 1880.[24]

Degas also made drawings related to the central figure in both the painting and the pastel. On one sheet there are vigorous studies in charcoal of the seated figure of a rather grizzled jockey (cat. 73), and on another two studies of his head (cat. 74). On the drawing of the head Degas wrote "de Broutelles," for Théodore Albert de Broutelles (1840–after 1920), the painter of marine subjects. His pose in the left of the two drawings of his figure is very close to that of the figure in the middle of the pastel, where, instead of a vigorous and experienced bearded man on a horse, there is a sly and dangerous youth. The two drawings of the head of Broutelles still follow exactly the position of the jockey's in the pastel but do not have the same mellow, authoritative strength of the heads in the drawings of his full figure. Whereas Lepic was a Napoleonic aristocrat, an upstart to those who had been part of the *ancien régime*, Broutelles was a self-proclaimed provincial aristocrat.[25] Nevertheless, in his pretensions there was also some measure of the largeness and vigor of the man.

Much closer to the interpretation of the jockey in the pastel is the powerful charcoal drawing from the Ashmolean Museum at Oxford (cat. 75), where the figure, like the one drawing of Broutelles, fits into the same pose as the central jockey. His resemblance to the figure in the pastel is a matter of relative youth and a lack of physical charm. His features are homely but not petty or mean. He also reveals greater physical force as he leans forward somewhat more than the jockey in the pastel, suggesting both commitment and desire. The very handling of the charcoal – willful, brusque, energetic – can be seen as a form of interpretation of this youth. He is certainly not a gentleman, has probably, like most of Degas' little dancers, grown up, if not on a farm, on the streets of Montmartre – under-

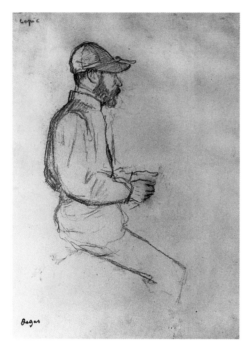

fig. 75. *Jockey (Portrait of Baron Lepic)*, c. 1882–1884, graphite on paper. Location unknown

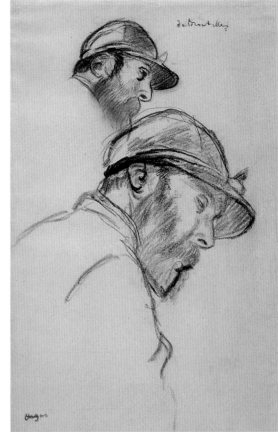

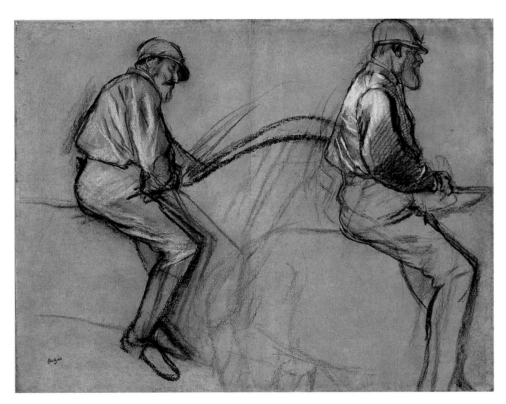

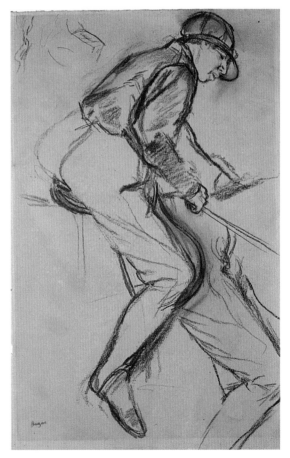

cat. 73. *Two Studies of a Jockey*, c. 1884, graphite heightened with pastel on paper. Collection of Mr. and Mrs. Paul Mellon, Upperville, Virginia

cat. 74. *Study of a Jockey (M. de Broutelles)*, c. 1884, charcoal on paper. Collection of Mr. and Mrs. Paul Mellon, Upperville, Virginia *(top right)*

cat. 75. *Jockey in Profile*, c. 1884, charcoal on paper. The Visitors of the Ashmolean Museum, Oxford

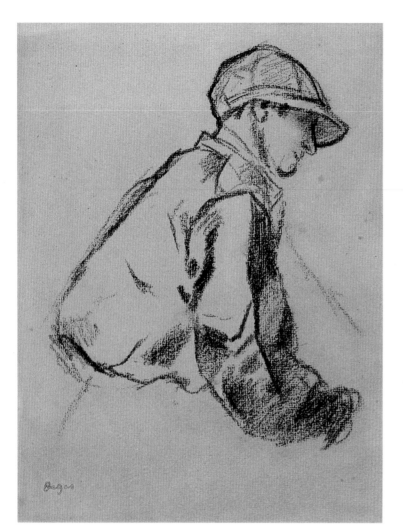

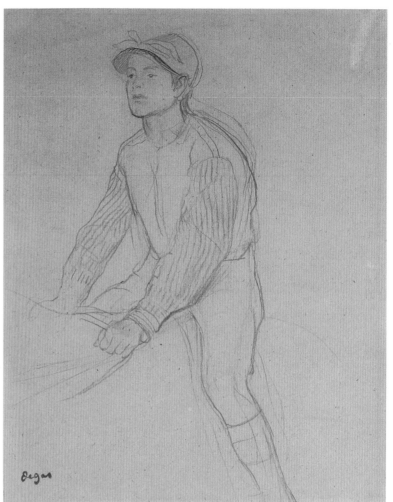

nourished but tough. He has the indomitable willpower Degas admired in the young.

Degas made charcoal drawings of another youth (cat. 76) that seem related to the Rhode Island pastel. The relative fragility of his body makes him appear young, but his pinched profile, somewhat shadowed by his cap, seems, like so many jockeys, to combine youth with age. He could have posed for the central jockey in the pastel, but he is more reserved and accommodating than the figures in the finished work. In these drawings Degas is sympathizing with the fundamental helplessness of the young.

These drawings of individual jockeys are all related in some way to the pastel *Before the Race*, even if they seem to contradict the interpretations in that work. They increase the emotional and psychological range in Degas' exploration of the significance of the jockeys waiting at the track for the race to begin. But there are also drawings of other jockeys that cannot be tied to a known painting or pastel. *Jockey* (cat. 77) in pencil is one of a group he made of jockeys who were more nearly boys than men,[26] drawn rather faintly as if the lightness of the pencil could express the fragility of their passage from adolescence to maturity, their faces exposed to show how empty they are of feeling, except rather sadly of faith.

By 1884 Degas was increasingly committed to pastel in his pictures of the track. The exact date of *The Racecourse* (cat. 78) from the Kunsthaus Zürich has

cat. 76. *Study of a Jockey*, c. 1884, charcoal on paper. Collection of Mr. and Mrs. Paul Mellon, Upperville, Virginia *(left)*

cat. 77. *Jockey*, c. 1885, graphite on paper. Private collection

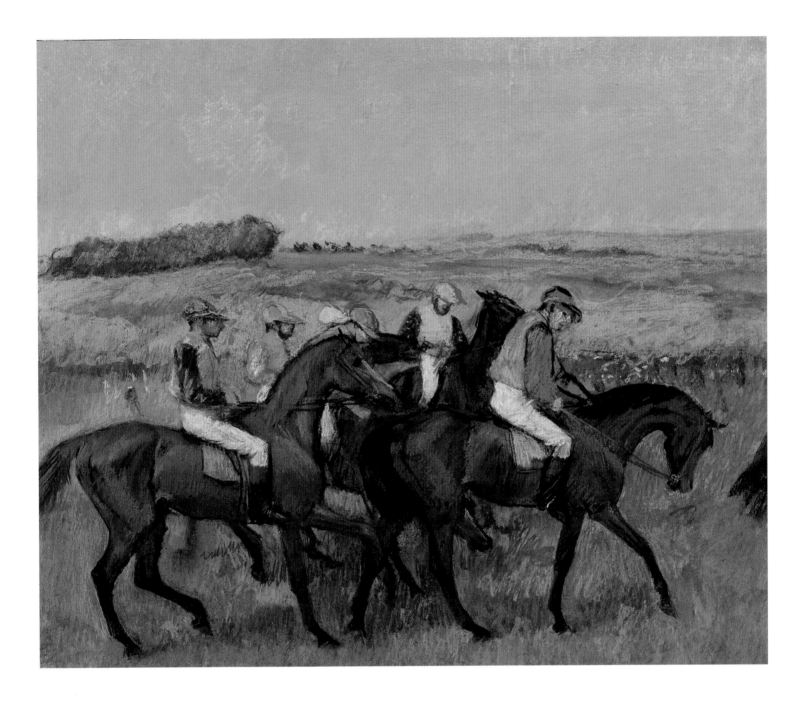

cat. 78. *The Racecourse*, c. 1885–1887, pastel on cardboard. Kunsthaus Zürich, Donation Walter Haefner

not been established, but it is certain that it is part of the series beginning with a band of jockeys, mounted on prancing horses, against a landscape with greater or lesser suggestion of a crowd from the beginning of the sixties and reaching a climax of a kind in the eccentric pastel *Before the Start* (fig. 76). The positions of the jockeys in this pastel have been taken directly from the one in Rhode Island and probably indicate that the two works were contemporary. The essential differ-

ences are that the Zurich pastel is somewhat larger, the grimacing jockey and his horse at the right in the work from Providence and its fence have been eliminated, and the landscape and the suggestion of crowds have been changed. All of this makes the Zurich pastel in one sense more monumental, which the reduction of the differences between the jockeys enhances. But basically the almost nervous animation of the strokes of pastel, the vibrant colors, the appreciation of the same

stances for the horses Degas had drawn and painted twenty years before, and the new sensitivity to nature which may "requite" in their beauty, are common to both works. Unlike *Before the Race* from Providence, however, there is not the distraction of characterization and humor.

Degas had never approached the spectators at the track or a country steeplechase since his drawings and oil sketches at Longchamp, or some other Parisian track, in the late sixties or early seventies. But he did make pastels from the mideighties into the early nineties of women leaning over fences and chatting against landscape settings that have been described as racecourses. Like the drawings Degas made in the stands at Longchamp (cat. 53), they provide an agreeable break with the masculine world of the races themselves. One of these, *Three Women at the Races* (cat. 79), resembles earlier drawings in *essence* in having one model pose in similar, if not identical, costume for all three women. That model so closely resembles some of the customers in Degas' pastels of milliners for which Mary Cassatt posed[27] that it is tempting to think that she is the model here. But the pastel from the eighties and the *essence* drawing from the late sixties are very different — not only in medium but also in scale, setting, and the dress and behavior of the women. They wear sober wool coats, which fit their waists very neatly as the sleeves do their arms, but flare below the waist, without the buoyancy or flirtatiousness of the earlier costume. Nevertheless, the women are still absorbed in conversation against the background of grass, which represents the races without the more specific references of a jockey or horse.[28]

In 1884, the year Degas reached fifty, he inscribed "Degas 84" òn two works — *Racehorses* (cat. 80), a canvas, and *Before the Start* (fig. 76), a pastel. Besides having

cat. 79. *Three Women at the Races*, c. 1885, pastel on paper. Denver Art Museum, Anonymous Gift

cat. 80. *Racehorses*, 1884, oil on canvas. Private collection

fig. 76. *Before the Start*, dated 1884, pastel. Private collection

the same inscription, they share a similar arrangement of horses and jockeys that emphasizes the breadth of the rectangle of the canvas, in the first case, and of the sheet of paper, in the other. Above the horses and riders, more than half the picture surface is given to an immense panoramic landscape with a horizon so near the top that it could be described as mountainous. The juxtaposition of horses and jockeys against such a setting would have been improbable in any place in France in 1884, so the scene is evidently one from Degas' imagination.

It could be argued that the horses and riders are so much part of Degas' stock repertoire that they are meaningless. The positions of the horses and jockeys, most of them from the back, derive from Boston's *Racehorses at Longchamp* (cat. 49) or the drawings Degas made of individual jockeys using *essence* on oiled paper (cats. 42–48; fig. 58). With the exception of the angle of the isolated horse and rider on the right and the position of the head of the horse at the right of the group, the compositions of the oil and pastel dated 1884 appear identical. One could be forgiven for believing that Degas used a tracing to transfer it from one work to the other. However, Degas has applied lights differently, for example, on the rumps of the horses, and has chosen different colors for the oil than for the pastel. The greatest difference between them (even if it is still slight) is in the single figure separated from the rest, a stock concept in many of Degas' grouping of horses. A certain eccentricity is demanded of these isolated figures, and in this case each is walking away, with considerable dignity, from the others as if moving beyond the picture frame. The significance of this outsider is difficult to establish and in that way is reminiscent of the ambiguous horse and rider in the upper right corner of *Promenade on Horseback* (cat. 28) painted almost twenty years earlier. But in these two works the riders reveal almost nothing of themselves. It is significant that the jockeys (but not the horses) seem wearier than those in *Racehorses at Longchamp*, for example; their bodies and their clothes, even their caps, are limper, their shoulders bent, and their necks almost invisible. They have achieved a state of complete neutrality above the animation of the horses' legs.

The scale of the landscapes behind these figures is so vast that mere men and horses might, under any circumstances, appear inconsequential. The relationship in terms of proportion is, however, comparable to the National Gallery's tiny *Before the Race* (cat. 50), painted about eighteen years earlier, but there the lower horizon pushes the figures closer to the earth, where they more nearly take root. In the two works from 1884 they do not quite float, but they seem indifferent to gravity.

The most difficult thing to explain about these two equestrian works of 1884 is their landscapes.[29] As Valéry pointed out,[30] Degas always emphasized the *ground*. This applies to the humblest mud and straw on a racetrack paddock but more often it was grass, sometimes changing color toward the horizon. These glimpses of "nature" were growing in Degas' works in the eighties – a few more bushes, a few more trees, a radiant sky – but in these two scenes the landscapes almost dominate the compositions. The horses and jockeys either move toward the beauty or the solace its mountains might offer or, exceptionally, escape, like the rider at the right in each work. It is a surprise to see Degas, whose knowledge of landscape one might have expected to have been formed by the Île de France[31] or the interior of Normandy, painting or drawing such vast, mountainous vistas. But we are forgetting his Italian background and how frequently he returned to Naples, presumably renewing his impressions of the Apennines, if only from the train, as well as of Vesuvius. In addition, in 1882 he did go to several cities in Switzerland, including Geneva and Zurich, from Veyrier.[32] It is unlikely that on his visits to Italy or Switzerland that, after 1860, he ever painted or drew a landscape *in situ*, but the impressions of height and distances and geological formations may have stayed with him as the basis for fantasies if not exact topographi-

cal descriptions. In this painting and pastel, the weary jockeys and their mounts must experience a certain liberation, freed from fences, paddocks, starting posts, and the tension of the race, as they ride casually toward such a beautiful sky and dramatic earth.

In 1887, Muybridge published his *Animal Locomotion*, after which Degas made some drawings.[33] Degas was able to use Muybridge's photographs as a source for his own horses in movement or as a yardstick by which his others would be measured. He made very few copies from the photographer's work, but there are large and impressive drawings and counterproofs in red chalk and charcoal. His drawings were monochromatic, which may have been in one sense a tribute to photography, but the choice of red chalk may have been influenced by the red wax with which he was working in his sculpture, which would owe something to Muybridge as well. In one drawing (cat. 81) after Muybridge's Annie G. cantering (fig. 77) with its left legs outward, Degas made two changes to capture an unexpected, unconventional, and fleeting vision of speed by cropping the jockey's head so that there would be no distraction from the horse's body, and by combing out the tail so that it would also convey the freedom of movement. These were studies, works of art he kept for himself, magnificent drawings and very rare.

On 9 July 1888 Theo van Gogh bought a small panel, *Four Jockeys* (cat. 82), from Degas for 1,200 francs, which he sold three days later for 1,800 francs.[34] In *Four Jockeys*, the riders and horses are so casually distributed on the grass that it could only be for their own enjoyment. The horses even raise their tails as if this were a gesture of pleasure, and the coats of all but the black horse seem glossy in the sun. They cast rather small but irregular shadows on the grass. Nature is infor-

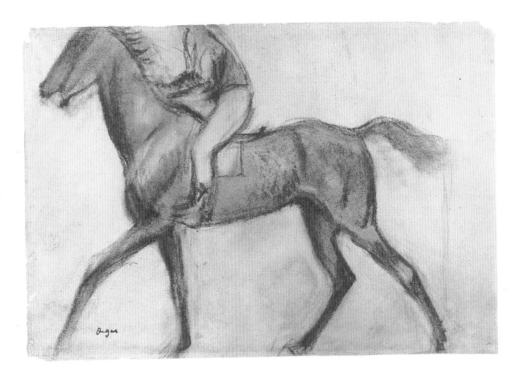

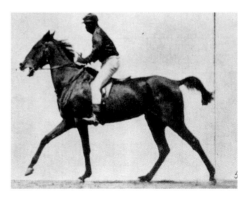

cat. 81. *Jockey seen in Profile*, 1889, chalk on paper. Museum Boijmans Van Beuningen, Rotterdam

fig. 77. Eadweard Muybridge, *Annie G. in Canter*, photograph from *Animal Locomotion* (Philadelphia, 1887), vol. 9, plate 621

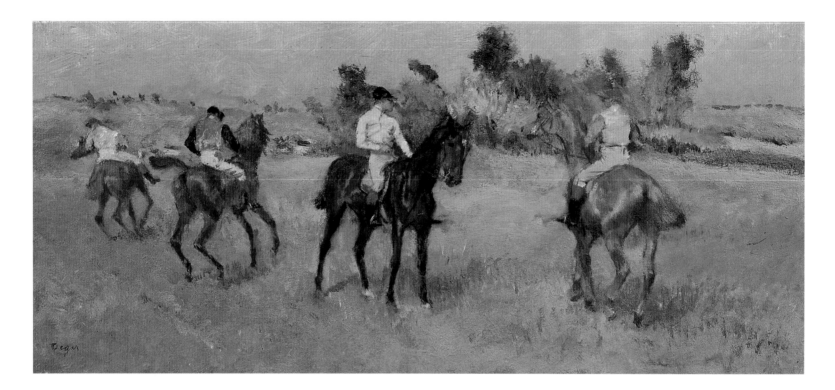

cat. 82. *Four Jockeys*, c. 1886–1888, oil on panel. Private collection, courtesy of Galerie Schmit, Paris

mal, asymmetrical, the contours of the trees ragged and, of the fields, indistinct. The soft pink and green of the meadows and the pale blue of the sky are not saccharine but they are very close to a confection. The strokes of paint and the light seem to be measured by a single pulse. This must have been an idyllic day, very probably near Ménil-Hubert, the home of Paul Valpinçon. It may have been there on a colder, grayer day that Degas painted three other jockeys huddled together in the lower right corner of the painting *Horses and Jockeys* (cat. 83), as if escaping from that cold. The gray color, the expanse of barren fields, and the

trunks and branches of the trees without leaves evoke nature as convincingly as the pretty day in *Four Jockeys*.

More in the spirit of *Four Jockeys* is a pastel, *Before the Race* (fig. 78), in the Cleveland Museum of Art. As in the small panel, this pastel seems to evoke even the smell of spring. Its first owner was Henry Lerolle, whose purchase of the Clark's *Before the Race* (cat. 70) had given Degas so much pleasure in 1883. Here, probably five or six years later, he added a larger version of the theme in pastel with a greater gesture toward the fertility of nature. The background, which is reinforced by the glowing colors of the

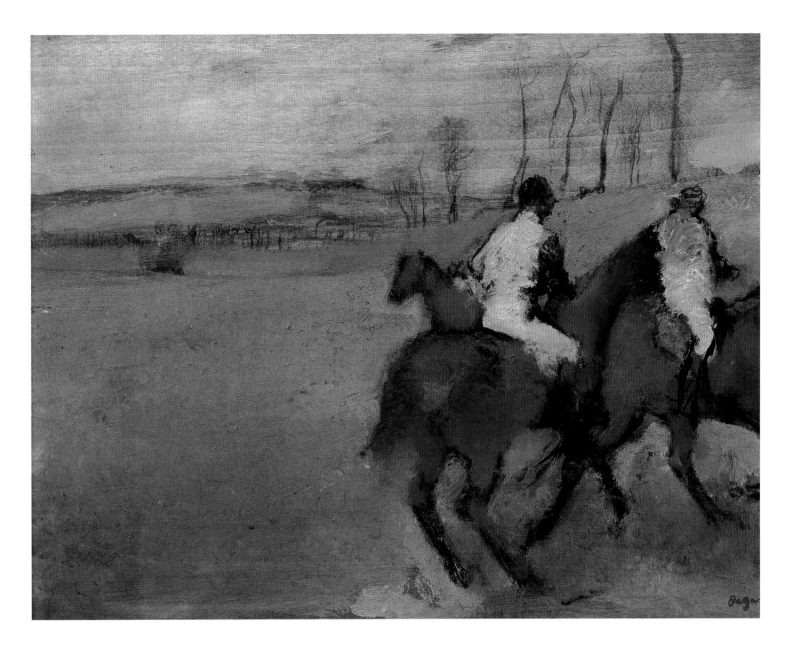

cat. 83. *Horses and Jockeys*, 1886–1890, oil on panel.
Private collection, courtesy of Galerie Schmit, Paris

jockeys' silks, is contradicted by the abruptness of the diagonal recession of the horses and riders, their angularity, and the summary faces of the jockeys. In some ways horses and riders seem as flat as a piece of cardboard. This very contradiction, however, makes *Before the Race* memorable and, understated though the borrowing is, it shows Degas introducing two frames of Muybridge's Annie G. as the furthest horses in the pastel.[35]

When Degas was working toward Cleveland's pastel, he made some drawings with the interpretation of the jockeys in mind, which he erased in the final ver-

sion. One of these, *Three Studies of a Jockey* (cat. 84), is in black and blue pencil. On the left of the page he drew the profile of the jockey who appears second from the left in the pastel, and made two sketches on the right half of the page of the jockey at the left. To pose for these boys, Degas chose, for the figure on the left, one youth without much chin but a dashing nose and the confidence of a street urchin and, for the other two, a lad with a gentle expression in reflection, his full lips slightly petulant. A tenderness is expressed in this drawing, which even the use of black pencil for the jockey at the

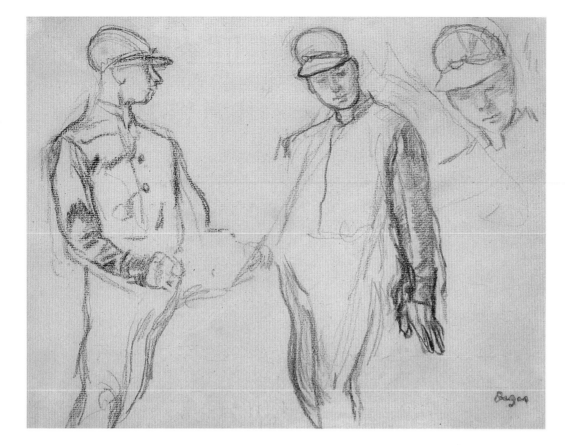

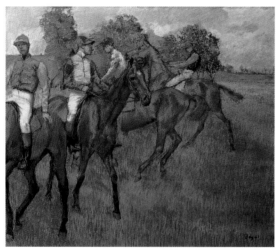

cat. 84. *Three Studies of a Jockey*, 1887–1889, graphite on paper. Private collection

fig. 78. *Before the Race*, 1887–1889, pastel. The Cleveland Museum of Art, 1997, Bequest of Leonard C. Hanna, Jr., 1958.27

left and blue for the figure and the head at the right also conveys. It may be that something of this sympathy is transmitted to Cleveland's pastel even if it is not as overt. Even in the large and fundamentally harsh *Group of Jockeys* (cat. 85) he drew more spiritedly and sympathetically with brief strokes of charcoal than he would use in pastel.

The more nearly sentimental side of Degas, which might have embarrassed him, comes out in charcoal drawings of young horses out for pasture in a state of perfect freedom, undoubtedly fenced but unfettered by a harness, saddle, or rider. One colt (cat. 86), with a gentle expression conveyed by its large black eyes, can only be described as gamboling, apparently flying through the air. The changes in pressure Degas exerts in describing the colt's body in action suggest the sculptor; we seem to be able in our imagination to transpose the changes in weight to his fingers modeling in wax. In fact, the only evidence to suggest a date for these drawings is that the handling of the charcoal is very close to the contours in a drawing made for the sculpture of the fourteen-year-old dancer nude.[36]

A drawing and a counterproof (cats. 87, 88) show that Degas was as much liberated as the young horses in composing his drawings. He could combine a foal grazing with a young horse stretching its neck and repeat its rump and hind legs, perhaps because he was dissatisfied with the first. His drawing is so rhythmic that it unites them very easily on the page. Again his approach to drawing seems very sculptural, repeating strokes to give a fuller exploration of the form. He varies the weight of the strokes to suggest space as well as form; the foal remains in the distance because it is so lightly drawn. Although the concept in some ways is so simple, there is a certain tenderness expressed toward the foal with its head bent

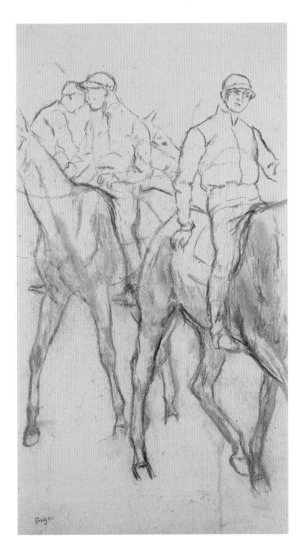

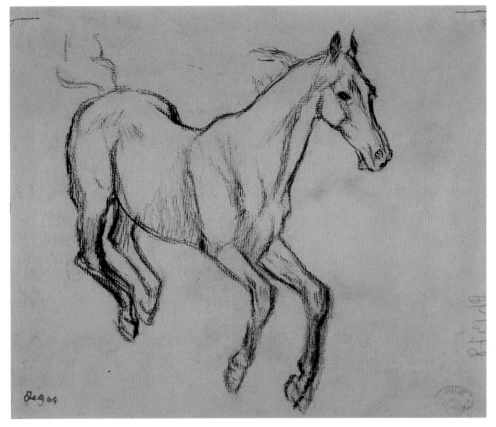

cat. 85. *Group of Jockeys*, 1887–1889, charcoal on tracing paper, mounted. The Art Museum, Princeton University, gift of Albert E. McVitty, Class of 1898

cat. 86. *Horse Galloping*, 1885–1890, charcoal on paper. Nasjonalgalleriet, Oslo

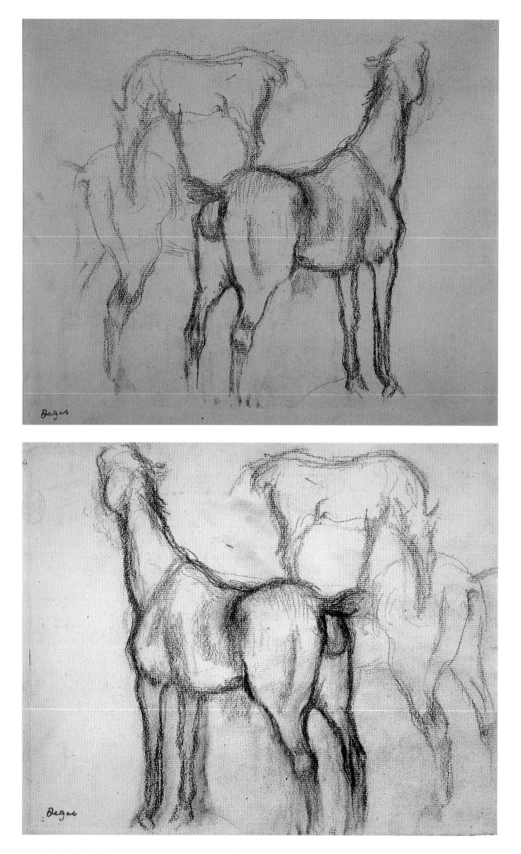

and a certain admiration for the aggression of the horse in front. Degas made a counterproof of it on a slightly larger piece of paper with a pink cast. There is a slight loss in the counterproof, not quite the same range in values, which the slight color in the paper to some extent masks, and some loss of poignancy in the image. And yet the two drawings are satisfying as they confront each other.

To bring an end to this consideration of this fertile period of Degas' career, which did, indeed, give birth to a great many horses by the artist, it seems appropriate to find a coda. And a suitable one exists in a particular position of horse and jockey that Degas used for more than twenty years but which achieves a particular power about 1890. It is in that seminal work *Racehorses at Longchamp* (cat. 49), painted some twenty years earlier, that we find at the left (fig. 79), detached from the other jockeys, a rider in a blue jacket who sits on his horse with apparent equanimity, but the horse's head projects boldly in one direction whereas its body is moving, presumably under duress, in another. This produces a dramatic silhouette and also creates a spiraling composition in space, very much like the *contrapposto* of High Renaissance art, except that one spiral, the jockey's body, is placed on another, the horse. Degas uses this image again in *Four Jockeys* in the eighties, once more isolating horse and rider (fig. 80) from the others at the right, but this time he increases the drama by making the jockey's position more perilous: his right leg stretched out in an effort to balance himself, while his torso twists far to the left as he tries to rein in the horse. This conflict, in which the horse and rider are playful protagonists, is contained as the action spirals around an imaginary axis, never threatening the other riders.

cat. 87. *Studies of Horses*, 1885–1890, counterproof of charcoal on paper. Nasjonalgalleriet, Oslo *(top)*

cat. 88. *Studies of Horses*, 1885–1890, charcoal on paper. Nasjonalgalleriet, Oslo

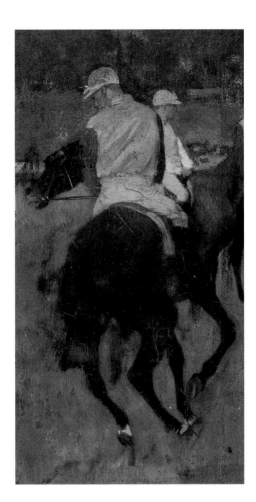

fig. 79. Detail of cat. 49

fig. 80. Detail of cat. 82

fig. 81. *Horse Turning*, 1882–1886, graphite on paper.
Bibliothèque Nationale, Paris

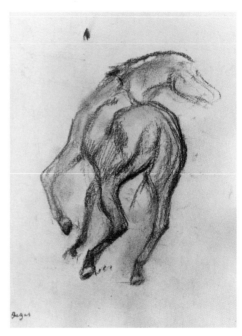

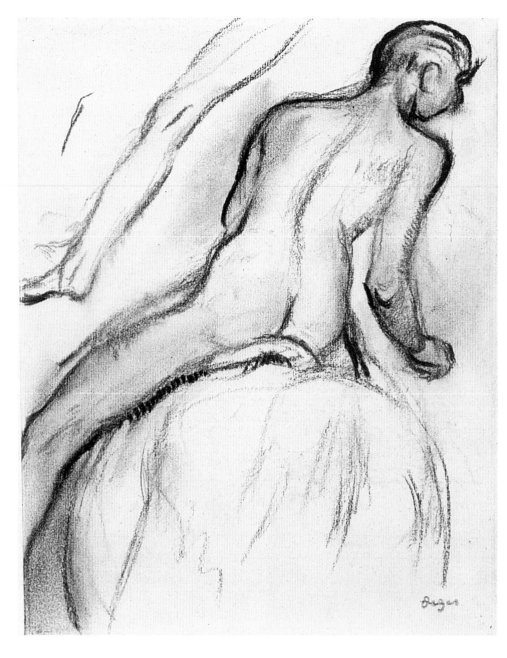

A notebook used between 1882 and 1886 has at least six drawings for that position of horse and jockey, with the head of the horse projecting to the left. These are tiny and summary sketches, all emphasizing the angularity of the horse and the prominence of its joints. In one, the horse's expression has the superiority of a dowager.[37] In another the emphasis is on the arc of its neck.[38] In one drawing (fig. 81) the animal is undecided but still gives that sense of contained energy; it almost anticipates cubism. Another[39]

could easily have been a study for the twisted horse and rider in *Four Jockeys*.

At one point Degas decided to change the direction and make a mirror image of the horse and rider. In doing this he produced a remarkably forceful and highly sculptural drawing in charcoal of a horse alone (fig. 82), in which the head of the horse, rather faintly sketched compared with the rest, is stretched out with apparent curiosity and unquestionable self-will. The line is drawn so robustly that it leads us around its body rhythmically as if we

fig. 82. *Horse Galloping*, c. 1885–1890, charcoal on paper. Private collection

cat. 89. *Nude Study of a Jockey*, 1885–1890, charcoal on paper. Museum Boijmans Van Beuningen, Rotterdam

cat. 90. *Jockey in Blue on a Chestnut Horse*, c. 1889, oil on panel. Virginia Museum of Fine Arts, Collection of Mr. and Mrs. Paul Mellon

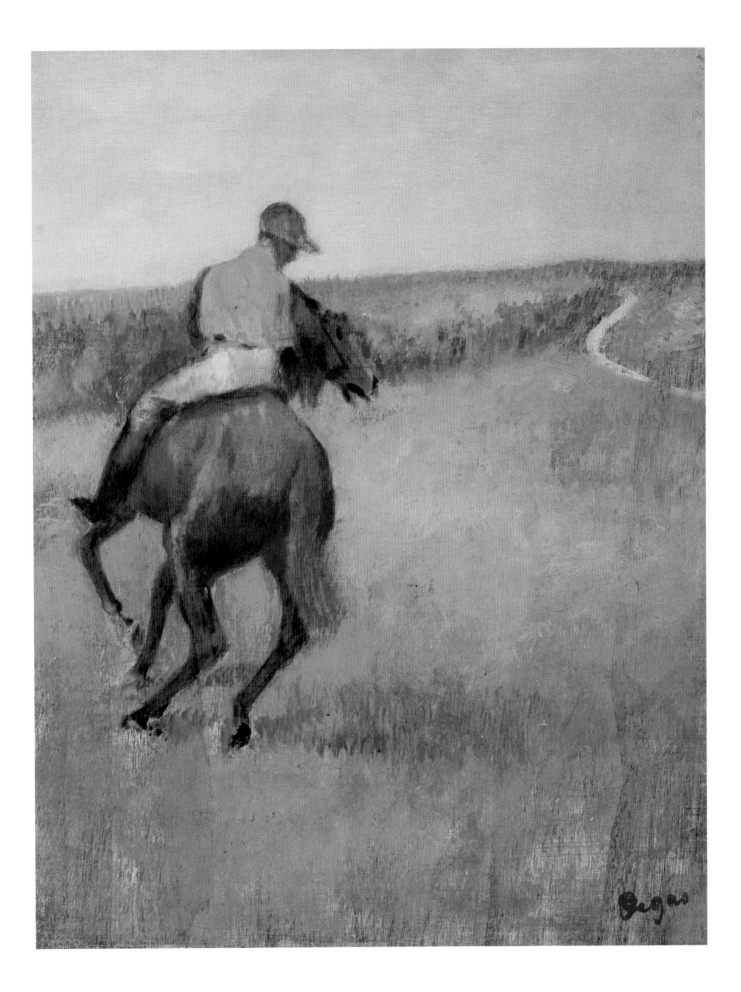

were examining a piece of sculpture. The horse is a natural force, but as if its energy would always be contained. In a magnificent charcoal drawing of the back of a jockey (cat. 89), also attracted in two directions but disciplined to balance himself, Degas drew the youth as nude as the horse. He twists in the same direction as the animal and with equal energy. His strength does not depend as much upon mass as the horse's would have done; in fact, he is small when compared with the faintly outlined but gigantic body of the animal on which his saddle is placed. His head, although powerfully drawn, does not convey as much feeling as the head of the animal, but his total figure is a bold demonstration of determination and will, expressed by the muscles in that lithe but economically drawn body.

Having explored this theme with the horse and rider separately and together, Degas made the pair the theme of small, intimate paintings in which they are on their own against nature. Although Degas did upon occasion place this pair in the center of a work, they were normally drawn like a magnet to their natural location on the left, as they are in *Jockey in*

Blue on a Chestnut Horse (cat. 90), so that they can be very much isolated in the world Degas chose to paint. In this canvas it is a flat prairie through which a narrow stream winds, suggestive of some of the landscapes Degas would make in, or over, monotype and exhibit in his one-man exhibition in Paris in 1892.[40]

The field is fertile but without variety, except for the color that sets off the animated and decorative combination of horse and jockey. In another panel of charcoal and pastel on wood,[41] which is probably much later, in the nineties, the horse and rider are placed against a landscape which is vaster, more horizontal, and seems melancholy. The horse is vigorous but the rider is so insubstantial that the contour of the hill is visible behind him through his jacket and his torso. The head is not just turned away from us so that we won't be distracted by his features, but the lines that describe it vibrate so much that we cannot see where the cranium begins and ends. This is a horse and rider transformed into a lonely, ghostly fantasy, but still expressing, as they challenge each other, the significance of energy and will.

Notes

1. *Letters*, 111, 124, to Bartholomé, Sunday morning, 1888. The implication in the blank between the square brackets would have been that Degas wished he had tried more ambitious works of sculpture like Bartholomé's tomb with its Crucifixion; a polite fiction.

2. Lafond 1918–1919, 1: 93: Degas dined with Alexis Rouart (1839–1911) every other Tuesday, when there would be Henri Rouart, a professor of drawing at some university, the abbé de Kergariou, a distinguished Breton priest, Dr. Descouts, a doctor (on legal matters) for the City of Paris. Henri Rouart, the professor of drawing, and Degas each painted about a dozen plates. Degas' one platter and ten plates, four plates with jockeys, were inherited by Alexis' son, Henri. Paul Jamot ("Peintre" 1924, 298), adds to the guest list Gaston Cave, head of an important furniture factory on the rue Charles V and identifies the professor of drawing as Delavaud.

3. The color is described by Jamot 1924, 300.

4. Degas painted a copy of the head of the horse from the east pediment of the Parthenon: L 98 (location unknown).

5. See Druick and Zegers in exh. cat. Boston 1984–1985, xxix–11; Pantazzi in exh. cat. Paris 1988–1989, 304–305.

6. Nancy Mowll Mathews, ed., *Cassatt and Her Circle: Selected Letters* (New York, 1984), 151, letter of Katherine Cassatt (the painter's mother) to her son Alexander from Paris, 9 April 1880.

7. Mathews 1984, 154–155, letter of Katherine Cassatt to her son Alexander from Paris, 10 December 1880.

8. Douglas Druick was the first to point out the spectator to the author.

9. Pickvance in exh. cat. New York 1968, no. 3, as c. 1866.

10. Tinterow in exh. cat. Paris 1988–1989, 563, fig. 317, as 1870s.

11. An example combining both, National Gallery of Art, Washington, which Lemoisne dates 1877–1880, but Tinterow in exh. cat. Paris 1988–1989, 440–442, no. 267, dates c. 1885.

12. Kendall wrote of it when it was shown at a gallery in London in 1989, "Though quite able to hold its own as a spontaneous and vividly perceived study of a galloping, riderless horse, this drawing is also one piece in an elaborate jig-saw of inter-related works and art-historical controversy. The rapidly modelled forms of the horse and its persistently re-drawn contours all suggest a working drawing developed in conjunction with an oil or pastel, and both point toward the freer manner of Degas' later career." Richard Kendall, "Cheval echappé," in *Degas* [exh. cat., Browse and Darby] (London, 1989), no. 6.

13. The reversed drawing, which is not reproduced here, is Vente IV: 216.a (private collection).

14. *Letters*, 61, 78–79, to Mme Bartholomé, undated.

15. Renoir, *Yvonne and Christine Lerolle at the Piano*, 1897 (Musée de l'Orangerie, Paris).

16. L 486, *Danseuses roses* (Norton Simon Museum, Pasadena).

17. BR no. 110, "was bought by Durand-Ruel in 1884."

18. See cat. 99, L 896 bis, *Jockeys*. It is the same size as the paintings from the Clark and the Walters, but it is much less disciplined and its movements are wilder, which suggest a date later than Lemoisne's 1886–1890.

19. *Letters*, 61, 79, to Mme Bartholomé, undated.

20. Reff Notebook 31, c. 1878–1879, 81, where Degas wrote "*Journal: La Nature* / Victor Masson (année 1878)." Reff (p. 137) points out that it was published by G. Masson and that in the issue of 5 October 1878, Marey published his article on "Moteurs animés," and that on 14 December 1878, Tissandier published his article "Les allures du cheval," which was illustrated by the first photographs by Muybridge to reach Paris.

21. Louis-Jean Delton, *Album Delton: Le Tour du Bois, Première Série* (Paris, 1882), 26.

22. *Letters*, 109, 123, to Henry Lerolle, 2 March 1887.

23. Janis in exh. cat. Cambridge, Mass., 1968, no. 1.

24. For Degas' studies of criminals at a trial that began on 27 August 1880, and for which Paul Valpinçon was one of the jurors, see Reff Notebook 33, fols. 5v–6, 10v–11, 14, 15v, 16, 46v, 47v, 49v; also Douglas Druick, "La petite danseuse et les criminels: Degas moraliste?" in *Degas inédit* 1989, 225–250. The edge of the dock played a role for the criminals similar to the barrier in L 880, *Before the Race*.

25. The pretension of Broutelles was rather like the two brothers of the painter, Achille De Gas, who commissioned a fictitious family tree, and René de Gas, who adopted the aristocratic particle.

26. See drawings in Vente III: 92.3; Vente III: 107.2; Vente IV: 274.b.

27. L 281, *At the Milliner's*, 1882 (The Metropolitan Museum of Art, New York), and possibly others.

28. When the pastel was sold at the first of the four sales of the paintings, pastels, and drawings in Degas' studio after his death, 6–8 May 1918, no. 309, it was called *Aux courses* (*trois femmes causant*).

29. Interestingly, Kendall in exh. cat. New York 1993 essentially ignores them.

30. Valéry 1960, 42.

31. Both the Rouarts and the Halévys had country properties at Sucy-en-Brie, which is seventeen kilometers from Paris and within the Île de France.

32. He wrote a letter from the Hotel Beauséjour, Veyrier: *Letters*, 50, 71, to Bartholomé, 9 September 1882.

33. See cat. 81, L 665, L 665 bis, and L 674 bis.

34. The buyer was Jules-Émile Boivin (see John Rewald, "Theo van Gogh as Art Dealer," Appendix I: "Excerpts from the Goupil-Boussod and Valadon Ledgers," in *Studies in Post-Impressionism* [New York, 1986], 89), who the next year would buy the painting in the Metropolitan Museum of Art we familiarly know as "The Woman with the Chrysanthemums," but which Henri Loyrette has shown is probably a portrait of Mme Paul Valpinçon (Loyrette in exh. cat. Paris 1988–1989, no. 60, 114–116). It is pleasant to think of these two sun-filled paintings by Degas having hung together in a Paris apartment. Since Degas had a reputation, which he certainly encouraged, of being hostile toward nature and, in his last years, would refuse to eat at a table with fresh flowers, probably because he was allergic to them, it is salutary to be reminded by these works that he was capable of showing his affection for both landscape and fresh flowers in paint.

35. Pickvance in exh. cat. Martigny 1993, 35, points out that "by clever overlapping, Degas half-disguised his source."

36. *Study for the Little Dancer of Fourteen Years*, Vente IV: 287.a, c. 1879 (Nasjiongalleriet, Oslo B 15574).

37. Reff Notebook 37, fol. 199.

38. Reff Notebook 37, fol. 198.

39. Reff Notebook 37, fol. 196.

40. This exhibition of Degas' landscapes, held in November 1892 at Durand-Ruel in Paris, was the only one-man exhibition in which Degas participated. For information about it and illustrations, see Kendall in exh. cat. New York 1993, chap. 7, "The 1892 Exhibition at the Durand-Ruel Gallery," 183–229.

41. BR 126, *Jockey from the Back*, charcoal, pastel, and oil on wood, private collection, Switzerland.

Toward Spectral Horses

Some Adventures, 1890–1893

About 1890 Edgar Degas was more light-hearted and adventurous than he had ever been, even in youth. Part of this was his enjoyment of moving into a new studio at 37 rue Victor Massé, across from the Bal Tabarin.[1] Eventually he was to occupy three floors of the building: the top served as his studio, the middle as his living quarters, and the lowest his bedroom as well as his gallery or private museum.[2] He had a passion for his growing collection of the works of other artists,[3] particularly those of Paul Gauguin (1848–1903). In 1891 Degas bought his *La Belle Angèle* and *Martinique Landscape,* and in 1892 he acquired *The Moon and the Earth* by exchange as the beginning of his small but exceptionally fine group of this artist's works.[4] Paintings of Martinique and Tahiti must have made Degas' apartment seem a relatively exotic place.

Sometimes music provided these adventures for Degas, as it did in August 1890 when he was taking the waters at Cauterets in the French Pyrenees and decided it would be amusing to have the first flute at the Paris opera play from the overture of Gluck's *Orpheus* in the woods near the hotel.[5] In the end, it left Degas finding nature insipid beside such a work of art and deciding that, when he was moved to tears by such music, it was in a theater.[6] The conflicting attractions of both nature and the theater would dominate his work in the nineties, with the theater, as at Cauterets, winning.

When about 1889 Degas was encouraged by the increasingly stimulating company he was keeping to write sonnets,[7] he dedicated one to the singer Rose Caron (1857–1930), another to Mary Cassatt, and still another to the dancer Marie Sanlaville (1847–1930), who was Lepic's lover. But his first sonnet was for a horse, a *Sang Pur*:

Pure Bred

You can hear his coming, his pace checked
 by the bit,
His breath strong and sound. Ever since
 dawn
The groom has been putting him through his
 paces
And the brave colt, galloping, cuts through
 the dew.

Blood-strength, like the burgeoning day
 drawn up from
The East, gives our novice runner,
Precocious, impervious to ceaseless work,
The right to command cross-breeds.

Nonchalant and diffident, with slow-
 seeming step,
He returns home for oats. He is ready.
Now, all at once, the gambler grabs him

And for the various games where he's used
 for gain
He's forced onto the field for his debut as a
 thief,
All nervously naked in his dress of silk.

(translated by Linda Nochlin)

cat. 103 (detail)

ing the horse in his arms."[19] Before this he had admitted, "One needs to have been sad and serious for a long time to enjoy oneself so much."[20]

With the shortage of specific links between Degas' drawings of horses and particular places and dates, it is perhaps forgivable to speculate that on this trip Degas was in a position to make drawings of horses he saw in the fields as they passed or in the outbuildings where they stabled M. Plomer. One group of such drawings, in black charcoal or chalk and colored chalks, depicts horses liberated from their trappings, seemingly free and natural against green grass. With his new sense of the physical and psychological reality of one horse, Degas was able to see these horses with greater realism and a stronger sense of individual personality. He was charmed with the idea of mirror reflections and used counterproofs as one way of getting two very different effects from a single drawing. One such drawing (fig. 84) was of a horse from behind, spreading his legs awkwardly as he prepares to lunge upward. The splayed legs are comical but powerful, the pressure of chalk along its back strong enough to support the rising body, its neck held upward and forward to a head that is almost fastidious, and certainly willful, in its expression. The comparative illustration here is only of the counterproof in black chalk, but it has nevertheless been strengthened at certain places, such as the right haunch of the horse. It has the humor, the energy, and the determination that fills Degas' accounts of that trip into Burgundy.

Two other drawings, which may have been from this trip, are the original black drawing retouched with colored chalks after the counterproofs have been pulled. Degas must have been most amused by the play of young horses in a field, as well as the potential power in their bodies. In

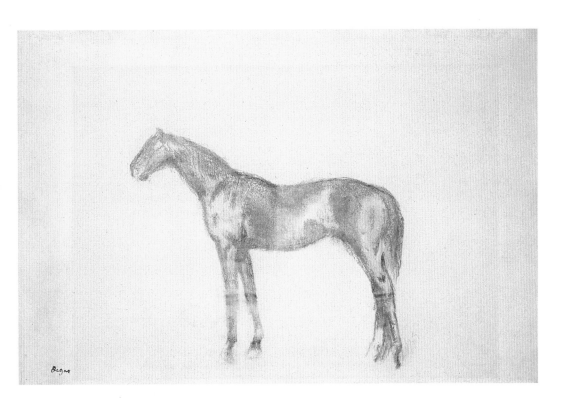

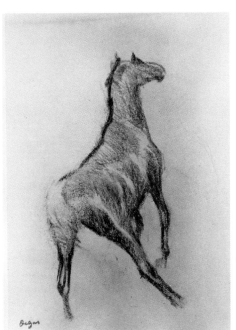

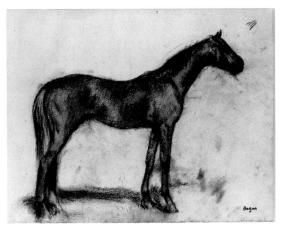

cat. 91. *Horse*, c. 1890, counterproof on paper. National Gallery of Art, Washington, Collection of Mr. and Mrs. Paul Mellon, 1985.64.166 *(top)*

fig. 83. *Racehorse*, c. 1890, charcoal and chalk on paper. Sterling and Francine Clark Art Institute, Williamstown *(bottom right)*

fig. 84. *Rearing Horse*, c. 1890, counterproof from charcoal on paper. Private collection

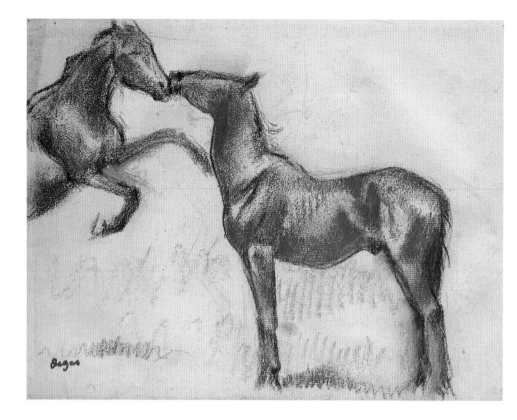

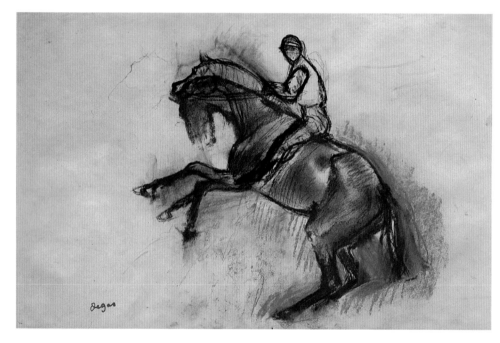

cat. 92. *Two Horses, One Nuzzling the Other*, c. 1890–1892, pastel on paper. Sterling and Francine Clark Art Institute, Williamstown, Massachusetts

cat. 93. *Jockey on a Rearing Horse*, c. 1890–1892, chalk on paper. Sterling and Francine Clark Art Institute, Williamstown

one they bunt each other, their bodies seemingly massive and their legs fragile.[21] In another (cat. 92)[22] they nuzzle each other, the one with leg extended as if to shake hands. There is great force in his manipulation of the black, brown, and emerald green chalk, but tenderness as well in his gentle humor. The green is reminiscent of that he used with more self-conscious artistry behind the head of the horse in the drawing for *Sémiramis* (cat. 7), made about thirty years earlier. He applies it now in a loose but vibrant hatching around parts of the bodies of the horses as a convention to suggest nature – green grass, green leaves – and even their smell. He nevertheless smudges two patches with a dark gray to cast shadows and to remind us of the earth.

It is possible that on this trip he saw a subject more traditional for a painter of racetrack scenes: this is *Jockey on a Rearing Horse* (cat. 93) in which a small jockey in many respects seems unequal to the wildly rearing horse on which he is mounted. That horse in its violent energy has the evidence of Muybridge's photographs behind it, but also Degas' own experimentation over the years with the suggestion of motion by purely graphic means. The jockey maintains any authority and dignity by his quiet control. Once again, Degas uses the vibrant strokes of green chalk to indicate the background against which the jockey is performing.

These drawings of horses, with or without riders, which may have been made in the carriage as Degas and Bartholomé traveled through Burgundy, or perhaps from memory in a hotel room or studio later, were not the most important consequence of that journey. In those five short days with the Jeanniots Degas experimented with the other artist's old printing press in his shabby studio and presumably produced the first of his land-

scapes in monotype.[23] From what descriptions there are from Bartholomé and Jeanniot, their creation was a bravura performance in which Degas either remembered the landscapes he had passed or created new ones from his imagination, but did not work from nature itself. He was to continue to make others after he returned from Burgundy and exhibited a group of them at the Galerie Durand-Ruel in November 1892.[24]

Horse at the Edge of a Pond is a pastel (fig. 85)[25] that Lemoisne dates 1880–1890 and places (with one interruption) before another pastel of the same size, now called *Landscape with Cows*,[26] which he gives to the same period. For the 1988 retrospective exhibition of the work of Degas it was confirmed that the latter work is indeed a pastel over monotype like most of the works in the 1892 exhibition. The two – the landscape with cows and the landscape with a horse – seem to form a pair, but unfortunately the owner of the horse is unknown and the work only reproduced in the small format of Lemoisne's catalogue. Yet it is likely that *Horse at the Edge of a Pond* has a thin and almost translucent black monotype base, which most evocatively suggests in its delicate atmospheric drawing the formation and spatial relationships of the trees in the distance. Pastel would be used to define the mass of the body of the horse – perhaps a white one, perhaps even M. Plomer – who seems to be drinking water from a pool in the foreground. The field behind is probably suggested by very open, calligraphic strokes of pastel in that same jade green seen in Degas' drawings of the early nineties. Ultimately, although the horse's back is vigorous, the animal is subordinated to the landscape or at least in harmony with it, but certainly not dominating it. These landscapes over a monotype base, however, in their

very smallness indicate that Degas sees nature – with or without the horse – as a microcosm. It may have been necessary for the artist, in undertaking a new subject or theme, to reduce it to a miniature in order to understand it. More cynically, beautiful as these monotypes are, their size might suggest the artist's well-known prejudices against landscape in the order of things. Yet in the act of their creation his very attitude toward the nature represented by earth, trees, grass, and water could have been reversed.

In his reminiscences of Degas, Daniel Halévy describes an exchange in September 1892 in the house of his parents, when Degas proudly boasted of his readiness to buy the fifteen volumes of a new English translation of the *Arabian Nights* for 900 francs. He insisted, "I shall have them, I shall have them, and the joke is that I shan't be able to read them myself." One significance of this is that love of the oriental and the fairy tale that would make him treasure their possession. Although the subject matter of his works was the contemporary world he knew, he was fascinated by the imaginary. He nevertheless explained to the Halévys that he would be able to afford to buy the *Arabian Nights* because he would sell some of his landscapes, "the fruit of my travels this summer." Ludovic Halévy asked him perceptively, "What kind of things? Vague things? . . . Reflections of your soul?" To which Degas replied, "A reflection of my eyesight. We painters do not use such pretentious language."[27] But both these old friends were right. The landscapes are a reflection of both Degas' soul and his eyes. And in that soul there was a great deal of the ephemeral magic of the *Arabian Nights*.

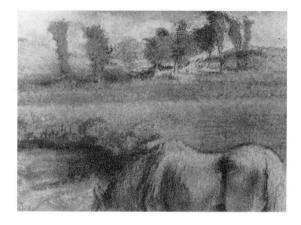

fig. 85. *Horse at the Edge of a Pond*, 1880–1890, pastel over monotype. Location unknown

The Racetrack Transformed, 1892–1897

Degas did return to horses and riders in which the landscape was subordinated, to oil on canvas or to pastel without the intrusion of monotype, and to a more conventional size. This is true of *The Mounted Horsemen* (fig. 86), in which seven riders are confronted against the light, their shadows falling toward the paddock. Their frontality inevitably suggests Manet's races, including *Reviewing Stand and Gardens at Longchamp* (fig. 87), presumably painted more than a quarter of a century earlier. The ribbon of crowd behind the horsemen and the pastoral landscape with a variety of trees echo Manet's work, although painted by an artist who is more interested in the exact relationship of trees, crowds, and performers to the ground. Degas chose a moment when the horses were sauntering to the starting gate rather than exploding from it. This gave him an opportunity to study the relationship of the twenty-eight horses' legs to each other and the earth, as well as to the four legs of one smaller horse at the left, and the splayed legs of a man in a top hat at the right, who recalls the male visitors in Degas' monotypes of brothels from the seventies. The light, which sets off the figures, sparkles over the white parasols, and binds together all the activity within the landscape, and also reduces the faces to the simplest masks and the torsos of the jockeys to flat, square-shouldered silhouettes. The question of dating is certainly problematic. Lemoisne proposes c. 1885 without any explanation. A drawing (fig. 88) for the figure of the jockey on a rearing horse, in particular in its very looseness, suggests the nineties.

Periodically since the late 1870s Degas had been attracted by a horizontal canvas, its width more than twice its height, suggesting a frieze. Although he used it pri-

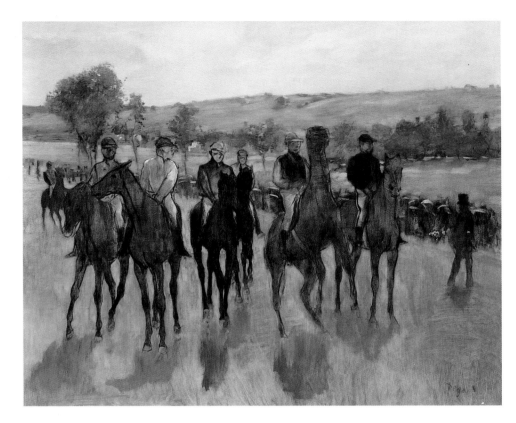

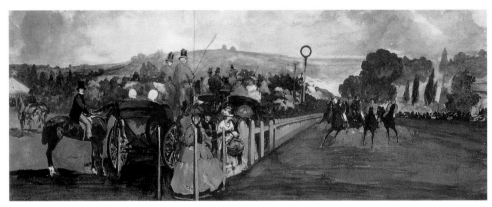

fig. 86. *The Mounted Horsemen*, c. 1893, oil on canvas. Collection of Mr. and Mrs. Paul Mellon, Upperville, Virginia

fig. 87. Édouard Manet, *Reviewing Stand and Gardens at Longchamp*, 1864, watercolor and gouache over graphite on paper. Fogg Art Museum, Harvard University Art Museums, Bequest of Grenville L. Winthrop

fig. 88. *Study of Horses*, c. 1893, graphite on paper. Collection of Mr. and Mrs. Paul Mellon, Upperville, Virginia

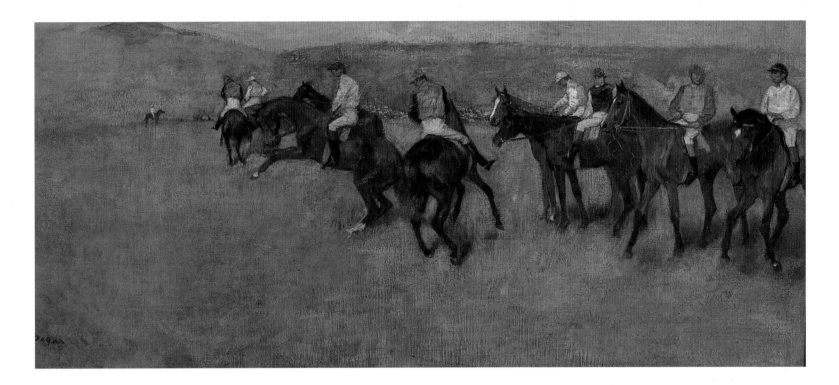

cat. 94. *At the Races: Before the Start*, c. 1885–1892, oil on canvas. Virginia Museum of Fine Arts, Collection of Mr. and Mrs. Paul Mellon

marily for dance classes in shadowed rooms, it was natural that Degas should think of horses and riders in a similar composition, particularly as he was becoming more immersed in the mysteries of landscape and natural light. One frieze he began in the eighties and seems to have reworked in the early nineties is *At the Races: Before the Start* (cat. 94), in which he used the diagonal composition he had evolved in the early eighties for the three paintings called *Before the Race* (cats. 70–72), but strung the horses and riders along the horizontal and more open landscape, reaching a teasing climax in the tiny horse and rider in the distance. This

is painted in oil paints with an intensity of color that rivals Degas' pastels.

A frieze composition from the early nineties is *Hacking to the Track* (cat. 95), which, it has often been pointed out, was strongly influenced by Degas' early drawings after the Benozzo Gozzolis in the Medici-Riccardi palace in Florence (cats. 3–5). Although not nearly as precise nor as decorative as Benozzo's, the bare trunks in the background could be an acknowledgment of Degas' admiration for the exquisite trees in the quattrocento master's work. Tinterow, who found sources for four of the horses in this painting in Muybridge's photographs in

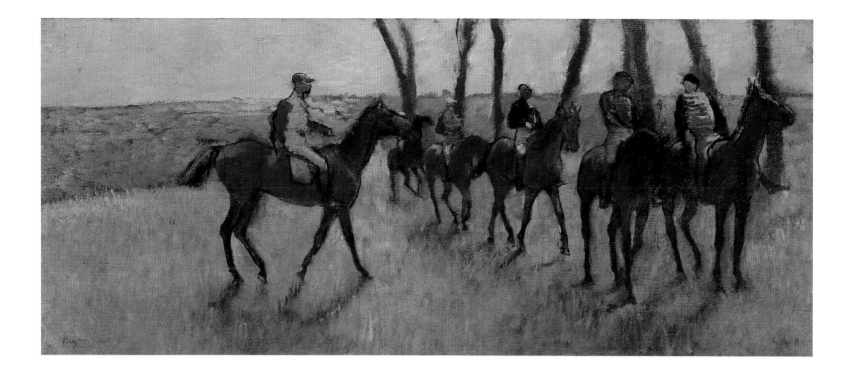

Animal Locomotion, also suggests that the poplars in the background might be a reference to Monet's poplar series of 1891–1892, exhibited at Durand-Ruel in 1892.[28]

Drawings by Degas of highly individualized young jockeys for the painting have been identified.[29] As the figures in the painting are almost neutrally mature, these preparatory studies are surprising in the power of their characterization of both the insecurity and cockiness of youth. The drawing for the principal jockey (cat. 96), at the left in profile, is executed simply in charcoal. The jockey is smaller in relation to the horse and the horse scrawnier than in the painting. The youth seems insecure as he sits back pressing his weight down on his right arm, which appears to crumple, and holds the invisible reins with his left hand, which Degas repeats as if to emphasize its uncertainty. His profile is that endearing mixture of age and youth that is sometimes to be found in the faces of jockeys. It recalls what Gauguin wrote in his Journal in 1903, "The race-horses, the jock-

eys, in Degas' scenes are often enough sorry jades ridden by monkeys,"[30] a description more apt for the drawings, like this, than for the paintings or pastels. This callow "monkey," for example, is transformed in the painting by broadening his chest, by giving the right arm more freedom and energy by pulling it further back from his body, and by thrusting his head further forward in showing something of his right shoulder. He has, however, very little individuality in the painting, aside from an assumption of authority.

A second drawing, *Mounted Jockey* (fig. 89), was used for the horseman at the right. In the drawing of charcoal heightened with pastel he sits back with the assurance of the inexperienced on the horse, his two legs sticking out with the animation of pieces of wood. Although Degas does not seem tempted to enlarge upon the fragility of this youthful arrogance and barely indicates the eyes, nose, and mouth, he does manage to communicate a certain affection for him in the soft lines of his jacket, which belie the jockey's assumption of such a self-confident pose.

cat. 95. *Hacking to the Track,* c. 1892, oil on canvas. Collection of Mrs. John Hay Whitney

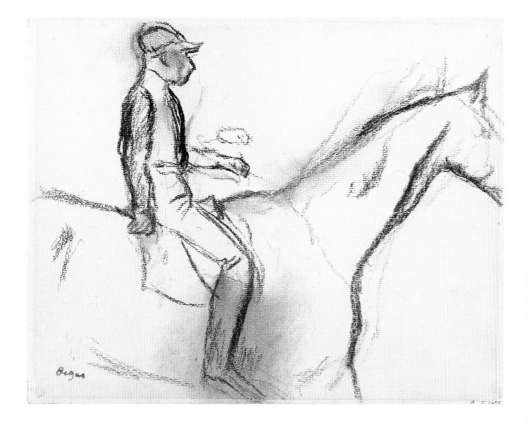

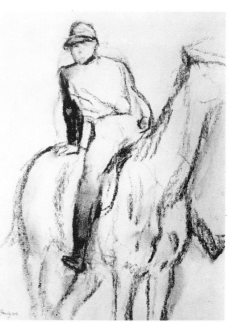

cat. 96. *Jockey* (study for *Hacking to the Track*), c. 1890–1892, charcoal on paper. Ateneum, The Finnish National Gallery *(left)*

fig. 89. *Mounted Jockey* (study for *Hacking to the Track*), c. 1892, charcoal heightened with pastel on paper. Location unknown

Again, in the painting the jockey has been aged, fattened, and neutered.

Degas' remarkable achievement in *Hacking to the Track* is that he was able to combine such strong elements as his early studies from Benozzo, the photographs of Muybridge, and his own drawings of assertive jockeys, and to have modified and restrained these aggressive influences into such a classically simple painting. Certainly his growing love of landscape, here shown in its simplest form, a row of poplars in the right half of the painting dividing the foreground grass from the distant and very low hills in the background, unifies the whole by the autumnal light and the overcast sky. But it is in the subordination of the personalities of the faceless riders to the remarkable pacing of the horses and jockeys against the trees that the painting is supreme. Although not in the least assertive, the changes from horse to horse, the left somewhat assured, the furthest back recalcitrant, the next self-absorbed, led by one that moves sensibly forward, the next subdued and the one on the right confidently prepared, suggest the subtle changes in the Parthenon's frieze that Degas had copied almost forty years earlier (cat. 1; figs. 1, 2). And, in that pacing, restrained though it may be, there is an anticipation of the race to follow in the almost ritualistic informality of hacking.

The gravity of Degas' reflections at this time determined the ideal conveyed by *Hacking to the Track*. In some of his later works they gnawed at the idealism and began to express a growing pessimism. It is possible that this was facilitated by the immediacy of using pastel, a medium upon which he depended increasingly. The change that was occurring was not expressed by a change in subject matter – he still drew and painted horses and riders, for example – but in their conveyance of a sense of time and space. On the one hand, the time in *Hacking to the Track* is measured and comprehensible as part of a classical tradition. Its

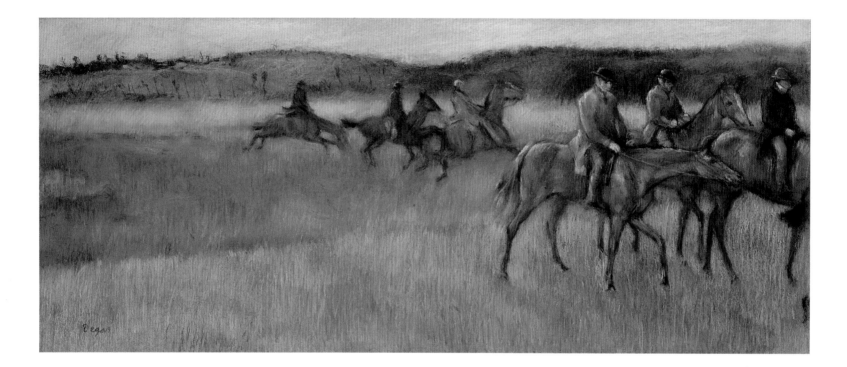

space equally rationally contains it. On the other hand there is a certain nostalgia, even a melancholy in the crepuscular, autumnal light. For many reasons the nineties was not only a period of transition but, in spite of its exuberant beginning, a period of serious contemplation.

That nostalgia and melancholy seem intensified in *The Trainers* (cat. 97), a pastel in a horizontal or frieze format. Degas, who had demonstrated his respect for trainers in his drawings in the mid seventies (cats. 58–60), shows here, with beautiful pacing, his respect for the identification of the trainers with their

horses as well as their sense of purpose. A trio in the background has been galloping and is now reining in the horses, whereas in the foreground another trio proceeds with its own quiet and natural dignity. All of this takes place along a river bank before low hills, a landscape enhancing the horizontal format Degas had chosen and the movement of the horses. In the early morning we sense the heavy dew Degas had mentioned in his sonnet and see the mist rising heavily and eerily from the river.

This is a convincing picture of such a landscape at that time of the day and,

cat. 97. *The Trainers*, c. 1892–1894, pastel on cardboard. The Wohl Family

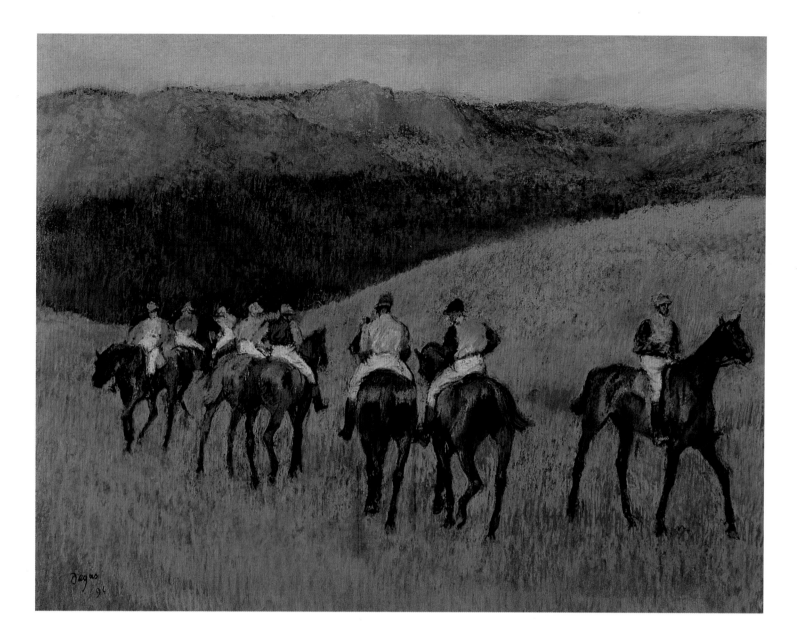

cat. 98. *Racehorses in a Landscape*, 1894, pastel on paper. Collection Carmen Thyssen-Bornemisza on loan to Fundación colección Thyssen-Bornemisza, Madrid

even if it is in expectation of the morning, a certain melancholy invades it, enhanced by the grouping of the horses. Almost in the middle of the pastel, three draw up as if in anticipation of the necessity of assuming the dignity of the group at the right, who, most sadly of all, are moving out of that space, their goal beyond it.

In 1894 Degas was sixty, which he seems to have commemorated by uncharacteristically dating three pastels 1894: *Dancers, Pink and Green*,[31] depicting the backs of two dancers as they prepare to go on stage; *Young Girl Braiding Her Hair*,[32] where a frail adolescent in a white

chemise stands by the edge of her narrow bed and looks into a mirror as she disciplines her – for Degas – rather subdued head of hair; and *Racehorses in a Landscape* (cat. 98). One of the curiosities of the three pastels as a group is that they are so different, one in the theater, one exceedingly domestic, and the third out-of-doors. It is as if Degas wanted to exhibit the range of his interests in the works he must have chosen to date. All of them share, however, in that brilliance of his use of pastel, building it up layer after layer, often with fixative or steam between the layers, applying most strokes

in a form of hatching, parallel with others, but breaking into freer forms when the subject warranted it. His colors in all three barely escape being saccharine but show an enjoyment of the hues that pastel made possible, particularly in the roses and greens. Almost all are artificial colors, the result of the use of aniline rather than natural dyes in the manufacture of the medium since 1856.[33] Consistent with his enthusiasm for the *Arabian Nights,* these evoke the old or faded colors of the art of the Near East, its rugs which he was collecting, its miniatures he had copied,[34] even its embroideries and other textiles. They also conjure up the artificial light of the theater more than that of a landscape or a modest bedroom. As each of the three dated pastels is the same size, it is natural to assume that they must have represented a manifesto on Degas' part. This may only have been the capacity of the theatrical to expose, but also interpret tenderly, the more private aspect of people's lives.

Such a manifesto was undoubtedly, in part, the consequence of the artist's turning sixty. This is clearer with *Racehorses in a Landscape,* since he had dated two earlier versions of its composition 1884 (cat. 80 and fig. 76), the year of his fiftieth birthday.[35] It is always a surprise to discover how much this later pastel resembles the two works painted a decade before, even in size, but most remarkably in the configuration of the jockeys against the hills and fields. Degas could have used the same tracing of horses and jockeys for all three works, merely adjusting the position of the isolated rider at the right. With their backs turned and the two visible faces (at the far left and the far right) featureless, the jockeys are anonymous; only the colors of their silks distinguish one from another. The horses are somewhat differentiated by color and action, but although animated they are not indi-

vidualized. It is curious that Degas should have chosen to repeat this group except that he may have found it significant that most of the riders, with the exception of one on either side, seem pulled as if by a magnet to the distant horizon. They are like the chorus in an opera or possibly a male *corps de ballet,* overwhelmed by the vastness, the exotic shimmering beauty, the very magic of the scenery to which they sing and against which they appear trivial and inconsequential.

And the horizon has changed in the pastel. Instead of the cool, chalky, and massively structured range of hills in the distance (cat. 80), the jockeys in the 1894 pastel are drawn across a rolling field of long and rough grass, magnificently suggested by brusque strokes of pastel, to a mysterious drop of blue to violet, which is almost like a cavernous cloud, deep but offering no support. Above its vaporous form and color rises the bluish pink of a mountain range tinged with shadows of blue. That glimpse of the mountain range, seductively beautiful but also threatening is reminiscent of the works and ideas of J. M. W. Turner (1775–1851). The jockeys in their jewellike silks are drawn dangerously toward the sublime.

It is rewarding in this pastel to look at the edges of things. Since the areas of the landscape or the jockeys' silks and caps are so strongly colored, it is a surprise to discover that the parts are not isolated by clear contours but are deliberately blurred. The edges, like the pink mountain range against the sky, are not only broken and penetrated by other strokes of pastel, they are applied sculpturally as well as discontinuously so that they always seem in a state of flux. This is even true of the jockeys' caps and silks. They are drawn quite differently, but the lime greens, the deep blues, and the soft oranges are executed so cursorily in thick pastel as the top layer that they also have

no edges, brilliant as they are. It is a landscape, which includes the jockeys and in which all the parts have been integrated organically with each movement of the pastel into a harmonious, timeless, pulsating whole.

Many aspects of this work suggest Degas' admiration for Gauguin and even Gauguin's admiration for him. The rose and the deep blue in the background are colors that were already appearing in Gauguin's work.[36] Undoubtedly Degas was also influenced by the basic serenity of Gauguin's paintings. In his turn Gauguin is believed to have been thinking of Degas, in particular his *Racehorses at Longchamp* (cat. 49), when he was to paint *Riders to the Beach* of 1902 in the Marquesas with sand even pinker than the mountains in Degas' *Racehorses in a Landscape.*[37] In terms of their respect for each other, it is appropriate that in 1903 Gauguin records that at his debut, perhaps in the sixth impressionist exhibition in 1881, to which Degas lent a painting by Gauguin he had already bought, Degas said to him, "You have your foot in the stirrup."[38]

The *Steeplechase* Remembered

Sometime before 1900 Degas returned to the theme of *Scene from the Steeplechase: The Fallen Jockey.* When he died he had in his studio two large vertical canvases of the same size: one, the *Steeplechase* he had exhibited at the Salon of 1866 but which he repainted in the early eighties, and was to paint again in the nineties, probably toward 1897 (cat. 16), and the other the *Fallen Jockey* (cat. 100), upon which he may have worked simultaneously in the final phase. Aside from their size and subject, the two canvases are not much alike. In the nineties Degas did enjoy making very different variations upon a subject, sometimes ranging from the

delicacy of color possible in pastel, with its open luminosity, to the strength and solidity of oil.[39] Both these works were painted in opaque oil on canvas but the range in color and the attitude toward the subject differ greatly.

It is appropriate to record here the few external clues that might provide evidence about the dating of both in the nineties. In 1893 Achille De Gas, who had probably posed for the early fallen jockey, died in Paris. Degas was sentimentally if realistically affected by his death, and he might have thought the first painting an appropriate memorial to that unhappy brother. In addition, that early version of the painting submitted to the Salon of 1866 seemed very important to Degas in his conversations in 1897 with the journalist Thiébault-Sisson, and this could have been because he was already at work on the two new versions or, on the other hand, was stimulated by the conversation to begin either one. It is true that Thiébault-Sisson reports Degas to have said, "now that my bad eyes prevent me from undertaking a canvas, now that I am allowed only pencil and pastel, now more than ever I feel the need to convey my impression of form through sculpture,"[40] but there are other canvases that were to be painted later in the nineties in spite of Degas' assertion, in particular his landscapes at Saint-Valéry-sur-Somme about 1896–1898.[41]

In the absence of any evidence about the order in which the two canvases were painted, it seems appropriate to begin with the *Scene from the Steeplechase: The Fallen Jockey,* which has the longest history. In his compositional drawing of the eighties (cat. 68), Degas had already made the dynamic and threatening additions to the 1866 painting of another riderless horse and at least two mounted riders in the background, and he had accelerated their movement. Underneath

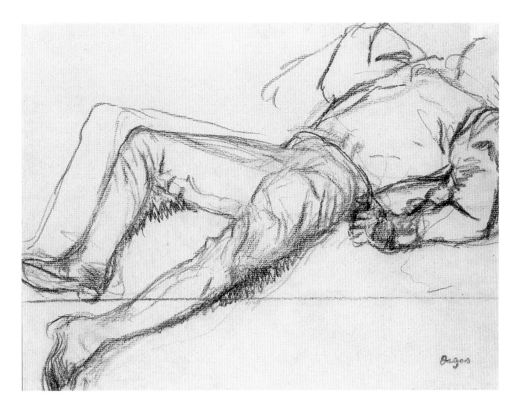

cat. 99. *The Fallen Jockey* (study for *Scene from the Steeplechase: The Fallen Jockey*), c. 1895, charcoal on paper. Private collection

the bellies of the horses he very sketchily outlined the angular form of the fallen jockey. He had, therefore, by then intended to place him in a more dangerous position under the legs of one riderless horse, as he is in the canvas as it is known today. A robust charcoal drawing for the reclining jockey (cat. 99), which has often been dated 1866,[42] is so close to the figure in the finished painting, even to the soles of his boots and the creases over his crotch, that Degas could have produced it in the 1890s. There is supporting evidence for the later date in the assured zigzagging of the lines by his knees, his right arm raised (as it is not in the painting) as if to protest the closeness of the horse, and the fading out of the drawing toward the head where his earlier painting of 1866 would be revealed. In the final work the speed with which the horses are supposed to be moving is expressed by the remarkable raised and wind-blown tail of the second riderless horse. The brown mass behind the horses to the right is difficult to decipher, but it could be the

poignant dying horses that Degas had drawn (cat. 24) when he was thinking of the work for the Salon of 1866. In the 1890s, the more energetic composition and the consequently heightened drama that the campaign of the early 1880s outlined in the compositional drawing and to some degree on the canvas itself, might have seemed impossible to sustain. Instead, Degas chose to paint the subject more nostalgically as if the very action and the danger were displaced by memory.

In many ways *Scene from the Steeplechase: The Fallen Jockey* appears to be a landscape. It is, of course, set outside, with rough grass in the foreground, muted green fields stretching toward an irregular row of poplars on the horizon, which cover the pentimenti of the higher horse that was shown in 1866. The sky has that rose to golden light he used in so many of his late paintings and that seems to make the orange cap and sleeves of the mounted rider even richer and more mellow. It also falls upon the horses, making their coats more lustrous. Other areas of color, not part of the landscape, seem intended to ornament it like an occasional flower. The green and rose of the first mounted jockey blend easily into the tonality of the painting, but the blue jacket and white cap of the jockey almost concealed behind the other rider is a charming surprise, if with the discretion of a growing object. In the same way the pink cap, lined with green, under the head of the fallen jockey is exquisite but as natural as a mushroom. Degas handles white as cleverly from the fallen jockey's slightly soiled jodhpurs through the brilliant slash of white across the girth of the nearest horse's saddle, teasing us in a touch on the front hoof of the first horse and the stars on the foreheads of both. It was undoubtedly in the nineties that he

made this gentle and poetic interpretation as a web of strokes of paint over what could have been a harrowing scene. One should not, however, forget that when what is now the underpainting was exhibited at the Salon of 1866, one anonymous critic praised it for "its clarity and delicacy of tone."[43] The same words could apply to the *Studio Interior with "The Steeplechase"* (cat. 67), presumably from the early eighties, where the pinks and greens are used with great tenderness. *The Steeplechase* may have been gentle, and even caressing, in color and tone at each of its principal stages of development.

The *Steeplechase* is very close to the landscapes Degas painted in oil at Saint-Valéry-sur-Somme, the northern coastal town to which he and his brother René traveled in the late nineties, perhaps because it reminded them of vacations spent there with their father some forty to fifty years earlier.[44] The painting's color and the light are like the landscapes he found there, as the trees resemble those he painted and in one case even photographed at Saint-Valéry.[45] And the coarseness and freedom of touch in applying the paint to the earth is very similar. In some later landscapes, for example, *View of Saint Valéry-sur-Somme*,[46] he used black lines as obviously and as boldly as he did around the horses in the *Scene from the Steeplechase*. Actually Tinterow has shown that Mary Cassatt was disturbed by those black lines and wrote of them in 1918, the year after Degas' death, to Louisine Havemeyer, informing her that Joseph Durand-Ruel had bought the painting at the first of the Degas auction sales: "Joseph bought for Fr 9,000 the splendid picture of the steeple chase. Degas you know wanted to retouch it and drew black lines over the horse's head and wanted to change the movement. I

cat. 100. *The Fallen Jockey*, c. 1896–1898, oil on canvas. Öffentliche Kunstsammlung Basel, Kunstmuseum

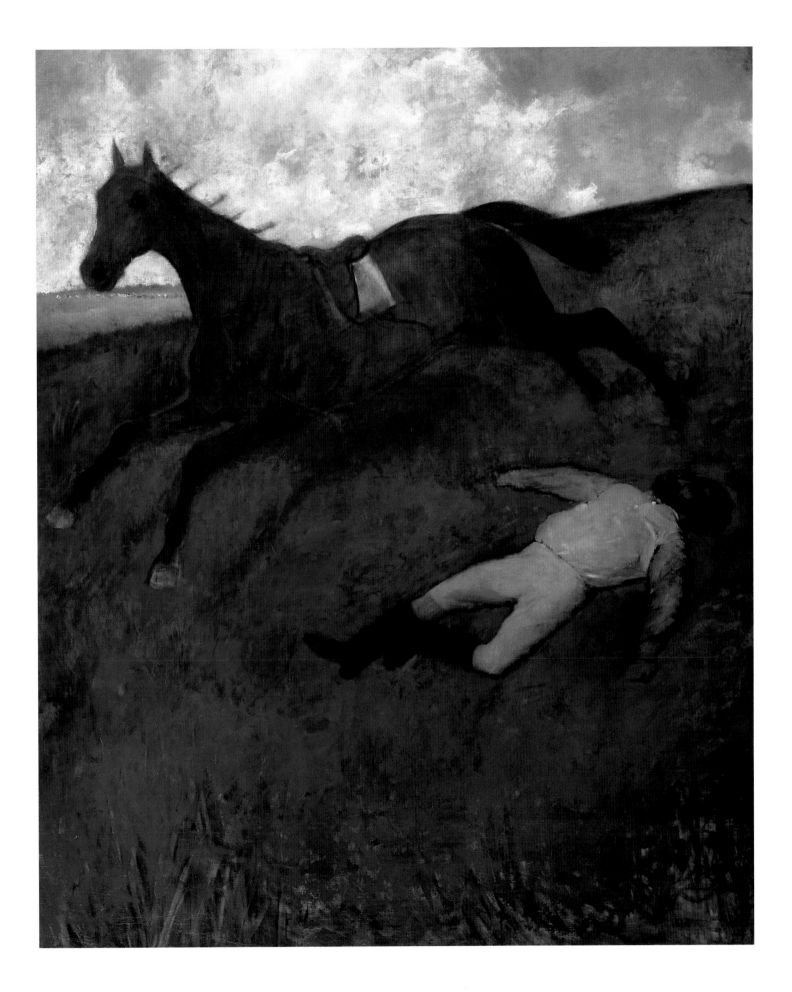

thought these could be effaced but it was not possible. Well now, Joseph has had the lines filled in no doubt he will sell it for $40,000. or more."[47] Today, since other conservators with more consideration for the original state of the painting have worked upon it, it is probably almost exactly as Degas left it on his easel.

In his study of the late work of the painter, Kendall points out that there is a division among historians of the late work of Degas about whether or not a work is finished or whether or not this is a relevant question.[48] The visibility of the black lines in the *Steeplechase* and the fact that most seem to provide emphases as one might find it in a drawing, for example, on the jodhpurs of the fallen jockey or around the nose of the mounted rider, or along the back of the upper horse, are presumably acceptable. They are acceptable in spite of the fact that the contours in Degas' late pastels, between the background and the edges of an object, human being or an animal, normally merge into each other and seem interwoven. And the black lines are still forgivable for interfering with the subtlety and flexibility of these transitions, because they reveal such an immediate sense of the artist emphasizing what is important and building up to a crescendo of meaning. The problem is largely with the contours around the nearest horse. The contours under its belly seem shaky and unsure, but not as distracting or as deceptive as those around and through the head of that horse. Although Mary Cassatt may have been right about Degas having defaced that head, and Degas himself may have agreed with her and never believed that he had finished the painting, the very harshness and daring of those black lines, which record what Degas was thinking and feeling, give a provocative dynamic energy to what is otherwise an exquisitely harmonious whole. Like incisions, their

cuts penetrate the nostalgia and accentuate the danger of the scene and the possibility of death.

Having sharpened the sensitivity of the spectator's nerve ends with the slashes of black paint, Degas could depend upon more subtle skills to convey the meaning of the *Steeplechase*, including leaving exposed the early painting of the head of the jockey, with all its sensitivity and the nuances it suggests of the balance between life and death. Although the principal mounted jockey seems to be in the same position as he was in the drawing Degas had made some thirty years earlier (cat. 17), and may be equally indifferent to the fate of the other rider, Degas softened his features considerably, giving him the mien of a Venetian aristocrat. Callous he may be, but he does not appear to be a smugly gratified competitor anticipating victory. Even more reticent and an even less likely protagonist is the other rider in blue and white. The horses, however, do express their enjoyment at liberation. The furthest removed uses its tail to convey pleasure, but it remains a rather endearing horse with a large, dark eye and white stars on the forehead and nostril, much like the head of a horse in a drawing, *The Bolting Horse* (cat. 19), for the 1866 campaign on the painting. Achieving freedom has been a greater struggle for the horse in front, whose four legs stretch outward and whose expression is somewhat craven. Both animals are so thinly painted that, with the exception of the head against the two mounted riders, they do not have a convincing or disturbing solidity. The drama seems to be on the diagonal between the surviving mounted rider and the prone, but probably not dead, jockey; the one assured and self-confident, the other humiliated on the ground. Everything has been risked, even life itself. One wins. One loses. The greatest sadness is

the ultimate futility of risking so much in the steeplechase itself.

Much less complicated than the *Steeplechase* is the other large canvas in Degas' studio in the late nineties, the *Fallen Jockey* (cat. 100), which has only one horse instead of four, one jockey instead of three, and a landscape without any trees. It seems probable that Degas turned to two very early drawings (cat. 18; fig. 36) he may have kept in his portfolios with other preparatory studies for all three versions of the *Steeplechase*.

Degas so often worked on a small scale that he must have enjoyed the expanse and the liberty of this painting. Unlike the *Steeplechase*, where the handling and tonality make the same sized canvas more intimate, Degas painted broadly in great areas of color, the largest, of course, the green sward of grass. He limited the hues and the intensities of those colors, basically to one green, one yellow, one black, and one pale blue, which give the painting the simplicity and the carrying power of the posters with which *fin-de-siècle* artists, like his admirer Henri Toulouse-Lautrec (1864–1901), had been papering Paris. The one color most obviously missing from his palette is red, which as a pink or rose is the greatest enhancement of the *Steeplechase*. In fact, in the *Fallen Jockey* the weather, as indicated by the stormy sky and the blue light, is cold, an adjective that could be applied to the mood of the painting. This mood is also established by Degas' very selectivity and calculation.

The fact that he had used thirty-year-old drawings for the primitive images of the galloping horse and the fallen jockey, and nevertheless transformed the timid drawings into large and unforgettable protagonists, shows that Degas was not denying his past but radically reinterpreting on a grand scale a theme that had been important to him as a young man. The

painting is expansive – the horse looming over the land, the jockey as limp (and probably as dead) as a rag doll extending his arms like gray wings, which could carry him to his destiny.

The *Fallen Jockey* is such a boldly conceived work that it inevitably invites questions about its surface as well as its date. There are those who believe that it is essentially an underpainting, which Degas had intended to build up with glazes of paint. But it seems so consistent that it is difficult to question its completeness. The *Fallen Jockey* is also startling because it would have seemed so new – in spirit almost diabolic, in language so stark and so daring. In its very simplicity this painting easily transmits a message in which the black horse, its back outlined against a stormy sky and casting a spider-like shadow on the grass, symbolizes the imminence of death, whereas the fallen jockey, with the diabolic profile, represents its reality.

When in 1963 the *Fallen Jockey* was bought by the Kunstmuseum Basel, where it has had affinities with its great collection of early twentieth-century art and also with Holbein's *Dead Christ*, Paul-Henry Boerlin ended a perceptive article on the painting, "In its lack of concern for spatial recession, in the massing of its colors into large overlapping planes, in making the forms more important than the story, Degas's *Wounded Jockey* forms a bridge to expressionist and abstract art."[49] In some ways Degas was already in the twentieth century.

The Shadows of the Track, 1896–1900

Degas continued to go back to a theme or even an earlier preparatory drawing as the basis for a new interpretation of horses and jockeys at the track. It was natural that he thought, as he had in

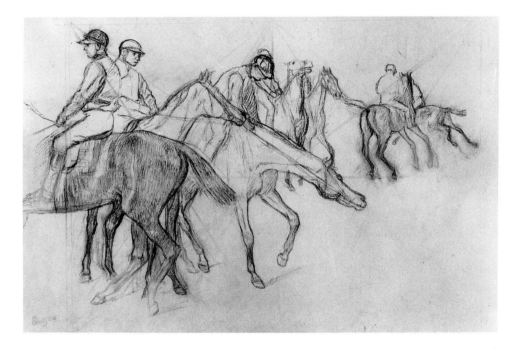

fig. 90. *Jockeys*, 1885–1890, graphite on paper. Private collection

painting *At the Races: Before the Start* (cat. 94), of the three panels from the eighties, *Before the Race* (cats. 70–72), in which he had lined up jockeys and their mounts on a diagonal, just before the race is about to begin. In each of these compositions there is a recalcitrant horse and in one case two, but they are always kept within the diagonal formation. In the nineties he must have found himself looking at what would appear to be a preparatory drawing made in the eighties (fig. 90) for an additional version, extending the group horizontally, partly by adding two other horses and riders. In a small painting five to ten years later, *Jockeys* (cat. 101), Degas essentially retained the drawing's composition. The greatest departures were in the positions

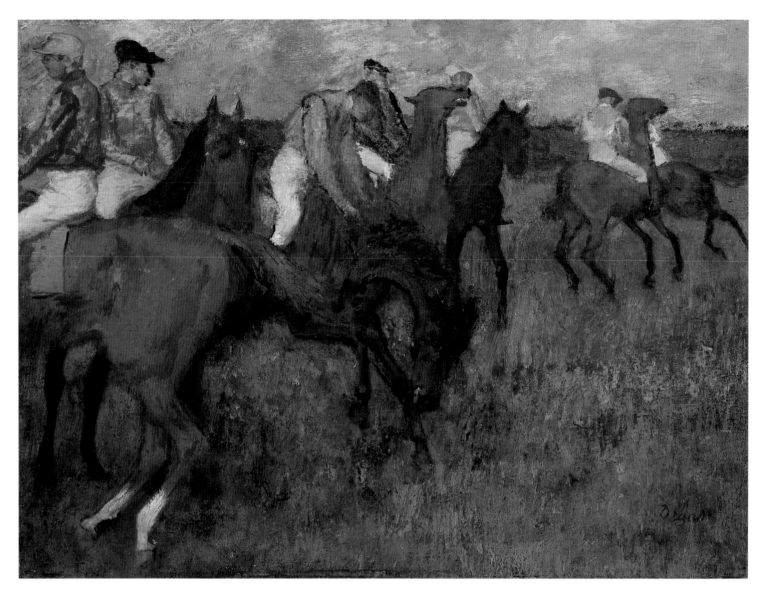

cat. 101. *Jockeys*, c. 1895, oil on canvas. Private collection, courtesy of Galerie Schmit, Paris

of the horses' heads, breaking down the logically beautiful coordination of the earlier drawing. The diagonal recession has become ragged. The composition seems haphazard and the dissidence of the three unruly horses natural in that chaotic environment.

The individual horses tend to be lost in the inchoate whole, although the up-lifted head of one with an opened mouth near the center, which does appear rather faintly in the drawing, seems to be like the balking horse Degas was to explore in drawings, sculpture, and other paintings in the late nineties. The drawing's three disruptive horses are not so different from the others; all are restless and most seem uncooperative. The jockeys are frailer than they are in the drawing and less clearly defined. Their character can best be perceived by the two at the left. In the painting, quite irrationally, they are on the same plane and their backs touch as if they were Siamese twins. All the jockeys appear vague and powerless, only feeble shades of the jockeys in the drawing or those in the trio of paintings of *Before the Race*. But this is not a painting about struggle for authority; instead it is a cyni-cal and pessimistic admission of the essen-tial chaos in the relationship of man to nature as represented by jockeys on their horses. It is painted with strokes that convey the restlessness which is as much

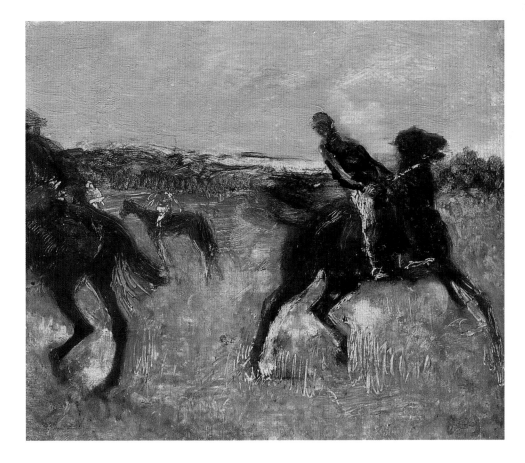

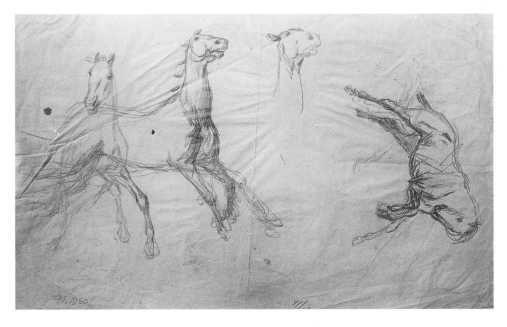

cat. 102. *Jockeys*, c. 1895, oil on panel. Private
collection, courtesy of Galerie Schmit, Paris

fig. 91. *Study of Horses*, c. 1895, graphite on paper.
Location unknown

emotional and philosophical as physical.
In the end the painting's meaning seems
best conveyed by the neck and upturned
head of the horse just to the right of the
center and set off against the light silks
of the jockey behind; it seems a cry for
help, whereas the earlier compositional
drawing is more nearly a detached record
of the general activity before the race
begins.

For this group of paintings and related
drawings about 1896,[50] Degas did choose
a more focused but romantic theme, the
horse resisting its rider. Degas seldom
worked on a very large scale, but these
new paintings, in spite of the potential
grandeur of their theme, are exceptionally
small. A second *Jockeys* (cat. 102), for
example, is only a little over five inches by
a little over six, so that one almost has to
take it in one's hands to enjoy it.[51] In the
Degas sales there was a drawing (fig. 91)
in pencil almost four times the size of this
panel painting with four drawings of
parts of horses. The horse at the far right
of the sheet, if it is turned vertically, and
the horse at the far left have their heads
bent reflectively; they do not appear in
the painting, although the drawings
might represent the other horse, shown
twice in the center of the page, in the
pause before deciding to struggle against
its rider. In the drawing the difficult horse
does not have a rider so that the reins do
not offer the same restraint. Its hind-
quarters, which disappear into the other
horse, are not visible, but, gawky as it is,
the horse bounds forward and upward,
its small eyes eager and its nose sniffing
its freedom.

In the painting, the horse gains a
jockey and more assertive reins. Degas
has also given him as companions a horse
and rider, who are bisected by the edge
of the panel at the left and a quiet and
very small horse and rider in the distance.
The struggling animal, in spite of the fact

that it is not spreading across more than three inches, its tail a blur and its ears mere circumflex accents breaking the silhouette, is heroic. It tries to rise on its powerful haunches, raises its forelegs delicately, arches out its neck, and opens its mouth as it struggles with its bit. Although the horse at the left in moving in the opposite direction remains unknown, it seems to be obeying the conventions. The small horse in the distance is quiet although the proportion and slant of its legs suggest its readiness to follow its nose, even sleekly into a race.

It is not surprising under any circumstances to discover that the jockeys are anonymous, but the very miniature scale on which Degas was working makes it almost a necessity. The largest rider, although inevitably simplified, his face a blur, does have a certain energy emphasized by the strokes of light paint on his sleeve and his jodhpurs and by the vibrant white rein with which he is trying to impose his control over the animal. His upper torso and, in particular, his face lose any substance, whereas the chest and legs are denser and more corporeal as they struggle with the horse. On the horse in the distance Degas suggests a jockey twisted as he surveys the small drama in the foreground, but he does it with such a few strokes of animated white paint that the jockey appears more of a spectral skeleton than a human being.

All of this takes place against a gray sky, which is cool and damp, and a landscape with a view of white which might be water, over land which is predominantly golden straw but with a patch of very green grass in the distance. The freedom with which Degas applies the paint, with his fingers as well as a brush, and incises through the oil to the surface of the wooden panel underneath, recalls his monotypes.[52] The difference is that against the landscape the balking horse

and the ultimately quiet supremacy of the rider symbolize that continuing conflict in nature between man's desire for domination and the animal's desire for liberation.

From his years in Rome, forty years earlier, Degas had been fascinated not only with the concept of the horse's search for freedom but with his own sympathy with the animal. His finest expression of the horse's desire to escape the civilizing by man is the work of sculpture, *Rearing Horse* (fig. 92). Among many drawings and paintings related to it is the pencil *Jockey on a Balking Horse* (fig. 93), which has a rather complacent rider and in which the steed has not risen so high nor pulled back its head as much as in the wax. Nevertheless, in the almost Gothic drawing of the horse, which seems to eschew flesh so that the body is like a carcass, an almost physical agony is indicated by the grotesquely opened mouth, the large black nostril, and the raised eyes. The animal suffers with the dignity of a medieval saint.

In the wax (cat. 117),[53] which must have been the consequence of such studies as these over the years, the animal is rid of the rider and any trappings so that its pain is not the result of any external force. In balking it remains in the same place, a reminder of the futility of the action. But it does struggle and suffer as it twists in different directions, the modeling of the surface indicating discomfort but also pride from its brushing tail to its confident ears. To Degas, who had always admired determination in his dancers, as well as horses and riders, it is a symbol of the courage of self-will. He was, as he was in the other works of sculpture that have survived except for a few bathers, freed from the need to indicate anything of the setting but a suggestion of his famous ground. It is through the body of the balking horse alone that Degas communicates with us.

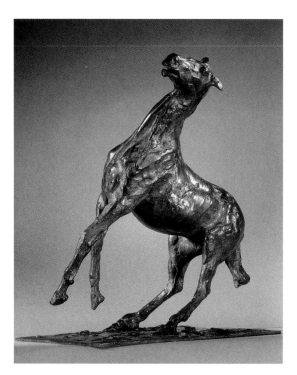

fig. 92. *Rearing Horse*, 1895–1900, bronze. The Metropolitan Museum of Art, Bequest of Mrs. H. O. Havemeyer, The Havemeyer Collection

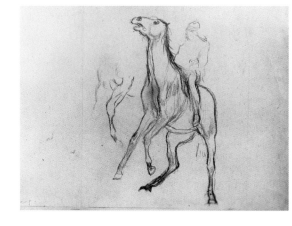

fig. 93. *Jockey on Balking Horse*, c. 1895, graphite on paper. Location unknown

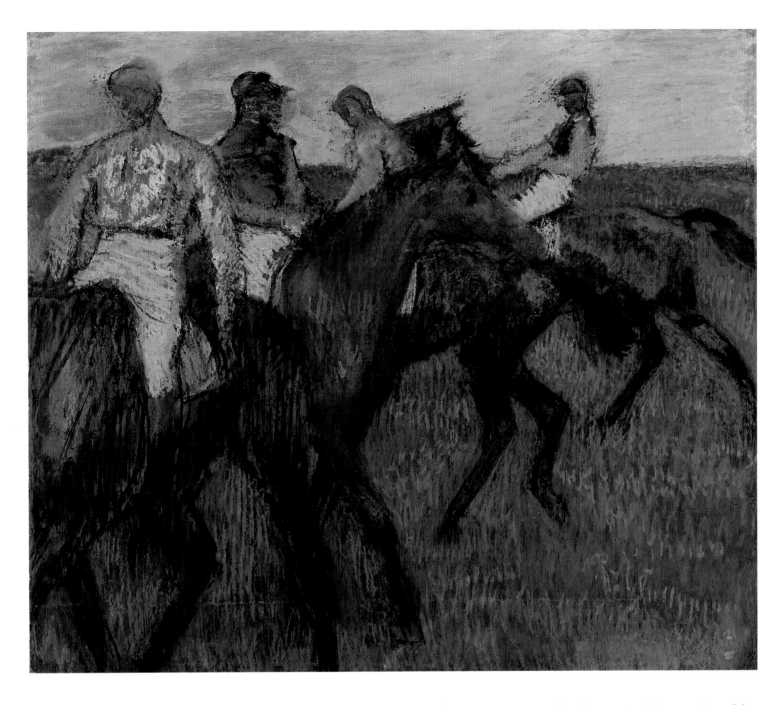

cat. 103. *Racehorses*, 1895–1900, pastel on paper, on cardboard. National Gallery of Canada, Ottawa

Racehorses (cat. 103), based on one of Degas' great successes of the eighties, *Before the Race* (fig. 78), from the Cleveland Museum of Art, shows that the artist must have wanted here as well to free himself from the demands or innuendos of a setting. This could not be accomplished with the freedom he was achieving in his sculpture, but it is of some significance nevertheless. Although he used a piece of tracing paper almost identical in size to the support for the earlier

pastel and maintained the grouping of the four horses and jockeys and the positions of the riders, if not of their mounts, he did make certain important changes. One was to eliminate the trees and the other elements of a springlike landscape that make Cleveland's pastel so exhilarating. He not only liberated the figures from such an accommodating background but he panned in upon them so that horses and riders are larger than in the earlier work; less sky appears above their heads,

and the lower edge cuts through two horses' legs. The spacing between the riders is not as clear; the bodies of the two jockeys at the left are so close that they seem to touch, rather as the riders do in *Jockeys* (cat. 101). Whereas in Cleveland's pastel the colors of the horses change, which helps clarify their relationships to each other in space, in the later work the slight distinctions in hue that do exist among the animals are obscured by very dark blue pastel or black charcoal hatching. Even the head of the horse, which in the center of Cleveland's pastel looks out endearingly, is being brushed away in the late pastel.

Degas had rid himself of the excess baggage of trees and a beautiful day, of the clarity of his description of the horses, or of the welcoming gesture to the spectator of the head of the horse in the center of the pastel. In this later work, the horses and jockeys merge into an untidy whole; the jockeys are cramped and the horses and pasture more expansive. The bodies of the jockeys are like puppets or stuffed dolls under the silk. The horses are heavier and less articulated. Neither men nor horses seem important except as the basis for animated and forceful abstraction.

One thing that Degas did achieve in this later pastel is comparable to a desire he expressed to Daniel Halévy – to make photographs by moonlight or artificial light.[54] Although it might be inferred from the subdued sky and the blue strokes through the grass that it is the beginning of the day or the end – dawn or dusk – the jockeys' jodhpurs are so white and their silks so jewellike in color that they could only be seen in artificial light. What features of the jockeys there were[55] have been deliberately and energetically effaced, smudged into anonymity, and replaced by dark shadows – an absence of light. Degas was courting the mystery and the obscurity of the dark.

Although the comparison of the pastel with *Before the Race* might seem belittling, *Racehorses* is, in fact, compellingly beautiful. Aside from the horses that remain intractably earthen, the strokes of pastel through the grass are like jade, the moody gray sky is like a moonstone, the white jodhpurs like mother-of-pearl, the jockey's silks like topaz, amethyst, ultramarine. Degas' remarkable orange is surely more a botanical than a lapidary color, but it is to be found, although rarely, among citrine, topaz, and garnet. He was probably indifferent to these analogies with gems, although not to the luminous resonance they possess, as if light comes from some source within the color. Just as the colors make the pastel more sumptuous, so does his handling of the medium itself. It has been built up layer after layer of drawing with pastel, each layer sprayed with a fixative. Finally in the upper layer, he mixed pastel with a liquid to paint the moody sky, helping obliterate the faces it touches to some degree, but also providing the jockeys with haloes, particularly obvious in the second jockey at the left where the halo even emphasizes his left shoulder. And then Degas used dry sticks of pastel to provide a certain swagger to the jodhpurs and, with particular daring and darting calligraphic mastery, in gold to the chest and arms of the jockey at the left. And he did not mute this top layer with a fixative.

What is happening in the work of Degas? *Racehorses* is such a visually sensual feast that it can hardly be regarded as a monastic denial of the world of the flesh. Even by the eighties most of the humor had gone from his work; Degas no longer reveals his acerbic and ironic wit. In the nineties, in addition, he was renouncing the pleasures of seeing and recording the world as he found it around him, with fresh eyes, in the light of the day, rather, if perhaps reluctantly, in the

impressionist spirit. He had given the images of that world an order that did not destroy their vitality. Now, although he still wanted his images to be based upon reality or upon his earlier records of that reality as signs or points of reference, he felt no obligation or desire to record that world illusionistically. He transformed such images into his own creations, which had more in common with the theater than with nature. It is a world of artifice that can move us greatly as it exposes, as it does here, the lack of order, the lack of clarity, the neutering of human beings until they can become eunuchs – like the jockeys in this pastel – and even the figurative nobbling of the horses. Degas was implying that we live in a world of shadows, for which the only solace he can provide is the work of art. This is where Degas stood as the century was drawing to a close.

The Horses and Jockeys Disappear

Degas probably never traveled by tram or train to a racetrack in the country or suburb after 1897, the year in which he took his unreasonable anti-Dreyfus stand, which was to separate him from some of his greatest friends, in particular Ludovic Halévy.[56] The races must have seemed peripheral as a subject, perhaps because in his new loneliness and isolation he felt somewhat as he had in the seventies, that they did not offer him either sufficient distraction or consolation. In the late nineties he had had the catharsis of having finished both large versions of his *Steeplechase* (cats. 16, 100), a response to one incident at the track on a heroic and even tragic scale. Whenever he made pastels of horses and jockeys now, he routinely based them upon his own earlier works without refreshing his eye by a visit to the track. For example, he used a pastel

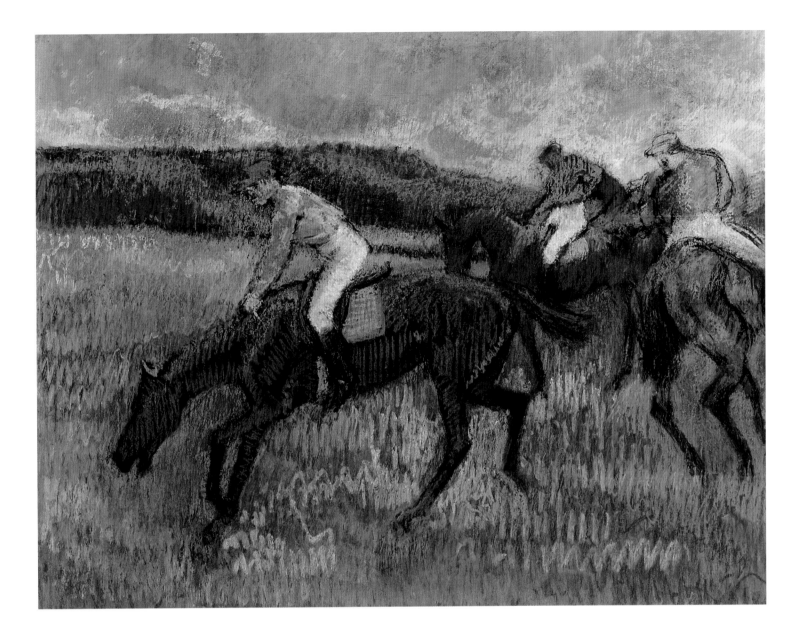

cat. 104. *Three Jockeys*, c. 1900, pastel on paper, on board. The Metropolitan Museum of Art. Partial and Promised Gift of Mr. and Mrs. Douglas Dillon, 1992

fig. 94. *Before the Start*, c. 1885, pastel on paper. Private collection

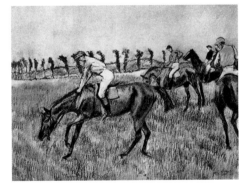

he had made in the eighties, *Before the Start* (fig. 94), in which a group of jockeys on horseback lazily wait in a spring-green field with a row of poplars in the distance, as the basis for his *Three Jockeys* (cat. 104). He nevertheless significantly replaced the sprightly poplars by moodier hills, the clear sky by storm clouds, the bright spring grass by dark, and the clarity of the drawing of the horses and riders by less distinct and even more passive bodies, all described with the most expressive but beautifully controlled pastel. Degas seemed to be continuing in his search for a shadowed world. The jockeys

are apathetic ghosts, but nevertheless a distillation of his riders of the past.

The horse and rider at the right in *Three Jockeys* can be found to the left of center in *Jockeys* (cat. 105); they form the same double spiral that appears so often in the work of Degas going back to *Racehorses at Longchamp* (cat. 49). The other horses have similar derivations and are brought together for a visual effect rather than for a description or interpretation of any interactions at a track. The stormy relationship of clouds to sky could have been derived from *Three Horses* but, in-

stead of using the subdued colors of an approaching storm, Degas applied penetratingly blue and white pastel as if he were painting with a great brush, unconcerned with the connection between sky and earth. His horses are similarly illogically active, their heads small and their forelegs frequently raised as if they were participating in a perfectly silly, if enchanting, primordial dance. They are further removed from the abstractions of perspective or anatomy that control the artist's perception and recreation of the visible world than *Three Horses*. As a re-

cat. 105. *Jockeys*, c. 1885–1900, pastel and graphite on paper. Private collection

sult, the sky is like a flimsy gauze curtain in the theater, the horses and riders are absurd if relatively joyous marionettes in a pretty but ghostly premonition of their particular paradise. This must have been an adventure for Degas' imagination at the end of the century.

It may have been his own loneliness and a natural premonition that would increase as his poor eyesight would turn into something close to blindness[57] that caused Degas to make drawings and counterproofs of individual horses and riders toward the end of his career. One such "Jockey," actually a trainer in a bowler hat, or *Horseman Looking to the Left*, as it has recently been renamed,[58] is

the bare counterproof of a charcoal drawing,[59] which was carefully squared for transfer, probably to be used in a painting or pastel like *The Trainers* (cat. 97) of the early 1890s. In it the horse is walking confidently forward while the trainer turns to watch other horses and riders or to talk. Later in the decade Degas made a series of other drawings and counterproofs of a single horse and rider (cats. 106, 107, 108),[60] the latter this time more probably a jockey as he was described in the catalogues of the sales of the Degas studio after his death in 1917. Although their positions are not unlike the earlier counterproof, the later horse is clearly moving forward with greater determina-

cat. 106. *Jockey*, c. 1900, charcoal heightened with pastel on paper; counterproof. Private collection, Italy *(left)*

cat. 107. *Jockey*, c. 1900, pastel, wash, and pastel on paper. National Gallery of Art, Washington, Gift of Mrs. Jane C. Carey as an addition to the Addie Burr Clark Memorial Collection, 1959.12.10 *(center)*

cat. 108. *Jockey*, c. 1900, charcoal on paper. Private collection c/o Paul Prouté S. A.

of riders in the seventies, such as the Barber's princely jockey in *Jockeys before the Start* (fig. 64) or the jockey like a courtier in a tiny monotype (cat. 65). These late drawings seem to be the only works in which Degas, never much of a horseman as far as we know, could autobiographically have conceived himself as the rider, in command, going forward with dispatch, and, even better, in harmony with his amiable horse. He has used the charcoal or occasional strokes of chalk or pastel vigorously as an expression of both his energy and his control. At the same time, those jabs of irritation or even something close to anger, which give the drawings and counterproofs such force, betray his frustrations. Powerful as these drawings are, they show that the artist's will is no longer triumphant. It is significant that in most of the impressions one of the hind legs is lost.

These riders were probably Degas' last reflections upon the racetrack, but he did think once more of the horse. He had continued to visit Ménil-Hubert after the death of Paul Valpinçon in 1894, largely because of his affection for his daughter Hortense Fourchy. It was probably there that he was inspired to introduce into his large and late pastel *Washerwomen and Horses* (cat. 109) two of the great draft horses, the Percherons, which are bred in Normandy. He had originally conceived the work when he reconsidered the oil painting *Laundresses Carrying Linen into Town*,[61] with charming young women for whom one of his prettier models could have posed, which he had exhibited in the fourth impressionist exhibition of 1879. In the early twentieth century he had made drawings of two considerably older and harsher women in a similar composition;[62] the left arm of the laundress on the left stretched out to balance herself, not to touch a horse. The horses may have been added to increase

cat. 109. *Washerwomen and Horses*, c. 1904, pastel on tracing paper. Musée Cantonal des Beaux-Arts, Lausanne. Bequest of Henri-Auguste Widmer, 1936

tion and speed, indicated by the stronger diagonal of its neck, the action through its mane, the crossing, sometimes uncertain, of its forelegs, and the tightness of the reins. The rider is considerably less casual than the trainer in *Horseman Looking to the Left*: he sits with his shoulders thrust back, and his legs and feet thrust outward with great assurance. Horse and rider seem to be a team with the same goal, to move forward without hesitation. They have something of the distinction

the activity, while at the same time framing the two women, to give them an environment of a stable with straw on the ground, or to threaten them somewhat by the size and the movement of the animals. The profile of the Percheron in the upper right can recall the glimpse of the profile of the head of one of two horses in Yale's small painting of the early eighties, *Jockeys* (cat. 66), although the later horse does not have the star and stripe on its nose, the tongue hanging out, or the deep black eye to make it so immediately compelling. The almost featureless Percheron, which is its own natural gray, has nevertheless been generalized to a point that it could be a substantial ghost of the large cart horses Degas had known in the past. The rump and tail of the browner horse in the background is more suggestive of the reality Degas was not entirely willing to forgo.

When Degas had begun to draw horses, they were the creations of other artists, like those of the sculptors of the Parthenon or of Uccello. At the end of his life he was equally removed from the animal itself but by his own imagination. He had always had difficulty perceiving a horse in its entirety as he had explained to Ambroise Vollard, as he "picked up a little wooden horse from his work table, and examined it thoughtfully, 'When I come back from the races, I use these as models. I could not get along without them. You can't turn live horses around to get the proper effects of light.'"[63] It was consequently natural that in his last years he should have retreated from the theme of the racetrack to the dancers and bathers who could be employed in his studio and directed toward the light as he wished. Degas also over the years had transformed his work from his interest in the thing seen to an art that has affinities with the symbolists, which his photography, which unfortunately was never directed to the horse, reveals,[64] and to a reliance upon formal abstractions, which made him a formidable influence on artists of the twentieth century like Picasso and Matisse. Redon had already written in his journal in 1889, "this proud man will be credited for having all his life held out for liberty,"[65] and this no less proud man continued with this originality until he could no longer work, many years before he was to die in 1917. It is sad that at his end as at his beginning as a child there is nothing to attach Degas to the horse and even less to the racecourse itself. Mrs. Havemeyer, who did visit his studio, tells us of what was uncovered when Degas was forced to move in 1912 from his apartment and studio on the rue Victor Massé to another on the nearby boulevard de Clichy, but it is quite clear she is reporting what she heard rather than what she saw. Under the dust that had been accumulated for several years his mother's wedding dress was found in the top of an old piano and "the moths had eaten their way into the very entrails of the horse which had served him as a model when he did his now famous 'Race Horses and Jockeys.'"[66] We do not know to which painting she was referring, but we can be skeptical that the stuffed animal was an actual horse, since Vollard records seeing one being hoisted into a studio near Degas' on the boulevard de Clichy and telling Degas this as something unusual when he was visiting the artist.[67] But whether it was real or a toy, it symbolizes the neglect of the races by the artist at the end. There is not a whisper of his interest in this subject in the twentieth century. He had already sent his horses and jockeys to their own painted paradise.

Notes

1. For a letter to his future landlord, M. Brébien, discussing the terms of the lease, see *Letters*, 130, 142–143, 13 April 1890.

2. As described by Valéry 1960, "37, rue Victor-Massé," 18–22; for the fullest details see Kendall 1996, 23–29.

3. *The Private Collection of Edgar Degas* [exh. cat., The Metropolitan Museum of Art] (New York, 1997).

4. Anne Dumas (52–57) and Françoise Cachin (221–233) in exh. cat. New York 1997, *La Belle Angèle* (Musée d'Orsay); *Martinique Landscape* (Thyssen Collection, Madrid); *The Moon and the Earth* (Museum of Modern Art, New York).

5. *Letters*, 134, 147, to Bartholomé from Cauterets, 16 August 1890; Letter 135, from Cauterets, 18 August 1890.

6. *Letters*, 137, 151, to Bartholomé from Cauterets, 28 August 1890.

7. The sonnets were edited by his grand-nephew Jean Nepveu-Degas, *Huit Sonnets* (Paris, 1946).

8. Valéry 1960, 62.

9. Valéry 1960, 63.

10. Lemoisne 1946–1949, I: 200.

11. This counterproof was published by Adhémar and Cachin 1973, no. 171, as monotype, lightly touched with charcoal, and, incorrectly, as in The Corcoran Gallery of Art, Washington. Gift of the Hon. Francis Biddle.

12. *Letters*, 164, 166, to Ludovic Halévy from Sens, 17 October 1890.

13. *Letters*, 152. These are now rather improbably housed in the architectural and administrative grandeur of the Institut de France, catalogued as Ms.4.483.

14. *Letters*, 170, 170, to Evariste de Valernes from Paris, 26 October 1890. This does not suggest any improvement in travel over Degas' trip by stage-coach from Lyons to Bourg in 1855, 65 kilometers at an average of 11 kilometers an hour: Reff Notebook 3, fol. 2.

15. *Letters*, 151, 159, to Ludovic Halévy from Tanlay (Yonne), 4 October 1890.

16. *Letters*, 143, 155, to Ludovic Halévy, Tuesday evening 30 September 1890.

17. *Letters*, 158, 163, to Ludovic Halévy from Montbard, 14 October 1890.

18. *Letters*, 160, 164, to Ludovic Halévy, undated.

19. *Letters*, 150, 159, to Ludovic Halévy from Flogny, 3 October 1890.

20. *Letters*, 150, 159, to Ludovic Halévy from Flogny, 3 October 1890.

21. L 667 (location unknown).

22. The counterproof was exhibited and repro-duced in the catalogue of Pickvance in exh. cat. New York 1968, no. 41, and sold at Christie's, New York, 14 February 1991, no. 7.

23. Janis in exh. cat. Cambridge, Mass., 1968, "The Landscapes, 1890–93," xxiv–xxvii.

24. See Boggs in exh. cat. Paris 1988–1989, 502–503 for an account of the exhibition; the date should be changed, however, from September to November 1892. Kendall (in exh. cat. New York 1993, 144–229) gives the fullest account of these works and of their immediate successors, largely with monotype as a base but often coated rather than heightened with pastel. They are relevant to Degas' equestrian works as they are to his late studies of the dance, if only in influencing the backgrounds he provides for both. On the other hand, with one possible exception, none of them contains a horse.

25. Listed by Kendall in exh. cat. New York 1993, under "Additions to the Catalogue of Colour Monotype Landscapes," no. 9, 276, as c. 1892.

26. L 633 (private collection). Reproduced in color in exh. cat. Paris 1988–1989, no. 283, 464.

27. Halévy 1964, 65–66.

28. Tinterow in exh. cat. Paris 1988–1989, 509.

29. Tinterow in exh. cat. Paris 1988–1989, 509, note 4.

30. Gauguin, *Journal* (1903), 65.

31. L 1149 (private collection, New York).

32. L 1146 (private collection).

33. See Anne F. Maheux, *Degas Pastels* (Ottawa, 1988), 41, quoting Gettens and Stout, *Painting Materials and a Short Encyclopaedia* (New York, 1966), 130.

34. Reff Notebook 14A, 11, 18; Notebook 18, 218, 235, 241, and *Letters*, 132, 145–146, to Bartholomé, 29 April 1892.

35. For a comparison of the 1884 and 1894 pastels, see Anne F. Maheux in Boggs and Maheux 1992, no. 47.

36. They can be found together in some of the conventional but exotic Tahitian landscapes, like *Street in Tahiti* (Toledo Museum of Art), or more daring subjects like *Fatata te miti* (National Gallery of Art), which were shown in Gauguin's exhibition at Durand-Ruel when he returned from Tahiti in 1893. They also appear in the *Day of the God* (Art Institute of Chicago), which was painted in 1894 and bought by Degas in December of that year.

37. Richard Brettell in *The Art of Paul Gauguin* [exh. cat., National Gallery of Art, Washington; The Art Institute of Chicago; Grand Palais, Paris] (Washington, 1988), 489.

38. Gauguin, *Journal* (1903), 63.

39. An example is the comparison of two *Dancers at the Barre* of about 1900 (L 808, National Gallery of Canada, Ottawa, pastel; L 807, The Phillips Collection, Washington, oil on canvas). Both are reproduced in color in exh. cat. Paris 1988–1989, nos. 374, 375, 588–589. There are more parallels to be found in exh. cat. London 1996.

40. Exh. cat. Paris 1984–1985, 179.

41. For these landscapes see Kendall, "Saint-Valéry-sur-Somme," in exh. cat. New York 1993, 248–272.

42. Boggs in exh. cat. Saint Louis 1967, no. 45, 79; Pickvance in exh. cat. New York 1968, no. 26, as c. 1866.

43. Anonymous, "Salon of 1866."

44. See exh. cat. Paris 1988–1989, under 11 November 1857, 50, for reference to an unpublished letter in which the painter's sister Thérèse writes that she has returned from Saint-Valéry-sur-Somme. For letters written by Degas from 1897 to 1909 to a painter friend of his who had a house at Saint-Valéry-sur-Somme, Louis Braquaval (1854–1919), see *Degas inédit* 1989, 388–400.

45. The photograph is in the Harvard Art Museums. See Terrasse 1983, no. 61, 96, and Kendall in exh. cat. New York 1993, no. 212, 241.

46. See BR 150, *View of Saint-Valéry-sur-Somme* (Metropolitan Museum of Art, New York, 1975.1.167). For a detail in which the lines are particularly visible, see Kendall in exh. cat. New York 1993, fig. 217, 248.

47. For the otherwise unpublished letter on deposit at the Metropolitan Museum of Art, see Tinterow in exh. cat. Paris 1988–1989, 561.

48. Kendall 1996, 113–115.

49. Boerlin 1963, 51.

50. Aside from the two paintings reproduced here, cats. 101 and 102, L 896 (Kunstmuseum Bern), and L 1006 (location unknown).

51. Richard Kendall in exh. cat. London 1989, no. 10, suggests that it may have been "a phase of interest in decorative panels for furniture," but this seems too small to decorate anything except a box.

52. Kendall discussed this in exh. cat. London 1989, no. 10.

53. The dating assumed here is later than the date given by Barbour and Sturman (cat. 117).

54. Halévy 1964, 69.

55. Maheux 1988, 67–72, describes the techniques used in this pastel and illustrates figs. 30a and 32a, 59–60, revealing details of the heads of the jockeys in Ottawa's and Cleveland's pastels, and records of the jockeys' faces, "Their faces are abstracted: their distinguishing features obliterated by complex layers of pastel," and in note 74, 83, that "Examination of this Ottawa *Jockeys* with infrared reflectography has revealed underdrawing in their faces, the features of which are not unlike the Cleveland jockeys."

56. For an account by a member of the Halévy family see Daniel Halévy, *Regards sur l'affaire Dreyfus*, ed. Jean-Pierre Halévy (Paris, 1994), 262–264.

57. For Degas' eyesight see Richard Kendall, "Degas and the Contingency of Vision," *Burlington Magazine* 130, no. 1020 (March 1988), 180–197.

58. Pickvance in exh. cat. New York 1968, no. 59.

59. Vente IV:259a (location unknown).

60. Among others, Vente III:45.3 and 106.3 (locations unknown); Vente IV:384.b (Fitzwilliam Museum, Cambridge).

61. L 410 (private collection).

62. L 1420, L 1420 bis (locations unknown).

63. Ambroise Vollard, *Degas: An Intimate Portrait*, trans. Randolph T. Weaver (New York, 1986), 56.

64. For Degas as a photographer, see Donald Crimp, "Positive/Negative: A Note on Degas' Photographs," *October* 5 (summer 1978), 89–100; Eugenia Janis, "Edgar Degas's Photographic Theater," in exh. cat. Paris 1984–1985, 451–486; Jean Sutherland Boggs in exh. cat. Paris 1988–1989, 535–542; Françoise Heilbrun, "Sur les photographes de Degas," in *Degas inédit* 1989, 159–180.

65. Odilon Redon, *To Myself: Notes on Life, Art, and Artists* (New York, 1986), 79–80.

66. Louisine Havemeyer, *Sixteen to Sixty: Memoirs of a Collector* (New York, 1964), 247.

67. Vollard 1986, 56.

SECTION II

The Horse in Wax and Bronze

Daphne S. Barbour and Shelley G. Sturman

The Wax Horses

It is unclear when Degas first began to make sculpture. Only one, *Little Dancer Fourteen Years Old*, was ever exhibited in his lifetime, in the sixth impressionist exhibition of 1881, and only those who were privileged to visit his studio knew of his devotion to the plastic arts. Yet in 1919 his dealer, Joseph Durand-Ruel, wrote that Degas " . . . spent a good deal of time not only in the later years of his life, but for the past fifty years, in modeling in clay. Thus, as far as I can remember – that is to say, perhaps forty years – whenever I called on Degas I was almost as sure to find him modeling in clay as painting."[1] Even after Degas' death in 1917, when the contents of his studio were made public, the works of sculpture were often dismissed as models fashioned by an old man too blind to paint, and only recently has interest in Degas as a sculptor truly ignited.[2]

The extent of Degas' productivity as a sculptor is also unknown. Much of it crumbled in his studio or was destroyed by his own hand. Unlike Auguste Rodin (1840 – 1917), his contemporary, Degas never cast his sculpture in bronze, claiming that it was a "tremendous responsibility to leave anything behind in bronze – this medium is for eternity."[3] Instead, he chose wax as his medium. Wax can be easily modeled or remodeled and retain its pliability, yet at the same time it provides a surface that can be carved and finished with the finest precision. Although Degas' original works of sculpture are usually referred to as "waxes," the term is misleading. Not a single sculpture has been found to be made exclusively of wax, and none was intended to be sacrificed and melted during lost-wax casting.[4]

Degas' quixotic technique, in which he used such material as cork, wood, paper, and paint brushes on the interior, and cloth, paper, or color on the exterior, places him among the sculptors of the nineteenth-century avant-garde. In his horses, however, Degas appears to have been more interested in exploiting the flexibility of the medium than experimenting with color or mixed media.

Many lacunae surround the history of Degas as a sculptor and as a result no definitive chronology of his sculpture has ever been realized. Despite the obvious difficulties of dating Degas' three-dimensional work, this essay aims to chronicle a stylistic evolution of the horses with a more precise range of dates than has been attempted previously. Of Degas' fifteen original wax statuettes of horses and two of jockeys, sixteen are shown in the exhibition and the seventeenth is represented by its modèle in bronze. All were radiographed for this exhibition, providing a unique glimpse into their fabrication and technical development. Using the sculpture itself as a primary resource, focusing on the role

cat. 123 (detail)

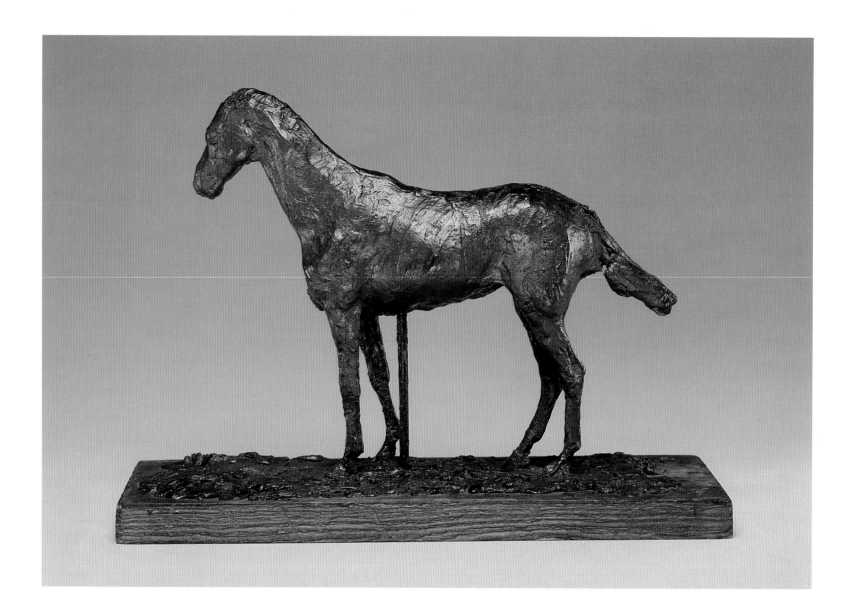

of interior metal armatures in the forma-
tion of the sculpture, the combinations
of materials employed, and the degree of
surface finish, we have been able to pro-
pose a chronology based on Degas' own
working methods. In many cases, Degas'
personal notebooks as well as literature
about the artist support this chronology.

Degas' interest in three dimensions
can be traced to his Italian years, from
July 1856 to March/April 1859. Note-
books from this period are filled with
drawings of classical sculpture. His earli-
est extant sculpture, *Study of a Mustang*
(cat. 110), dates to 1859 – 1860, shortly
after his return to France. The *Mustang*'s
stylized "Roman" nose[5] is perhaps Degas'

cat. 110. *Study of a Mustang*, 1859 – 1860, wax and
clay. Virginia Museum of Fine Arts, Collection of
Mr. and Mrs. Paul Mellon

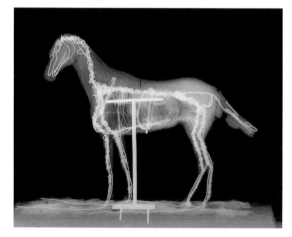

fig. 1. X-radiograph of cat. 110

attempt to render an exotic physiognomy in keeping with the Babylonian setting of *Sémiramis Building a City* (Boggs, fig. 21). The pose of the *Mustang*, clearly derived from classical antiquity, recalls that of the standing horse in the painting, which, according to Degas' contemporary, the painter James Tissot (1836 – 1902), was not yet completed in 1862.[6] Indeed, a drawing of the same horse, *Study of a Horse and a Group of Attendants* (cat. 7), is generally dated 1860 – 1862, a range consistent with the date of *Study of a Mustang*. Charles Millard has further linked the pose with a sketch Degas made as a student of a classical relief.[7] However, the horse's tail on the sculpture appears strikingly different in the drawing and painting, where the root is set noticeably high on the croup. On the sculpture, the tail is perpendicular to the haunches. This distinction might be explained by the sculpture's X-radiograph (fig. 1), which shows a repair to the tail. Originally it may have resembled that of the horse in the student drawing, as a section of braided wire hangs along the contour of the haunches, and Degas himself may have reworked its position. The wire armature also suggests that Degas may have intended the tail to be longer than it is today, perhaps mimicking that of the tail in his *Study of a Horse and a Group of Attendants*. Ultimately, Degas folded the internal wire armature over itself for the tail's current length.

The radiograph of *Study of a Mustang* provides an introduction to Degas' approach to sculpture. As was typical of works in clay or wax, the piece was roughly modeled over an inner wire structure. What distinguished Degas' sculptural works from that of many of his contemporaries is that he not only combined clay and wax, but he often bulked the interiors with household materials in order to save money: "I must be an idiot to have put corks in this figure. Imbecile that I am, with my mania for wanting to make economies of two coppers."[8] In *Study of a Mustang*, wine-bottle corks – lightweight, inert, and readily available – held in place with modeling clay, fill the rib cage and stomach. Both the green clay and a cork are visible on the exterior of the statuette under the rib cage.

The fabrication of *Study of a Mustang*, as observed in the X-radiograph, is typical of early Degas sculpture. Characterized by tightly wrapped and intricately twisted wires, a labor-intensive contour of the entire horse is suggested, complete with an arched neck and facial silhouette. A second sculpture from this period, *Horse at a Trough* (cat. 111), is dated by John Rewald to 1866 – 1868 based on the conviction that it served as a model for the horse in *Mlle Fiocre in the Ballet "La Source"* (cat. 8), exhibited in the 1868 Salon.[9] It is more likely, however, that the sculpture dates from the early 1860s and merely reflects Degas' interest in the pose of a grazing horse, as do numerous sketches and drawings (fig. 2) at this time.[10]

Rewald's observation is important, nonetheless, as *Horse at a Trough* does bear a striking resemblance to the animal in *Mlle Fiocre in the Ballet "La Source,"* and it is quite possible that the statuette served as the inspiration for the horse in the painting. It undoubtedly predates the painting, but it would be unfair to dismiss the wax horse as a mere model.[11] Such a highly articulated surface, with the finely incised mane, indicates that the sculpture is extremely finished. The radiograph (fig. 3) reveals the intricate network of carefully wrapped and coiled wires of the armature to be similar to the construction of *Study of a Mustang*, which also argues for an early date.

Degas was not alone in his choice of medium, although no one else incor-

fig. 2. *Grazing Horse*, 1860–1862, pencil on paper. Bibliothèque Nationale, Paris

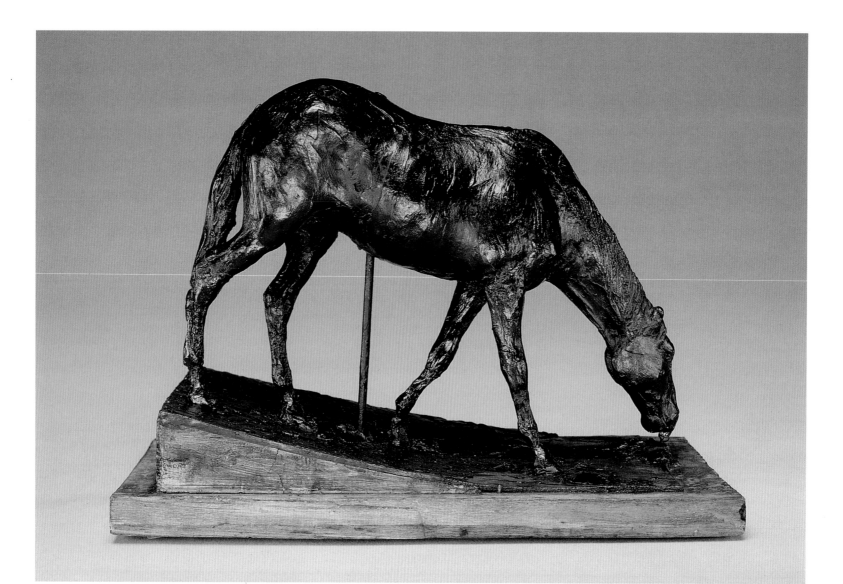

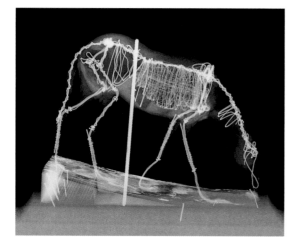

porated the variety of materials found on both the interior and exterior of his works. Several of his contemporaries modeled and exhibited statuettes of wax horses, notably Joseph Cuvelier (d. 1870), about whom little is documented. Cuvelier is described as "l'ami de Degas,"[12] and is mentioned three times in Degas' notebooks.[13] He exhibited two equestrian portraits in wax at the Salon of 1869.[14] Furthermore, Degas and Cuvelier were both grappling with the subject of the fallen jockey in the mid to late 1860s, and while no sculpture of the theme by Degas is extant, a number of his paintings and drawings of the subject survive (e.g., cats. 16, 67, 100; 18, 20 – 23, 68). Many of

cat. 111. *Horse at Trough,* early 1860s, wax. Virginia Museum of Fine Arts, Collection of Mr. and Mrs. Paul Mellon

fig. 3. X-radiograph of cat. 111

these horses are depicted in a stylized flying gallop popularized by English sporting prints. In both sporting prints and works of the fallen jockey, the splayed posture was appropriate as the horse was clearing an obstacle and not galloping. Degas later acknowledged that he did not fully comprehend equine movement, as evidenced in some of his early works.

> . . . even though I had the opportunity to mount a horse quite often, even though I could distinguish a thoroughbred from a half-bred without too much difficulty, even though I had a fairly good understanding of the animal's anatomy and myology, having studied one of those plaster models found in all the casters' shops, I was completely ignorant of the mechanism of its movements. . . .[15]

A small bronze toy racehorse found in Degas' studio (fig. 4) bears an uncanny resemblance to the horse in Cuvelier's *Jockey Falling off His Horse* (fig. 5).[16] Clearly the two artists were familiar with the same stylized horses and may have worked in collaboration. Cuvelier's *Standing Horse* is similar in pose to Degas' *Standing Horse* (fig. 6).[17] Theodore Reff has postulated that Degas' *Standing Horse* is, in fact, a tribute to Cuvelier, who was killed 21 October 1870 during the Franco-Prussian War. Reff notes that Degas intentionally borrows from the "finely worked equestrian sculptures, also typically seen in a classical profile view, in which Cuvelier specialized."[18] Such borrowings, however, undoubtedly occurred before Cuvelier's death. Stylistic evidence alone does not prove that Degas' *Standing Horse* postdates 1870.

The influence of Gustave Moreau (1826 – 1898), Degas' friend and mentor,

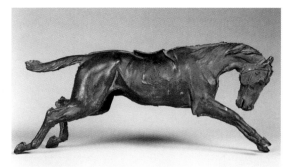

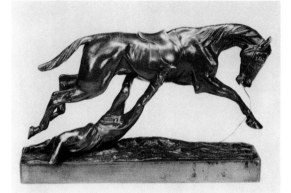

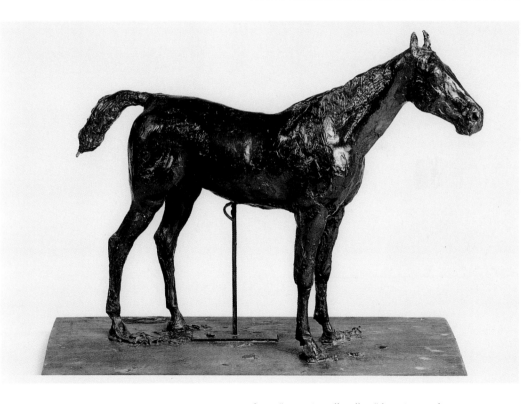

fig. 4. "Horse in Full Gallop," late nineteenth century, bronze toy. Musée d'Orsay, Paris, Gift fonds Degas-Fevre

fig. 5. Joseph Cuvelier, *Jockey Falling off His Horse*, 1860s, bronze. Location unknown

fig. 6. *Standing Horse*, late 1860s–early 1870s, wax. Musée d'Orsay, Paris

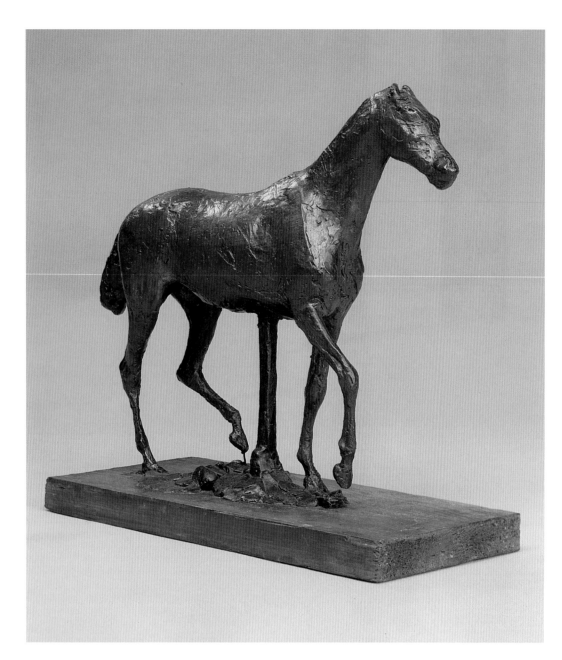

cat. 112. *Horse Walking*, early 1870s, wax. Collection of Mr. and Mrs. Paul Mellon, Upperville, Virginia

fig. 7. Gustave Moreau, *Standing Horse*, nineteenth century, wax. Musée Gustave Moreau, Paris

is also apparent in *Standing Horse*. Moreau created his own horse in wax (fig. 7) that assumes the pose of Degas', but which appears more as a hybrid of *Standing Horse* and *Horse Walking* (cat. 112). Moreau modeled a textured but loosely rendered exterior in a manner foretelling the direction in which Degas' sculpture would evolve. Indeed, *Horse Walking* has subtly displayed this quality but nonetheless exhibits an earlier, more formal approach, shared with *Thoroughbred Horse Walking* (cat. 113) and *Horse Walking* (cat. 114). The affinity between these three walking horses and works of other *animalier* sculptors such as Emmanuel Frémiet (1824 – 1910) is also significant. Degas' sculpture of horses have even been included among the so-called French impressionist school of *animalier* sculptors.[19] Frémiet's bronze *Pair of Horses and Jockeys* shares similar postures with the walking horses by Degas, but is entirely different conceptually. Frémiet's horses are wed to a more formal, realistic tradition, so that the tiniest details – a braided mane, bulging veins, or a woven saddle blanket – are laboriously reproduced. What Degas' walking horses do share with those of Frémiet is mobility. No longer are the four feet firmly planted on the ground. Such a subtle introduction of motion into Degas' works may well have been sparked by Frémiet's lively compositions of orangutans and African natives, which, as Millard noted, "were among the most advanced explorations of an open sculpture to be made."[20]

The concept of liberating sculpture from immobility, and ultimately freeing it from the confines of gravity, is also reflected in Degas' works of horses in other media. Michèle Beaulieu has identified *Horse Walking* (cat. 114) in the pastel *Racehorses*, dated 1885 by Paul-André Lemoisne.[21] The sculpture, however, is more likely a work of the early

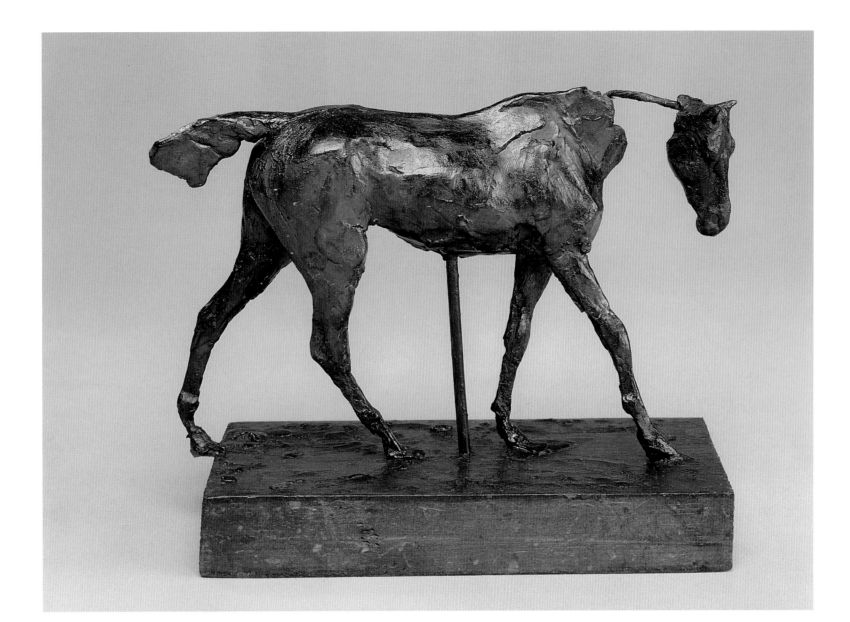

cat. 113. *Thoroughbred Horse Walking*, early 1870s, wax. Collection of Mr. and Mrs. Paul Mellon, Upperville, Virginia

fig. 8. Bronze cast of cat. 113. Norton Simon Art Foundation, Pasadena, California

1870s. In fact, *Horse Walking*, as well as its slight variants, appears in many paintings and pastels. The same is true of *Thoroughbred Horse Walking* (cat. 113) and the other *Horse Walking* (cat. 112). Two examples, the drawing *Horse with a Saddle* (cat. 14) and the pastel *The Racecourse* (cat. 78) are directly related to the sculpture. This is not to say that the sculpture served merely as models for the paintings or pastels, but that Degas was struggling with the same issues of depicting movement in different media. This comparison is lost when examining the bronze versions of *Thoroughbred Horse*

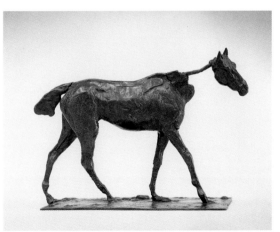

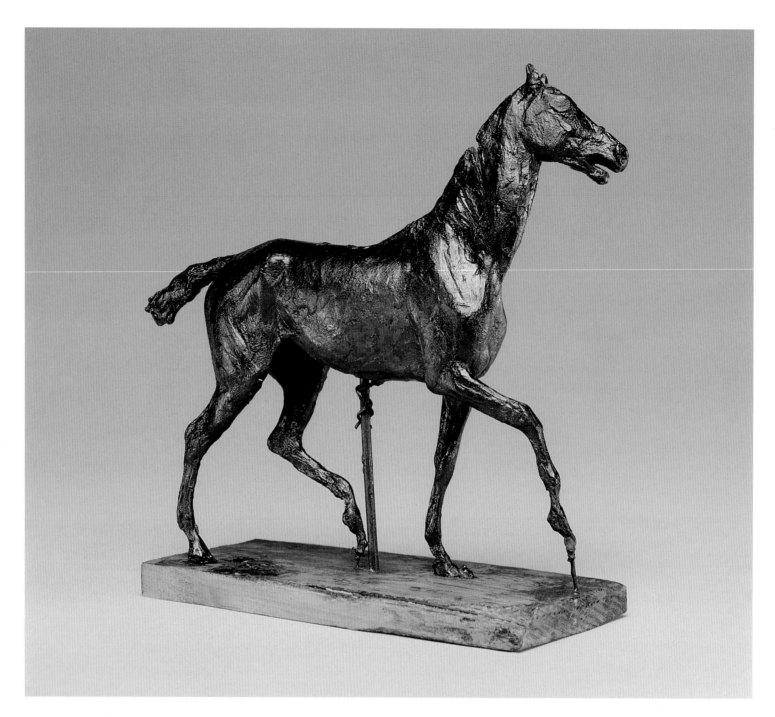

cat. 114. *Horse Walking*, early 1870s, wax. Virginia
Museum of Fine Arts, Collection of Mr. and Mrs.
Paul Mellon

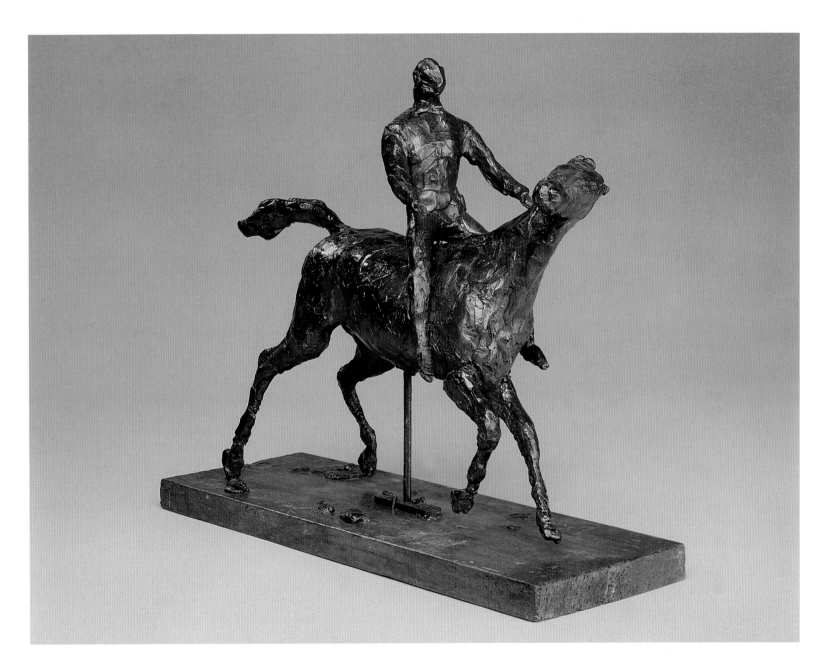

cat. 115. *Horse with Jockey; Horse Galloping, Turning the Head to the Right, the Feet Not Touching the Ground*, mid 1870s, wax and clay. Collection of Mr. and Mrs. Paul Mellon, Upperville, Virginia

fig. 9. X-radiograph of cat. 115

Walking. Unfortunately, the exposed wire armature was awkwardly modified in the bronzes to raise the head of the horse. In the process, the thoroughbred's beautifully arched neck was sacrificed and its obvious relation with works in other media was eliminated (fig. 8).

By the middle of the 1870s, after completing his walking horse series, Degas succeeded in boldly capturing action in *Horse with Jockey; Horse Galloping, Turning the Head to the Right, the Feet Not Touching the Ground* (cat. 115), his first sculpture to include a jockey. Examina-

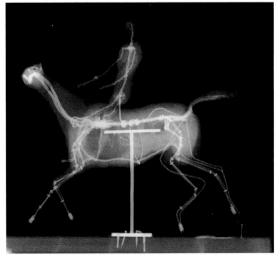

tion of the radiograph of this active sculpture reveals an armature more experimental than the earlier well-defined interiors of the standing or gently moving horses (fig. 9). Degas abandoned his standard flexible and rigid wrapped wire leg supports for an armature system observed for the first time in this wax. In fact, its internal construction bears a remarkable similarity to that of Moreau's *Hercules* of the same period.[22] Degas and Moreau may have shared ideas and materials while sculpting these particular figures, as the same unusual hardware is found on the interior of both works. The constructions incorporate identical, tightly coiled wires reminiscent of tiny bed springs, wrapped around multistrand wire, and both employ the same system of fixed wire sections, tightly looped at either end around the flexible wire network, producing a movable joint between rigid sections. An expandable armature with fixed points between the hard wires to allow adjustment permitted the artist to change a pose during any stage of production. The fact that the Moreau armature is unique among those observed in more than one hundred radiographs of wax sculpture published by the national museums of France, suggests that Moreau and Degas collaborated in searching for new ways to make wax sculpture. *Horse with Jockey* (cat. 115) is one of only two Degas waxes studied thus far with such an inner framework.[23] Perhaps the tentative use of inner springs by the two artists did not prove productive, since Degas did not incorporate them in any other horses. The unfinished state of *Horse with Jockey*, together with its unusual armature, confirms that the statuette was an experimental work; numerous patches of interior green modeling clay, tooled to receive a top coat of red-brown wax, are visible on the head, belly, and legs of the horse. Unique in the materials of its fabrication,

the cumbersome armature with coils and articulated joints places *Horse with Jockey* as a transitional piece of the 1870s. The sculpture fits precisely between the traditional and academic constructions of Degas' early works of the 1860s and those more fluidly shaped interiors of the lively horses of the 1880s and 1890s.

The similarity of armatures in the Degas and Moreau sculpture may be another key for dating *Horse with Jockey* to the mid 1870s, when Moreau was actively making sculpture. Moreau's wax *Hercules* has been dated to the period between 1870 and 1876 based on the exhibition of his painting *Hercules et l'hydre de Lerne* in the Salon of 1876.[24] Since Degas' *Horse with Jockey* appears in a number of his paintings, the sculpture must have served as a reference for the artist over the course of several decades. In the background of *Racehorses in a Landscape* of 1894 (cat. 98), a mounted, angular jockey reins in a horse whose head is turned to the right and whose front and back legs are outstretched, mimicking the sculpture. The rear legs of the racing horse are deliberately cropped at the left edge of the picture. In *Jockeys Before the Races* of 1879,[25] the same *Horse with Jockey* appears, only this time the horse's head and front legs are eliminated from the image, and its extended hind legs are depicted in the exact position as in the sculpture, including the unnatural upturned hooves. Although the wax horse's right rear foot now rests on the wooden base, in a photograph taken in 1918[26] the horse is pictured with its feet off the ground, a concept of animal motion that would become hotly debated later in the century.

Studies of animal motion, especially that of horses' gaits, became a great fascination as early as the 1860s, through the work of Étienne-Jules Marey (1830–1904), a French physiologist.[27] Intrigued by Marey's experiments, Leland Stanford,

governor of California from 1862 to 1863, financed the photographer Eadweard Muybridge (1830–1904) to analyze a horse's movement. In 1872 Muybridge succeeded in capturing, on film, a horse in mid-stride. By 1878 his extensive collection of stop-action or instantaneous photographs created considerable excitement among artists in America and Europe, prompting a revolution in the representation of a galloping horse. Debunking the prevailing artistic convention of a splayed-leg gallop, Muybridge's photographs proved that a horse tucks its legs up under its belly at the point when the legs leave the ground during the gallop. Images of the galloping horse in this spiderlike, mid-air position jolted the art world. As previously noted, even the astute draftsman Degas had depicted running horses using the same stylized flying gallop found in English sporting prints, with which he was keenly familiar.[28] Drawings and paintings from the late 1850s through the 1870s depict horses "galloping" inaccurately. But after the 1880s, Degas' renderings of horses in motion emulate the positions of the Muybridge photographs.[29] Though news of Muybridge's results spread through Europe almost immediately, among the first actual images reproduced in France were illustrations in the 14 December 1878 issue of *La Nature*.[30] A notation by Degas at the bottom of a page in his notebook of 1878–1879 reads, "Journal: La Nature/ Victor Masson (année 1878),"[31] undoubtedly to remind himself about the critical article.

Possibly even more influential to Degas was the presence of Muybridge and Stanford on lecture tours in Europe in 1881 and 1882. On 29 November 1881, Jean Louis Ernest Meissonier (1815–1891) invited Muybridge to his studio to meet a number of prominent Parisian painters and sculptors and to view some

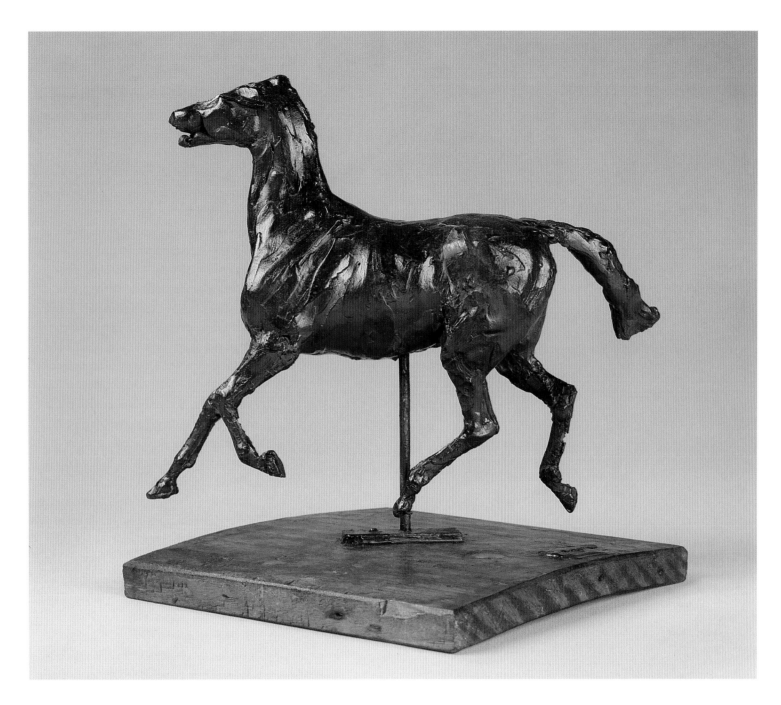

cat. 116. *Horse Trotting, the Feet Not Touching the Ground*, 1880s, wax. Collection of Mr. and Mrs. Paul Mellon, Upperville, Virginia

of the horse locomotion studies. Degas was not present, but he would have been well aware of the event. As an admirer of Meissonier's work,[32] Degas may have had access to the photographs while the artist was painting Stanford's portrait, if not from viewing them in Muybridge's 1878 publication *Horse in Motion*.

Only two of Degas' extant horse figures embrace the latest scientific discovery by portraying horses with all four feet off the ground, *Horse with Jockey* and *Horse Trotting, the Feet Not Touching the Ground* (cat. 116). But each of these works depicts a horse whose two opposing legs alternately tuck while the other two are outstretched, rather than a galloping horse in the four-leg tuck position.[33] In *Horse Trotting, the Feet Not Touching the Ground,* the raised figure of the horse is supported only by a slender rod below the belly that prevents any of the hooves from making contact with the ground. Even the bare, concave base deliberately

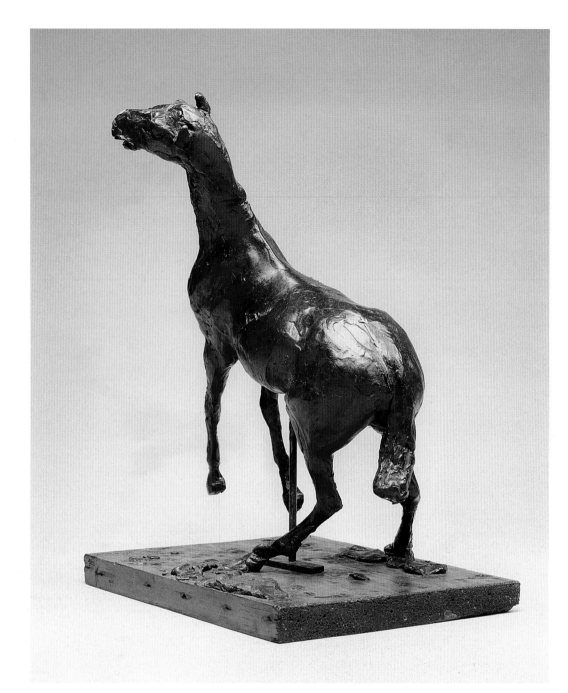

cat. 117. *Rearing Horse*, 1880s, wax. Collection of
Mr. and Mrs. Paul Mellon, Upperville, Virginia

curves away from the lifted horse, thereby
increasing the tension and the acute sense
of movement. Upon close scrutiny of
the sculpture's fabrication, it is clear that
Degas struggled and reworked the legs
of this red-wax horse to portray such a
complex movement. In fact, the X-
radiograph reveals that Degas relied on
a fairly traditional wrapped wire arma-
ture with body cavity, neck, head, tail,
and four appendages supported from
a central T-bar, which is still the standard
framework used by sculptors for con-
structing quadrupeds in clay and wax.

After the late 1870s, the stylized flying
gallop disappeared from Degas' horses,
but he does not appear to have replaced
it with the accurate, photo-documented
gallop position achieved by other major
equestrian and history painters of the late
nineteenth century. In other words, De-
gas ceased painting inaccurate representa-
tions of a horse in motion, but did not
produce an image or sculpture in the sci-
entifically correct, tucked-up leg position
of the gallop recorded by Muybridge.

A number of Degas waxes from the
1880s depicting lively, even frisky horses
are indebted to the Muybridge studies,
including *Rearing Horse, Horse Balking,*
and *Prancing Horse* (cats. 117, 118, 119).
All three demonstrate that Degas had
firsthand knowledge of horses and their
personalities, possibly from observations
made during his visits to the Valpinçon
family estate, which was near Haras-le-
Pin, the Norman horse-breeding estab-
lishment. *Prancing Horse* and *Rearing
Horse* are often compared to Muybridge
photos of rearing horses. While *Rearing
Horse* portrays a realistic animal with
bulging eyes and flaring nostrils, *Prancing
Horse* is somewhat mischievous or per-
haps just startled, impatient for the race
to start, or reacting to the hard pull of the
reins by an anxious jockey. *Balking,* on
the other hand, represents an angry horse.

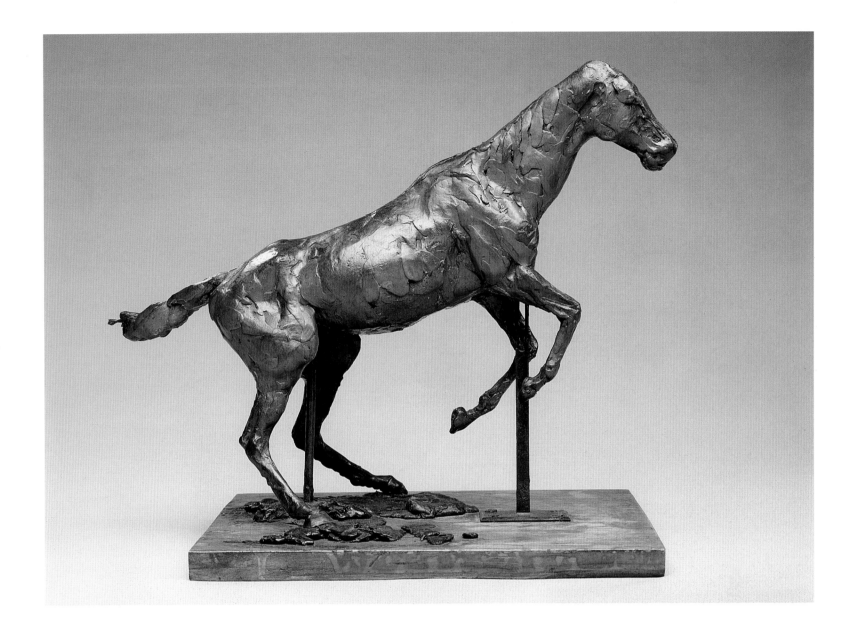

cat. 118. *Horse Balking (Horse Clearing an Obstacle)*, 1880s, wax. Collection of Mr. and Mrs. Paul Mellon, Upperville, Virginia

fig. 10. Detail of cat. 118

fig. 11. X-radiograph of cat. 118

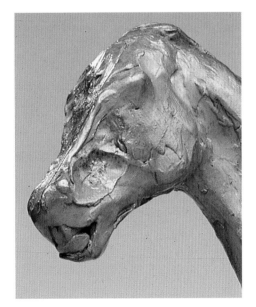

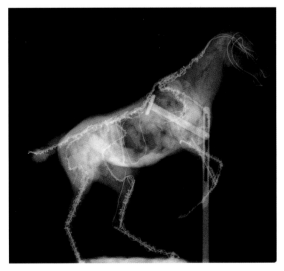

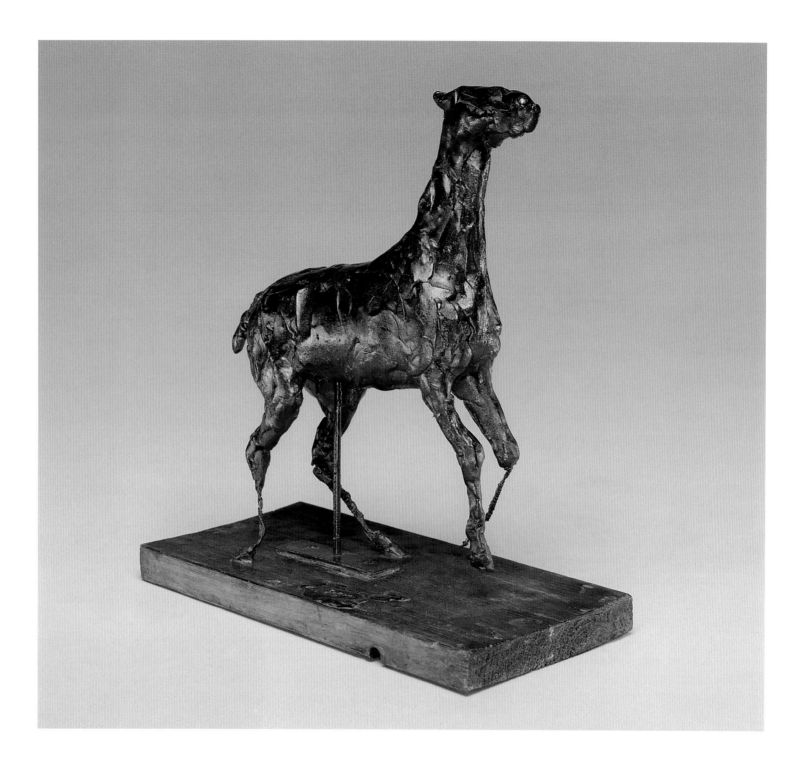

Degas added yellow wax inside the animal's mouth to demarcate the bared teeth of a threatening animal (fig. 10). For that reason, an earlier title change from *Horse Clearing an Obstacle* to *Horse Balking* has merit. Millard claims that *Horse Balking* is "spatially the most sophisticated of Degas' horses, combining forward, backward, rising, and twisting motion. . . ."[34]

Tinterow suggested that the back legs are more akin to a balking horse, since their wide spread causes a broken gait, which is not the stance of a horse about to jump.[35] However, a comparison with the Muybridge photographs suggests that the horse's stance indeed simulates that of a horse about to jump a hurdle. Muybridge carefully photographed his subjects

cat. 119. *Prancing Horse*, 1880s, wax. Virginia Museum of Fine Arts, Collection of Mr. and Mrs. Paul Mellon

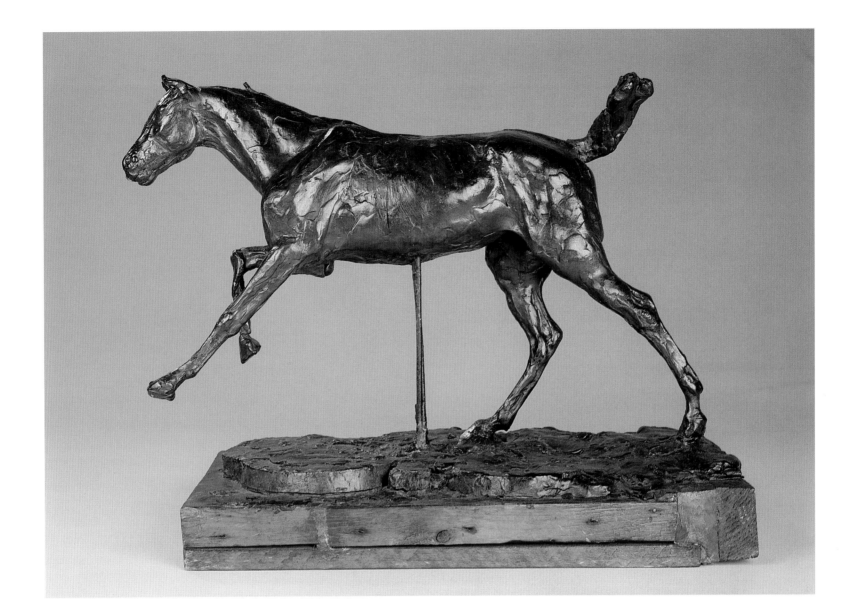

cat. 120. *Horse Galloping on Right Foot*, 1889/1890, wax and cork. Collection of Mr. and Mrs. Paul Mellon, Upperville, Virginia

fig. 12. X-radiograph of cat. 120

against a gridded background, visible in the frames, for the benefit of artists, who could count the squares to determine the height of the horse's legs prior to the jump. These grids may have inspired Degas to create another distinctive armature for *Horse Balking*, which incorporated an adjustable slide, visible only in the radiograph, for changing the position of the horse's chest up or down (fig. 11). With this interior armature Degas provided himself with a means to achieve whatever position he ultimately desired for his horse balanced on its hind legs.

In 1887, Muybridge enlarged his earlier work and published the complete set

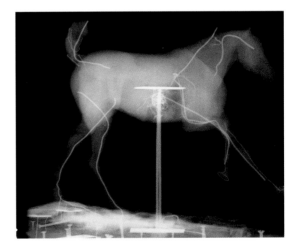

of photographs in *Animal Locomotion*. Paul Valéry pointed out that Degas "was one of the first to study the true appearance of the noble animal by means of Major Muybridge's instantaneous photographs."[36] The exquisitely finished *Horse Galloping on Right Foot* (cat. 120), the largest of the horse statuettes, probably made in 1889, duplicates the position of the horse in Muybridge's *"Annie G." Galloping* (fig. 13). There is even a textile impression enhanced using a single point tool across the horse's back to replicate the blanket under the jockey in the photograph. It is quite possible that *Horse Galloping* once carried a jockey that has since been destroyed or placed on another sculpture.[37] In *The Jockey* (Philadelphia Museum of Art), a pastel of 1889, which borrows from the same Muybridge frame for the horse's body, tail, and legs, Degas altered the horse's neck and the jockey's angle to create a slightly awkward stance for the horse that portrays less active motion than the sculpture. An 1889 date for *Horse Galloping on Right Foot* can be arrived at independent of the pastel, on the basis of the large corks on the base and its highly realistic and carefully finished surface. While cork from wine bottles is found on the interior and exterior of a number of the waxes, only *Horse Galloping on Right Foot* and *The Tub*, of 1889, incorporate large, semicircular pieces of cork similar to those found on mustard jars.[38] Both *Horse Galloping on Right Foot* (fig. 12) and *The Tub* exhibit scant internal armatures that bear little resemblance to the labored inner frameworks observed in the radiographs of Degas' early horse figures.

Horse with Lowered Head (cat. 121) has a similar minimalist armature that offers no structural support. Although a horse with lowered head appears in a painting dated by Lemoisne to around 1882 (cat. 70),[39] the sculpture is clearly later. A

fig. 13. Eadweard Muybridge, *"Annie G" Galloping*, photograph from *Animal Locomotion* (Philadelphia, 1887), vol. 9, plate 626

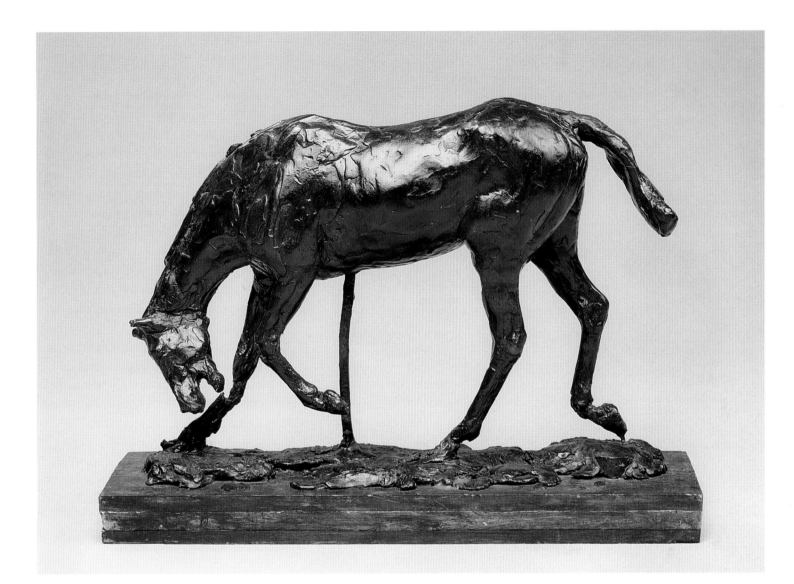

cat. 121. *Horse with Lowered Head*, 1889/1890, wax and cork. Collection of Mr. and Mrs. Paul Mellon, Upperville, Virginia

sophisticated stance, with two hooves off the ground, coupled with the tension of the horse's head twisting to the left, separates this horse from the painting. Like *Horse Galloping*, this horse was conceived with a jockey, as the horse's open mouth is clearly fighting a bit. Furthermore, *Horse with Lowered Head*, *Horse Galloping on Right Foot*, and *The Tub* exhibit smooth wax surfaces that carefully preserve the details of the modeling in the musculature and features. Perhaps these carefully finished, late horse statuettes were on the artist's mind when he wrote to Albert Bartholomé "Happy sculptor . . . but I have not yet made enough

horses. The women must wait in their basins."[40]

Another sculpture, the small *Draft Horse* (cat. 122), is often compared to Muybridge's images of *"Johnson" Hauling*.[41] Although there are definite similarities in the thick head, angled neck, and broad shoulders of both work horses, at the same time they are totally dissimilar with respect to position of the front and back legs. *Draft Horse* is the only one among Degas' horse sculpture that does not depict a long-legged thoroughbred, and the only one made to such a tiny scale. Its armature is simple and the honey-colored wax, now darkened, was

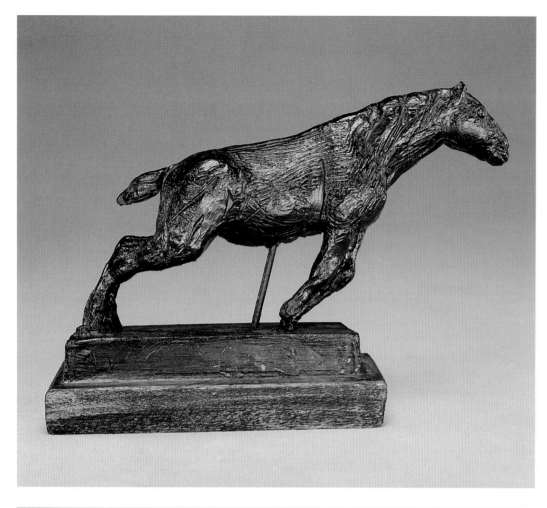

cat. 122. *Draft Horse*, late 1880s/early 1890s, wax. Virginia Museum of Fine Arts, Collection of Mr. and Mrs. Paul Mellon

fig. 14. Eadweard Muybridge, *"Hornet" Rocking*, photograph from *Animal Locomotion* (Philadelphia, 1887), vol. 9, plate 649

heavily tooled. Drawings of draft horses appear in Degas' early sketchbooks, dated to 1859 – 1860, but none of these drawings matches the sculpted horse. The sculpture actually bears a close affinity to Muybridge's small pony balancing on a rocker entitled *"Hornet" Rocking* (fig. 14), first published in *Animal Locomotion*, and therefore datable to the late 1880s or early 1890s. Both figures exhibit thick-set necks, straight profiles with snub flat noses, and compact short backs and limbs. Furthermore, the peculiar angled-back position of *Draft Horse*'s front and hind legs emulates those in *"Hornet" Rocking*. Millard also noted that *Draft Horse* represents a horse pulling against a weight rather than one hauling a load.[42] The entire horse is straining, like "Hornet," to maintain its balance, and even the central support is angled to convey the push against gravity,[43] although this subtle point is lost in the bronze replicas reproduced without the support below the belly.

Degas' last racehorse, *Horse with Jockey; Horse Galloping on Right Foot, the Back Left Only Touching the Ground* (cat. 123), should be dated to the 1890s. For Degas the challenge was to capture the bodily tension of a rider straining with his horse; even the base is undulated. This impressionistic sculpture admirably achieves Degas' aim and combines so much of what has been observed in the other horses. By this time Degas was more assured in his desired final product, thus very little internal armature is found (fig. 15). Like the one for *Draft Horse*, this armature is a simple wire fabrication that can be easily manipulated and adjusted. On the other hand, evidence of Degas' love of experimentation is present both in the horse's unnaturally elongated neck and in the mixed-media aspect of the work. While modeling the horse's neck, Degas pulled and folded the wax over

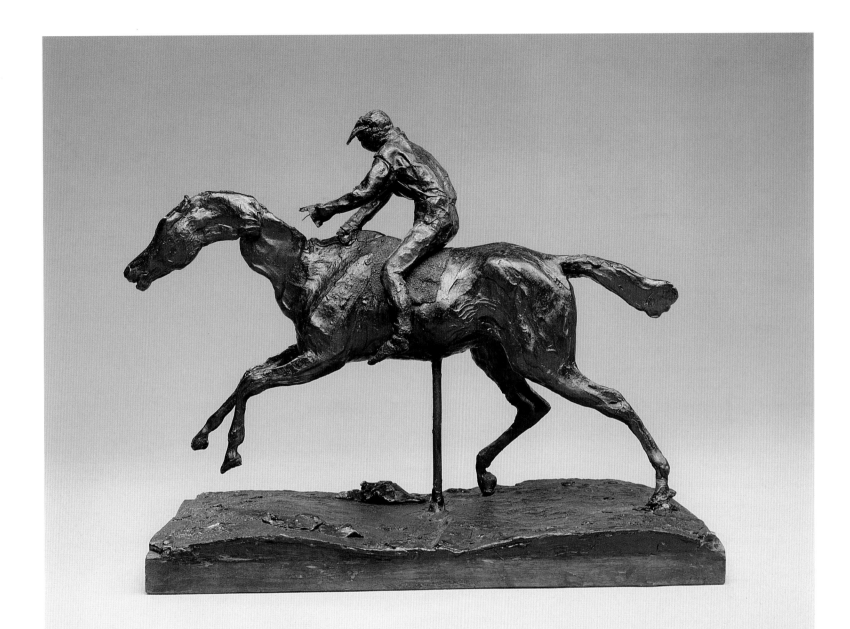

cat. 123. *Horse with Jockey; Horse Galloping on Right Foot, the Back Left Only Touching the Ground*, 1890s, wax and cloth. Collection of Mr. and Mrs. Paul Mellon, Upperville, Virginia

fig. 15. X-radiograph of cat. 123

itself. In fact, from the fingerprints and impressions still visible, it is apparent how Degas squeezed thumb and forefinger into the soft wax. The mounted jockey sports a real cloth shirt, cap, and boots, and he is seated on a fabric saddle. Like his other mixed-media works, *Little Dancer Fourteen Years Old*, *Woman Washing Her Left Leg*, and *The Tub*, which incorporate nontraditional, foreign elements, *Horse with Jockey* can be viewed as a precursor to the modern sculpture of cubism, surrealism, and later twentieth-century movements.[44] These works of sculpture are often cited as examples of Degas' inventiveness and daring as they introduce exotic elements as well as color into the contemporary monochromatic sculptural repertoire.

By the mid 1890s, after sculpting horses for more than thirty years, it is quite possible that Degas was satisfied with capturing equine movement in three dimensions and stopped modeling horses. In his handling of the exterior surfaces, as well as in his hidden, interior forms, Degas' horse sculpture became freer after the 1870s. His latest horses no longer relied on well-articulated inner armatures found in the standing and walking horses of the 1860s and early 1870s. Through the 1880s, Degas' rendering of internal structures tended toward minimalism and he was able to achieve the desired result with only a few reinforcing wires. The same progression is reflected on the exterior from the belabored fabrications and highly finished early works, to loosely rendered but accurate anatomical depictions conveying movement. The last horse represents not only another example of Degas' constant exploration of new materials and techniques, but its variation in texture and color firmly place Degas within the changing aesthetic of the late nineteenth century.

The Bronze Horses

At the time of Degas' death, an estimated one hundred and fifty works of sculpture and fragments were found in his studio. Durand-Ruel wrote, "we put apart all those that we thought might be seen, which was about one hundred and we made an inventory of them.[45] Out of these thirty are about valueless; thirty badly broken up and very sketchy; the remaining thirty are quite fine. They can be cast in bronze."[46] Ultimately seventy-four were transformed into multiple bronze images. A production contract generated between the Hébrard Foundry and the Degas heirs (the artist's brother René and four children of his sister Marguerite) sanctioning the casting was signed 13 May 1918.[47] The production contract specified that each sculpture would be reproduced in bronze twenty-two times. One series, marked HER.D, would be reserved for the heirs; a second series, allocated to the foundry, would be marked HER; and twenty sets, each assigned its own letter, would be sold.[48] In the National Gallery collections, for example, *Study of a Mustang* (cat. 127) is stamped 21/B (fig. 17) and *Horse Walking* is stamped 10/B. Both form part of the same set (B), but bear the number unique to that particular sculpture. In other words, all bronzes of *Study of a Mustang* carry the number 21, but each forms part of a different set, presumably ascribed a letter from A to T.

Sara Campbell's recently compiled catalogue raisonné, however, indicates that far fewer bronzes appear to have been cast. Furthermore, unmarked casts, or casts marked with the initials *A P*, of the master founder Albino Palazzolo, as well as unidentified casts suggest that the contract was not adhered to as closely as had been believed.[49]

Hébrard's master founder Palazzolo was entrusted with casting the wax origi-

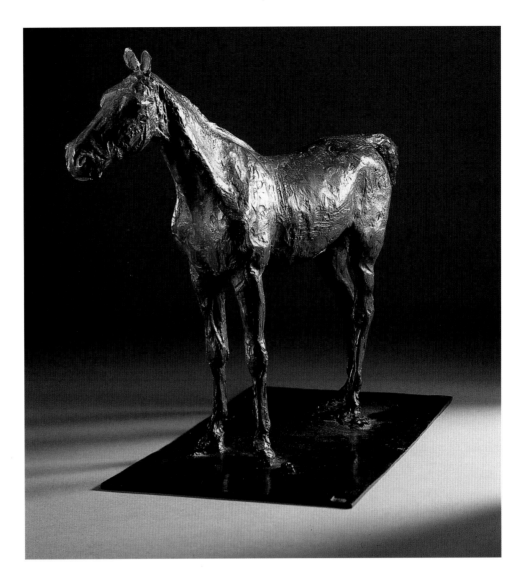

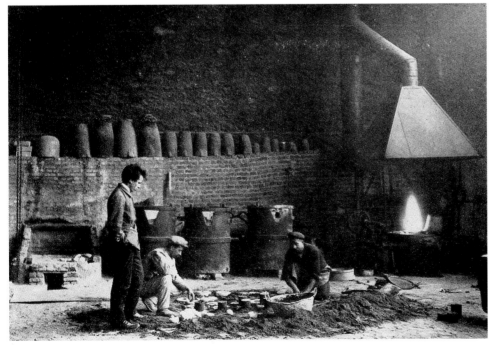

cat. 124. *Horse Standing*, modeled late 1860s/early 1870s, cast 1919/1921, bronze. Norton Simon Art Foundation, Pasadena, California

fig. 16. Palazzolo overseeing casting of bronzes at Hébrard, 1919 – 1921, photograph

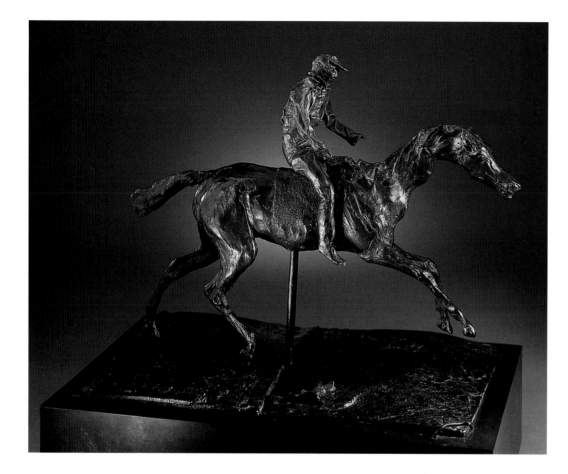

cat. 125. *Horse Galloping on Right Foot* and *Jockey*, modeled 1890s, cast 1919/1921, bronze. Norton Simon Art Foundation, Pasadena, California

nals into bronze (fig. 16), an achievement for which he was awarded the Légion d'Honneur. Jean Adhémar described Palazzolo's technique, verifying that the original waxes were preserved:

> *Palazzolo covered the figures with earth, then he enveloped the whole with a coat of plaster, then he removed the earth and poured in its place a specially prepared gelatine, which he then allowed to harden, thus obtaining a gelatine mold. He extracted the original wax figures unharmed and poured wax into the mold reinforcing it with a central core of sand.*[50]

Not until 1976 was a complete set of bronzes discovered in the Hébrard cellar, and it was purchased by Norton Simon for the Norton Simon Art Foundation, Pasadena, California.[51] These bronzes, marked MODÈLE, preserved more surface detail than other Hébrard casts and were one and a half to three percent larger. Unknown to Adhémar when he described the process in 1955 was that from the secondary wax model, a bronze model or modèle had been cast. It was from the modèles that all subsequent bronzes were reproduced.[52] Three modèles, *Horse Standing*, *Horse Galloping on Right Foot* and *Jockey*, and *Rearing Horse*, on loan from The Norton Simon Foundation for the first time, are included in the exhibition (cats. 124 – 126). In addition to preserving greater detail, the range of color in the patina of the modèles is closer to that of the original waxes. Arthur Beale has suggested that some of the modèles are so true to the original waxes that even the soot accumulated on the surface while stored in the foundry's basement was reproduced as a darker hue on the top of the sculpture.[53] *Horse Standing* is seen in the exhibition only in this bronze modèle,

whereas *Horse* and *Jockey* are shown as wax figures and master bronzes made shortly after the artist's death. This exhibition marks the first occasion that an original wax, *Rearing Horse* (cat. 117), its *modèle* (cat. 126), and the bronze version cast for the Degas heirs, marked HER.D (cat. 128), are displayed side by side.

While no bronze sculpture by Degas is known to have been cast in his lifetime, he was clearly interested in the casting process from a young age and was known to have cast in plaster and wax.[54] Two letters to his father, written in 1858, describe problems with plaster sculpture that was broken and being repaired by a molder.[55] The correspondence is unclear on whether the damaged sculpture was created by Degas, or whether it was purchased from an art store to be used as studio models. One could argue that having the sculpture repaired by a molder suggests that it was more valued by Degas than studio models, and could well have been his own. More importantly, however, upon Degas' return to Paris from his trip to Italy, he may have visited the Barbedienne Foundry in 1859 or 1860 perhaps intending to cast the sculpture from his Italian venture into bronze. The notation "Barbedienne/ateliers/ rue de Lancry 63" in a sketchbook lists the address of the foundry itself and not the gallery located at 30, boulevard Poissonnière.[56]

Never entirely abandoning the idea of casting his waxes into bronze, Degas purportedly visited Hébrard and Palazzolo often and continued to pursue his interest in foundries. In the mid 1870s, he refers to "M. Gonon" first at "21 Avenue du / Maine," and again at "78 ou 80 / rue de Sèvres."[57] Located at 80 rue de Sèvres was the Gonon foundry, renowned for its technical expertise and credited for reviving the lost-wax casting process in France.[58] Eugène Gonon, its

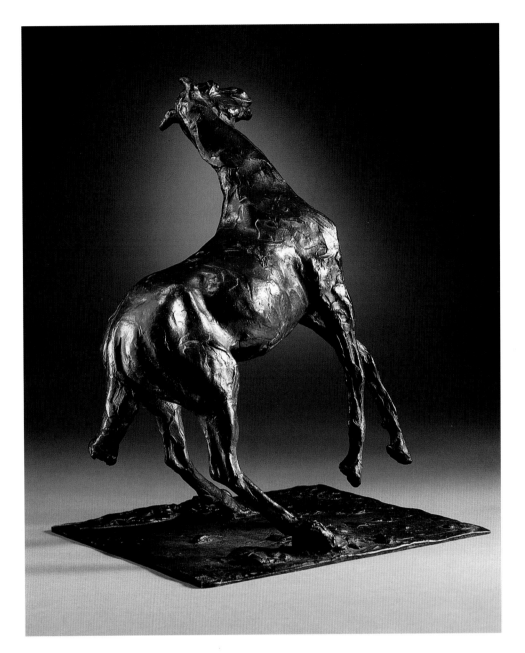

cat. 126. *Rearing Horse*, modeled 1880s, cast 1919/1921, bronze. Norton Simon Art Foundation, Pasadena, California

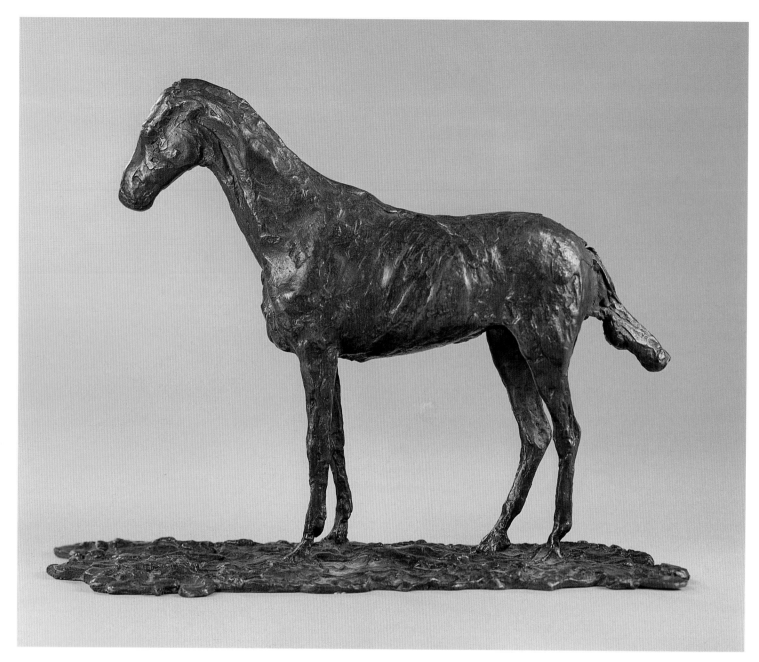

cat. 127. *Study of a Mustang*, modeled 1859–1860, cast 1919/1921, bronze. National Gallery of Art, Washington, Gift of Mrs. Lessing J. Rosenwald, 1989.28.1

fig. 17. Detail of cat. 127

master founder during Degas' lifetime, was sketched by Degas,[59] so the two clearly knew one another.

For his entire artistic career, Degas was engaged in experimentation and novel developments. Even though he never had his sculpture cast in bronze, he was clearly interested in the technology and process. His preoccupation with materials and technique can be seen in his ability to create sculpture in a thoroughly new fashion. And it is this extraordinary sculpture that bears testimony to his genius and his insatiable quest for the perfect technique.

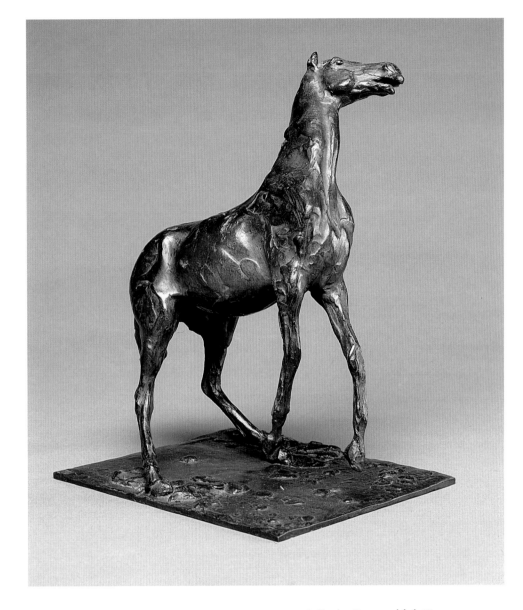

cat. 128. *Rearing Horse*, modeled 1880s, cast 1919/1921, bronze. Collection of Mr. and Mrs. Paul Mellon, Upperville, Virginia

Notes

The authors are extremely grateful to Mr. and Mrs. Paul Mellon, Beverly Carter, and the staff at the Virginia Museum of Fine Arts for allowing us to examine the sculpture expressly for this exhibition. Thanks are also due to Helen Spande for radiographing the objects.

1. Royal Cortissoz, *Personalities in Art* (New York, 1925), 245. Although the quote refers specifically to his working in clay, Degas generally worked with a combination of wax and clay.

2. Recent scholarship includes Pingeot 1991, and the entire issue of *Apollo* (August 1995).

3. Vollard 1924, 112.

4. Wax had long been the material of choice for funeral effigies, but does not appear to have been used in France for sculpture until the end of the seventeenth century. One hundred years later, Philippe Curtis (1737 – 1794), whose works were exhibited at the Salon des Refusés, established the Cabinet de Cire in Paris. In 1802, his niece Madame Tussaud took her wax collection to London, where Degas later visited it. The Parisian equivalent, the Musée Grévin, opened in 1882. Edward Gatacre and Laura Dru, "Portraiture in Le Cabinet de Cire de Curtis and Its Successor Madame Tussaud's Exhibition," in *La ceroplastica nella scienza e nell'arte. Atti del I Congresso Internazionale* (Florence, 1977), 619 – 623.

5. The word "mustang" is misleading in that it links the sculpture with wild horses of the American West, but the title (albeit incorrectly) does serve to distinguish this horse from all others in Degas' sculptural oeuvre. "Roman" refers to the aquiline shape of the nose and not to a civilization of origin. A "Roman"-nosed horse is typical of a steppe horse, whose roots can be traced to the primitive Asian wild horse. Elwyn Hartley Edwards, *The Ultimate Horse* (New York, 1991), 49.

6. Henry Loyrette, "What is fermenting in that head is frightening," in exh. cat. Paris 1988 – 1989, 91. See also Lemoisine 1946 – 1949, 1: 230.

7. Millard 1976, 59, and fig. 5.

8. Alice Michel, "Degas and His Model," *Mercure de France*, 16 February 1919, 623.

9. Rewald 1944, 14.

10. Millard 1976, 6, does not assign a date to this sculpture but is inclined toward a later date for the sculpture in general.

11. Degas is purported to have had actual models in his studio, including a life-sized stuffed horse. Louisine W. Havemeyer, *Memoirs of a Collector* (New York, 1961), 247, recalled, " . . . and the moths had eaten their way into the very entrails of the horse which had served him as a model when he did his now famous 'Race Horses and Jockeys.'"

12. See, for example, the letter dated 23 October 1870 from Edouard Manet to Suzanne Leenhof in *Lettres du Siège de Paris* (Paris, 1996), 61.

13. Reff Notebook 21, 13v; Notebook 22, 220; Notebook 23, 157.

14. *Exposition Universelle de 1878 à Paris* (Paris, 1878), 1, 1: nos. 1176, 1177.

15. Thiébault-Sisson 1921, 3. See also Loyrette in exh. cat. Paris 1988 – 1989, 123.

16. This toy has recently been given to the Musée d'Orsay as part of the Fonds Degas-Fèvre. We are grateful to Anne Pingeot, conservateur général at the Musée d'Orsay, for bringing the unpublished piece to our attention.

17. For an illustration of Cuvelier's *Standing Horse* see Millard 1976, fig. 3.

18. Theodore Reff, "The Morbid Content of Degas' Sculptures," *Apollo* (August 1995), 65.

19. James Mackay, *The Animaliers* (London, 1973), 89 – 95.

20. Millard 1976, 96 – 97.

21. See Michèle Beaulieu, "Les sculptures de Degas," *La Revue du Louvre et des Musées de France* (1969), and Lemoisine 1946 – 1949, 3: 852.

22. See X-radiograph of Moreau's *Hercules* published in Colinart, Drilhon, and Scherf 1987, 326 – 327. Radiographs of Moreau's horse sculpture have not been taken. Future comparisons between internal structures of the Degas and Moreau horses could prove useful.

23. Five Degas waxes are on exhibit at the Musée d'Orsay. For X-rays of the four originally at the Musée du Louvre, see Colinart, Drilhon, and Scherf 1987, 226 – 237. Of the approximately forty works of Degas sculpture radiographed to date, only *Horse with Jockey* (cat. 115) and *Dancer Moving Forward*, both in the Mellon Collection, exhibit the distinctive armature described. Moreover, Moreau's *Hercules* and *Dancer Moving Forward* share another unique element, that of a lengthy coiled sleeve, "manchion flexible."

24. In his entry on the *Hercules*, Guilhem Scherf reviews the various dates and arguments related to Moreau's sculpture serving as models for his paintings, Colinart, Drihon, and Scherf 1987, 325. The painting *Hercules et l'hydre de Lerne*, now forms part of the collections of the Art Institute of Chicago.

25. Barber Institute of Arts, Birmingham. For a color reproduction of the painting see Sutton 1986, 153, plate 127.

26. Pingeot 1991, 193, and 178 fig.

27. Refer to Françoise Forster-Hahn, "Marey, Muybridge and Meissonier: The Study of Movement in Science and Art," in *Eadweard Muybridge: The Stanford Years, 1872–1882* (Palo Alto, 1972), 86 – 89.

28. In *Sulking* (cat. 25), Degas included a copy of a sporting print by J. F. Herring, *Steeplechase Cracks*. There the rocking-horse position of the animals is legitimate, as the horses are jumping a hurdle.

29. These same observations are made by Aaron Scharf in *Art and Photography* (London, 1968), 158.

30. Gaston Tissandier, *La Nature* (14 December 1878), 23 – 26. In his letter of 18 December 1878, Marey wrote, " . . . So far as artists are concerned, it would create revolution for them, since one could furnish them with true attitudes of movement; positions of the body during unstable balances in which a model would find it impossible to pose." (Perhaps one use Degas had for the sculpture with highly flexible armatures was to deconstruct the positions of the horse's legs himself.)

31. Reff Notebook 23, 81. Millard 1976, 23, clarified that Victor Masson et fils was a Paris bookseller.

32. Thiébault-Sisson quotes Degas as stating that "he wanted to work at least as well as Meissonier . . . the poor painter who was one of the men most informed about the horse whom I've ever known" (quoted in *Ernest Meissonier* [exh. cat., Musée des Beaux-Arts] [Lyon, 1993], 240). Valéry reported that one day when he was with Degas at the Durand-Ruel gallery, Degas kept him in front of the little Meissonier equestrian bronze horse of Napoléon, greatly praising the work and describing the beauty of all its parts (Valéry 1938, 74).

33. Meissonier also produced a wax sculpture of a horse trotting that is similar to Degas' work, while dependent on Muybridge as well. Unlike Degas', the Meissonier horse has a thick, wax-covered support below the belly, and in that sense the figure appears much closer to Moreau's flying pony, also with feet not touching the ground.

34. Millard 1976, 100 – 101.

35. Tinterow in exh. cat. Paris 1988 – 1989, 460 – 461.

36. Valéry 1938, 70.

37. For example, there is a Durand-Ruel inventory photograph of two horses facing each other. One of the horses is *Study of a Mustang* and the other is *Horse with Jockey: Horse Galloping on Right Foot*, without the jockey. See Pingeot 1991, 176.

38. For discussion of *The Tub* and images of sculpture and the internal corks, see Sturman and Barbour 1995, 53 – 54. For an illustration of the X-radiograph see Barbour and Sturman 1995, 35, 38.

39. The painting was purchased by the painter Henri Lerolle in 1883.

40. *Letters* [B.7], 127.

41. Van Deren Coke, *The Painter and the Photograph* (New Mexico, 1964) 15, frame 573, illustrates the sculpture with the Muybridge plate.

42. Millard 1976, 23.

43. McCarty 1986, 220, commented on the angled support.

44. Reff (1976, 291) describes the clothed and accessorized figures made of multicolored waxes as anticipating the assemblage techniques of the twentieth century.

45. Pingeot 1991, 192, publishes the inventory that lists eighty works.

46. Royal Cortissoz, "Degas as He was seen by His Model," *New York Tribune*, 19 October 1919, section 4, 9, reprinted in "Degas: His Seventy-Two Achievements as a Sculptor," *New York Herald Tribune*, 25 October 1925, section 5, 8.

47. Pingeot 1995, 62.

48. The HER and HER.D assignations are not entirely correct. Adrien Hébrard agreed to purchase any sculpture from those heirs who did not wish to keep the sculpture designated to him/her from the set to be divided among the heirs. The heirs who wished to keep their share of the set received bronzes marked HER.D (héritiers Degas). Those which he repurchased he marked HER just as he marked his own set. So, for example, there are two bronzes entitled *Dancer Fastening the String of Her Tights* (Pingeot 15) marked HER. Campbell 1995, 27.

49. Campbell 1995, 6 – 48.

50. Adhémar 1955, 70.

51. Rewald, *The Complete Sculptures of Degas* [exh. cat., The Lefevre Gallery] (London, 1976).

52. Campbell 1995, 6. The one exception appears to have been *Little Dancer Fourteen Years Old*, which has two extant intermediary plasters used in the casting process. For further information refer to Arthur Beale, "*Little Dancer Fourteen Years Old* : The Search for the Lost *Modèle*," in *Degas and the Little Dancer* [exh. cat., Joslyn Art Museum] (New Haven, 1998).

53. Beale 1998.

54. Three plaster casts were found in Degas' studio at the time of his death, Pingeot 1991, 160, 169, and 178. The National Gallery of Art owns a cast wax sculpture. See Barbour 1995, 28 – 32.

55. Millard 1976, 3. The letters are dated 28 August 1858 and 6 October 1858.

56. Reff 89, Notebook 16, 43. Reff dates the notation to the Paris notebook of 1859 – 1860. For the foundry address, see Isabelle Vassalo, "Barbedienne et Rodin: l'histoire d'un succès," in *Rodin sculpteur: oeuvres connues* [exh. cat., Musée Rodin] (Paris, 1993), 189 fig. 2. Millard 1976, 74 n. 16, also noted that Degas had written Barbedienne in a notebook.

57. Reff Notebook 26, 7, 8.

58. For the foundry address see Monique Laurent, "Observations on Rodin and His Founders," in *Rodin Rediscovered* [exh. cat., National Gallery of Art] (Washington, 1982), 288. Michael Shapiro, *Bronze Casting and American Sculpture 1850 –1900* (London, 1985), 114 – 117, writes that Eugène Gonon's father, Honoré, committed himself to understanding the lost-wax casting process and was credited with rediscovering its ancient methods. His treatise on lost-wax casting was considered important enough to be purchased by the French government in 1876. It was Eugène who sold the manuscript, now in the École des Beaux-Arts library, for an annual stipend. See also G. Vapereau, *Dictionnaire Universel des Contemporains* (Paris, 1870), 783, and Bernard Metman, "Documents sur la sculpture française, Répertoire des fondeurs du XIXe siècle," *Archives de l'Art française* 30 (1989), 197.

59. Reff Notebook 26, 89.

A Day at the Races: A Brief History of Horse Racing in France

KIMBERLY JONES

Any history of horse racing in France must inevitably begin, not in France itself, but across the channel in England. It is England that is the true home of this pastime that became known as "the sport of kings." The vogue for horse racing in England dates to the first quarter of the eighteenth century, when it was popularized by the British aristocracy. Although the prizes awarded at these races tended to be rather meager, large wagers among owners and spectators added considerable interest to the competition. More than money, however, it was the honor of the owner and of the stable that was the true stake in such aristocratic competitions.

A turning point in the history of horse racing occurred in 1750, when the Jockey Club of Newmarket was founded by British racing enthusiasts. The primary goal of this society was the advancement of the sport and the establishment of regular competitions, particularly at Newmarket, which quickly became the premier racing center in England as well as the most important training center for thoroughbred horses.

The sport was now flourishing in England as never before. In 1766, the Tattersall, the foremost market for thoroughbreds, was established in London near Hyde Park.[1] Between 1776 and 1780, three prestigious horse races were founded: the Saint Leger at Doncaster, established in 1776; the Oaks at Woodmansterne in 1779; and the most

renowned of all, the Derby at Epsom in 1780. Named for its founder Edward Stanley, the 12th earl of Derby – who had also founded the Oaks – this race was *the* Derby (fig. 1). This famed race served as the model for horse races; the term Derby quickly became generic and was used for important races on both sides of the English Channel and in the United States as well. The Derby at Epsom, along with the Saint Leger and the 2,000 Guineas, a one-mile race for three-year-olds that was established at Newmarket in 1809, would form what became known as the Triple Crown, the most coveted and challenging of racing achievements.[2]

By this time, horse racing was just beginning to take hold in France. Like the thoroughbred, the sport was a wholly British import, a fact that has at times hindered and at others stimulated its development in France. With the exception of some informal races, usually undertaken as wagers between individuals, horse racing as a sport did not exist in France until the last quarter of the eighteenth century. The first true horse race took place on 9 March 1775 on the plain of Sablons, northwest of Paris, and was attended by members of the royal family and the court. The first French "hippodrome," or racetrack, was inaugurated there on 20 April 1776.[3]

The sport – along with the introduction of betting – now enjoyed a period of popularity. On 11 November 1776, the

cat. 55 (detail)

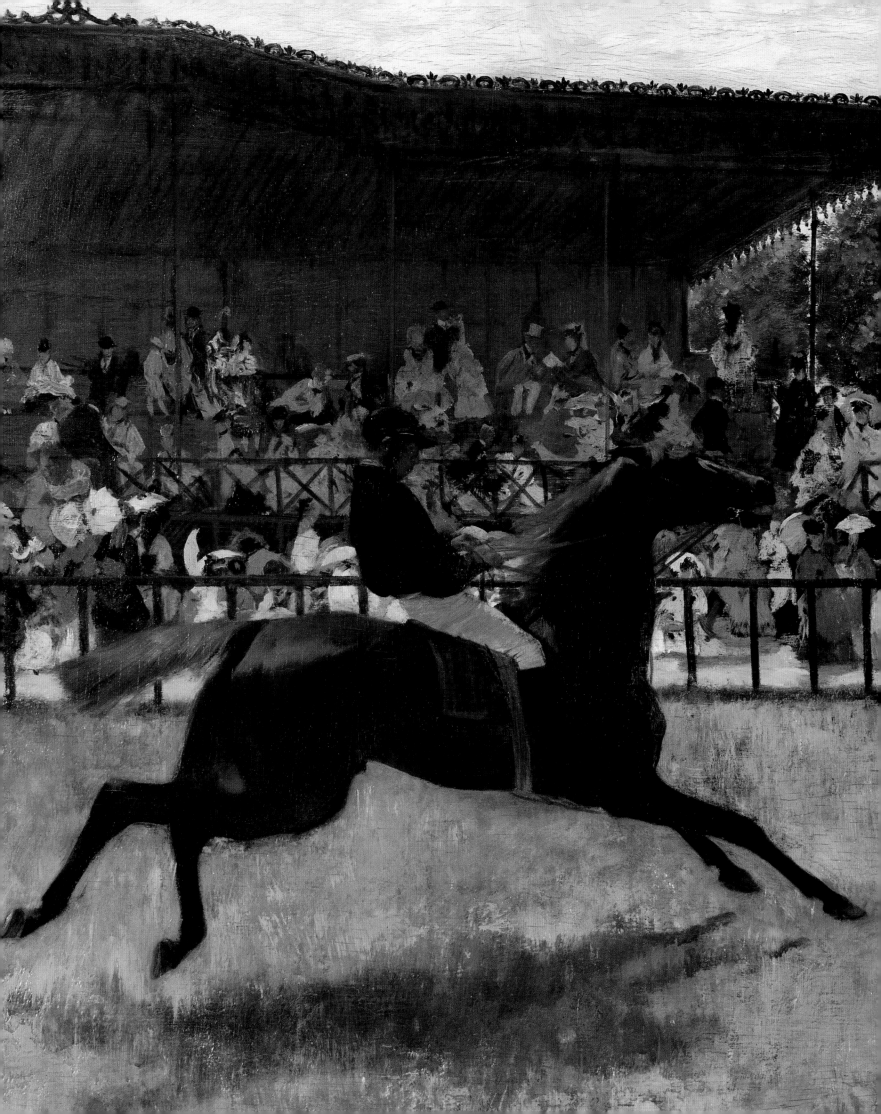

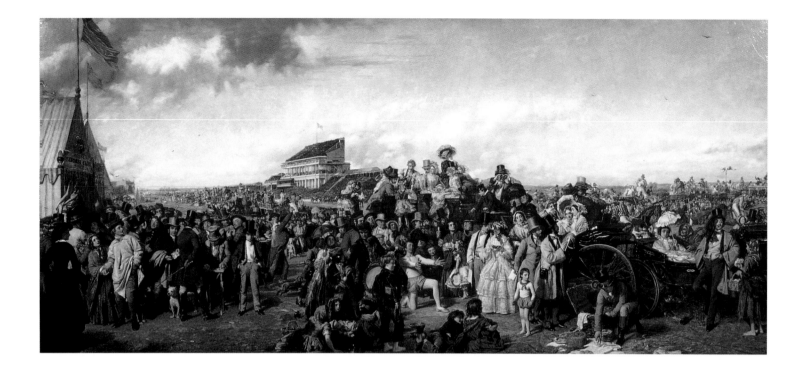

first races were held at Fontainebleau. There the autumn races, which included a *poule* (a trial race) for four-year-old horses each November, would enjoy great success until the French Revolution.[4] On 2 April 1781, another racecourse was inaugurated in the royal park of Vincennes on the outskirts of Paris, which hosted spring races.[5] With the creation of these new venues, the number of races also increased. Between 1775 and 1783, ninety-one races would be held, an impressive number given the novelty of the sport, but still a fraction of the number held in England during the same period.[6] Despite this vogue, the appeal of the sport remained a mystery for many contemporaries. Louis-Sébastien Mercier, in his *Tableau de Paris*, published in 1782–1788, remarked: "One goes to the plains of Sablons to watch some speeding animals run, as they pass by like an arrow shot, completely covered with sweat, all in about six minutes; afterwards, in the discussions that follow these races, we speak with a kind of gravity and an importance that seem almost ludicrous."[7]

With the onset of the French Revolution, the predominantly aristocratic sport inevitably suffered a decline. An attempt to replace horse racing with chariot races *à l'antique*, in keeping with the classicizing practices of the period, proved an abysmal failure.[8] Under the Directory (1795–1799), a number of social activities that had been barred after the revolution reappeared, including horse racing. In 1796, races began to take place on the Champ de Mars, a large stretch of ground between the École militaire and the Seine that had been created under Louis XV as a military parade ground. While not ideally suited for races – the terrain was sandy and uneven – its location within Paris made it extremely convenient, and in 1806 a racetrack would be established at that site. The Champ de Mars would remain the most popular racecourse in the Parisian region until 1857, when it was supplanted by the track at Longchamp.

Napoléon Bonaparte proved to be a great, though not wholly successful, proponent of horse racing. In an official decree of 31 August 1805, he established

fig. 1. William Powell Frith, *Derby Day*, 1856–1858, oil on canvas. Tate Gallery, London

races in the provincial departments that were principal areas of horse production: Orne, Corrèze, Seine, Côtes-du-Nord, Sarre, and Hautes-Pyrénées. The following year a series of prizes was established as a means of encouraging the sport.[9] Perhaps more importantly, Napoléon also recognized the necessity of raising thoroughbred horses in France – both for racing and for the military – a practice that was virtually nonexistent at the time. In the wake of the French Revolution and the subsequent emigration of the aristocracy, stables and studfarms that had belonged to the Crown and the nobility had been seized and the property and horses sold off. In 1806, in an effort to reverse the process, Napoléon repurchased the lands and buildings that had once belonged to Haras-le-Pin in Normandy, one of the oldest and most prestigious studfarms in France.[10] Unfortunately, poor relations with England that had arisen as a result of the revolution and Napoléon's subsequent military campaigns, hindered efforts to introduce British practices in the care, breeding, and grooming of horses, and more importantly, the import of thoroughbred stallions and broodmares.[11] It would not be until 1814, with the reestablishment of amicable relationships between the two nations, that the raising of thoroughbred horses in France once again became possible.

With the reopening of trade and travel between England and France during the Bourbon Restoration (1814–1830), horse breeding and racing began to revive, albeit slowly. It was not until the July Monarchy (1830–1848) that horse racing would truly flourish in France. The sport found one of its greatest champions in Ferdinand Philippe, the duc d'Orléans (1810–1842), the charismatic and popular son of King Louis-Philippe and the heir to the French throne. A devoted Anglophile, the duc d'Orléans developed a passion for all things British, its sports in particular. The French aristocracy quickly followed suit, ushering in a widespread vogue for such gentlemanly pursuits as boxing, pigeon shoots, and, of course, horse racing, which gained momentum over the course of the 1830s and 1840s. The British influence on the development of this sport in France was pervasive, and even extended into the terminology itself. English words such as "le jockey," "le gentleman rider," "le turf," and "le steeple-chase" quickly entered into the standard usage and remain in use even today.

Perhaps the clearest manifestation of the influence of British racing culture in France was the creation of the French Jockey Club. Its model was the Jockey Club of Newmarket, which was renowned both for its efforts on behalf of equestrian sport as well as its exclusive and aristocratic character.[12] The impetus for this association came, not surprisingly, from an Englishman, Thomas Byron. Byron's devotion to the sport was thorough and wide-ranging, and among his contributions was the creation of a grandstand that could be transported between the Champ de Mars and the Bois de Boulogne, as well as the establishment in 1828 of the first French studbook.[13] More important, however, was Byron's role in the foundation, in 1826, of the Société des amateurs de courses, the first such organization in France and a predecessor, of sorts, to the French Jockey Club. Seven years later Byron helped to found a second, more enduring organization, the Société d'Encouragement pour l'Amélioration des Races des Chevaux en France. As its name indicates, the purpose of this society was to promulgate the breeding of thoroughbred horses, les pur sang, by adopting successful British practices, as well as the pro-motion of the sport. Among the fourteen founding members were a number of renowned horse enthusiasts, including its president Lord Henry Seymour, who owned one of the most important stables in France; Prince Napoléon-Joseph de la Moskowa, the eldest son of Maréchal Ney; Anne Edouard, the duc de Normandie; Anatole Demidoff; the duc d'Orléans and his brother the duc de Nemours, who were both honorary members. These were the true "gentleman riders." Avid horsemen, virtually all of the original members owned and raced their own horses, both in traditional races, courses plates, as well as the more perilous steeple-chases.

The following year they created an auxiliary society, the Cercle de la Société d'Encouragement pour l'Amélioration des Races des Chevaux en France. This association, which was the social organ of the earlier Société d'Encouragement, was familiarly known as the French Jockey Club, though it would not officially take the name until 1904. Membership in the Cercle was strictly limited to members of the parent association, though it was not required. In its early years, the membership of the French Jockey Club was international in scope and included a relatively broad social range, such as bankers and members of the haute bourgeoisie as well as aristocrats. Over the years, however, it would become increasingly snobbish and conservative, factors that merely added to its allure for some, even as it fueled criticism among others. Unfortunately, the ostensible goal of the Jockey Club – the promotion of thoroughbred racing – soon became peripheral as the association took on the character of an exclusive men's club. As early as 1853, one contemporary complained: "One becomes a member of the Jockey Club not only without taking part in the races, but even without having a single horse in one's

stable and without knowing anything at all on the subject."[14] Almost immediately, membership came to be viewed as a sign of the highest social distinction, and as such became a coveted prize.[15] Marcel Proust, who had been an ardent admirer of the Jockey Club in his youth, made frequent references to it in his novels, describing its members as "these demi-gods of the Jockey."[16]

The Jockey Club, or even more simply "le Jockey," became shorthand for elegance, refinement, and social position. The longing for the prestige that membership would confer became fodder for contemporary literati. Gustave Flaubert, in his *Dictionnaire des idées reçues*, wrote rather mockingly: "Jockey Club – its members are all young wags and quite rich. Simply say 'the jockey'; this is very chic and it will lead people to think that one is actually a member."[17] Similarly, the Goncourt brothers (whose feelings toward the Jockey Club were somewhat ambivalent) evoked this pursuit in their novel *Renée Mauperin*, first published in 1864: "You must become a member of the Jockey, Jules, at least for the races, said Mme Davarande turning towards her husband. I find it so common to sit with the crowd! Really, if one has any self respect . . . for a woman . . . there is only the stands of the Jockey."[18]

Although the original intent of the French Jockey Club became somewhat diluted over the course of the nineteenth century, it did play an important role in helping to popularize the sport in France. The club encouraged racing activities both in and outside Paris, including the creation of *poule de hacks,* a small local race in the provinces with a modest purse, while also inspiring the foundation of local racing associations throughout France, thus furthering their goals.[19]

The Jockey Club was also responsible for the creation of the Prix du Jockey

Club at the recently constructed race-course at Chantilly.[20] Known as the "Derby de Chantilly" – it was modeled after the Epsom Derby and covered the same distance, 2,400 meters or one and one-half miles – it was run for the first time in 1836 and carried a prize of 5,000 francs, and was reserved exclusively for horses bred and raised in France.[21] In 1843, the club founded a second race at Chantilly, the Prix de Diane, intended as the French equivalent to the Oaks.[22] Already renowned as the premier horse training ground in France, and easily accessible by rail on the Paris-Lille line, Chantilly quickly became a fashionable racing center (fig. 2). The spring and autumn races at Chantilly, and particu-larly the Prix du Jockey Club in late May, became the place to see and be seen and would remain such until the end of the July Monarchy in 1848.[23]

Chantilly was not the only racecourse to be constructed in France during the July Monarchy. Racecourses proliferated across France during the 1830s and 1840s, particularly in Normandy and Brittany

fig. 2. "The Races at Chantilly," 1858, wood engrav-ing after E. Riou from *Monde Illustré*, reproduced in John Grand-Carteret, *L'histoire–la vie–les moeurs et la curiosité par image, le pamphlet et le document (1450 –1900)* (Paris, 1927), 5: 203, fig. 245. National Gal-lery of Art, Washington

where the races benefitted from their proximity to England, which enabled them to draw riders and spectators from both sides of the Channel. By 1853 there were no fewer than forty-three active racecourses in France, including Versailles, founded in 1836, Caen and Dieppe, both founded in 1837, Saint-Lô in 1838, and Saint-Malo in 1840.[24]

Although the sport of horse racing enjoyed considerable renown during the July Monarchy, it was ultimately the Second Empire (1851–1870) that was to become its true golden age: "In recent years, 'horse fever' has asserted itself with considerable force in Paris and its environs. . . . Now the entire Empire has been affected."[25] The popularity of the sport of horse racing during this period was due in no small part to the generous official patronage of Emperor Napoléon III who, like the duc d'Orléans, was an avid sportsman.

Perhaps the most important contribution to the popularity of horse racing during the Second Empire was the creation of the racecourse at Longchamp (fig. 3). For half a century, the primary racing center in the Parisian region had been the Champ de Mars, but it had been widely criticized for the poor quality of its terrain.[26] The Société d'Encouragement, which had long desired to construct a new racecourse in the region and knowing that the French government was about to cede the Bois de Boulogne to the city of Paris, sought to secure a tract of this land. With the support of the duc de Morny, a member of the French Jockey Club since 1838 and the half-brother and counselor of Napoléon III, and the approval of Baron Haussmann and the emperor himself, the Société d'Encouragement received the desired authorization in 1856.[27] Construction began shortly thereafter and on Sunday, 26 April 1857, the new racecourse of Longchamp was

inaugurated before a crowd of twelve thousand, a relatively restrained number due to the overcast weather. Five races were run that day, including the Prix de la ville de Paris and the Prix du Cadran.[28]

Longchamp quickly became the premier racing site in France, eclipsing even Chantilly, the grand bastion of the Jockey Club. Its location on the outskirts of Paris obviously played a central role in its popularity, as did the beauty of the surrounding parks that made it an ideal site for a weekend outing. Another factor was the institution of a number of prestigious races under the auspices of Napoléon III that served to garner attention for the races, therefore attracting larger crowds. One of the most important of these was the Grand Prix Royal, first run in 1834 and held every autumn at the Champ de Mars until 1857, when it moved to Longchamp. Renamed a number of times, first the Grand Prix National (in 1848), then the Grand Prix Impérial (in 1853), it became known as the Grand Prix de l'Empereur in 1861 and carried with it a purse of 6,200 francs, making it the best endowed race on French soil.[29] By 1861, it was joined by the Grand Prix de

fig. 3. "The Stands at Longchamp (Racecourse at Longchamp)," c. 1860–1870, engraving. Bibliothèque Nationale, Paris

l'Impératrice, run every April with a purse of 5,000 francs, and the Grand Prix du Prince Impérial, run every October and carrying a purse of 3,200 francs.[30]

These races, however, would pale in comparison with the Grand Prix de Paris. This race was the brainchild of the ever industrious duc de Morny who convinced the city of Paris to donate 50,000 francs in conjunction with each of the five major railroad lines, which he persuaded to donate an additional 10,000 francs each. With a prize totaling 100,000 francs, the Grand Prix de Paris became one of the richest endowed races in the world. The first Grand Prix de Paris was run at Long-champ on 31 May 1863 and was won by an English horse, *The Ranger*.[31] In a single stroke, France had proven the seriousness of its commitment to the sport of racing and its determination to rival the British in their own domain of expertise.

Outside of Paris, in Normandy and Brittany, the sport of horse racing was also flourishing under the aegis of the Second Empire. This region was the home of a number of other key racing centers, the most fashionable of which was Deauville. The first races were held at Deauville on 15 July 1863. Due to the lack of a racecourse, the races were run on the beach at the neighboring resort of Trouville during low tide (fig. 4). Following on this success, another race was held on 8 August, with the prizes being awarded by the auspicious person of the princesse de Metternich, the wife of the Austrian ambassador and a friend of Empress Eugénie of France. These races immediately became the social event of the season, necessitating the construction of a new racecourse. Yet another creation made possible through the efforts of the duc de Morny, this racecourse was inaugurated on 14–15 August 1864 and soon became the center of the summer racing season, hosting both a Prix spécial (2,500 francs) and a Prix impérial (4,500 francs) each July.[32]

By the 1860s, horse racing became one of the most popular – and, despite the existence of the exclusive Jockey Club,

fig. 4. "The Races at Deauville," 1863, wood engraving after H. Riballier. Bibliothèque Nationale, Paris

in many respects one of the most democratic – diversions in France during the nineteenth century. The growing number of racecourses, the increasing number of races, combined with relatively modest entrance fees and the promise of betting, attracted large crowds of spectators of all classes. While some came to enjoy the races themselves, most came to witness the spectacle of modern life, drawn by the glittering presence of wealth and aristocracy (fig. 5). Like most entertainments in the nineteenth century, the races had their own social hierarchy and their own rules of conduct, particularly in regard to women. In 1865, Louis Enault noted:

> *The regulations at Chantilly are not as severe as those at Longchamp, and they do not ostracize young women who make the mistake or have the misfortune to arrive unaccompanied to the barrier at the perimeter of the paddock. They are permitted to enter . . . ; but if they wish to do justice to themselves, they will invariably take a place in the stands at the left, leaving the one at the right for women who are accompanied.*[33]

As Enault noted, the stands were the "respectable" place from which to view the races at the major racecourses, the most coveted of which were inevitably the central stand, which was reserved for the imperial family and their court, and the stand reserved for the members of the Jockey Club and their guests. Next were the private carriages belonging primarily to the more mondaine crowd, which became riotous little parties, with "women . . . mildly amusing . . . who drink champagne in their calash."[34] And lastly, there were the other, less reputable women to whom Émile Zola alluded in his novel Nana (1880):

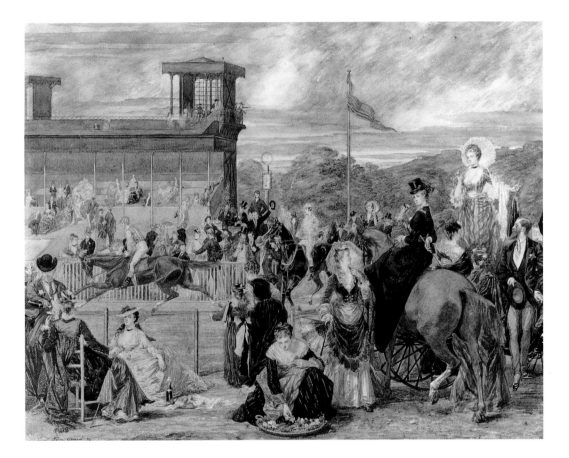

But Nana was amused above all by the women that had been chased by the storm from the rows of chairs arranged on the sand at the foot of the stands. As the entry to the perimeter of the paddock was strictly forbidden to young women, Nana, as was appropriate, made comments full of spite regarding these women who she found to be frightfully dressed with ludicrous faces.[35]

fig. 5. Pierre Gavarni, *The Races at Longchamp*, 1874, watercolor. Musée Carnavalet, Paris

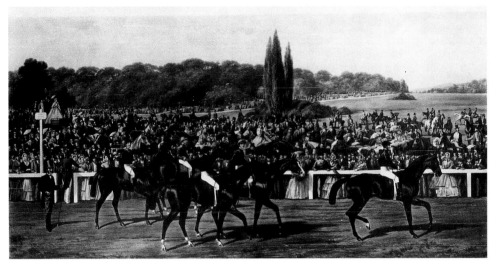

fig. 6. Cham, caricature of jockey training methods, in Cham, *Les Folies Parisiennes. Quinze années comiques, 1864–1879* (Paris, 1883), 137. National Gallery of Art, Washington

fig. 7. Henri Delamarre, *Parade at the Grand Prix of 1864*, 1864, oil on canvas. Bibliothèque Nationale, Paris

As races became more competitive and the prizes became more substantial, the professional jockey began to supplant the amateur gentleman rider. Like the thoroughbreds they rode, jockeys also underwent stringent preparation in both diet and exercise to keep them as light as possible (fig. 6). Most of the larger stables kept their own jockeys on exclusive retainer, though by the 1860s there were a handful of independent jockeys such as Harry Grimshaw, who rode *Gladiateur* to fame and fortune in 1865, becoming the first true "star" within the sport.[36]

Given the stakes involved, the horses themselves were carefully prepared as well. At this time, horses would begin training, "*entraînement*," at eighteen months with the main training centers being Newmarket (England) and Chantilly (France). Each horse in training had its own lad or stable boy who cared for the horse (feeding, grooming) under the supervision of the trainer. The training period generally lasted one year and comprised two phases, the first of which was to rid the horse of every superfluous ounce of fat through extensive exercise, and the second was to work on speed and opening the respiratory passages.[37]

Horses sometimes made their debut at the end of their second year, usually at the autumn races at Longchamp or Chantilly, though serious competition would not begin until their third year. Traditionally, a horse would make its formal debut in April at the *poule d'essai*, a race of 1,500 meters, followed by the *poule de produits* run in early May, at 1,900 meters. The horse would then be ready to participate in the more prestigious races, such as the Prix du Jockey Club or the Grand Prix

de la Ville de Paris, both of which were limited exclusively to three-year-olds.[38]

Despite the introduction of English methods in the breeding and raising of horses and rigorous training practices, English horses continued to dominate racing on both sides of the Channel. By mid-century, however, this began to change. The first crack in this dominance came in 1853 when the filly *Jouvence* won the famed Goodwood Cup, becoming the first French horse to win a major race on English soil.[39] This was the first in a succession of accomplishments by French horses during the Second Empire, one of the most famous of which was the victory of *Vermout* at the second Grand Prix de Paris where he beat out *Blair Athol*, the winner of that year's Epsom Derby (fig. 7).[40] That same year, the filly *Fille de l'Air* electrified spectators on both sides of the Channel by winning both the Prix de Diane at Chantilly and the Oaks in the space of a week.[41]

Ultimately it was the horse *Gladiateur* who would transform the sport and become a legend within the annals of French racing. *Gladiateur* burst onto the racing scene in 1864, when he won the Newmarket Derby, the first in a string of high-profile victories, the most stunning of which came on 31 May 1865 when *Gladiateur* became the first French horse ever to win the Epsom Derby, a feat that would not be repeated until 1948 when *Pearl Diver* won the title.[42] He was also the first French horse to win the prestigious Triple Crown, earning him the nickname, "Avenger of Waterloo."[43] *Gladiateur* went on to win numerous races in France as well, including the illustrious Grand Prix de Paris on 11 June 1865 and culminating with the Grand Prix de l'Empereur, his final race on 7 October 1866. By the end of his career he had won sixteen of the nineteen races that he ran, of which eleven were held in England, and had

earned winnings totaling more than 760,000 francs.[44] A statue of *Gladiateur* by the sculptor Isidore Bonheur was erected that year at the entrance of the racecourse at Longchamp and in 1869, the Grand Prix de l'Empereur was officially renamed the Prix Gladiateur in his honor.[45]

As the interest in horse racing increased, other equestrian competitions were introduced. During the nineteenth century there were three forms of horse racing practiced in France: the *course plate* (flat racing), the conventional horse race; the *course au trot,* or trotting, which was introduced rather late in the century and was considered to be the least prestigious of the three; and the *course aux obstacles,* or obstacle race. The *courses aux obstacles* proved to be the most intriguing – and controversial – by far. This category comprised three separate forms of race: the *course au clocher,* the *steeple-chase,* and the *course aux haies* (hurdles). The first to be introduced into France was the *course au clocher,* which was modeled after the English and Irish steeplechase. The goal of this race was to be the first to reach the finish – generally a church steeple, or *clocher,* a relatively visible, fixed landmark – by taking as straight a line as possible jumping over any and all obstacles in the riders' path. Traditionally an improvised race held in the countryside, the *course au clocher* (which was occasionally called *cross-country* for obvious reasons) was a brash, no-holds-barred competition and an extremely dangerous proposition. Perhaps not surprisingly given the French admiration for order and structure, the *course au clocher* never caught on in France and was soon eclipsed by the more systematic, though still perilous, steeplechase.[46]

The French steeplechase was a slightly more controlled version of the *course au clocher* and may be considered

as its successor. Unlike its antecedent, the French steeplechase covered a specified distance ranging from three to six kilometers and would contain a specified number of obstacles – between fifteen and thirty – of various types and sizes, including stone walls, open ditches, water jumps, banks (known as *banquettes* or *banquettes irlandaises*), and hedges (known as *bullfinchers*). Because of the precarious nature of the terrain, the riders were permitted to walk the course twenty-four hours prior to the race; however, any horse having been found to have traversed the course would be disqualified.[47]

The earliest steeplechases held in France were essentially private competitions that received virtually no notice. The first informal one appears to have taken place on 4 March 1830, at Jouy, near Versailles. It covered 2.25 leagues (6.75 miles) and was won by the duc de Chartres.[48] It was four years later, on 1 April 1834, that the first serious steeplechase took place outside Paris at La Croix-de-Berny, the site that came to be known as the "cradle" of the steeplechase (fig. 8). Six horses ran, though only three crossed the finish line. Among the riders were the duc d'Orléans, the duc de Normandie, and the comte de Vaublanc, who rode his horse *Mayfly* to victory.[49] On 29 September 1834 another steeplechase was held, this time in the meadows of Garanjoux between Moulins and Sauvigny. Four horses and riders participated, including the prince de la Moskowa, a founding member of the French Jockey Club. The race was won by his brother Edgar Ney.[50]

If horse racing is truly the sport of kings, then the steeplechase was the sport of the aristocracy. The steeplechase, more than any other race, was the province of the "gentleman rider" rather than the professional jockey. Unlike the *course plate,* in which the speed of the horse was the measure, in the steeplechase it was the

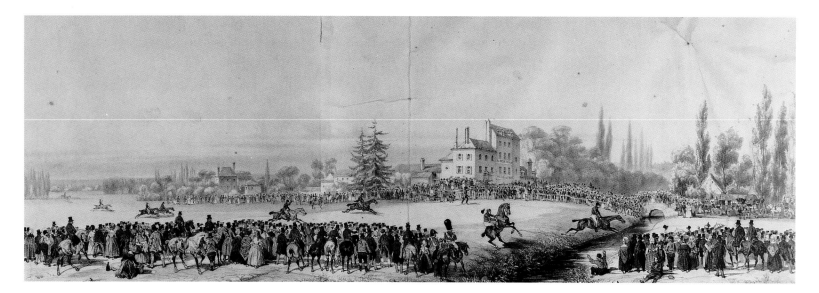

fig. 8. "A Steeplechase at La Croix-de-Berny," c. 1834, engraving. Bibliothèque Nationale, Paris

intelligence, courage, and above all the *sang-froid* of the rider himself that was to be most challenged. When properly run, it was, as one contemporary described it, "a battle waged with art . . . that brought forth the strength and power of the horse and the virile energy and skill of the jockey."[51]

The steeplechase received criticism for its danger and seeming cruelty, characteristics that earned it the title of the "illegitimate sport" among racing purists.[52] In 1842, one contemporary author wrote a self-styled "obituary" for the steeplechase, which he disparaged as "yet another British eccentricity that could not acclimate itself to France." He further went on to state that "first the public and later amateurs, promptly became disgusted with this dare-devil exercise, of its dangers devoid of any plausibly useful purpose, of these grotesque and muddy falls, of its riders, of its horses. . . . The French steeplechase is most decidedly dead and buried at the bottom of the stream of the Bièvre. May it rest in peace!"[53]

Although this death knell was premature, the author was correct in asserting the danger inherent in the sport. Falls were a common occurrence; indeed, if contemporary prints and caricatures are

any indication, such spills were the most salient characteristic of these races (fig. 9). In the steeplechase held at La Croix-de-Berny in 1834, for example, the horse *Guitare* and its rider the duc d'Orléans fell no fewer than three times, while at a race held later that same year at Garanjoux near Moulins, the horse *Counterpart* and its rider, the prince de la Moskowa, took a fall that forced him out of the race.[54] Even the Goncourt brothers made allusion to such occurrences in their play *Henriette Maréchal* (1865), including a description of a steeplechase accident in a pivotal scene, underscoring their familiarity.[55]

Unfortunately, these accidents proved fatal on occasion. On 5 September 1845, the marquis de MacMahon was killed while riding in a *course aux haies* at Autun after his horse *Glaucus* fell on him, fracturing the base of his skull and rupturing one of his cervical vertebrae. The death of MacMahon, who was an excellent sportsman and a member of the Société de Rallie Bourgogne, a regional sporting club that had sponsored the race, was a tragic reminder of the risks involved in this treacherous sport.[56]

Over the course of the 1840s and 1850s, there was a noticeable decline in the number of steeplechases across

France. The steeplechase remained popular in Normandy and Brittany, however, which boasted a number of important steeplechase sites, including Avranches, Caen, Le Pin, Saint-Lô, Saint-Malo, and Saint-Omer.[57] This process of decline underwent a dramatic reversal beginning in 1863 when the Société des Steeplechases was founded under the presidency of Prince Joseph Joachim Napoléon Murat, the grandson of King Joachim of Naples.[58] Like the Société d'Encouragement upon which it was based, the Société des Steeple-chases was founded in order to promote the sport. One of the most important contributions of this society was the creation of a new racecourse at Vincennes. Inaugurated on 29 March 1863, this locale would specialize in steeplechases and obstacle races, later adding trotting as well.[59] By 1867, the racecourse at La Marche, the most important site for steeplechases in the Parisian region, soon began to draw the same fashionable crowd that patronized Longchamp and Deauville: "The very name of La Marche conjures forth images of beautiful days, of splendid riders, of lovely, vivacious women, of sumptuous carriages, of aristocratic luxury. . . . "[60] The dangerous character of these races, the very element that detractors deplored, also lent them much of their attraction, particularly in aristocratic circles where they were vaunted as a test of a man's true mettle: "As for the steeplechase, it has retained the glorious privilege to be contested by aristocratic riders, the true pick of the bunch among gentlemen, eager to prove that they themselves, like their ancestors, will hold their own in times of trial and peril."[61]

As with the *courses plates*, the steeplechase in France was carefully regulated. In a decree of 2 December 1862, issued by the Administration des haras and the Société générale des steeple-chases, two categories of races were established: the first category comprised races covering a distance of 5,000 to 6,000 meters with a total of 25 to 30 obstacles and would carry a purse of 5,000 francs, while the second category would comprise those covering a distance of 4,000 meters with a total of 20 obstacles and would carry a purse of 1,000 to 2,000 francs.[62] The regulation of these races extended to the horses and the riders themselves as well. Unlike a conventional horse race where thoroughbreds were highly prized as mounts, for the steeplechase riders generally used saddle horses or hunting horses, which tended to be mixed breed, or *demi-sang*.[63] Although known for their speed, thoroughbreds were generally considered to be too highly strung and incapable of coping with the variety of tests within the rough and tumble steeplechase, although this opinion gradually changed over the course of the nineteenth century.[64] According to the regulations of 1862, the horses were to be between four and eight years of age and were required to fall within a weight range of seventy-three to seventy-six kilos. Of the two categories of race, the second proved to be more restricted, permitting only geldings and mares born and raised in France.[65]

By 1864, there were a total of six courses offering races of the first category and ten offering races of the second category.[66] The Société des Steeple-chases constructed a new racecourse at Auteuil, which was inaugurated on 1 November 1873. The following year the first Grand Steeple-chase of France was held. By the end of the nineteenth century, obstacle races in general, and the steeplechase in particular, had become sufficiently recognized to have races at Auteuil that offered purses of 10,000, 20,000, 50,000, and even 100,000 francs, culminating in the Grand Steeple-chase with a purse of

fig. 9. Cham, caricature of a steeplechase, in Cham, *Paris aux courses* [n.d.], 5. Bibliothèque Nationale, Paris

Ce qui, à l'école de natation, s'appelle piquer proprement une tête.

120,000 francs plus an *objet d'art* worth 10,000 francs.[67]

Although the excitement of the equestrian competition itself and the pageantry of the fashionable spectators were key factors in the growing popularity of the sport of horse racing in France, one of the greatest catalysts was the introduction of betting. In France, betting developed almost side by side with horse racing, making its appearance at the earliest races held at Sablons in the 1770s. Initially, much of the betting took place between owners or members of various clubs. The French Jockey Club, like its English counterpart, kept a registry of wagers between its members that would be placed well in advance of the race itself. Given the large sums of money involved, proprietors would go to great lengths to conceal information about the horse they intended to enter in a given race – its state of health, its abilities, even its identity – from competitors and would-be wagerers to maintain the advantage while adding to the thrill of the challenge. Such activities were considered perfectly legal, though they appear somewhat questionable by modern standards. One of the most fa-mous examples of this kind of subterfuge took place at the Grand Prix de Paris of 1870, when a proprietor "Major Fridolin" (in reality Charles Laffitte), entered two horses in the competition, *Bigarreau* and *Sornette*. Speculation ran high as to which horse the owner favored to win and it was not until virtually the last minute that his star jockey Charles Pratt mounted *Sornette*. The favorite had been revealed, but too late for most potential betters. *Sornette* won the race, earning Laffitte not only a hefty purse but also an undisclosed sum from personal wagers.[68] In such a context, "*le bon tuyau*," as the inside tip was known in French racing slang, took on considerable importance.

As the sport of racing became open to a broader audience, betting became a popular pastime, leading to the introduction of another English import: the book-maker. The bookmaker – thus known because he inscribed bets and calculated odds in a register – became a ubiquitous presence at the racecourse. The most common form of wager was a *pari à la cote*, in which the bookmaker posted a list of horses running in a given race along with the *cote* (the odds on or against) that

fig. 10. "*Voitures des poules* at the Races," c. 1867, wood engraving after A. Marie, from *Illustration*, reproduced in John Grand-Carteret, *L'histoire – la vie – les moeurs et la curiosité par image, le pamphlet et le document (1450–1900)* (Paris, 1927), 5: 204, fig. 247. National Gallery of Art, Washington

he offered for each. This practice proved wildly successful and extremely profitable, at least for the bookmakers, and soon gave rise to a new form of wagering, pool betting. Closer in spirit to a lottery than the more traditional odds betting, pool betting involved the purchase of tickets corresponding to various horses, with the sum of the money wagered to be divided among the winning ticket holders. Unlike the *pari à la cote,* where the profit of the wager could be calculated in advance based upon the amount wagered and the odds being offered by the bookmaker, in pool betting the profit was based upon the number of betters who chose the winning horse. This element of chance, which held the prospect of higher returns, made such betting very appealing. Already by 1865, the first *agence des poules,* a kind of vehicle with multiple compartments and window counters, where such tickets were sold, were making their appearance at La Marche and Longchamp (fig. 10). In 1869 the *pari-mutuel,* the more formalized successor of pool betting, was created by a Spaniard, Joseph Oller, who was also responsible for the creation of the *agence des poules.*[69] Closed shortly thereafter by the city of Paris as gambling establishments, they reappeared after the Franco-Prussian War in 1870–1871, offering not only simple wagers but also pool betting, lotteries, and related variations.

In 1887, the French government, at the instigation of the municipal council, banned the *pari à la cote* at racetracks, which proved disastrous for the sport and eventually led to the authorization of *pari-mutuel* societies, which were permitted to operate in exchange for contributing two percent of their transactions to the state.[70] On 2 June 1891, a law was passed placing the races under state control in order to weaken the authority of the Société d'Encouragement, stop the proliferation of suburban racecourses, and regulate betting. This law transformed horse racing into a genuine industry, giving them the means to enrich themselves and to prosper, and established the *pari-mutuel* as an official betting practice.[71] Today, the *pari-mutuel* remains the only legal form of betting for the sport in France.

With the reorganization of the races under the authority of the French government, what had begun as an aristocratic diversion and a gentleman's challenge had become a fully fledged and officially sanctioned national pastime. The races in all their forms — the *course plate,* the *course au trot,* and the *course aux obstacles* — had flourished during the nineteenth century. By the dawn of the twentieth century, France enjoyed a full-scale racing season, beginning on 15 March with the Prix de Vincennes and running through 15 November and boasted numerous racecourses throughout the country, as well as large and enthusiastic crowds, and prestigious prize races that attracted participants not only from both sides of the Channel but from the rest of Europe and America as well.[72] After more than a century under the shadow of English influence, horse racing had become a truly French tradition.

Notes

1. Created by Richard Tattersall, this market was moved to Knightsbridge in 1865. *La Grande Encyclopédie, inventaire raisonné des sciences, des lettres et des arts*, vol. 13 (Paris, [1886–1902]), 153, "Course."

2. The first horse to win this title was *The West* in 1853. See Charles Lane, *British Racing Prints 1700–1940* (London, 1990), 28, 34, 52.

3. Marc Gaillard, *Les hippodromes* (Paris, 1984), 30.

4. Gaillard 1984, 32, and *La Grande Encyclopédie* 13: 162, "Course." The age of a horse is based not upon the date of birth, but rather is calculated from 1 January after the birth. For example, a horse born on 1 April 1865 turns one year old (a yearling) on 1 January 1866, two years old on 1 January 1867, and so forth.

5. Gaillard 1984, 32.

6. Nicole de Blomac, *La gloire et le jeu. Des hommes et des chevaux, 1766–1866* (Paris, 1991), 45.

7. "On se transporte dans la plaine des Sablons pour voir courir des animaux enflanqués, qui passe comme un trait, tous couverts de sueur au bout de six minutes; et nous mettrons ensuite dans les discussions qui résultent de ces courses un air de profondeur et une importance qui ont quelque chose de burlesque." Louis-Sébastien Mercier, *Tableau de Paris*, vol. 1 (Paris, 1994), 1164.

8. Joseph-Antoine Roy, *Historique du Jockey Club* (Paris, 1958), 6.

9. *La Grande Encyclopédie* 13: 162, "Course."

10. Comte Gabriel de Bonneval, *Les haras français. Production, amélioration, élevage.* Preface by Eugène Gayot (Paris, 1884), 15.

11. Bonneval 1884, 12.

12. Roy 1958, 3.

13. Roy 1958, 8. A studbook is a compilation of horse genealogies that contains the parentage of all thoroughbred horses in any given year.

14. "On fait partie du Jockey Club non seulement sans figurer sur le turf, mais sans posséder un seul cheval dans ses écuries et sans rien entendre à la question." Eugène Chapus, *Le turf ou les courses de chevaux en France et en Angleterre* (Paris, 1853), 175.

15. When it was founded in 1834, the French Jockey Club had 89 members; by 1891, that number had risen to 850. This growth stands in stark contrast to the ultra exclusive British Jockey Club, whose membership in 1891 was limited to only 275 members. Roy 1958, 3.

16. ". . . ces demi-dieux du Jockey." Marcel Proust, *Le côté de Guermantes* (Paris, 1994), 57.

17. "Jockey Club – Ses membres sont tous des jeunes gens farceurs et très riches. Dire simplement 'le jockey'; très chic, donne à croire qu'on en fait partie." Gustave Flaubert, *Dictionnaire des idées reçues* (Paris, 1994), 59. Although written prior to his death in 1880, this brief compendium was not published until 1911.

18. "Vous devriez bien vous faire recevoir du Jockey, Jules, pour les courses, fit Mme Davarande en se tournant vers son mari. Je trouve cela si commun d'être avec tout le monde! Vraiment, quand on se respecte un peu . . . une femme . . . il n'y a que la tribune de Jockey." Edmond and Jules de Goncourt, *Renée Mauperin* (Paris, 1990), 69–70. On the attitude of the Goncourt brothers toward the Jockey Club, see Edmond and Jules de Goncourt, *Journal. Mémoires d'une vie littéraire*, 3 vols. (Paris, 1989), 1 (1851–1865), 639, 682, 740, 856; 2 (1866–1886), 227; 3 (1887–1896), 282, 464.

19. E. Gayot, *Guide du sportsman, ou l'entraînement des courses de chevaux* (Paris, 1865), 287.

20. The racecourse was constructed on the initiative of the duc d'Orléans who contributed the land. It was inaugurated on 15 May 1834. Gaillard 1984, 45.

21. Roy 1958, 138. Appropriately, the race was won by *Franck*, a horse belonging to Lord Seymour, a founding member and the president of the Jockey Club itself. *Lydia*, the winner in 1837, and *Vendredi*, the winner in 1838, were also from his stables.

22. *La Grande Encyclopédie* 13: 163, "Course."

23. "Du jour où il y eut un air d'aristocratie à respirer en assistant aux courses de Chantilly, Chantilly devint un rendez-vous brillant et recherché." Chapus 1853, 178.

24. Chapus 1853, 175 note. Chapus reports that there were forty-seven racecourses in England at that time. See also Blomac 1991, 277–278.

25. "Dans ces dernières années, la *fièvre de cheval* [. . .] s'était declarée avec tant de violence à Paris et dans ses environs. . . . Maintenant tout l'Empire en est atteint." V. J., "Courrier de Paris," *Illustration* 42 (1 August 1863), 83.

26. "Tout le monde connait ce triste et misérable emplacement du Champ de Mars, aride, nu, presque désolé, terrain inégal, sablonneux, déshonoré par de hideuses baraques, aussi incommodes qu'insuffisantes." Louis Enault, *Les courses de chevaux en France et en Angleterre.* Excerpt from the *Revue Française* (November 1865) (Paris, 1865), 34.

27. The first bail leasing the terrain was signed with the city of Paris and took effect on 1 July 1856. Jean-Pierre Reynaldo, *Histoire des courses plates* (Epinay-sur-Seine, 1990), 123–124.

28. Reynaldo 1990, 125. On the inauguration of the racecourse, see Henri Grignan, "Inauguration du champ de course du bois de Boulogne," *Illustration* 29 (2 May 1857), 279–281.

29. Henry Lee, *Historique des courses de chevaux de l'antiquité à ce jour* (Paris, 1914), 777.

30. Gayot 1865, 256–257.

31. On the first Grand Prix de Paris, see X. Feyrnet, "Courrier de Paris," *Illustration* 41 (6 June 1863), 354–355.

32. Gayot 1865, 256–257.

33. "Les règlements de Chantilly n'ont pas la même sévérité que ceux de Longchamp, et ils ne frappent point du même ostracisme les belles personnes qui ont le tort ou le malheur de se présenter toutes seules à la barrière de l'enceinte du pesage. On les laisse entrer [. . .]; mais, comme si elles voulaient se rendre justice à elles-mêmes, elles se placent invariablement dans la tribune de gauche, laissant la droite aux personnes accompagnées." Enault 1865, 37.

34. ". . . des dames . . . un peu drôles . . . qui boivent du champagne dans les calèches." Goncourt, *Renée Mauperin*, 52.

35. "Mais Nana s'amusait surtout des dames que l'averse avait chassées des rangées de chaises, alignés sur le sable, au pied des tribunes. Comme l'entrée de l'enceinte du pesage était absolument interdite aux filles, Nana faisait des remarques pleines d'aigreur sur toutes ces femmes comme il faut, qu'elle trouvait fagotées, avec de drôles de têtes." Émile Zola, *Nana* (Paris, 1977), 359. It should be mentioned that the same rules did not necessarily apply at the provincial racetracks, which tended to be much less formal in custom and certainly less grandiose.

36. Enault 1865, 18. For a contemporary account of the training practices for grooms, trainers, and jockeys during the nineteenth century, see Albert de Saint-Albin, *Les courses de chevaux en France* (Paris, 1890), 161–199.

37. Enault 1865, 14–15.

38. Enault 1865, 12–13.

39. Gaillard 1984, 66.

40. The Grand Prix de Paris was run on 5 June 1864. Blomac 1991, 274.

41. Blomac 1991, 274.

42. Alban d'Hauthuille, *Les courses de chevaux* (Paris, 1982), 21.

43. Lane 1990, 52.

44. Blomac 1991, 272–273.

45. F. Laffon, *Monde des courses, moeurs actuelles du Turf. Etudes nouvelles et historiques suivis d'un dictionnaire-annuaire* (Paris, 1896), 777.

46. Enault 1865, 24.

47. Gayot 1865, 329–330.

48. Hauthuille 1982, 12.

49. Chapus 1853, 49.

50. There is some confusion over the date of this race; Chapus states it was 29 September, Enault gives the date as 20 September. They agree on all the other details of the race. Chapus 1853, 49–52; Enault 1865, 24.

51. ". . . une lutte disputée avec art. . . . faisant ressortir la force et la vigueur du cheval, la mâle énergie et l'habilité du jockey." Gayot 1865, 184–185.

52. Hauthuille 1982, 13.

53. ". . . encore une des excentricités britanniques qui n'ont pu s'acclimater en France." ". . . le public d'abord, et les amateurs ensuite, se sont promptement dégoûtés de cet exercice de casse-cou, de ces dangers sans le moindre but plausible d'utilité, de ces chutes grotesques ou fangeuses, de ces cavaliers, de ces chevaux. . . . Le steeple-chase français est decidement mort, et enterré au fond du ruisseau de la Bièvre. Que la vase lui soit légère!" Albert Cler, *La comédie à cheval, ou manies et travers du monde équestre* (Paris, 1842), 63–64.

54. Chapus 1853, 49, 52.

55. This scene is described in act III, scene 5 of the play. Edmond and Jules de Goncourt, *Théâtre. Henriette Maréchal, La Patrie en danger* (Paris, 1885), 128–129. This play made its debut at the Comédie-Française on 5 December 1865 and was serialized in the journal *L'Événement* from 9 to 14 December 1865. On the possible association between this play and Degas' painting *The Fallen Jockey*, see Herbert 1988, 160.

56. Chapus 1853, 207–211. Louis Enault, in his history of horse racing, mentioned another victim, a Léonce de Saint-Germain, who had also been killed in a more recent steeplechase. Enault 1865, 25.

57. Chapus 1853, 53–54.

58. Hauthuille 1982, 13.

59. Another racecourse was later built at Vincennes and was inaugurated on 7 September 1879.

60. "Le nom de la Marche évoque des idées de beaux jours, de brillants cavaliers, de femmes rieuses et belles, de voitures somptueuses, de luxe aristocratique . . ." Émile de Bédouilliere, *Description des environs de Paris, et le Nouveau Paris* (1867). Quoted in Gaillard 1984, 96.

61. "Quant aux steeple-chases, ils ont gardé le glorieux privilège d'être disputés par des coureurs aristocratiques, vraie fleur des pois des gentilhommes, jaloux de prouver qu'eux aussi, comme leurs aïeux, savent bien faire à l'heure de l'épreuve et du péril." Enault 1865, 25.

62. Gayot 1865, 332.

63. A *demi-sang* is the crossbred of a thoroughbred and a horse of a different race, or a crossbred between two half-breeds.

64. Hauthuille 1982, 13.

65. Gayot 1865, 332.

66. Gayot 1865, 333.

67. Laffon 1896, 66.

68. Pierre Larousse, *Grand dictionnaire universel du XIXe siècle*, vol. 12 (Paris, [1865–1876]), 222, "Pari."

69. Blomac 1991, 270.

70. *La Grande Encyclopédie* 13: 175, "Course."

71. Reynaldo 1990, 145–146.

72. In 1881, *Foxhall* became the first American horse to win the Grand Prix de Paris. Laffon 1896, 21–23.

Chronology

	1775	1776	1780	1781	1806	1809

DEGAS' LIFE

HORSE RACING IN FRANCE

9 March. The first true horse race in France is held on the plains of Sablons, northwest of Paris

20 April. The first French racetrack is inaugurated at Sablons

Creation of the Derby at Epsom, England

2 April. Inauguration of the racetrack at Vincennes, on the outskirts of Paris, in the royal park near the chateau

Establishment of a racetrack at the Champ-de-Mars, Paris

The 2,000 Guineas, a one-mile race for three-year-olds, is established at Newmarket, England. This race, along with the Epsom Derby and the Saint-Leger at Doncaster (founded in 1776), would form the British Triple Crown, the most coveted racing title

ARTISTIC EVENTS

Théodore Géricault, *The Derby at Epsom*, 1821, oil on canvas. Musée du Louvre, Paris

224

1817	1821	1827	1831	1833	1834

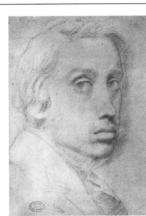

Degas, *Self-Portrait*, c. 1857, chalk on paper. National Gallery of Art, Woodner Family Collection

Degas, *Portrait of M and Mme Paul Valpinçon*, 1861, graphite on paper. The Pierpont Morgan Library, New York

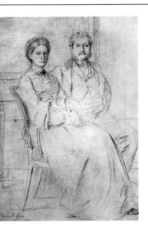

1 January. Paul Valpinçon, one of Degas' closest friends and his host at Ménil-Hubert, is born

19 July. Edgar Degas is born in Paris to Auguste De Gas and Célestine Musson Degas

"Sunday Riders," engraving, from Albert Cler, *La comédie à cheval* (Paris, 1842), 96. National Gallery of Art

11 November. The Société d'Encouragement pour l'Amélioration des Races des Chevaux en France is founded to promulgate the breeding of pure bred horses in France and promote thoroughbred horse racing

1 April. The first serious steeplechase takes place at La Croix-de-Berny outside of Paris

At the Paris Salon, the sculptor Jacques-Nicolas Brunot exhibits three studies of equestrian anatomy: *A Flayed Horse in a Trotting Gait, A Horse's Head Dissected,* and *A Horse's Legs Dissected, From Nature*

Théodore Géricault paints *The Derby at Epsom*

Carle Vernet exhibits *Deer Hunt on Saint Hubert's Day in 1818* in the Salon (Boggs, fig. 48)

Alfred de Dreux, a painter of equestrian subjects, makes his Salon debut with *Interior of a Stable* and *Horse Jumping a Ditch.* The *animalier* sculptor Christophe Fratin also debuts with two waxes, including *Fermer, English Thoroughbred Horse*

Jacques-Auguste Fauginet exhibits three equestrian plaster portraits at the Salon: *Le George, Horse; Le Spot, Horse;* and *Le Prince, Horse.* All are lent by Lord Seymour, a founding member of the French Jockey Club

DEGAS' LIFE

16 November. Achille De Gas, the artist's brother, is born in Paris

8 April. Thérèse De Gas, the artist's sister, is born in Naples

Degas, *Achille De Gas in the Uniform of a Cadet,* 1856/1857, oil on canvas. National Gallery of Art, Chester Dale Collection

HORSE RACING IN FRANCE

15 May. Inauguration of the racetrack at Chantilly. Patronized by the French court and aristocracy, it becomes the most popular racing venue in France throughout the 1830s and 1840s

17–19 June. The Cercle de la Société d'Encouragement pour l'Amélioration des Races des Chevaux en France, more informally known as the Jockey Club (until its official designation as such in 1904), is founded

18 June. Establishment of the Prix du Jockey Club at Chantilly. Known as the "Derby de Chantilly" – it is modeled after the Epsom Derby and covers the same distance, 2,400 meters or one and one-half miles – it is run for the first time in 1836 and carries a prize of 5,000 francs

A racetrack is founded at Caen in Normandy

A racetrack is established at Avranches, where the specialty is the *course au clocher,* a variant on the English and Irish steeplechase

ARTISTIC EVENTS

Antoine-Louis Barye, the renowned *animalier* sculptor, exhibits *Young Lion Attacking a Horse,* a bronze, at the Salon

Jean-François-Théodore Gechter exhibits an iron-cast sculpture, *Horse of English Blood,* at the Salon

Eugène Delacroix paints *The Capture of Constantinople* for the Galeries Historiques at the Château de Versailles (Musée du Louvre), a painting that Degas would later copy

2 July. Marguerite De Gas, the artist's sister, is born in Passy

Degas, *René de Gas*, 1855, oil on canvas. National Gallery of Art, Collection of Mr. and Mrs. Paul Mellon

5 May. René de Gas, the artist's brother, is born in Paris

Edgar attends the Lycée Louis-le-Grand as a boarder until 1853

7 April. Receives permission to copy at the Cabinet des Dessins, Musée du Louvre

9 April. Receives permission to copy at the Cabinet des Estampes, Bibliothèque Nationale

12 November. Registers at the École de Droit, which he probably did not attend

Caricature of a steeplechase, engraving, from Cham, *Paris aux courses* (Paris, n.d.)

The filly *Jouvence* wins the famed Goodwood Cup, becoming the first French horse to win a major race on English soil

Alfred de Dreux, *Equestrian Portrait of the Duc d'Orléans*, 1844, oil on canvas. Musée des Beaux-Arts, Bordeaux

Alfred de Dreux is awarded a second-class medal at the Salon, where he exhibits three equestrian subjects, including *Equestrian Portrait of His Royal Highness Mgr. the Duc d'Orléans*

Isidore Bonheur, brother of painter Rosa Bonheur and a sculptor who would become renowned for his equestrian subjects, exhibits *Horse, Study after Hamdani-Blanc, Arabian Stallion,* a wax, at the Salon

Rosa Bonheur paints *The Horse Fair,* which she exhibits in the Salon

Rosa Bonheur, *The Horse Fair,* 1853, oil on canvas. The Metropolitan Museum of Art, Gift of Cornelius Vanderbilt, 1887

DEGAS' LIFE

1855

Paul Valpinçon's father takes Degas to visit Jean-Auguste-Dominique Ingres, the living artist whom he most admires

6 April. Registers as a pupil of Louis Lamothe at the École des Beaux-Arts, where he probably made copies of the casts of the Parthenon frieze

1856

July – September. Travels to Lyons, where he visits with Lamothe and Hippolyte Flandrin. At the École des Beaux-Arts, makes copies after another cast of the Parthenon frieze

1857

17 July. In Naples to visit his grandfather, René-Hilaire Degas, and the rest of his Neapolitan family

7 October – late July 1857. Lives, draws, and paints in Rome

1858

1 August. With his grandfather in Naples until the end of October

late October – 24 July 1858. Works in Rome, where he meets and is befriended by Gustave Moreau

1859

4 August. In Florence at the Bellellis until March 1859. Visits the Uffizi Gallery, where he copies Italian masters, including Uccello (cat. 2)

31 August. Death of his grandfather, in Naples

about 6 April. Returns to Paris and lives with his father at 4, rue de Mondavi

1 October. Moves into 13, rue de Laval, which is principally his studio

HORSE RACING IN FRANCE

26 April. Inauguration of the racetrack at Longchamp, Paris

"Autumn Races at the Bois de Boulogne (Longchamp): The Paddock," 1858, wood engraving. Cabinet des Estampes, Bibliothèque Nationale, Paris

Caricature of a steeplechase, engraving, from Cham, *Paris aux courses* (Paris, n.d.)

ARTISTIC EVENTS

Ernest Meissonier, *The Emperor at Solferino,* 1864, oil on canvas. Musée National du château, Compiègne

21 March. Arrives in Naples

2 April. Leaves Naples for Florence, where he copies Benozzo Gozzoli's frescoes in the Medici-Riccardi palace (cats. 3–5)

9 July. Rossini's *Sémiramis* performed at the Paris Opéra

September–October. Spends three weeks in Normandy at Ménil-Hubert, the Valpinçons' estate near Orne

Dates *The Gentlemen's Race* (cat. 11). Meets Manet for the first time while copying at the Louvre

Degas, *Édouard Manet, Bust-Length Portrait,* c. 1861, etching, drypoint, and aquatint on paper. National Gallery of Art, Rosenwald Collection

Creation of four new prizes: the Grand Prix de l'Empereur, the Grand Prix de l'Impératrice, the Grand Prix du Prince Impérial, and the Prix de Longchamp

29 March. Inauguration of the new racetrack at Vincennes

31 May. The first Grand Prix de Paris is run at Longchamp, and *The Ranger,* an English horse, wins. With a prize of 100,000 francs – 50,000 francs donated by the city of Paris and an additional 50,000 francs contributed by the five leading French railroad companies – it will become one of the best endowed races in the world

15 July. The first races are held at Deauville

The Société des Steeple-Chases is founded under the presidency of Joseph Joachim Napoléon Murat, the grandson of King Joachim of Naples

5 June. Vermout, a French horse, wins the second Grand Prix de Paris, beating *Blair Athol,* the winner of the Epsom Derby

14–15 August. Inauguration of the racetrack at Deauville

11 October. Gladiateur wins the Newmarket "Derby" in England

Delacroix paints *Arabian Horses Fighting in a Stable* (Musée du Louvre)

John Lewis Brown exhibits three equestrian paintings at the Salon, including *Steeplechase.* Gustave Courbet exhibits five paintings, including *The Whipper-In* (Neue Pinakothek, Munich) and *The Fox in the Snow.* The painter Henry Delamarre, a renowned horse breeder and the director of the studfarm at Bois-Roussel, exhibits *The Start: The Turf at Chantilly*

Delamarre exhibits two equestrian works at the Salon, including *Thoroughbred Foals in Training on the Turf at Chantilly.* Pierre-Jules Mène exhibits three works of sculpture, including his wax *The Victor of the Derby: Group*

At the Salon, Ernest Meissonier exhibits *The Emperor at Solferino,* lent by Emperor Napoléon III. Also at the Salon is *The Derby of Chantilly Run in 1863* by the painter Georges Washington, a bronze *The Jockey* by Isidore Bonheur, as well as a bronze cast of Mène's sculpture *The Victor of the Derby: Group*

DEGAS' LIFE

1 May. Debuts at the Paris Salon with *Scene of War in the Middle Ages* (Boggs, fig. 26)

1 May. Exhibits *Scene from the Steeplechase* at the Salon (cat. 16)

15 April. Exhibits two family portraits at the Salon

Degas, *Madame Camus*, 1869/1870, oil on canvas. National Gallery of Art, Chester Dale Collection

HORSE RACING IN FRANCE

31 May. Gladiateur becomes the first French horse ever to win the Epsom Derby. This feat would not be repeated until 1948, when *Pearl Diver* would win the title

11 June. Gladiateur wins the Grand Prix de Paris

7 October. Gladiateur wins the Grand Prix de l'Empereur at Longchamp, his last race. During his career he won sixteen of his nineteen races, eleven of which were held in England

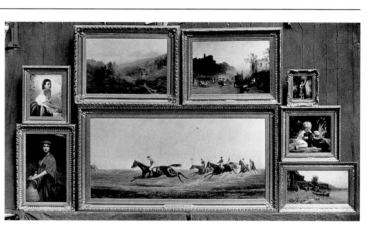

Olivier Pichat, *The Grand Prix de Paris of 1866*, 1866, oil on canvas. Location unknown

ARTISTIC EVENTS

Delamarre exhibits *Grand Prix de Paris, 1864*, a painting depicting the victory of *Vermout*, a horse from his own stable (Jones, fig. 7). *Vermout* was also portrayed in two other works at the Salon: a painting by the Dutch painter Martinus Kuytenbrouwer and a bronze by the sculptor Alfred Barye, son of Antoine-Louis Barye. The Dutch painter Charles Bombled exhibits *A Steeplechase* and Olivier Pichat shows *Steeplechase: cracks français*

At the Salon, Pichat shows his painting *The Grand Prix de Paris of 1866*, lent by Emperor Napoléon III, and Gustave Moreau exhibits the painting *Diomedes Devoured by His Horses*. Alfred Barye exhibits a bronze, *Racehorse Mounted by a Jockey*; Isidore Bonheur exhibits his plaster *English Thoroughbred Horse*; Mène exhibits his wax *The Victor of the Race: Group*

Publication of Louis-Jean Delton's *Album Hippique*, his first compendium of equestrian photographs

Edouard Manet exhibits *The Races at the Bois de Boulogne* (location unknown; presumed to have been cut, with fragments in a private collection in France and the Cincinnati Art Museum) at his private retrospective exhibition held at the Place d'Alma. At the Salon, Delamarre exhibits *Brood Mares* and *Steeplechase Horses*. Joseph

Cuvelier, a friend of Degas, exhibits a bronze *Carrossier, Half-Bred Horse*; Mène exhibits a life-size bronze *"Amazone"*; and Emmanuel de Santa-Coloma exhibits a wax group *Irish Horse*

1868	1869		1870		1871

26 March. Registers for the last time as a copyist at the Musée du Louvre

1 May. Shows *Portrait of Mlle E. F . . . [Eugénie Fiocre] in the Ballet "La Source"* at the Salon (cat. 8)

1 May. Exhibits *Portrait of Mme G . . . [Mme Gaujelin]* (Isabella Stewart Gardner Museum, Boston) at the Salon. A second portrait, *Mme Camus at the Piano* (Bührle Collection, Zurich), is refused

1 May. Exhibits at the Salon for the last time with *Portrait of Mme C . . . [Mme Camus]*, a painting, and *Portrait of Mme G . . . [Mme Gobillard]*, a pastel (Metropolitan Museum of Art)

19 July. France declares war on Prussia

September. Volunteers for the National Guard

4 September. Proclamation of the Third Republic in France

21 October. Degas' friend Cuvelier is fatally wounded in battle at Malmaison during the Franco-Prussian War

18 March. Proclamation of the Commune. Degas goes to Ménil-Hubert

1 June. Returns to Paris

October. Visits London, apparently for the first time

The Grand Prix de l'Empereur is renamed the Grand Prix Gladiateur. A statue of *Gladiateur* by Isidore Bonheur is erected at the entrance to Longchamp

Creation of the *pari-mutuel*

The Prix de l'Empereur, founded in 1855, is renamed the Prix Morny, in honor of the duc de Morny, the half-brother of Emperor Napoléon III who created the racetracks at Deauville and Longchamp. Following the collapse of the Second Empire, the race is renamed the Grand Poule des Produits

As a result of the upheaval of the Franco-Prussian War and the Commune, all racing activities in France are suspended until 1871. A number of horse breeders, including Major Fridolin, Henry Delamarre, and Auguste Lupin, move their stables to England, where they would compete with great success

At the Salon, Delamarre exhibits *"Vertugadin," Racehorse*; Cuvelier exhibits a wax *Portrait of Mlle V. de W . . . : Equestrian Statuette*; and Mène exhibits a wax *Norman Mare and Her Foal: Group.* Ferdinand Pautrot exhibits a wax *Horse* and Jules Vast exhibits a wax sculpture *Horse Winning a Victory*

At the Salon, Edmond-Georges Grandjean exhibits *"Suzerain," Winner of the Derby in 1868*; Etienne Leroy exhibits *At the Races*; Nicolas Sicard exhibits *Steeplechase: Jockey Clearing a Hurdle.* Cuvelier exhibits a pair of waxes, *Equestrian Portrait of M. d'H . . .* and *Equestrian Portrait of M. A. B*

Ferdinand Moutier exhibits a wax *Horse* and de Santa-Coloma exhibits *Woman on Horseback* and *Percheron Horse*, both wax

Publication of six miniature *Albums Delton*, composed of equestrian photographs. At the Salon, Annet-Gustave-Paul Lagrange exhibits *Horse in Training*; Victor Renault exhibits *Horse Race at Rosporden, Brittany*; Nicolas Sicard exhibits *The Races at Lyon: The Prix de l'Empereur.* Cuvelier exhibits two equestrian sculptures,

Leaving the Paddock: Group and *Equestrian Portrait of M. d'H . . .*; and Pierre Duberteau exhibits a pair of waxes, *Skeleton of a Horse* and *English-Norman Horse with Harness.* Degas' friend Paul Valpinçon exhibits a painting *Entrance to the Forest: Ménil-Hubert (Orne)*

Gustave Moreau, *Diomedes Devoured by His Horses*, 1866, oil on canvas. Musée des Beaux-Arts, Rouen

DEGAS' LIFE

January–September. Durand-Ruel buys eight Degas paintings, including five equestrian pictures: *Before the Race* (cat. 50), *Horses in a Meadow* (cat. 39), *At the Races in the Countryside* (cat. 38), *Racehorses before the Stands* (cat. 56), and *Mare with Colt*

Summer. Exhibits two paintings, including *A False Start* (cat. 55), in the *Fourth Exhibition of the Society of French Artists* in London

12 October. With René, sails from Liverpool to New York on his way to New Orleans

2 November. At the Races (cat. 38) on view at the *Fifth Exhibition of the Society of French Artists* in London

28 April–7 May. A collector, Ernest Hoschedé, purchases *The False Start* (cat. 55). Jean-Baptiste Faure, the renowned singer and avid collector of impressionist paintings, purchases three equestrian pictures by Degas through Charles W. Deschamps, manager of Durand-Ruel's London galleries: *At the Races in the Countryside* (cat. 38), *Before the Race* (cat. 50), and *The Racecourse*

Summer. Shows three paintings at the *Sixth Exhibition of the Society of French Artists* in London: *Getting Ready for the Start, A Race-Course in Normandy* (cat. 38), and *Horses at Grass* (cat. 39)

28–29 October. Degas meets Faure

16 February. Faure buys *Racehorses before the Stands* (cat. 56)

23 February. The artist's father dies in Naples, leaving his family bankrupt

5 March. Persuades Faure to buy him six pictures owned by his dealer, including *Horses in a Meadow* (cat. 39) and *Out of the Paddock* (cat. 57). In exchange, promises to paint new works for the singer, including *The Racecourse, Amateur Jockeys* (Boggs, fig. 63)

15 April. At the first impressionist exhibition shows ten works, including *Start of the Races, The False Start* (cat. 55), and *At the Races in the Provinces* (cat. 38)

HORSE RACING IN FRANCE

"The Races," engraving, from Albert Cler, *La comédie à cheval* (Paris, 1842), 69. National Gallery of Art

1 November. Inauguration of the racetrack at Auteuil in Paris

Boiard becomes the first horse to win both the Grand Prix de Paris and the Prix du Jockey Club, the two most prestigious flat races run on French soil

The first grand steeplechase is run as the Grand National de France. An English horse, *Miss Hungerford*, wins the race. The following year it would become known as the Grand Steeple-Chase de Paris

ARTISTIC EVENTS

Manet paints *The Races at the Bois de Boulogne*

Renoir paints *Riding in the Bois de Boulogne*. Rejected for the Salon, it is exhibited in the Salon des Refusés

Pierre-Auguste Renoir, *Riding in the Bois de Boulogne*, 1873, oil on canvas. Kunsthalle, Hamburg

April. Shows twenty-four works at the second impressionist exhibition

1876

16 June. In a letter to Faure, apologizes for his delay in finishing *Racehorses before the Stands*: "I . . . am going to start right away on your *Races* The unfortunate thing is that I shall have to go and see some real racing

again and I do not know if there will be anything after the Grand Prix. . . . In any case you will be able to see something of your own next Saturday, 24 June between 4 and 6 o'clock"

April. Exhibits twenty-five works at the third impressionist exhibition

31 October. Writes to Faure, continuing to apologize for not delivering the works that the singer had commissioned, and promises "You will have *The Races* on Monday. I have been at it for two days and it is going better than I thought"

10 April. Exhibits twenty-five works at the fourth impressionist exhibition, including *Jockeys before the Race* (Boggs, fig. 64)

10 December. Mrs. Cassatt writes to her son Alexander that Degas is unlikely to finish *The Steeplechase* for him

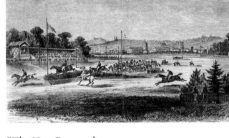

"The New Racetrack at Vincennes—Steeplechase run on Monday, 6 April 1863," c. 1863, wood engraving. Cabinet des Estampes, Bibliothèque Nationale, Paris

The French horse *Verneuil* wins the Jockey Club Cup in Newmarket, the first in a string of victories in England, including the Doncaster Cup and the New-Stakes the following year

7 September. Inauguration of the new racetrack at Vincennes, which would specialize in steeplechase and trotting races

Meissonier paints his monumental *1807, Friedland*

November. A posthumous retrospective of the *animalier* sculptor Antoine-Louis Barye is held at the École des Beaux-Arts in Paris, which includes a number of equestrian works

Ernest Meissonier, *1807, Friedland*, 1875, oil on canvas. The Metropolitan Museum of Art, Gift of Henry Hilton, 1887

15 October. Dr. Étienne-Jules Marey publishes his studies of animal motion in the journal *La Nature*

At the World's Fair in Paris, four waxes by Cuvelier are exhibited posthumously, including three equestrian portraits and *Leaving the Paddock: Group*. At the Salon, Isidore Bonheur exhibits two plasters, including *Racehorse: Group*

Henri de Toulouse-Lautrec paints *The Races at Chantilly* (private collection). At the Salon, Isidore Bonheur exhibits his bronze *A Jockey*; Louis-François-Georges Ferrières exhibits a wax sculpture, *Horse and Jockey: Group*

DEGAS' LIFE

1880

1 April. Opening of the fifth impressionist exhibition. Although the catalogue lists twelve works by Degas, not all of those were actually shown, while others not listed were exhibited

27 December. For the first time in ten years, Durand-Ruel buys a work by Degas, a pastel of jockeys

1881

2 April. The sixth impressionist exhibition includes seven pictures and his wax *Little Dancer Fourteen Years Old*, the only sculpture exhibited during his lifetime

18 April. The father of Mary Cassatt writes to his son Alexander that Degas is still reworking *The Steeplechase*, which Cassatt had hoped to buy, and believes that it requires only two hours of work

1882

9 September. In Veyrier, Switzerland; also visits Geneva and Zurich

10 December. Sells *Before the Race* (cat. 70) to Durand-Ruel for 2,500 francs. The following month the painter Henri Lerolle, who will become a friend and an admirer of Degas, buys the painting

1883

14 February. Durand-Ruel purchases *The Gentlemen's Race* (cat. 11) for 5,200 francs, a work that had been executed in 1862 but was reworked prior to this transaction

April. Shows seven works, including *Gentlemen's Race* (cat. 11) and *Jockeys before the Race*, at the Dowdeswell and Dowdeswell Galleries in London

1884

Executes a pastel (L 878) and a painting (cat. 80) with the title *Before the Race*

Degas, *Little Dancer Fourteen Years Old*, c. 1878—1881, wax. Collection of Mr. and Mrs. Paul Mellon, Upperville, Virginia Collection *(right)*

HORSE RACING IN FRANCE

1881

Foxhall becomes the first American horse to win the Grand Prix de Paris

1882

Creation of The Société de Sport de France, an association conceived to encourage sporting activities, including racing

Édouard Manet, *The Races at the Bois de Boulogne*, 1872, oil on canvas. Collection of Mrs. John Hay Whitney

ARTISTIC EVENTS

1881

3 November. In Meissonier's studio in Paris, Eadweard Muybridge gives a demonstration of instant photographs of the movement of animals

1882

Isidore Bonheur exhibits his plaster *Jumping the Hurdle* at the Salon. Brown paints *To the Starting Post*

1883

Jean-Baptiste-Gustave Deloye exhibits a silver statuette, *The Prize of the Jockey-Club*, at the Salon

1884

14 December. Le Sport dans l'Art opens at the Galerie Georges Petit, Paris, and Degas is represented by two works, *The Start of the Gentlemen's Race* (cat. 11) and *The Start*

Publication of Delton's collection of equestrian photographs, *Le tour de Bois*

10 April. Special Exhibition: Works in Oil and Pastel by the Impressionists of Paris, organized by Durand-Ruel, opens at the American Art Association, New York. This is the first exhibition of impressionist painting in the United States. Nineteen works by Degas were shown, including *Jockeys* (cat. 66)

15 May. Exhibits fifteen works at the eighth and final impressionist exhibition

2 July. Writes to Faure, "I shall need a few more days to finish your big picture of the Races. I have taken it up again"

2 January. Writes to Faure, "This summer I set to work again on your pictures, particularly the one of the horses"

In a letter to his friend Albert Bartholomé, the sculptor, remarks "I have not done enough horses"

9 July. Theo van Gogh, the brother of the painter Vincent van Gogh and an agent for Goupil, Boussod, and Valadon, purchases *Four Racehorses and Riders* (cat. 82) from the artist

22 October. Durand-Ruel purchases *Jockey* (Philadelphia Museum of Art), a pastel that Mary Cassatt would buy for her brother on 18 December 1889

Writes sonnets, including one dedicated to a thoroughbred

The Prix de Longchamp is renamed the Prix Hocquart. Following the victories of the French horse *Plaisanterie* at both the Cesarawitch Stakes and the Cambridgeshire Stakes, The Jockey Club of Newmarket introduces strict handicapping rules against French horses racing more often on English soil

In an attempt to curtail betting, the French government bans the *pari à la cote* at racetracks

Emmanuel Frémiet exhibits a bronze sculpture, *Racehorses and Jockeys*, at the Salon

Jean Béraud paints *The Races at Longchamp: Arriving at the Finishing Post*

Muybridge publishes *Animal Locomotion*

Pierre-Nicolas Tourgenoff exhibits his plaster *Two Horses* at the Salon

Brown exhibits *"Before the Steeplechase"* at the Salon

Emmanuel Frémiet, *Racehorses and Jockeys*, 1885, bronze. Virginia Museum of Fine Arts, The Paul Mellon Collection

John Lewis Brown, *Before the Start*, 1890, oil on canvas. Musée d'Orsay, Paris

	1889	1890	1891	1892	1893
DEGAS' LIFE		*26 September.* With Bartholomé, travels by horse and carriage into the Burgundy region to visit Georges and Henriette Jeanniot at their chateau in Diénay	*December.* Opening of *A Small Collection of Pictures by Degas and Others* at Mr. Collie's Rooms, 398 Old Bond Street, London. Seven works by Degas are shown, including *Racehorses*	*September.* An exhibition of Degas' landscapes is held at the Galerie Durand-Ruel, Paris, the first of only two exhibitions in his lifetime devoted exclusively to his work	*2 January.* Faure sells five works to Durand-Ruel, at a considerable profit: *Racehorses before the Stands* (cat. 56), *At the Races in the Countryside* (cat. 38), *The Racecourse, Amateur Jockeys* (Boggs, fig. 63), *Women Ironing* (Musée d'Orsay), and *Woman Ironing* (National Gallery of Art)
HORSE RACING IN FRANCE	On the initiative of the Comité des Steeple-Chases, the purse for the Grand Steeple-Chase de Paris is augmented to the sum of 120,000 francs, making it the best endowed race run on French soil		*2 June.* A law is passed placing the races under state control in order to weaken the authority of the Société d'Encouragement, stop the proliferation of suburban racetracks, and regulate betting		*Ragotsky* wins both the Grand Prix de Paris and the Prix du Jockey Club
ARTISTIC EVENTS	*1 May.* The World's Fair opens in Paris. Among the works shown in the French Fine Arts Section are Brown's painting *"Before the Steeplechase,"* Frémiet's bronze *Racehorses and Jockeys*, and four bronzes by Isidore Bonheur, including *Jockey Caressing his Horse* and *Jumping the Hurdle.* Bonheur is awarded a first-class medal	*La photographie hippique,* Delton's collection of equestrian photographs, begins publication	Brown exhibits his painting *Before the Start* at the Salon of the National Society of Fine Arts. It is purchased by the French State for the Musée du Luxembourg	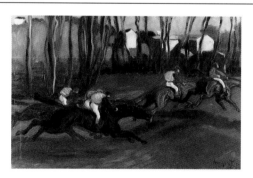 Louis Anquetin, *The Races*, 1893, oil on canvas. Musée d'Orsay, Paris	Louis Anquetin paints *The Races*

1894	1896	1897	1899	1901	1902
Produces *Horses in Training*, a pastel (cat. 98)	*5 November.* Opening of the *First Annual Exhibition* at the Carnegie Art Gallery, Pittsburgh. Two works by Degas are shown, including *Racehorses* (Bührle Foundation, Zurich)			*7 November.* The *Sixth Annual Exhibition* opens at the Carnegie Institute, Pittsburgh, which includes *The Racecourse*	*6 November.* Opening of *A Loan Exhibition (Seventh Annual Exhibition)* at the Carnegie Institute, Pittsburgh. Four works by Degas are shown, including two entitled *Racehorses*, both lent by Durand-Ruel

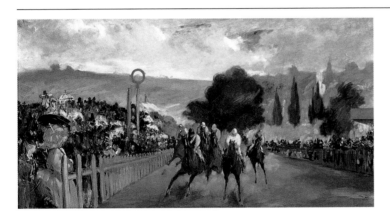

Édouard Manet, *The Races at Longchamp*, 1866, oil on canvas. The Art Institute of Chicago, Mr. and Mrs. Potter Palmer Collection

The renowned horse breeder Edmond Blanc creates a new racetrack at Saint Cloud, on the edge of the Bois de Boulogne

Pierre-Auguste Renoir paints *Yvonne and Christine Lerolle at the Piano*, which depicts Degas' *Before the Race* (cat. 70) in the background

Toulouse-Lautrec executes *The Jockey*, a lithograph

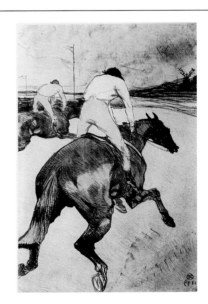

Pierre-Auguste Renoir, *Yvonne and Christine Lerolle at the Piano*, 1897, oil on canvas. Musée de l'Orangerie, Paris

Henri de Toulouse-Lautrec, *The Jockey*, 1899, lithograph. National Gallery of Art

DEGAS' LIFE

15 November. The *Comparative Exhibition of Native and Foreign Art* opens at The American Fine Arts Society, New York. Durand-Ruel lends two works by Degas, including *Racehorses*

January–February. Thirty-five works by Degas are shown in an exhibition of impressionist paintings held at the Grafton Galleries in London. Among the works exhibited are *The Races: Before the Start* (cat. 94), *Carriage at the Races* (pastel, cat. 38), and *Horses in the Meadows* (cat. 39)

12 February. Works of *Some French Impressionists* opens at the Art Association of Montreal. Durand-Ruel lends two works by Degas, including *Racehorses*

December. Seven pastels by Degas are shown in *Modern Francia Nagymesterek Tarlata* at the Nemzeti Szalon, Budapest. Among them is one equestrian work, *Horse by a Riverside*

24 February. Opening of *Exhibition of Paintings and Pastels by Degas* at the Durand-Ruel Galleries, New York. Among the eighteen works shown are *At the Racetrack* and *Racehorses*

19–30 December. The exhibition *La Faune* is held at Bernheim Jeune, Paris, which includes *Racehorses*

HORSE RACING IN FRANCE

The Société d'Encouragement officially becomes the Jockey Club

Saint Caradec wins the Grand Steeple-Chase

Jean Béraud, *The Races at Longchamp: Arriving at the Finishing Post*, 1886, oil on canvas. Musée Carnavalet, Paris

ARTISTIC EVENTS

At the Salon, Alfred Elias exhibits a pastel *Horses in a Pasture;* Maurice Bastide du Lude exhibits a wax statuette *Thoroughbred Horse;* Louis de Monard exhibits a pair of bronzes, *Pure-Bred Mare* and *"Cob," Horse;* and René Paris exhibits a plaster group, *At the Races: Jumping the Open Ditch*

At the Salon, Louise Schmitt exhibits a painting, *Horses in a Stable;* Gustave Surand exhibits a painting, *Boulognese Horses,* and a water-color, *Horses at the Entrance to an Inn;* F.-A. Hippolyte Peyrol exhibits a bronze *Horse;* and the American sculptor Armory C. Simons exhibits a bronze bas-relief, *Horse*

At the Salon, Jules Girardet exhibits a painting, *The First Riding Lesson;* Magdeleine Real del Sarte exhibits a painting, *In the Saddle;* Gustave Surand exhibits *Boulognese Horse, Brown Bay;* Roger Godchaux exhibits a wax *Study of a Horse;* Gaston d'Illiers exhibits a plaster statuette, *Horse from Camargue*

At the Salon, Louis-Eugène de Beaune exhibits *Auteuil, Jumping the Brook;* Raymond Lecourt exhibits *Horses at a Trough;* Alfred Nettement exhibits *Winter Race Meeting at Auteuil;* Eléanor Wigram exhibits *Towards the Finishing Post—The Races at Chantilly;* Aline de Beaulieu exhibits a bronze statuette, *Horse at Rest*

April. A Degas retro-
spective is held at the
Fogg Art Museum,
Cambridge, Massa-
chusetts, which in-
cludes *At the Races*
and *Racehorses*
(cat. 49)

10 December. When
asked how he felt
when his *Dancers at
the Bar* (Metropolitan
Museum of Art) was
sold at auction to Mrs.
Havemeyer for
430,000 francs, the
highest price ever
fetched at auction for
the work of a living
artist, Degas replied,
"I feel like a race-
horse who has won a
race and is given
some oats"

17 February. Opening
of the Armory Show,
New York. Three
works by Degas are
shown, including
Racehorses (cat. 80)

November. Twenty-
nine works by Degas
are shown at the
exhibition *Degas/
Cézanne* at the
galleries of Paul
Cassirer, Berlin,
including *Horse Race*

27 September. Dies
from cerebral conges-
tion. He is buried the
following day in the
family vault at Mont-
martre cemetery
in Paris

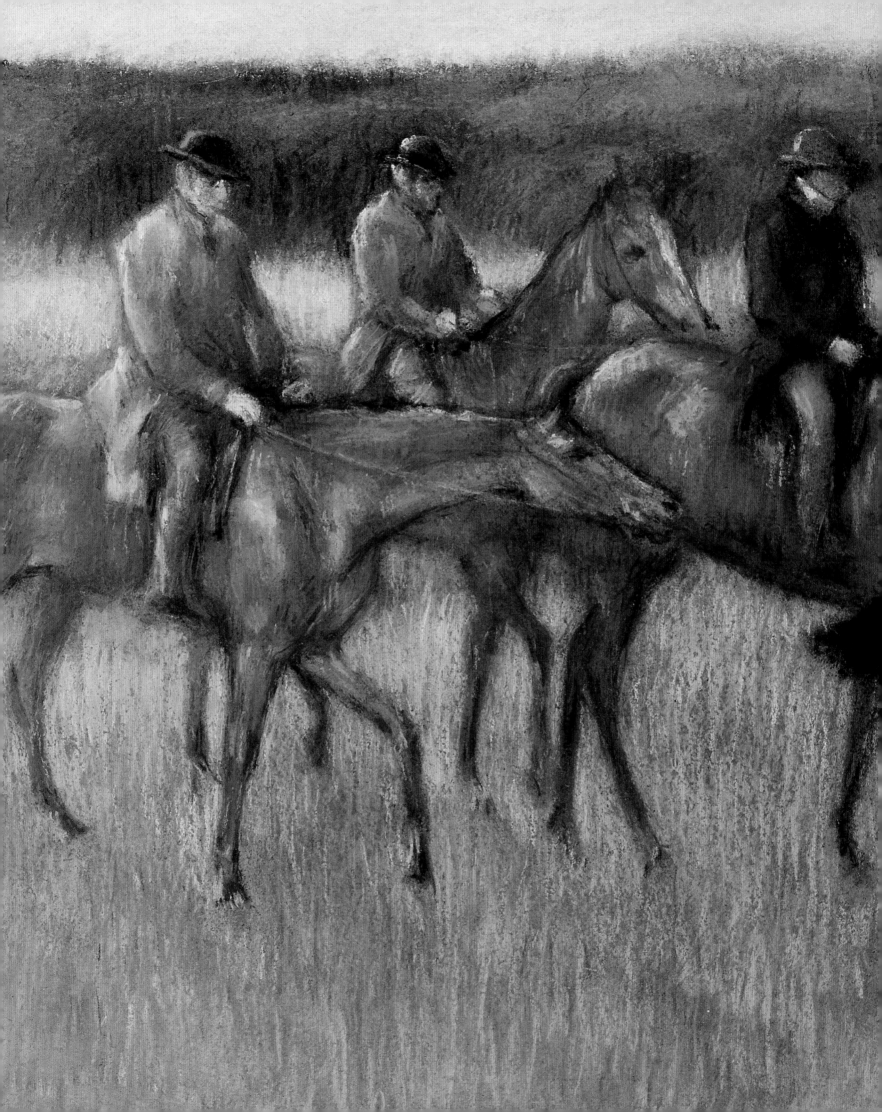

Catalogue

1

Sheet of Studies (after a plaster cast of the west frieze, Parthenon)

1855–1856
graphite on beige flecked wove paper
25.7 x 37.4 (10⅛ x 14¼)
vente stamp lower left: Degas
atelier stamp lower right
stamp of the Musée du Luxembourg lower right

Musée du Louvre, Département des Arts Graphiques, Fonds du Musée d'Orsay, Paris

Provenance
Atelier Degas, Vente I, part of lot 7.b; acquired at that sale by the Musée du Luxembourg, Paris, transferred to the Louvre, 1930

Exhibitions
Paris 1969, no. 101

Selected References
Monnier 1978, 408, 415 repr., fig. 16

2

Battle of San Romano (after Uccello)

1859
graphite on white paper
24 x 39 (9⁷⁄₁₆ x 15⅜)
vente stamp lower right: Degas
inscribed and dated upper left: Florence 1859/Paolo Uccello

Private collection

Provenance
Atelier Degas, Vente IV:92.b; Collection George Vignier, Paris

Exhibitions
Tübingen 1984, no. 36, repr.; Rome 1984–1985, no. 18, repr.

Selected References
Walker 1933, 185; Vitali 1963, 269, repr.; Reff 1964, 251, repr.; Kendall in exh. cat. New York 1993, 60

3

Three Pages (after Benozzo Gozzoli, *Journey of the Magi*, Palazzo Medici-Riccardi, Florence)

1860
graphite on white paper
41 x 20.5 (16⅛ x 8¹⁄₁₆)
vente stamp lower right: Degas
inscribed upper left: "Florence 1860" (latter number probably inscribed over 1859)

Fogg Art Museum, Harvard University Art Museums, Gift of Henry S. Bowers, Class of 1900

Provenance
Atelier Degas, Vente IV:91.a; Vaudoyer; César de Hauke, Paris; sale, Hôtel Drouot, Paris, 12–13 November 1928, no. 368; Henry S. Bowers; his gift to the museum, 1929

Selected References
Walker 1933, 185; Mongan and Sachs 1940, 1: 355, no. 660, 2: repr. fig. 336

4

Lorenzo de Medici and Attendants (after Benozzo Gozzoli, *Journey of the Magi*, Palazzo Medici-Riccardi, Florence)

1860
graphite on white paper
26.2 x 30.5 (10⁵⁄₁₆ x 12)
vente stamp lower right: Degas
inscribed upper left: Florence 1860

Fogg Art Museum, Harvard University Art Museums, Gift of Henry S. Bowers, Class of 1900

Provenance
Atelier Degas, Vente IV:91.c; Vaudoyer; César de Hauke, Paris; sale, Hôtel Drouot, Paris, 12–13 November 1928, no. 368; Henry S. Bowers; his gift to the museum, 1929

Exhibitions
New York, Jacques Seligmann and Company, 1930, *Drawings by Degas*, no. 59; Cambridge 1931, no. 14; New York 1960, no. 72; Manchester 1987, no. 12, repr., fig. 123

Selected References
Walker 1933, 185; Mongan and Sachs 1940, 1: 354–355, no. 659, 2: repr. fig. 337; Reff 1964, 251; Thomson in exh. cat. Manchester 1987, 93–95; Tinterow in exh. cat. Paris 1988–1989, 509, repr.; Kendall in exh. cat. New York 1993, 60, 67

5

Attendants of the Patriarch Joseph of Constantinople (after Benozzo Gozzoli, Journey of the Magi, Palazzo Medici-Riccardi, Florence)

1860
graphite on white paper
64 x 55 (25³⁄₁₆ x 21⅝)
vente stamp lower right: Degas
inscription lower right: Florence 1860

Rijksprentenkabinet, Rijksmuseum Amsterdam

Provenance
Atelier Degas, Vente IV:91.b

Selected References
Walker 1933, 185; Reff 1964, 251; Thomson in exh. cat. Manchester 1987, 99; Pantazzi in exh. cat. Paris 1988–1989, 268, repr.

6

Alexander and Bucephalus

1859–1861
oil on canvas
115 x 89 (45¼ x 35¹⁄₁₆)
vente stamp lower right: Degas
L 91

National Gallery of Art, Washington, Bequest of Lore Heinemann in memory of her husband, Dr. Rudolf J. Heinemann, 1997.57.1

Provenance
Atelier Degas, Vente I:5, as "Achille et le Bucéphale"; Collection Marseille, Paris; Collection Graber, Morcote (by 1951); Knoedler and Co., Inc., by 1958

Exhibitions
Bern 1951–1952, no. 4, as c. 1861–1862; Los Angeles 1958, no. 8, as 1861–1862

Selected References
Cooper 1953, 15; Kendall in exh. cat. New York 1993, 32, 39

7

Study of a Horse and a Group of Attendants (study for Sémiramis Building a City)

1860–1863
graphite and black chalk with *estompe*, touched with green crayon on buff wove paper
26.7 x 34.8 (10½ x 13¹¹⁄₁₆)
vente stamp lower right: Degas atelier stamp lower left

Musée du Louvre, Département des Arts Graphiques, Fonds du Musée d'Orsay, Paris

Provenance
Atelier Degas, Vente I, part of lot 7.b; acquired at that sale by the Musée du Luxembourg, Paris; transferred to the Louvre, 1930

Exhibitions
Saint Louis 1967, no. 38, repr., as 1860–1861 (exhibited in Saint Louis only); Paris 1969, no. 104; Paris 1988–1989, no. 33, repr., as c. 1860–1862 (exhibited in Paris only)

Selected References
Lafond 1918–1919, 1: repr. between 36 and 37; Monnier 1978, 408, 424 repr. fig. 52

8

Mlle Fiocre in the Ballet "La Source"

1867–1868
oil on canvas
130 x 144 (51³⁄₁₆ x 56¹¹⁄₁₆)
L 146

The Brooklyn Museum of Art, Gift of James H. Post, John T. Underwood, and A. Augustus Healy, 21.111

Provenance
Atelier Degas, Vente I:8.a; bought at that sale by a consortium of Seligmann, Bernheim-Jeune, Durand-Ruel, and Vollard; Seligmann sale, American Art Association, New York, 27 January 1921, no. 68; bought at that sale through Durand-Ruel by A. Augustus Healy, James H. Post, and John T. Underwood; their gift to the museum, 1921

Exhibitions
Paris 1868, no. 686, as "Portrait de Mlle E. F . . . ; à propos du ballet de 'la Source'"; London 1932, no. 391; Chicago 1933, no. 285; Northampton 1933, no. 9; Philadelphia 1936, no. 9, repr.; Cleveland 1947, no. 12, repr. pl. XI; New York 1949, no. 14, repr.; New York 1960, no. 13, repr.; Paris 1960, no. 4, repr.; New York, Brooklyn Museum, 1988, *Degas's "Mlle. Fiocre" in Context: A Study of Portrait de Mlle. E. F . . . ; à propos du ballet "La Source"*; Paris 1988–1989, no. 77, repr.; Paris 1994–1995, no. 61, repr.

Selected References
Zacharie Astruc, *L'Etendard*, 30 July 1868, 1; Louis Leroy, "Session du Salon de 1868," *Le Charivari*, 20 May 1868, 2; Raoul de Naveryn [pseud.], *Le Salon de 1868* (Paris, 1868), 42–43, no. 686; M. de Themines, "Salon de 1868," *La Patrie*, 19 May 1868, 3; Émile Zola, "Mon Salon," *L'Événement*, 9 June 1868, 2–3; Jules Castagnary, *Le bilan de l'année 1868* (Paris, 1869), 354; Jamot 1924, 25, 57, 58, 97, 135–136, pl. 18; Halévy in exh. cat. Paris 1924, 9–11; Rouart 1937, 21; Lillian Browse, *Degas Dancers* (London, 1949), 21, 28, 51, 335, pl. 3; H. Wegener, "French Impressionist and Post-Impressionist Paintings in the Brooklyn Museum," *The Brooklyn Museum Bulletin* 16,

no. 1 (Autumn 1954), 8–10, 23, fig. 4; Rewald 1961, 158, 186, repr. 175; Reff 1964, 255–256; Reff 1976, 29–30, 214, 232, 298, 306, 327 note 33, fig. 9; Shackelford 1984, 20–21, repr. fig. 1.2; Stuckey in exh. cat. Paris 1984–1985, 18–19, fig. 16; Thomson in exh. cat. Manchester 1987, 39–43; Loyrette in exh. cat. Paris 1988–1989, 133–135; Loyrette 1991, 208–212; Kendall in exh. cat. New York 1993, 77–79, 80, 82, 112, 77 repr.

9

Study of a Horse

1867–1868
graphite on light gray paper
23.7 x 26.3 (9⁵⁄₁₆ x 10⅜)
vente stamp lower left: Degas

Museum Boijmans Van Beuningen, Rotterdam

Provenance
Atelier Degas, Vente IV:228.a; purchased at that sale by Dr. Georges Viau, Paris; with Paul Cassirer, Berlin, 1928; Franz Koenigs, Haarlem, 1928; acquired as part of the Koenigs collection by D. G. van Beuningen, April 1940; his gift to the museum, 1940

Exhibitions
Tübingen 1984, no. 48, repr., as 1861–1863; Manchester 1987, no. 26, repr., as c. 1865–1868

Selected References
Hoetink in Museum Boymans-van Beuningen 1968, 71–72, no. 80, repr.

10

Promenade beside the Sea

c. 1860
oil on canvas
22.5 x 32.5 (8⅞ x 12¹³⁄₁₆)
BR 38

Private collection

Provenance
Edmond de Gas, Paris; Gustave
Pellet, Paris; Julian Lousada, Lon-
don; estate of Mrs. M. R. Lousada,
London; sale, Christie's, London,
8 May 1953, no. 36, repr.; Charles
Douie, London

Exhibitions
New York 1993, no. 7 repr.

Selected References
Manson 1927, 50; Kendall in exh. cat.
New York 1993, 61, 64, 65, 67, 74, 62
repr.

11

*The Gentlemen's Race: Before
the Start*

1862; reworked c. 1882; finished by
1883
oil on canvas
48.5 x 61.5 (19⅛ x 24³⁄₁₆)
signed and dated lower left: Degas
1862
L 101

Musée d'Orsay, Paris, Bequest of the
comte Isaac de Camondo, 1911

Provenance
Purchased from the artist by Du-
rand-Ruel, Paris, 14 February 1883
(as "Courses de Gentlemen," stock
no. 2755); deposited with Durand-
Ruel, Paris, 8 August–12 September
1883; deposited with Fritz Gurlitt,
Berlin, 25 September 1883–17 Janu-
ary 1884; deposited with M. Coti-
naud, Paris, 6 June 1884. Hector
Brame, Paris; deposited with
Durand-Ruel, Paris, 12 June 1889
(deposit no. 6784); purchased by
Durand-Ruel, Paris, 16 August 1889
(stock no. 2437); deposited with
Manzi, 19 August 1889, who pur-
chased it the next day; sold to Comte
Isaac de Camondo, Paris, April 1894;
his gift to the Musée du Louvre,
1911; transferred to the Musée du Jeu
de Paume, 1947; transferred to the
Musée d'Orsay, 1986

Exhibitions
London 1883, no. 6, as "Courses de
gentlemen"; (?) Paris 1884–1885,
no. 28, as "Départ de course de
gentlemen-riders"; Paris 1937, no. 5,
as "Courses de gentlemen: avant le
départ"; Paris 1969, no. 9; Paris
1988–1989, no. 42, repr., as 1862,
reworked c. 1882

Selected References
Jamot 1914, 459; Musée du Louvre
1914, 158; Lafond 1918–1919, 2: 41;
Jamot 1924, 147, 95; Bazin 1958, 190,
repr.; Reff 1977, repr. fig. 64; Lipton
1986, 19, 20, 29, 30, 62, 65, repr. 19,
63, pl. II; Sutton 1986, 147, 140 repr.

12

Jockeys at Epsom

1861–1862
oil on canvas
29.2 x 22.9 (11½ x 9)
L 75

Mr. and Mrs. H. Anthony Ittleson

Provenance
Percy-Moore Turner, London;
Étienne Bignou, Paris; Galerie
Caspari, Munich; Max Emden,
Ascona, Switzerland; to the current
owner, by 1968

Exhibitions
New York 1968, no. 1, repr.; Tokyo
1976–1977, no. 5, repr.; New York
1978, no. 3, repr.

Selected References
Manson 1927, repr. pl. 11; H. Rosen-
stein, "A Day at the Races," *Art
News* 67, no. 2 (April 1968), 30 repr.;
G. Brown, "The Horse in Art,"
Artsmagazine 42, no. 6 (April 1968),
45 repr.; Kendall in exh. cat. New
York 1993, 61, 281 n. 11

13

At the Races: The Start

1861–1862
oil on canvas
32 x 46 (12⅝ x 18⅛)
vente stamp lower left: Degas
L 76

Fogg Art Museum, Harvard Univer-
sity Art Museums, Bequest of Annie
Swan Coburn

Provenance
Atelier Degas, Vente I:91; Collection
Léon Orosdi; Étienne Bignou,
Paris; Howard Young, New York;
Mrs. L. L. Coburn, Chicago; her
gift to the museum, 1934

Exhibitions
Chicago 1933, no. 279, as "At the
Races: 'They're Off,'" c. 1870;
Philadelphia 1936, no. 6, repr.;
New York 1949, no. 7, as "At the
Races," 1862; Los Angeles 1958,
no. 9, repr. as c. 1860–1862; New
York 1960, no. 6, repr., as 1862;
Williamstown 1970, no. 2, as "At the
Races: They're Off," c. 1865–1870;
New York 1993, no. 9, repr.

Selected References
Edgar Peters Bowron, *European
Paintings before 1900 in the Fogg Art
Museum* (Cambridge, Mass.), 1991,
104, repr. fig. 327; Kendall in exh.
cat. New York 1993, 65, 67, 58 repr.
(detail), 66 repr.

14

Horse with a Saddle

1861–1862
graphite on paper
17.5 x 27.5 (6⅞ x 10¹³⁄₁₆)
vente stamp lower left: Degas

Private collection, courtesy of
Galerie Schmit, Paris

Provenance
Atelier Degas, Vente IV:224.b;
Galerie Schmit, Paris

Exhibitions
Paris 1975, no. 51, repr.

15

At the Races

c. 1865
graphite on reddish brown paper
34.9 x 48.3 (13¾ x 19)
vente stamp lower left: Degas

Sterling and Francine Clark
Art Institute, Williamstown,
Massachusetts

Provenance
Atelier Degas, Vente IV:253; Robert
Sterling Clark, 1919; his gift to the
museum, 1955

Exhibitions
Williamstown 1959, no. 19, repr.;
New York 1968, no. 18, repr., as
1862; Williamstown 1970, no. 18,
repr., as c. 1860–1865; Manchester
1987, no. 16, repr., as c. 1860;
Williamstown 1987, no. 12, repr.,
as c. 1860–1862

Selected References
Lemoisne 1946–1949, 1: 50, under
no. 101; Haverkamp-Begemann
1964, 1: 76, 2: repr. pl. 145; Thomson
in exh. cat. Manchester 1987, 93, 95,
96 repr.; Kendall in exh. cat. New
York 1993, 67

16

*Scene from the Steeplechase:
The Fallen Jockey*

1866; reworked, 1880–1881 and
c. 1897
oil on canvas
180 x 152 (71 x 59½)
vente stamp lower right: Degas
L 140

Collection of Mr. and Mrs. Paul
Mellon, Upperville, Virginia

Provenance
Atelier Degas, Vente I:19, as "Aux
Courses: le jockey blessé," bought
at that sale by Joseph Durand-Ruel,
Paris; Ambroise Vollard, Paris;
private collection of Jacques Selig-
mann, Paris; his sale, American Art
Galleries, New York, 27 January
1921, no. 70; Mrs. Gari Melchers,
Richmond, Virginia; to her residuary
legatee, Lawton Mackall; Wilden-
stein and Co., Inc.; Mr. and Mrs.
Paul Mellon, June 1960

Exhibitions
Paris 1866, no. 520, as "Scène de
steeple-chase"; Richmond, Virginia
Museum of Fine Arts, 1941 (indefi-
nite loan); Cleveland 1947, no. 28,
repr., as "The Dead Jockey," begun
c. 1875; New York 1960, no. 11, repr.,
as 1866; Washington 1966, no. 48,
repr., as 1866

Selected References
Bertall, "Le Salon de 1866 – revue
par Bertall," *Le journal amusant*, 12
May 1866, 5; Cham, *Le Salon de 1866
photographié par Cham* (Paris, 1866),
no. 520; Edmond About, *Salon de
1866* (Paris, 1867), 229; Lafond
1918–1919, 2: 42; Thiébault-Sisson
1921, 3; Cabanne 1957, 25, 27, 96,
105; Rewald 1961, 140, 141 repr.;
Boerlin 1963, 46, 48 repr.; Pickvance
in exh. cat. New York 1968 [4, 5
repr.]; Rewald 1973, 140, 193 note 2;
Joel Isaacson, "Impressionism and
Journalistic Illustration," *Arts Maga-
zine* 56, 10 (June 1982), 103–104,
100 repr.; Stuckey in exh. cat. Paris
1984–1985, 19, 21 repr.; Sutton 1986,
138, repr.; Herbert 1988, 160–161,
160 repr.; Tinterow in exh. cat. Paris
1988–1989, 561; Loyrette in exh. cat.
Paris 1988–1989, 123; Loyrette 1991,
206–207; Kendall in exh. cat. New
York 1993, 70, 80–82, repr. 81; Loy-
rette in exh. cat. Paris 1994–1995,
283–284, repr. 283

17

Jockey (study for *Scene from
the Steeplechase: The Fallen
Jockey*)

1865–1866
graphite and black chalk heightened
with white, squared in black chalk
on olive-brown paper
45 x 27 (17¹¹⁄₁₆ x 10⅝)
vente stamp lower left: Degas

The Snite Museum of Art, Univer-
sity of Notre Dame, Notre Dame,
Indiana, on extended loan as a
promised gift from Mr. John D.
Reilly, Class of 1963

Provenance
Atelier Degas, Vente IV:273.a;
Henry Fevre, Paris; Vente M. X . . .
(Henry Fevre), Hôtel Drouot, Paris,
22 June 1925, no. 30.1, repr. (sold
with 30.2); purchased at that sale by
Mme Gosset, Paris; sale, Hôtel
Drouot, Paris, 28 November 1988,
no. 23; Mr. John D. Reilly, 1989

Selected References
Stephen B. Spiro and Mary Frisk
Coffman, *Drawings from the Reilly
Collection* (South Bend, Ind., 1993),
53–54, no. 65, repr., as c. 1866

18

The Wounded Jockey and
Studies of Horses (compo-
sitional study for *Scene from
the Steeplechase: The Fallen
Jockey*)

c. 1866
graphite and charcoal on white
wove paper
34 x 22 (13⅜ x 8¹¹⁄₁₆)
vente stamp lower left: Degas

Private collection

Provenance
Atelier Degas, Vente IV:232.b;
Vignier; bought from Durand-Ruel
1950; Baron Louis de Chollet,
Fribourg

Exhibitions
Bern 1951–1952, no. 87; Saint Louis
1967, no. 44, repr.; New York 1968,
no. 27, repr.

Selected References
Boerlin 1963, 45, 47 repr. fig. 1

19

The Bolting Horse (study
for *Scene from the Steeplechase:
The Fallen Jockey*)

c. 1866
graphite and charcoal on paper
23.1 x 35.5 (9⅛ x 14)
vente stamp lower left: Degas

Sterling and Francine Clark
Art Institute, Williamstown,
Massachusetts

Provenance
Atelier Degas, Vente IV:241.a;
acquired at that sale by Knoedler
with no. 241.b; Robert Sterling
Clark, 1919–1955; his gift to the
museum, 1955

Exhibitions
Williamstown 1959, no. 20, repr.;
Williamstown 1970, no. 22, repr., as
c. 1865–1866; Williamstown 1987,
no. 19, repr., as 1866; Paris 1988–
1989, no. 67, repr., as 1866; Miami
1994, no. 54, repr., as c. 1866

Selected References
Lemoisne 1946–1949, 2: 72, under
no. 140; Rewald 1961, 140, repr.;
Haverkamp-Begemann 1964, 1: 81–
82, 2: repr. pl. 156

20

Fallen Jockey (study for
*Scene from the Steeplechase:
The Fallen Jockey*)

c. 1866
graphite on blue paper
23.2 x 30.2 (9⅛ x 11⅞)
atelier stamp lower left
stamp lower right: Nepveu-Degas

Collection of Mr. and Mrs. Paul
Mellon, Upperville, Virginia

Provenance
Atelier Degas; Collection Nepveu-
Degas; sale, Hôtel Drouot Rive
Gauche, Paris, 6 May 1976, no. 31,
as "Etude pour le jockey blessé";
Huguette Bérès, Paris; acquired by
the present owner, August 1976

21

The Fallen Jockey (study
for *Scene from the Steeplechase:
The Fallen Jockey*)

1866
black chalk heightened with white
on bluish-gray paper
31.4 x 44.6 (12⅜ x 17⁹⁄₁₆)
vente stamp lower left: Degas

Sterling and Francine Clark
Art Institute, Williamstown,
Massachusetts

Provenance
Atelier Degas, Vente IV:241.b;
Robert Sterling Clark, 1919; his gift
to the museum, 1955

Exhibitions
Williamstown 1959, no. 21, repr.;
New York 1968, no. 25, repr., as
c. 1866; Williamstown 1970, no. 21,
repr., as c. 1865–1866; Williamstown
1987, no. 20, repr., as 1866

Selected References
Lemoisne 1946–1949, 2: 72, under
no. 140; Boerlin 1963, 47, 53 repr.
fig. 10; Haverkamp-Begemann 1964,
1: 82, 2: repr. pl. 154

22

Fallen Jockey (study for
*Scene from the Steeplechase:
The Fallen Jockey*)

c. 1866
charcoal and white chalk on paper
26 x 34.3 (10¼ x 13½)
atelier stamp lower left
L 144

Collection of Mr. and Mrs. Paul
Mellon, Upperville, Virginia

Provenance
Atelier Degas; Collection René de
Gas, Paris; his sale, Hôtel Drouot,
Paris, 10 November 1927, no. 21,
repr.; Collection Pellet, Paris; sale,
Palais Galliera, Paris, 29 November
1972, no. 38, repr.; Otto Wertheimer;
acquired by present owner Decem-
ber 1972

Selected References
Rewald 1961, 140, repr.

23

Head of the Fallen Jockey
(study for *Scene from the
Steeplechase: The Fallen
Jockey*)

c. 1866
black crayon heightened with white
on brown paper
25.4 x 34 (10 x 13⅜)
atelier stamp lower left
L 143

Collection of Mr. and Mrs. Paul
Mellon, Upperville, Virginia

Provenance
Atelier Degas; Collection René de
Gas, Paris; his sale, Hôtel Drouot,
Paris, 10 November 1927, no. 20,
repr.; Collection Nepveu-de Gas,
Paris, until at least 1931; Collection
Armand Dorville, Paris; sale, Hôtel
Drouot, Paris, 24 November 1964,
no. 33, repr.; Hector Brame, Paris;
to present owner, 1964

Exhibitions
Paris 1931, no. 101, as "Portrait
d'Achille de Gas," c. 1860–1865

24

Studies of Horses

c. 1866
black chalk on paper
23.5 x 35.6 (9¼ x 14)
vente stamp lower left: Degas

Sterling and Francine Clark
Art Institute, Williamstown,
Massachusetts

Provenance
Atelier Degas, Vente IV: 225.b;
Robert Sterling Clark; his gift to
the museum, 1955

Exhibitions
Williamstown 1959, no. 32, repr.;
Williamstown 1970, no. 20, as
c. 1865; Williamstown 1987, no. 21,
repr., as c. 1866

Selected References
Haverkamp-Begemann 1964, 1: 81,
2: repr. pl. 151

25

Sulking

c. 1869
oil on canvas
32.4 x 46.4 (12¾ x 18¼)
signed lower right: E. Degas
L 335

The Metropolitan Museum of Art,
H. O. Havemeyer Collection,
Bequest of Mrs. H. O. Havemeyer,
1929

Provenance
Deposited by the artist with Du-
rand-Ruel, Paris, 27 December 1895
(deposit no. 8848), as "Bouderie";
bought by Durand-Ruel, Paris, 28
April 1897 (stock no. 4191); before
buying it Durand-Ruel, Paris had
already sold it to Durand-Ruel,
New York (stock no. N.Y. 1646) for
Mrs. H. O. Havemeyer; bought by
Mrs. H. O. Havemeyer, New York,
15 December 1896; her gift to the
museum, 1929

Exhibitions
New York 1915, no. 25, as "The
Dispute," 1876; New York, Metro-
politan Museum of Art, 1930, *The
H. O. Havemeyer Collection*, no. 46,
repr., as "Pouting," 1872–1875;
Philadelphia 1936, no. 19, repr., as
1872–1875; Paris 1937, no. 11; Min-
neapolis 1948, no no., as 1875–1876;
New York 1949, no. 28, 26 repr., as
1873; New York 1968, no. 6, repr.;
New York 1977, no. 10, as c. 1869–
1871; Richmond 1978, no. 6; Edin-
burgh 1979, no. 38, repr., as 1869–
1871; Paris 1988–1989, no. 85, as
c. 1869–1871; New York, Metro-
politan Museum of Art, 27 March–
20 June 1993, *Splendid Legacy: The
Havemeyer Collection*, no. 201, repr.;
Paris 1994–1995, no. 67, repr., as
c. 1869–1870

Selected References
Revue encyclopédique 1896, 481,
repr.; Georges Lecomte, "La crise
de la peinture française," *L'Art et les
Artistes* 12 (October 1910), 27 repr.;
Lafond 1918–1919, 2: 3; Havemeyer
1931, 111, 110 repr.; Louise Bur-
roughs, "Degas in the Havemeyer
Collection," *Metropolitan Museum
of Art Bulletin* 27, no. 5 (May 1932),
144, 143 repr.; Cabanne 1957, 29,
97, 110; Charles Sterling and Mar-
garetta M. Salinger, *French Paint-
ings: A Catalogue of the Collection*
of the Metropolitan Museum of Art,
III, XIX–XX Centuries (Greenwich,
Conn., 1967), 71–73; Reff 1976,
116–120, 144, 162–164, repr. fig. 83;
Charles S. Moffett, *Degas: Paintings
in the Metropolitan Museum of Art*
(New York, 1979), 10, repr. fig. 14;
Herbert 1988, 56, 155, 162, 308 n. 25,
n. 55, 56 repr.

26

The Morning Ride

1867–1868
oil on canvas
85.1 x 64.8 (33½ x 25½)
L 118

The Detroit Institute of Arts,
Founders Society Purchase, Ralph
Harman Booth Bequest Fund

Provenance
Atelier Degas, Vente III:21; bought
at that sale by Clairet; Hector
Brame, Paris; Étienne Bignou, Paris;
Howard Young Gallery, New York,
by 1932; sale, Parke-Bernet Gal-
leries, New York, 4 May 1944,
no. 34, repr.; purchased by the
museum, 1948

Exhibitions
Chicago, The Antiquarian Society
of the Art Institute of Chicago,
6 April–9 October 1932, *Exhibition
of the Mrs. L. L. Coburn Collection:
Modern Paintings and Watercolors*,
no. 10, as "The Morning Ride,"
c. 1880; New York 1968, no. 2, repr.,
as 1864–1868; Detroit Institute of
Arts, 6 November 1974–5 January
1975, *Degas in the Detroit Institute
of Arts*, no. 6, repr., as 1864–1868;
New York 1993, no. 12, repr., as
1865–1868

Selected References
Theodore Reff, "Works by Degas
in the Detroit Institute of Arts,"
Bulletin of the Detroit Institute of Arts
53, no. 1 (1974), 30–31, as 1864–
1868; Kendall in exh. cat. New York
1993, 74, 73 repr.

27

Horses and Riders on a Road

1867–1868
oil on panel
47 x 59.8 (18½ x 23⁹⁄₁₆)
vente stamp lower right: Degas
L 121

Private collection

Provenance
Atelier Degas, Vente I:80, as "Cavaliers sur une route"; acquired at that sale by Mr. Gumaelius, Paris; sale, Galerie Georges Petit, Paris, 8 June 1922, no. 7; acquired at that sale by Ambroise Vollard, Paris; Galerie Mouradian-Vallotan, by 1939; Mr. Nathan Cummings, by 1965; sale, Christie's, New York, 30 April 1996, no. 19, repr.

Exhibitions
London 1937, no. 7; Paris 1938, no. 9, as 1872; Paris 1939, no. 34, as "Au Bois de Boulogne"; Washington, National Gallery of Art, 28 June–11 September 1970, and New York, Metropolitan Museum of Art, 1 July–7 September 1971, *Selections from the Nathan Cummings Collection*, no. 6, repr., as "Horse Riders," 1864/1868; Chicago, The Art Institute of Chicago, 20 October–9 December 1973, *Major Works from the Collection of Nathan Cummings*, no. 6, repr. as "Horse Riders," 1864–1868

28

The Promenade on Horseback

1867–1868
oil on canvas
71 x 90 (27¹⁵⁄₁₆ x 35⁷⁄₁₆)
vente stamp lower right: Degas
L 117

Hiroshima Museum of Art

Provenance
Atelier Degas, Vente I:90; Durand-Ruel, Paris; Knoedler and Co., New York, until 1940; private collection; Dr. H. Ritz, Montclair, N.J.; sale, Sotheby's, London, 3 December 1975, no. 7, repr. (not sold); Ars Alto Ltd., London

Selected References
Kendall in exh. cat. New York 1993, 74, 82, repr., 75, as c. 1867

29

Woman Rider Viewed from Behind

1867–1868
graphite and *estompe* on white paper
31.5 x 19.7 (12⅜ x 7¾)
vente stamp lower left: Degas

Musée du Louvre, Département des Arts Graphiques, Fonds du Musée d'Orsay, Paris

Provenance
Atelier Degas, Vente IV:238.b; acquired at this sale by Marcel Bing; Collection Marcel Bing, Paris; his gift to the museum, 1922

Exhibitions
London 1932, no. 945, as c. 1865–1870; Philadelphia 1936, no. 70, repr., as c. 1865–1870; Paris 1969, no. 115, as c. 1865

Selected References
Rivière 1922–1923, no. 15, repr. pl. 15; Jamot 1924, pl. 16; Lemoisne 1946–1949, 1: repr. pl. facing 40; Monnier 1969, 361

30

Children and Ponies in a Park

1867–1868
oil on canvas
89 x 101 (35¹⁄₁₆ x 39¾)
vente stamp lower right: Degas
L 171

From the Collection of Joan Whitney Payson

Provenance
Atelier Degas, Vente I:95; Ambroise Vollard, Paris; Mrs. Charles S. Payson, New York

Exhibitions
New York, Metropolitan Museum of Art, 3 July–2 September 1968, *New York Collects*, no. 53; Tokyo 1976–1977, 9, repr., as 1867; Kyoto Municipal Museum, 13 September–12 October, and Tokyo, Isetan Museum of Art, 17 October–9 December 1980, *The Joan Whitney Payson Collection*, no. 18, repr., as 1867

Selected References
Cabanne 1957, repr. pl. 31; Kendall in exh. cat. New York 1993, 74–75

31

The Sportsman Mounting His Horse

1859
etching on gray-white, thin, smooth, oriental paper
9.5 x 7.9 (3¾ x 3⅛)
Reed and Shapiro 3, second state

Sterling and Francine Clark Art Institute, Williamstown, Massachusetts

Exhibitions
Williamstown 1970, no. 35, as c. 1855–1856; Boston 1984–1985, no. 3, repr. (another impression), as 1856 (Boston and Philadelphia only); Williamstown 1987, no. 4, repr., as c. 1856

Selected References
Loys Delteil, *Edgar Degas: Le Peintre-Graveur illustré* (Paris, 1919), 9: no. 9; Adhémar and Cachin 1973, XXXIX, no. 3 repr. (another impression); Reed and Shapiro in exh. cat. Boston 1984–1985, 5, no. 3.II (another impression); Kendall in exh. cat. New York 1993, 12–13, repr. (another impression)

32

Huntsman Blowing His Horn (after Carle Vernet, *Deer Hunt on Saint Hubert's Day in 1818*, detail)

1865–1870
graphite and charcoal on paper
19.5 x 23.5 (7¹¹⁄₁₆ x 9¼)
vente stamp lower left: Degas

Virginia Museum of Fine Arts, Collection of Mr. and Mrs. Paul Mellon

Provenance
Atelier Degas, Vente IV:240.b; Dr. Georges Viau, Paris; his sale, 11 December 1942, no. 45; Dr. Fritz Nathan; acquired by Mr. and Mrs. Paul Mellon, Upperville, Virginia, May 1963; their gift to the museum, 1985

Exhibitions
Washington 1966, no. 227, repr., as c. 1872 (?)

33

Leaving for the Hunt

c. 1866 and c. 1873
oil on canvas
70 x 89 (27⁹⁄₁₆ x 35¹⁄₁₆)
signed lower left: E. De Gas
L 119

Private collection, courtesy of Galerie Schmit, Paris

Provenance
Atelier Degas, Vente I:81, as "Le départ pour la chasse"; Ambroise Vollard, Paris; Émile C. Barrell, Basel, by 1951; Mrs. Holder-Barrell, Basel, by 1964; Galerie Schmit, Paris

Exhibitions
Detroit, The Arts and Craft Club of Detroit [no date], *Paintings from the Ambroise Vollard Collection*, no. 18, repr.; Bern 1951–1952, no. 8, repr.; New York 1993, no. 11 repr., 72

Selected References
Lipton 1986, 37, repr., as 1864–1868; Loyrette in exh. cat. Paris 1988–1989, 193; Kendall in exh. cat. New York 1993, 71–73, 74, 72 repr., as c. 1863–1865 and 1873

34

*Rider in a Red Coat Viewed
from Behind*

1873
essence, ink, and gouache on pink
paper
43.6 x 27.6 (17 3/16 x 10 7/8)
signed and dated lower right:
De Gas / 73
BR 66

Musée du Louvre, Département des
Arts Graphiques, Fonds du Musée
d'Orsay, Paris

Provenance
Bequest of Mme Eugène Frédéric
André (née Alquié), to the Musée du
Luxembourg, 1921; transferred to
the Musée du Louvre, 1930

Exhibitions
Paris 1924, no. 42, as "Cavalier en
habit rouge, saluant," 1873; Paris
1969, no. 162; Tübingen 1984, no. 64,
repr., as 1866–1868; Paris 1988–
1989, no. 121, repr. (Ottawa only)

Selected References
Rouart 1945, 13; Jakob Rosenberg,
*Great Draughtsmen from Pisanello to
Picasso* (Cambridge, Mass., 1959;
rev. ed., 1974), 114, repr. 2; Sutton
1986, 138, 137 repr.

35

Gentleman Rider

c. 1873
brush with black gouache, with
touches of white and brown oil
paint, over graphite, on pink wove
paper, laid down on board
44 x 28 (17 5/16 x 11)
vente stamp lower left: Degas

The Art Institute of Chicago,
Gift of Mrs. Josephine Albright

Provenance
Atelier Degas, Vente III:165.2; Dr.
Georges Viau, Paris; Mrs. Josephine
Albright, Woodstock, Vt.; her gift to
the museum, 1967

Exhibitions
Tokyo 1976–1977, no. 68, repr., as
1864–1868; Chicago 1984, no. 20,
repr., as 1866/1870

Selected References
Sutton 1986, 148, repr.

36

Gentleman Rider

c. 1873
graphite with traces of brush and
white gouache on pink wove paper,
laid down
43.5 x 27 (17 1/8 x 10 5/8)
vente stamp lower right: Degas

The Art Institute of Chicago,
Charles Deering Collection

Provenance
Atelier Degas, Vente III:165.1; Dr.
Georges Viau, Paris; Jacques Selig-
mann and Co., New York; acquired
by the museum, 1945

Exhibitions
(?) Northampton 1933, no. 21;
Cleveland 1947, no. 60, repr., as
c. 1864; Washington 1947, no. 23;
Chicago 1984, no. 19, repr., as
1866/1870

37

Dead Fox

c. 1864–1868
graphite and red pencil
20.6 x 27.8 (8 1/8 x 10 15/16)
verso: preliminary drawing from
the recto
vente stamp lower left: Degas

Sterling and Francine Clark
Art Institute, Williamstown,
Massachusetts

Provenance
Atelier Degas, Vente IV:225.a;
Robert Sterling Clark, 1919; his gift
to the museum, 1955

Exhibitions
Williamstown 1959, no. 18, repr.;
Williamstown 1970, no. 19, as
c. 1864–1868; Williamstown 1987,
no. 18, repr., as c. 1864–1868

Selected References
Lemoisne 1946–1949, 2: 60, under
no. 120; Haverkamp-Begemann
1964, 1: 80–81, 2: repr. pl. 155

38

*The Carriage Leaving the
Races in the Countryside
(Carriage at the Races)*

1869–1872
oil on canvas
36.5 x 55.9 (14 3/8 x 22)
signed lower left: Degas
L 281

Museum of Fine Arts, Boston,
1931 Purchase Fund

Provenance
Bought from the artist by Durand-
Ruel, Paris, 17 September 1872
("La voiture sortant du champ de
courses," stock no. 1910); sent to
Durand-Ruel, London, 12 October
1872; bought through Charles Des-
champs by Jean-Baptiste Faure, 25
April 1873; bought by Durand-Ruel,
Paris, 2 January 1893 (as "Voiture
aux courses," stock no. 2566); de-
posited with the Durand-Ruel fam-
ily, Les Balans, 29 March 1918;
acquired by the museum in New
York, 1926

Exhibitions
London 1872, no. 113, as "At the
Races"; London 1873, no. 79, as "A
Race Course in Normandy"; Paris
1874, no. 63, as "Aux courses en
province"; Saint Petersburg, Exhibi-
tion of Paintings organized by *Mir
Iskousstva*, 1899, no. 81; Vienna,
Secession, 1903–1904; London 1905,
no. 57; Zurich 1917, no. 88, repr.;
Paris 1922, 27; Paris 1924, no. 40,
as 1873; Chicago 1933, no. 282, repr.
pl. LIII, as "Carriage at the Races
in Provence"; Philadelphia 1936,
no. 21, repr.; Paris 1937, no. 14, repr.
pl. X; Los Angeles 1958, no. 17,
repr., as c. 1870; Paris 1974–1975,
no. 13, as c. 1871–1872; Boston
1984–1985, no. 39, repr.; Washing-
ton, National Gallery of Art, 17
January–6 April, and The Fine
Arts Museums of San Francisco,
19 April–6 July 1986, *The New
Painting: Impressionism 1874–1886*,
no. 4, repr., as c. 1872; Paris 1988–
1989, 95, repr., as 1869; Paris 1994–
1995, no. 66, repr., as 1869

Selected References
E. C., "Chronique: Beaux-Arts:
Exposition des peintures modernes,"
Revue de France 10 (April 1874),
254–255; Étienne Carjat, "L'Expo-
sition du boulevard des Capucines,"
Le Patriote français, 27 April 1874, 3;
Ernest Chesneau, "A côté du Salon.
II. – Le plein-air: Exposition du
boulevard des Capucines," *Paris-
Journal*, 7 May 1874, 2; Lemoisne
1912, 53–54, repr.; Lemoisne 1931,
291; S. Barazetti, Degas et ses amis
Valpinçon," *Beaux-Arts* 190, 21
August 1936, 1; R. H. Wilenski,
Modern French Painters (New York,
1940), 53; *Lettres Degas* 1945, 80;
Boggs 1962, 37, 46, 92, 93 no. 66,
pl. 72; Sutton 1986, 147, 144 repr.;
Herbert 1988, 160, 164, 168, 164
repr., 166–167 repr. (detail); Jean
Sutherland Boggs, "Degas et la
maternité," in *Degas inédit* 1989, 37,
38–39; Distel 1989, 89; Tinterow
and Norton 1989, 293; Loyrette
1991, 196–198; Kendall in exh. cat.
New York 1993, 110, 112, 113, 114,
124, 111 repr., 114 repr. (detail);
Berson 1996, 2: 7–8, 22, repr.

39

Horses in a Meadow

1871
oil on canvas
31.8 x 40 (12½ x 15¾)
signed and dated lower right:
E. Degas 71
L 289

National Gallery of Art, Washington, Chester Dale Fund, 1995.11.1

Provenance
Purchased from Degas by Galerie Durand-Ruel, Paris, 26 April 1872 (stock no. 1350); Galerie Durand-Ruel, London, to Jean-Baptiste Faure, Paris, 5 March 1874, as "Chevaux dans un pré"; Faure to Degas; Degas to James Tissot, Paris; purchased from Tissot by Galerie Durand-Ruel, Paris, 11 March 1890 (stock no. 2654); acquired by Joseph Durand-Ruel, Paris, 11 March 1890; acquired by Paul Durand-Ruel, Paris, for his private collection, 25 August 1891; Durand-Ruel Gallery, New York, January 1936 (stock no. N. Y. 8963); Mr. and Mrs. Jean d'Alayer de Costemore d'Arc, Paris, by 1951; sale, Sotheby's, London, 30 June 1992, no. 4; Janet Traeger Salz, New York; acquired by the museum, 1995

Exhibitions
London 1873, no. 100, as "Horses at Grass"; London 1905, no. 60, as "Horses in the Meadows"; New York 1937, no. 18; New York 1947, no. 17; Bern 1951–1952, no. 16; Paris 1955, no. 46; Paris 1960, no. 12; London 1991, no. 2, repr.; New York 1993, no. 25, repr.

Selected References
Lecomte 1892, 60–61 repr., as "Chevaux au paturage"; Lafond 1918–1919, 2: 44, repr. pl. facing 42; Guérin 1931, 17; Venturi 1939, 2: 194; Cabanne 1957, 107–108, no. 34; Pantazzi in exh. cat. Paris 1988–1989, 221, 222, 223; Loyrette 1991, 286; Kendall in exh. cat. New York 1993, 112, 113 repr., 123 repr. (detail)

40

Study of a Jockey

c. 1865–1868
graphite on paper laid down on board
23.6 x 17.3 (9⁵⁄₁₆ x 6¹³⁄₁₆)
vente stamp lower left: Degas

Private collection, The Netherlands

Provenance
Atelier Degas, Vente IV:236.a; sale, Christie's, New York, 12 February 1987, no. 7, repr.

41

Two Jockeys and a Woman with Field Glasses

c. 1868–1870
essence on paper
24.5 x 30 (9⅝ x 11¹³⁄₁₆)
vente stamp lower left: Degas
L 162

Private collection, Paris, courtesy of Fondation Pierre Gianadda, Martigny, Switzerland

Provenance
Atelier Degas, Vente III:37.2; Collection Nunès, Paris; private collection, Paris, hence by descent; sale, Sotheby's, London, 30 June 1992, no. 3, repr. as c. 1866–1872

Exhibitions
Martigny 1993, no. 10, repr., as c. 1868; Gordon and Forge 1988, 120

42

Four Studies of a Jockey

c. 1868–1870
brush and black gouache, with white and brown oil paint on brown wove paper discolored with *essence*, laid down on cream card
45 x 31.5 (17¹¹⁄₁₆ x 12⅜)
L 158

The Art Institute of Chicago, Mr. and Mrs. Lewis L. Coburn Memorial Collection

Provenance
Atelier Degas, Vente III:114.1; bought at that sale by Fiquet, Paris, with nos. 114.2 and 114.3; Mr. and Mrs. Lewis Larned Coburn, Chicago; their gift to the museum, 1933

Exhibitions
Cleveland 1947, no. 63, repr., as 1866; Los Angeles 1958, no. 16, as c. 1866–1872; Saint Louis 1967, no. 46, repr., as c. 1866; Chicago 1984, no. 17, repr., as 1866; Paris 1988–1989, no. 70, repr., as 1866

Selected References
Vingt dessins [1897], pl. 7; Lemoisne 1912, 35–36, repr. (detail)

43

Jockey Leaning Forward in His Saddle

1868–1870
essence and gouache on brown paper
31 x 28 (12³⁄₁₆ x 11)
vente stamp lower left: Degas
L 152

Private collection

Provenance
Atelier Degas, Vente III:127.2; Collection Nunès and Fiquet, Paris; Maurice Loncle, Paris; sale, Sotheby's, London, 7 December 1966, no. 36, repr.

Exhibitions
Paris 1960, no. 7, as "Jockey," 1866–1872; London 1983, no. 7; Tübingen 1984, no. 68, repr., as 1866–1868; Martigny 1993, no. 12, repr., as c. 1866–1868

Selected References
Terrasse 1981, no. 115, repr.

44

Studies of a Jockey

c. 1868–1870
brush and black gouache with white and brown oil paint on pink wove paper
32 x 40 (12⅝ x 15¾)
vente stamp lower left: Degas
L 159

Private collection

Provenance
Atelier Degas, Vente III:129.2; Marcel Guérin, Paris

Exhibitions
Paris 1939, no. 42; Paris 1955, no. 41, as 1870; Paris 1975, no. 8, repr., as c. 1866–1872; Tübingen 1984, no. 66, repr., as 1866–1868; Martigny 1993, no. 13, repr., as c. 1866–1868

45

Two Jockeys

c. 1868–1870
brush and black gouache with white and brown oil paint on pink wove paper
23 x 30 (9¹⁄₁₆ x 11¹³⁄₁₆)
vente stamp lower left: Degas
L 153

Private collection

Provenance
Atelier Degas, Vente III:141.3; Vaudoyer collection, Paris; Feilchenfeldt, Zurich

46

Study of Two Jockeys

c. 1868–1870
brush and black gouache with white and brown oil paint on pink wove paper
23 x 30 (9¹⁄₁₆ x 11¹³⁄₁₆)
vente stamp lower right: Degas
L 154

Private collection

Provenance
Atelier Degas, Vente III:141.4; G. Vaudoyer, Paris; Marcel Guérin, Paris, by 1924

Exhibitions
Paris 1924, no. 93, as c. 1866; Paris 1955, no. 40, repr. 26, as 1870; Paris 1975, no. 7, repr., as c. 1866–1872; Tübingen 1984, no. 67, repr., as 1866–1868; Martigny 1993, no. 14, repr., as c. 1866–1868

Selected References
Rouart 1945, 71; Pickvance in exh. cat. Edinburgh 1979, under no. 13; Kendall in exh. cat. New York 1993, 118

47

Four Studies of a Jockey

c. 1868–1870
brush and black gouache with white and brown oil paint on pink wove paper
31 x 18 (12³⁄₁₆ x 7¹⁄₁₆)
vente stamp lower left: Degas
L 156

Private collection

Provenance
Atelier Degas, Vente III:127.1; Collection Nunès, Paris; Maurice Loncle, Paris

Exhibitions
Bern 1951–1952, no. 88, as c. 1866–1872; Tübingen 1984, no. 65, repr., as 1866–1868; Martigny 1993, no. 11, repr., as c. 1866–1868

Selected References
Terrasse 1981, no. 122, repr.

48

A Jockey on His Horse

c. 1868–1870
oil and graphite on faded pink paper
32.7 x 18.3 (12⅞ x 7³⁄₁₆)
vente stamp lower left: Degas

The Metropolitan Museum of Art, Bequest of Walter C. Baker, 1971

Provenance
Atelier Degas, Vente III:128.2; Louis Rouart, Paris; Louis Godefroy, Paris, by 1930; Franz Koenigs, Haarlem; Walter C. Baker; his gift to the museum, 1971

Exhibitions
New York, Metropolitan Museum of Art, June–September 1960, *The Walter C. Baker Collection of Drawings*; Saint Louis 1967, no. 57, repr., as 1870–1872; New York 1968, no. 30, repr., as 1870–1872; New York 1977, no. 13, as 1870–1872

Selected References
Claus Virch, *Master Drawings in the Collection of Walter C. Baker* (New York, 1962), 59, no. 105

49

Racehorses at Longchamp

1871; reworked in 1874?
oil on canvas
30 x 40 (11¹³⁄₁₆ x 15¾)
signed lower left: E. Degas
L 334

Museum of Fine Arts, Boston, S. A. Denio Collection

Provenance
With Bernheim-Jeune, Paris; bought by Durand-Ruel, Paris, 10 February 1900 (as "Chevaux de courses," stock no. 5689); deposited with Cassirer, Berlin; returned to Durand-Ruel, Paris, 10 June 1900; deposited with M. Whitaker, Montreal, 19 December 1900; deposited with Durand-Ruel, New York, 18 February 1901 (stock no. N.Y. 2494); bought by Mrs. William H. Moore, New York, 27 March 1901; returned to Durand-Ruel, New York, 1 April 1901; bought by the museum, with the aid of the Sylvanius Adams Denio Fund, 1903

Exhibitions
Cambridge, Mass., 1911, no. 10; Paris 1937, no. 12, as "Chevaux de courses"; Cambridge, Mass., 1938, no. 16, repr.; Cleveland 1947, no. 31, repr., as "Race Horses," 1878; New York 1949, no. 29, repr., as 1874; Fort Worth 1957, no. 103; Richmond 1960, no. 59, as "Race Horses," c. 1873–1875; New York 1968, no. 5, repr.; Boston 1974, no. 11; New York 1978, no. 10, repr., as c. 1873–1875; Richmond 1978, no. 8; Paris 1988–1989, no. 96, repr. as 1871; reworked in 1874 (?)

Selected References
Grappe 1911, 20–21, repr.; Lemoisne 1912, 77–78, pl. XXXI, as "Chevaux de courses," 1878; Lafond 1918–1919, 2: 42; Cabanne 1957, 28, 48, 110, pl. 45 (detail); Dunlop 1979, 120, as c. 1874, 116 pl. 107, as 1873–1875; McMullen 1984, 239; Alexandra R. Murphy, *European Paintings in the Museum of Fine Arts, Boston: An Illustrated Summary Catalogue* (Boston, 1985), 74, repr.; Lipton 1986, 20, 23, 30, 62, repr. 21, 63; Sutton 1986, 146, 144 fig. 114; Kendall in exh. cat. New York 1993, 113, 115 repr.

50

Before the Race

1871–1872
oil on wood
26.5 x 35 (10½ x 13¾)
signed lower right: Degas
L 317

National Gallery of Art, Washington, Widener Collection, 1942.9.18

Provenance
Purchased from Degas by Durand-Ruel, April 1872 (stock no. 1332); sent to Brussels on 3 September 1872 (brought back on 21 December); sold to Jean-Baptiste Faure, 7 May 1873; sold to Durand-Ruel, 28 February 1881 (stock number 869 or 870 or 871); Jules Féder, Paris; Erwin Davis, New York; his sale, New York, 19 March 1889, no. 62, as "Before the Race." (Cottier and Co., New York); sold 1894 to Peter A. B. Widener [d. 1915], Elkins Park, Pennsylvania; Inheritance from the Estate of Peter A. B. Widener by gift through power of appointment of Joseph E. Widener, Elkins Park; gift 1942 to National Gallery of Art

Exhibitions
(?) London 1873, no. 33, as "Getting Ready for the Start"; New York, M. Knoedler and Co., 6–24 April 1915, *Loan Exhibition of Masterpieces by Old and Modern Painters*, no. 23; Washington 1982–1983, no. 48 repr., as c. 1873

Selected References
Galerie Durand-Ruel 1873, 1: pl. xlv, as "Avant la course"; *Catalogue of Paintings Forming the Private collection of P. A. B. Widener, Ashbourne – near Philadelphia. Part I. Modern Paintings Philadelphia*, 1885–1900, p. 37, repr.; Lipton 1986, 20, 32, 62, repr. 21, 63; Pantazzi in exh. cat. Paris 1988–1989, 160, 221, 222, 223 n. 9, 160 repr.; Distel 1989, 89; Loyrette 1991, 751 n. 437; Kendall in exh. cat. New York 1993, 112 repr.

51

Manet at the Races

1868–1870
graphite on light brown paper
32.1 x 24.6 (12⅝ x 9⅝)
vente stamp lower left: Degas

The Metropolitan Museum of Art,
Rogers Fund, 1919

Provenance
Atelier Degas, Vente II:210.3; pur-
chased by the museum at that sale

Exhibitions
Minneapolis 1948, no no., as 1864;
Saint Louis 1967, no. 55, repr., as
c. 1870; New York 1968, no. 31,
repr., as c. 1870; New York 1977,
no. 12; Edinburgh 1979, no. 4, repr.;
Zurich 1994–1995, no. 84, repr., as
c. 1870

Selected References
Bryson Burroughs, "Drawings by
Degas," *Bulletin of the Metropolitan
Museum of Art* 14, no. 5 (May 1919),
115; Agnes Mongan, "Portrait
Studies by Degas in American
Collections," *Bulletin of the Fogg
Art Museum* 1, no. 4 (May 1932), 65;
*European Drawings from the Collec-
tions of the Metropolitan Museum
of Art* (New York, 1943), 2: pl. 50;
Rewald 1946, 93, 98 repr.; Boggs
1962, 23, repr. pl. 43; Wells 1972,
131, 133 repr. fig. 9; Dunlop 1979,
89, repr.; Herbert 1988, 155 repr.

52

Achille De Gas

c. 1872–1873
oil on parchment
36 x 25 (14³⁄₁₆ x 9¹³⁄₁₆)
L 307

The Minneapolis Institute of Arts,
Bequest of Putnam Dana McMillan

Provenance
René de Gas, Paris; his sale, Hôtel
Drouot, Paris, 10 November 1927,
no. 81, repr.; Chester Dale, New
York; sale, Parke-Bernet, New York,
16 March 1944, no. 38; Jacques
Seligmann and Co., Inc., New York;
purchased by Putnam Dana McMil-
lan, Minneapolis, 15 November 1949;
his bequest to the museum, 1961

Exhibitions
Paris 1931, no. 22, as c. 1860; Cleve-
land 1947, no. 3, repr. pl. III, as
c. 1856–1857; Minneapolis 1948, no
no., as 1856–1857; Baltimore 1962,
no. 37, as 1872–1873; New Orleans
1965, 63, repr. pl. XVI, as c. 1872–
1873; Saint Louis 1967, no. 58, repr.,
as 1870–1872; New York 1968, no.
32, repr.; Edinburgh 1979, no. 5,
repr.; Tübingen 1984, no. 61, repr.,
as 1865–1866; Martigny 1993, no. 7,
repr. as "Achille De Gas (?)," c. 1868

Selected References
Goldthwaite Higginson Door III,
"The Putnam Dana McMillan Col-
lection," *Minneapolis Institute of Arts
Bulletin* 50, no. 4 (December 1961),
14, 15 repr.; Boggs 1962, 114, repr.
pl. 81; Reff 1967, 255, 258 repr.;
*Catalogue of European Paintings
in the Minneapolis Institute of Arts*
(Minneapolis, 1970), 229, no. 119,
repr.; Wells 1972, 130, 131, 133 repr.
fig. 8; Terrasse 1981, no. 189, repr.

53

At the Racecourse

1868–1872
essence and brown wash, heightened
with white gouache on ocher-
colored paper prepared with oil
45 x 31 (17¹¹⁄₁₆ x 12³⁄₁₆)
vente stamp lower left: Degas
L 259

Musée du Louvre, Département des
Arts Graphiques, Fonds du Musée
d'Orsay, Paris

Provenance
Atelier Degas, Vente III:153.1, in the
same lot with 153.2; acquired at this
sale by Marcel Bing; Collection
Marcel Bing, Paris; his gift to the
museum, 1922

Exhibitions
Paris 1969, no. 158, as "Femmes sur
la pelouse"; Edinburgh 1979, no. 1,
repr.; Paris 1988–1989, no. 69, repr.,
as "Women before the Stands,"
c. 1866–1868 (exhibited in Paris
only)

Selected References
Rivière 1922–1923, no. 65, repr. pl.
65; Leymarie 1947, no. 19, pl. XIX;
Monnier 1969, 361, 365; Sutton 1986,
147, 146 repr.

54

The Grandstand
(study for *The False Start*)

1869–1872
graphite on white paper
21 x 33 (8¼ x 13)
inscription in pencil lower right:
petit liséré de lumière sur la balus-
trade – taches d'ombre et de soleil
sur la petit porte [?]
Degas estate stamp on verso

Collection of Mrs. John Hay
Whitney

Provenance
Atelier Degas; Jeanne Fevre, the
artist's niece, Nice; Paris art market;
John Hay Whitney collection, until
1982; to the present owner

Exhibitions
London, Tate Gallery, 16 December
1960–29 January 1961, *The John
Hay Whitney Collection*, no. 17, repr.

Selected References
Reff in exh. cat. Washington 1982–
1983, 146, repr.; Loyrette in exh. cat.
Paris 1988–1989, 124

55

The False Start

1869–1872
oil on panel
32.1 x 40.3 (12⅝ x 15⅞)
signed lower right: Degas Degas
(twice)
L 258

Yale University Art Gallery,
John Hay Whitney, B.A. 1926,
Hon. M.A. 1956, Collection

Provenance
Reitlinger Collection; sold to
Durand-Ruel, Paris, 4 March 1872;
purchased by Ernest Hoschedé,
25 April 1873 (stock no. 1121, as
"Courses au Bois de Boulogne");
his sale (anonymous), Hôtel Drouot,
Paris, 13 January 1874, as "La tri-
bune des courses à Longchamps";
Durand-Ruel, New York; Reid
and Lefevre, London, by 1928;
Knoedler, New York, 1928; John
Hay Whitney, New York, by 1936;
his gift to the museum, 1982

Exhibitions
(?) London, Summer, 1872, no. 4,
as "A False Start"; New York 1918,
no. 2, as "Chevaux de course," 1871;
Glasgow and London, Reid and
Lefevre, 1928, *Works by Degas*, no.
12, repr.; Philadelphia 1936, no. 13,
repr., as "The False Start," c. 1868–
1870; Cleveland 1947, no. 14, repr.,
as c. 1868–1870; New York, Cen-
tury Club, *Paintings of Sports and
Pastimes*; London 1960–1961, no.
16, repr.; Washington 1982–1983,
no. 49, repr., as 1869–1871; Wash-
ington 1983, no. 11, repr., as 1864

Selected References
Lafond 1918–1919, 2: repr. between
44 and 45; Meier-Graefe 1923, repr.
pl. XXXI; Meier-Graefe 1924, repr.
pl. 17; Daniel Catton Rich, *Degas*
(New York, 1951), 48, 49 repr.;
Rewald 1961, 216 repr.; Lipton 1986,
19, 23, 25, 62, repr. 25, 63; Sutton
1986, 143, 146, repr.; Herbert 1988,
161–163, 165, 161 repr.; Pantazzi in
exh. cat. Paris 1988–1989, 124, 212,
222 n. 2, 125 repr.; Loyrette 1991,
286–287, 288

56

*The Parade (Racehorses before
the Stands)*

1866–1872
essence on paper, mounted on canvas
46 x 61 (18⅛ x 24)
signed lower left: Degas
L 262

Musée d'Orsay, Paris, Bequest of the
comte Isaac de Camondo, 1911

Provenance
Jean-Baptiste Faure, Paris, 1873 or
1874, until 1893; bought by Durand-
Ruel, Paris, 2 January 1893 (stock
no. 2568); bought by Comte Isaac de
Camando, Paris, 18 December 1893;
his gift to the Musée du Louvre,
1911; transferred to the Musée du Jeu
de Paume, 1947; transferred to the
Musée d'Orsay, 1986

Exhibitions
(?) Paris 1874, no. 59 as "Faux dé-
part, dessin à l'essence"; Amiens
1968, no no., as c. 1869–1872; Paris
1969, no. 18, as c. 1869–1872; Paris
1988–1989, no. 68, repr., as 1866–
1868; Paris 1994–1995, no. 59, repr.,
as c. 1866–1868

Selected References
F. de Gantès, "Courrier artistique:
L'Exposition de boulevard," *La
Semaine parisienne*, 23 April 1874,
63–64; *La République française*
[Philippe Burty], "Exposition de la
société anonyme des artistes," 25
April 1874, 2; Mauclair 1903, repr.
facing 384; Moore 1907–1908, 105,
repr.; Jamot 1914, 29; Musée du
Louvre 1914, 28–31, repr.; Lafond
1918–1919, 2: 42; Jamot 1924, 147,
repr. pl. 48b; Bazin 1958, 190, repr.;
Reff 1971, 538; Reff 1985, Notebook
22 (BN, Carnet 8, 109–17, 129),
Notebook 31 (BN, Carnet 23, 68);
Lipton 1986, 19, 23, 62, repr. 24, 63;
Sutton 1986, 146, 141 repr.; Herbert
1988, 162–163, 164, 165, 242–243,
163 repr.; Distel 1989, 89, 90 repr.;
Tinterow and Norton 1989, 292;
Kendall in exh. cat. New York 1993,
118, 133; Berson 1996, 2: 7

57

*Out of the Paddock
(Racehorses)*

1868–1872; reworked 1874–1878
oil on panel
32.5 x 40.4 (12¹³⁄₁₆ x 15⅞)
signed lower left: Degas
L 387

Private collection

NOT IN EXHIBITION

Provenance
Acquired by Ferdinand Bischoffs-
heim by April 1872; purchased by
Durand-Ruel, Paris, April 1872
(stock no. 1367, as "Sortie de
Pesage"); purchased by Jean Bap-
tiste Faure at Degas' behest on 5
March 1874 with five other paint-
ings; purchased from the artist by
Durand-Ruel, Paris, 16 October
1891 (stock no. 1865, as "Course de
Gentlemen"); deposited with Emil
Heilbut, Hamburg, 28 October 1891,
returned 13 November 1891; de-
posited with Theodor Behrens,
Hamburg, 22 February 1892, re-
turned 29 February 1892; purchased
by Durand-Ruel, New York, 14 June
1892 (stock no. 951); purchased by
Cyrus Lawrence, New York, 5
March 1894; purchased back from
Lawrence by Durand-Ruel, New
York, 8 February 1901 (stock no.
2494); transferred to Durand-Ruel,
Paris, 15 February 1910 (stock no.
9237); deposited with Paul Cassirer,
Berlin, 13 March 1911; purchased by
Edouard Arnhold, Berlin; his heirs;
European private collection, c. 1965;
sale, Christie's, Manson and Woods
Ltd., London, 24 June 1991, no. 7,
repr., as c. 1871–1872; reworked
c. 1874–1878; to the current owner

Exhibitions
Berlin, Paul Cassirer, 1913, *Degas/
Cézanne*, no. 23, as "Pferderennen";
Tokyo 1976–1977, no. 14, repr., as
1875–1878; New York 1978, no. 12,
repr., as c. 1875–1878; Manchester
1987, no. 50, repr., as c. 1875–1878;
Paris 1988–1989, no. 158, repr., as
1875–1878

Selected References
Moore 1907–1908, 140 repr.;
Grappe 1908, 17; Gabriel Mourey,
"Edgar Degas," *The Studio* 73, no.
302 (May 1918), 129 repr., as 1875;

Meier-Graefe 1920, repr. pl. xii, as
c. 1872; Marie Dormoy, "La collec-
tion Arnhold," *L'amour de l'art* 7
(1926), 245; Walker 1933, 181, 183
repr.; Georges Rivière, *M. Degas,
bourgeois de Paris* (Paris, 1935), 139
repr., as 1872; Cabanne 1957, 28;
Dunlop 1979, 119 repr., as "Before
the Start," c. 1875; Herbert 1988,
169, repr. pl. 169

58

Man Riding

c. 1878
brush and black ink, with touches of
bluish gray gouache, on heavy dark
brown oiled paper, with plumb line
in white chalk
24.6 x 34.3 (9¹¹⁄₁₆ x 13½)
vente stamp lower left: Degas
L 383 bis

Sterling and Francine Clark
Art Institute, Williamstown,
Massachusetts

Provenance
Atelier Degas, Vente IV:273.b;
Henri Fevre; Vente M. X . . . (Henri
Fevre), Paris, Hôtel Drouot, 22 June
1925, no. 30.2, repr. (sold with 30.1);
purchased at that sale by Mme Gos-
set, Paris; Robert Sterling Clark;
his gift to the museum, 1955

Exhibitions
Williamstown 1959, no. 23, repr.;
New York 1968, no. 36, repr., as
1875–1877; Williamstown 1970,
no. 23, repr., as c. 1875–1877;
Williamstown 1987, no. 22, repr.,
as c. 1875–1877

Selected References
Haverkamp-Begemann 1964, 1: 82–
83, 2: repr. pl. 152

59

Four Studies of a Groom

c. 1878
brush, ink, and *essence* on brown
oiled paper
39 x 24 (15⅜ x 9⁷⁄₁₆)
vente stamp lower right: Degas
L 383

Private collection

Provenance
Atelier Degas, Vente III:37.1;
Collection Nunès and Fiquet, Paris

Exhibitions
Saint Louis 1967, no. 76, repr.,
as c. 1875–1877; Tübingen 1984,
no. 89, repr., as c. 1875

60

Two Studies of a Groom

c. 1878
essence heightened with gouache
on tan paper, laid down, prepared
with oil
24.5 x 34.3 (9⅝ x 13½)
L 382

Musée du Louvre, Département des
Arts Graphiques, Fonds du Musée
d'Orsay, Paris

Provenance
Atelier Degas, Vente III:153.2, in the
same lot with 153.1; acquired at this
sale by Marcel Bing, Paris; his gift to
the museum, 1922

Exhibitions
Paris 1924, no. 92, as "Deux lads à
cheval," c. 1866; Saint Louis 1967,
no. 77, repr., as 1875–1877 (exhib-
ited in Saint Louis only); Paris 1969,
no. 171, as c. 1877–1880; Paris 1988–
1989, no. 156, repr., as c. 1875–1877?
(exhibited in Paris only)

Selected References
Lafond 1918–1919, 1: 44; Rivière
1922–1923, no. 16, repr. pl. 16
(reprint ed. 1973, pl. 29); Jamot
1924, pl. 30; Rouart 1945, 16, 71
note 38; Leymarie 1947, no. 13,
repr. pl. XIII; Cooper 1953, 16 no. 3,
repr.; Monnier 1969, 361, 365; Gor-
don and Forge 1988, 273, repr. 79

61

Studies of a Horse and Rider

c. 1878
charcoal on laid paper
25 x 31.5 (9¹³⁄₁₆ x 12⅜)

Nasjonalgalleriet, Oslo

Provenance
Atelier Degas, Vente IV:212.b;
acquired by the museum at that sale

Selected References
Willoch 1980, repr. 34

62

Horse Walking

c. 1878
charcoal on light brown paper
32.4 x 20.5 (12¾ x 8¹⁄₁₆)
vente stamp lower left: Degas

Thaw Collection, The Pierpont
Morgan Library, New York

Provenance
Atelier Degas, Vente IV:232.c;
Helena Rubenstein (Princess
Gourelli), New York; her sale
New York, Sotheby Parke Bernet,
28 April 1966, no. 761, repr.; to
the current owner

Exhibitions
New York, Pierpont Morgan Li-
brary, 10 December 1975–15 Febru-
ary 1976, The Cleveland Museum
of Art, 16 March–2 May, The Art
Institute of Chicago, 28 May–5 July,
and The National Gallery of Can-
ada, 6 August–17 September 1976,
*Drawings from the Collection of
Mr. and Mrs. Eugene V. Thaw*, no. 95,
repr.; Tübingen 1984, no. 62, repr.,
as 1866–1868

Selected References
Boggs in exh. cat. Saint Louis 1967,
94 under no. 56; Pickvance in exh.
cat. Edinburgh 1979, 12 under no. 8;
*The Thaw Collection: Master Draw-
ings and New Acquisitions* (New
York, 1994), 267 repr.

63

Head of a Horse

c. 1878
graphite on paper
16.7 x 12.1 (6⁹⁄₁₆ x 4¾)

The Metropolitan Museum of Art,
Gift of A. E. Gallatin, 1923

Provenance
Atelier Degas, Vente IV:233.f; A. E.
Gallatin; his gift to the museum,
1923

Exhibitions
New York 1977, no. 14, as 1870–
1872; Edinburgh 1979, no. 8

64

Jockey

c. 1868
graphite with *estompe* on tan wove
paper, formerly laid down
32.8 x 24.6 (12¹⁵⁄₁₆ x 9¹¹⁄₁₆)
vente stamp lower left: Degas

The Art Institute of Chicago,
Gift of Robert Allerton

Provenance
Atelier Degas, Vente IV:215.2;
Durand-Ruel, Paris; Robert Aller-
ton, Chicago; his gift to the museum,
1922

Exhibitions
(?) The Arts Club of Chicago,
19–31 January 1922, *Exhibition of
Drawings by Degas loaned by Du-
rand-Ruel*, no. 4; Saint Louis 1967,
no. 80, repr., as c. 1878–1880; Edin-
burgh 1979, no. 7; Chicago 1984,
no. 18, repr., as 1866/1868

Selected References
Bulletin of the Art Institute of Chicago
16, no. 1 (January–February 1922),
11–12; Eugenia Parry Janis [Review
of *Degas Drawings* by Jean Suther-
land Boggs], *Burlington Magazine*
109 (July 1967), repr. pl. 43

65

The Jockey

c. 1878
monotype in black ink on white
china paper
13 x 12 (5⅛ x 4¾)
Janis 261

Sterling and Francine Clark
Art Institute, Williamstown,
Massachusetts

Provenance
Atelier Degas, Vente d'Estampes,
22–23 November 1918, no. 302,
repr.; Marcel Guérin (stamp, Lugt
supplement 1872b) lower left in
margin; Gérald Cramer; Herbert
Michel, Chicago; to the current
owner, 1962[1]

Exhibitions
Cambridge, Mass., 1968, no. 60,
repr., as c. 1880–1885; Williamstown
1970, no. 49, as c. 1880–1885;
Williamstown 1987, no. 54, repr.,
as c. 1880–1885

Selected References
Janis in exh. cat. Cambridge, Mass.,
1968, no. 60, repr., checklist no. 261,
as c. 1880–1885; Adhémar and
Cachin 1973, no. 170, repr., as
c. 1878–1880; Kendall in exh. cat.
New York 1993, 128 repr.

1. Janis notes that according to the
Clark Art Institute, the original
mount bore an inscription in
Guérin's hand: "*Le Galop d'essai*,
Vente Degas, no. 302, acheté à
l'aimable Henri Fevre qui l'avait de
son oncle Degas."

66

Jockeys

c. 1882
oil on canvas, mounted on cardboard
29 x 39 (11⁷⁄₁₆ x 15⅜)
signed lower left: Degas
L 680

Yale University Art Gallery,
Gift of J. Watson Webb, B.A. 1907
and Electra Havemeyer Webb

Provenance
Durand-Ruel; purchased in 1886
by Mr. and Mrs. H. O. Havemeyer
Webb, New York, until 1907;
Mrs. H. O. Havemeyer, New York
1907–1929; her daughter Electra
Havemeyer Webb, New York, 1929–
1942; gift of J. Watson Webb and
Electra Havemeyer Webb to the
museum, 1942

Exhibitions
New York 1886, no. 288, as "Jock-
eys"; New York 1949, no. 62, as
1882; New York 1968, no. 9, repr.;
Edinburgh 1979, no. 13, repr.

Selected References
Havemeyer 1931, 379, as "Horses
with Jockeys"; G. H. Hamilton,
"The Webb Gift," *Yale University
Art Gallery Bulletin* 12 (June 1943),
4–5; Daniel Catton Rich, *Edgar-
Hilaire-Germain Degas* (New York,
1951), 96, repr.; Louisine W. Have-
meyer, *Sixteen to Sixty: Memoirs
of a Collector* (New York, 1961), 257;
Françoise Forster-Hahn, *French and
School of Paris Paintings in the Yale
University Art Gallery* (New Haven
and London, 1968), 6–7, repr. pl.
16, as c. 1881–1885; Gordon and
Forge 1988, 82, 81 repr., as c. 1881–
1885; *Splendid Legacy: The Have-
meyer Collection* (New York, 1993),
333, 335, repr. no. 234

67

*Studio Interior with
"The Steeplechase"*

c. 1881
oil on canvas, mounted on board
27 x 41 (10⅝ x 16⅛)
vente stamp lower right: Degas
L 142

The Israel Museum, Jerusalem,
Sam Spiegel Collection

Provenance
Atelier Degas, Vente I:29; Ambroise
Vollard, Paris; William Weinberg,
Scarsdale, N.Y.; sale, Sotheby's,
London, 10 July 1957, no. 20, repr.,
as "Aux courses: Le jockey blessé";
purchased at that sale by Sam
Spiegel, New York; his gift to the
museum

Exhibitions
New York 1960, no. 12, repr., as
"Aux courses, le Jockey Blessé,"
c. 1866; New York 1968, no. 3, as
"At the Races, the Wounded Jockey,"
c. 1866; Williamstown 1970, no. 3,
repr., as "Study for 'Steeplechase –
The Fallen Jockey,'" c. 1866; Jeru-
salem, The Israel Museum, June–
September 1993, *The Sam Spiegel
Collection*, no. 11, repr., as "Studio
Interior with 'The Steeplechase,'"
1870s

Selected References
Boerlin 1963, 46, repr. fig. 4; Tin-
terow in exh. cat. Paris 1988–1989,
561, 563 repr., as "Studio Interior
with 'The Steeplechase,'" 1870s;
Stephanie Rachum, *The Sam Spiegel
Collection* (Jerusalem, 1993), 24, 25
repr., 82

68

Racehorses (study for
*Scene from the Steeplechase:
The Fallen Jockey*)

c. 1881
charcoal on paper
27.6 x 43.2 (10⅞ x 17)
vente stamp lower left: Degas

Collection of Mr. and Mrs. Paul
Mellon, Upperville, Virginia

Provenance
Atelier Degas, Vente IV:227.b; sale,
Sotheby's, London, 1 December
1965, no. 285a, repr.; acquired at that
sale by P. and D. Colnaghi; to the
present owner, 1965

Exhibitions
Washington 1966, no. 225, repr.,
as c. 1865

Selected References
Rewald 1961, 140, repr.

69

Horse Escaping (study for
*Scene from the Steeplechase:
The Fallen Jockey*)

c. 1881
graphite and charcoal on paper
21 x 27 (8¼ x 10⅝)
vente stamp lower right: Degas

Private collection

Provenance
Atelier Degas, Vente IV:245.d;
Browse and Darby, London; Neffe-
Degandt, London

Exhibitions
London 1989, no. 8, repr., as c. 1880

70

Before the Race

1882
oil on panel
27 x 35 (10⅝ x 13¾)
signed lower right: Degas
L 702

Sterling and Francine Clark
Art Institute, Williamstown,
Massachusetts

Provenance
Bought from the artist by Durand-
Ruel, Paris, 10–12 December 1882
(stock no. 2648, as "Le départ");
bought by Henri Lerolle, Paris,
10 January 1883; Lerolle collection,
Paris, 1883–1929; Mme Lerolle, his
widow, 1929 until at least 1936. With
Hector Brame, Paris, 1937; bought
by Durand-Ruel, New York, 3 June
1937 (stock no. 5381, as "Chevaux de
courses"); bought by Robert Ster-
ling Clark, 6 or 15 June 1939; Clark
Collection, New York, 1939–1955;
his gift to the museum, 1955

Exhibitions
Paris 1924, no. 45, repr., as "Le dé-
part d'une course (La descente des
mains)"; Paris 1937, no. 35, repr.,
as c. 1882; Williamstown 1959, no. 1,
pl. XVI; New York 1968, no. 10,
repr., as c. 1882; Williamstown 1970,
no. 6, as c. 1878–1880; Williams-
town 1987, no. 52, repr., as c. 1882;
Paris 1988–1989, no. 236, repr.,
as 1882

Selected References
Lafond 1918–1919, 2: 42, repr.
after 44; Jamot 1924, 140, pl. 30a;
Guérin 1931, 61; Cabanne 1957, 29,
118, repr. pl. 105; Sterling and Fran-
cine Clark Art Institute, Williams-
town, 1963, *French Paintings of the
Nineteenth Century*, no. 34, repr.;
Dunlop 1979, 180, no. 171, repr.;
Johnston 1982, 134–135; Kendall in
exh. cat. New York 1993, 133, 135,
134 repr.

71

Before the Race

1882–1884
oil on two panels laminated together
26.4 x 34.9 (10⅜ x 13¾)
signed at lower right: Degas
BR 110

The Walters Art Gallery, Baltimore,
Maryland

Provenance
Galerie Durand-Ruel, Paris; Cyrus
J. Lawrence, New York; his sale,
American Art Association, New
York, 21–22 January 1910, no. 63,
repr.; Henry Walters, Baltimore;
his gift to the museum, 1931

Exhibitions
Cleveland 1947, no. 21, repr., as
1873–1875; Baltimore 1962, no. 47,
as c. 1882; New York 1968, no. 11,
repr., as c. 1882

Selected References
Johnston 1982, 134–135, 133 repr.,
as 1875–1877 or after

72

Before the Race

1882–1888
oil on paper, laid on cradled panel
29 x 46 (11⁷⁄₁₆ x 18⅛)
signed lower left: Degas
L 679

Collection of Mrs. John Hay
Whitney

Provenance
Sold by the artist to Goupil-Boussod
et Valadon, Paris, 8 June 1888;
bought by Paul Gallimard, Paris,
5 August 1889; Gallimard collection,
Paris, 1889 until sometime before
1927 (according to Manson 1927).
With Reid and Lefevre, London,
1927; bought by M. Knoedler and
Co., New York, 23 March 1927;
bought by John Hay Whitney, New
York, May 1928; Whitney collection,
New York, 1928–1982; to present
owner

Exhibitions
Paris, Bernheim-Jeune et Fils, April
1903, *Exposition d'oeuvres de l'école
impressioniste*, no. 14, lent by Paul
Gallimard; Brussels, La Libre Esthé-
tique, 25 February–29 March 1904,
Exposition des peintres impressionistes,
no. 27, as "Chevaux de courses";
London, New Gallery, January–
February 1908, *Eighth Exhibition of
the International Society of Sculptors,
Painters and Gravers*, no. 69; Brigh-
ton, Public Art Galleries, 10 June–
31 August 1910, *Exhibition of the
Works of Modern French Artists*, no.
111; Paris 1912, no. 114, as "Chevaux
de courses. – Le départ"; Copen-
hagen, Statens Museum for Kunst,
15 May–30 June 1914, *Art français
du XIXe siècle*, no. 69, lent by Paul
Gallimard; London 1960–1961,
no. 18, repr., as c. 1881–1885; Wash-
ington 1982–1983, no. 12, repr.,
as 1881–1885; Paris 1988–1989,
no. 237, repr. (New York only),
as 1882–1888

Selected References
Louis Vauxelles, "Collection de
M. P. Gallimard," *Les Arts*, no. 81
(September 1908), 21, repr. 26, as
"Les courses"; Arsène Alexandre,
"Exposition d'art moderne à l'Hôtel
de la Revue 'Les Arts,'" *Les Arts*
(August 1912), repr. IV; Rewald
1973, [89], as "Courses," 31 x 47;
Johnston 1982, 134; Rewald 1986,
Appendix I, n.p.

73

Two Studies of a Jockey

c. 1884
graphite heightened with pastel
on paper
47 x 62.2 (18½ x 24½)
vente stamp lower left: Degas
L 509

Collection of Mr. and Mrs. Paul
Mellon, Upperville, Virginia

Provenance
Atelier Degas; Vente III:76; sale,
Hôtel Drouot, Paris, 17 March 1933,
no. 29; Hector Brame, Paris; to the
present owner, February 1968

Selected References
Gordon and Forge 1988, 82, repr.

74

*Study of a Jockey
(M. de Broutelles)*

c. 1884
charcoal on paper
34.6 x 21.9 (13⅝ x 8⅝)
vente stamp lower left: Degas
inscribed upper right: de Broutelles

Collection of Mr. and Mrs. Paul
Mellon, Upperville, Virginia

Provenance
Atelier Degas; Vente III:160.2; Dr.
Georges Viau, Paris; his sale, Hôtel
Drouot, Paris, 11 December 1942,
no. 42; sale, Palais Galliera, Paris,
9 December 1968; acquired through
Hector Brame for the present owner

Exhibitions
Paris 1924, no. 136, as "Deux têtes
d'un gentleman rider (de Brou-
telles)"; Maison-Lafitte 1926, no. 92;
Paris 1931, no. 129, as "Portrait de
M. de Broutelles, en gentleman
rider," c. 1879–1880

Selected References
Rivière 1922–1923, no. 64, repr., as
"Monsieur de Broutelles en jockey,"
c. 1866–1868

75

Jockey in Profile

c. 1884
charcoal on blue-gray laid paper
now discolored to buff
50 x 32.5 (19¹¹⁄₁₆ x 12¹³⁄₁₆)
atelier stamp lower left: Degas

The Visitors of the Ashmolean
Museum, Oxford

Provenance
Atelier Degas, Vente III:98.2;
acquired by Durand-Ruel, Paris
(stock no. 11453); Percy Moore
Turner, London, until no later than
1952; John N. Bryson, Oxford, by
1966; his gift to the museum, 1977

Exhibitions
Saint Louis 1967, no. 102, repr., as
c. 1882; Edinburgh 1979, no. 14,
repr., as c. 1882; London 1983,
no. 24, repr., as c. 1882; Paris 1988–
1989, no. 238, repr., as c. 1882–1884
(exhibited Paris only)

Selected References
Bouret 1965, 244; Christopher
Lloyd, "Nineteenth Century French
Drawings in the Bryson Bequest to
the Ashmolean Museum," *Master
Drawings* 16, no. 3 (Autumn 1978),
285, 287 note 6, pl. 35; Sutton 1986,
150, repr.

76

Study of a Jockey

c. 1884
charcoal on paper
31.8 x 24.8 (12½ x 9¾)
vente stamp lower left: Degas

Collection of Mr. and Mrs. Paul
Mellon, Upperville, Virginia

Provenance
Atelier Degas; Vente III:105.4;
Galerie Schmit, Paris; E. V. Thaw
and Co., Inc., New York; to the
current owner, January 1978

Exhibitions
Paris 1975, no. 80, repr., as c. 1889;
Richmond 1978, no. 24

77

Jockey

c. 1885
graphite on paper
29.5 x 23.5 (11⅝ x 9¼)
vente stamp lower left: Degas

Private collection

Provenance
Atelier Degas, Vente III:128.3;
Louis Rouart, Paris

Selected References
Rivière 1922–1923, repr. pl. 63, as
c. 1866–1868

78

The Racecourse

c. 1885–1887
pastel on cardboard
42.5 x 49.5 (16¾ x 19½)
signed lower right: Degas
L 850

Kunsthaus Zürich, Donation
Walter Haefner

Provenance
Durand-Ruel, Paris; Oskar Schmitz,
Dresden, 1904 until at least 1936;
Vladimir Horowitz, New York, by
1949; Walter Haefner, Zurich; his
gift to the museum, 1995

Exhibitions
Kunsthaus Zürich, 1932, *Collec-
tion Oskar Schmitz*, no. 25; Paris,
Galerie Wildenstein, 1936, *The Oscar
Schmitz Collection*, no. 25, repr., as
"The Races," 1894; New York 1949,
no. 71, repr., as "Race Horses," 1885;
Tübingen 1984, no. 146, repr., as
1883–1885

Selected References
Paul Fechter, "Die Sammlung
Schmitz," *Kunst und Künstler* 8
(1910), 22, 21 repr.; Arsène Alexan-
dre, "Essai sur Monsieur Degas,"
Les Arts 166 (1918), 4, repr.; Karl
Scheffler, "Die Sammlung Oskar
Schmitz in Dresden," *Kunst und
Künstler* 19 (1920–1921), 186; Marie
Dormoy, "La collection Schmitz à
Dresde," *L'Amour de l'Art* 7 (1926),
343; Manson 1927, 52; Sutton 1986,
150, 149 repr.; *Schenkung Walter
Haefner* (Zurich, 1995), n.p.

79

Three Women at the Races

c. 1885
pastel on paper
68.6 x 68.6 (27 x 27)
L 825

The Denver Art Museum,
Anonymous Gift

Provenance
Atelier Degas, Vente I:309; Collec-
tion Trotti, Paris; Durand-Ruel,
New York, by 1932; private collec-
tion; anonymous gift to the museum,
1973

Exhibitions
New York 1932, no. 1, as "Trois
femmes aux courses"

Selected References
G. B., "Degas et l'objectif," *L'Amour
de l'art* (July 1931), 309 repr.; Lewis
Wingfield Story, "Edgar Degas," in
*The Denver Art Museum: The First
Hundred Years* (Denver, 1996), 176,
177 repr.

80

Racehorses

1884
oil on canvas
45 x 55 (17¹¹⁄₁₆ x 21⅝)
signed and dated lower left:
Degas 84
L 767

Private collection

Provenance
Durand-Ruel; Albert Spencer, New
York; Durand-Ruel, 1911; Lillie P.
Bliss, 1913; her gift to the Museum of
Modern Art, New York, 1934

Exhibitions
New York 1913, no. 1012; New York,
Museum of Modern Art, 1931, *Bliss
Memorial*, no. 59, repr.; Chicago
1933, no. 288; Northampton 1933,
no. 14; Paris 1937, no. 37; Cleveland
1947, no. 43

Selected References
Lafond 1918–1919, 2: 41–43, repr.;
Museum of Modern Art, *The Lillie
P. Bliss Collection* (New York, 1934),
44, no. 25, repr.

81

Jockey seen in Profile

1889
red chalk on off-white thin wove
paper
28.3 x 41.8 (11⅛ x 16⁷⁄₁₆)
vente stamp lower left

Museum Boijmans Van Beuningen,
Rotterdam

Provenance
Atelier Degas, Vente III:130.1;
purchased at that sale by Henry
Fevre, Paris; Vente M. X . . . (Henry
Fevre), Hôtel Drouot, 22 June
1925, no. 40, repr.; purchased at that
sale by H. Hain, Paris; S. Meller,
Paris; with Paul Cassirer, Berlin
until 1927; Franz Koenigs, Haarlem,
1927; acquired as part of the Koenigs
collection by D. G. van Beuningen,
April 1940; his gift to the museum,
1940

Exhibitions
Bern 1951–1952, no. 98, as c. 1881–
1885; Paris, Bibliothèque Nationale,
20 February–20 April 1952, *Musée
Boymans de Rotterdam: dessins du
XVe au XIXe siècle*, no. 135, as 1881–
1885; Saint Louis 1967, no. 107,
repr., as 1887–1890; Nottingham
1969, no. 24, repr. pl. XIII; Tübin-
gen 1984, no. 152, repr., as 1887–
1888; Manchester 1987, no. 81, as
c. 1887–1890; Paris 1988–1989,
no. 279, repr., as c. 1887–1890;
Martigny 1993, no. 23, repr., as
c. 1888

Selected References
"Degas," *Art et Décoration* 11, no. 3
(July 1919), 114 repr.; Lemoisne
1946–1949, 2: under 674 bis; Jean
Vallery-Radot, "Dessins de Pisa-
nello à Cézanne: Collection Koenigs,
Musée Boymans," *Art et Style* 23
(1952), repr.; Scharf 1962, 191,
repr. fig. 13; Hoetink in Museum
Boymans-van Beuningen 1968, 68–
69, no. 73, repr.; Sutton 1986, 152,
155 repr.

82

Four Jockeys

c. 1886–1888
oil on panel
20 x 45 (7⅞ x 17¹¹⁄₁₆)
L 446

Private collection, courtesy of
Galerie Schmit, Paris

Provenance
Sold by the artist to Goupil, Boussod
and Valadon, Paris, 9 July 1888; sold
to Boivin, 12 July 1888; Collection
Boivin. Collection Henry Soulange-
Bodin, Paris. Collection Roger
Soulange-Bodin, Paris; Galerie
Schmit, Paris

Exhibitions
Paris 1924, no. 138, as "Le départ
d'une course," pastel; Paris 1955,
no. 74, repr., as "Le départ pour
la course," 1877; Paris 1960, no. 18,
repr., as c. 1877; Paris 1975, no. 17,
repr., as c. 1877

Selected References
Rewald 1973, Appendix I, 89,
as "Quatre chevaux de course";
Rewald 1986, Appendix I, n.p.

83

Horses and Jockeys

1886–1890
oil on panel
32 x 41 (12⅝ x 16⅛)
L 1088

Private collection, courtesy of
Galerie Schmit, Paris

Provenance
Atelier Degas, Vente II:8, as "Che-
vaux et jockeys dans un paysage";
Collection Nunès and Fiquet, Paris;
Collection of Mme Friedmann,
Paris; Galerie Schmit, Paris

Exhibitions
Paris 1955, no. 130, as 1890; Paris
1960, no. 46, as 1890–1895

84

Three Studies of a Jockey

1887–1889
blue and black graphite on paper
41 x 46 (16⅛ x 18⅛)
vente stamp lower right: Degas

Private collection

Provenance
Atelier Degas, Vente III:104.2;
bought by Marcel Guérin, Paris;
his sale, Hôtel Drouot, Paris, 12
December 1936, no. 1bis; bought
by Durand-Ruel, Paris (15775);
bought by Baron Louis de Chollet,
Fribourg, 12 February 1939;
David Bathurst Ltd., London; sale,
Christie's, London, 28 June 1994,
no. 120, repr., as c. 1883–1885

Exhibitions
Bern 1951–1952, no. 125; Amster-
dam 1952, no. 65; Paris 1960, no. 6,
repr., as 1866–1872; Saint Louis
1967, no. 103, repr., as 1882–1884;
New York 1968, no. 53, repr.; Tübin-
gen 1984, no. 147, repr., as 1883–
1885; London 1991, no. 12, repr.,
as c. 1883–1885; Paris, F. Perreau-
Saussine, Galerie du Carrousel,
11 October–21 December 1991,
Degas, no. 11, repr., as c. 1883–1885

Selected References
Reff 1967, 256, 263

85

Group of Jockeys

1887–1889
charcoal on tan "tracing" paper,
mounted
58.2 x 31.8 (22¹⁵⁄₁₆ x 12½)

The Art Museum, Princeton Uni-
versity, gift of Albert E. McVitty,
Class of 1898

Provenance
Atelier Degas, Vente III:377; A. E.
McVitty; his gift to the museum

Exhibitions
New York 1968, no. 56, repr., as
c. 1885; Princeton, The Art Museum,
Princeton University, 4 March–
9 April 1972, *19th and 20th Century
French Drawings from the Art Mu-
seum, Princeton University*, no. 34;
Miami 1994, no. 42, repr., as c. 1885

86

Horse Galloping

1885–1890
charcoal on thin, pale pink laid paper
23.4 x 27.5 (9³⁄₁₆ x 10¹³⁄₁₆)

Nasjonalgalleriet, Oslo

Provenance
Atelier Degas, Vente IV:212.a;
acquired by the museum at that sale

Selected References
Willoch 1980, repr. 34

87

Studies of Horses

1885–1890
counterproof of charcoal on laid
paper with a pink cast
28 x 35.9 (11 x 14⅛)

Nasjonalgalleriet, Oslo

Provenance
Atelier Degas, Vente IV:222.a;
acquired by the museum at that sale

Selected References
Willoch 1980, 35 repr.

88

Studies of Horses

1885–1890
charcoal on cream laid paper
24.5 x 31.4 (9⅝ x 12⅜)

Nasjonalgalleriet, Oslo

Provenance
Atelier Degas, Vente IV:212.c;
acquired by the museum at that sale

Selected References
Willoch 1980, 35 repr.

89

Nude Study of a Jockey

1885–1890
charcoal on off-white laid paper
31 x 24.9 (12³⁄₁₆ x 9¹³⁄₁₆)
vente stamp lower right

Museum Boijmans Van Beuningen,
Rotterdam

Provenance
Atelier Degas, Vente III:131.2; pur-
chased at that sale by Dr. Georges
Viau, Paris; with Paul Cassirer,
Berlin, 1928; purchased by Franz
Koenigs, Haarlem, 1928; acquired
as part of the Koenigs collection
by D. G. van Beuningen, April 1940;
his gift to the museum, 1940

Exhibitions
Saint Louis 1967, no. 106, repr., as
c. 1887–1890; Nottingham 1969,
no. 25, repr. (cover), as c. 1887–
1890; Tübingen 1984, no. 149, repr.,
as 1884–1888; Paris 1988–1989,
no. 282, repr.; Martigny 1993, no. 24,
repr., as c. 1890

Selected References
Eugenia Parry Janis, "Degas Draw-
ings," *Burlington Magazine* 109 (July
1967), 413, 415 repr.; Reff 1967, 261;
Hoetink in Museum Boymans-van
Beuningen 1968, 72, no. 82, repr.

90

*Jockey in Blue on a
Chestnut Horse*

c. 1889
oil on panel
27 x 22 (10⅝ x 8¹¹⁄₁₆)
L 986

Virginia Museum of Fine Arts,
Collection of Mr. and Mrs. Paul
Mellon

Provenance
Atelier Degas, Vente I:18; Marseille
collection, Paris; Fiquet collection,
Paris; Mr. and Mrs. Paul Mellon;
their gift to the museum, 1993

Exhibitions
Washington 1966, no. 59, repr., as
c. 1889

91

Horse

c. 1890
counterproof on heavy wove paper
35.3 x 53.9 (13¹⁵⁄₁₆ x 21¼)
vente stamp lower left in plate:
Degas
atelier stamp upper center verso
inscription lower right in graphite
by later hand: 125
inscription, underlined, lower right
verso: 2 160
L 664bis

National Gallery of Art, Washing-
ton, Collection of Mr. and Mrs.
Paul Mellon, 1985.64.166

Provenance
Atelier Degas, Vente IV:335.a; Le
Garrec collection, Paris; Mr. and
Mrs. Paul Mellon; their gift to the
museum, 1985

Selected References
Adhémar and Cachin 1973, LXIII–
LXIV, no. 171, repr., as c. 1878–
1880 (as collection of the Corcoran
Museum of Art, gift of Francis
Biddle)

92

*Two Horses, One Nuzzling
the Other*

c. 1890–1892
pastel on ivory paper
22 x 31 (8¹¹⁄₁₆ x 12³⁄₁₆)
vente stamp lower left: Degas
L 662

Sterling and Francine Clark
Art Institute, Williamstown,
Massachusetts

Provenance
Atelier Degas, Vente III:47.1;
Robert Sterling Clark, 1919; his gift
to the museum, 1955

Exhibitions
Williamstown 1959, no. 33, repr.;
Williamstown 1970, no. 30, as
c. 1880–1885; Williamstown 1987,
no. 51, repr., as c. 1881–1885

Selected References
Haverkamp-Begemann 1964, 1: 85,
2: repr. pl. 158

93

Jockey on a Rearing Horse

c. 1890–1892
black, olive, and light green chalk
on paper
22 x 31 (8¹¹⁄₁₆ x 12³⁄₁₆)
vente stamp lower left: Degas
L 666

Sterling and Francine Clark
Art Institute, Williamstown,
Massachusetts

Provenance
Atelier Degas, Vente III:47.3;
Robert Sterling Clark, 1919; his gift
to the museum, 1955

Exhibitions
Williamstown 1959, no. 22, repr.;
Williamstown 1970, no. 32, as
c. 1880–1885; Williamstown 1987,
no. 53, repr., as c. 1881–1885

Selected References
Haverkamp-Begemann 1964, 1: 85,
2: repr. pl. 159

94

At the Races: Before the Start

c. 1885–1892
oil on canvas
40 x 89 (15¾ x 35¹⁄₁₆)
signed lower left: Degas
L 502

Virginia Museum of Fine Arts,
Collection of Mr. and Mrs. Paul
Mellon

Provenance
Durand-Ruel, Paris, by 1892; Mrs.
A. Chester Beatty, London, by 1932;
Paul Rosenberg and Co., New York
until 1955; Mr. and Mrs. Paul Mellon;
their gift to the museum, 1985

Exhibitions
London 1905, no. 50; London 1932,
no. 453, as "The Races: Before the
Start"; Paris 1937, no. 28, as c. 1878;
Richmond 1960, no. 60, repr., as
c. 1878–1880; Washington 1966, no.
54, repr., as 1878–1880; New York
1968, no. 7, repr. as 1878; Richmond
1978, no. 11

Selected References
Lecomte 1892, 61–62, 65, repr. 55
as "Avant la course"; Geoffroy 1908,
15 repr.; Grappe 1908, 1911, 1913,
6, repr.; Hourticq 1912, 97 repr.;
Lemoisne 1912, 79–80, repr. pl.
XXXII; Meier-Graefe 1920, 1924,
repr. pl. LIV; Huyghe 1931, 273,
272, repr.; Pinkney L. Near, *French
Paintings: The Collection of Mr. and
Mrs. Paul Mellon in the Virginia
Museum of Fine Arts* (Seattle and
London, 1985), 32, repr. 33

95

Hacking to the Track

c. 1892
oil on canvas
39 x 89 (15⅜ x 35¹⁄₁₆)
vente stamp lower left: Degas
L 764

Collection of Mrs. John Hay
Whitney

Provenance
Atelier Degas, Vente I:102, as "La
promenade des chevaux (six jock-
eys)"; purchased at that sale by
Jacques Seligmann; his sale, Ameri-
can Art Association, New York, 27
January 1927, no. 41; purchased at
that sale by art agent Rose Lorenz;
Helen Hay Whitney collection, from
1927; by inheritance to John Hay
Whitney until 1982; to the present
owner

Exhibitions
New York 1960, no. 39, repr., as "La
promenade des chevaux," c. 1883–
1890; Washington 1982–1983, no.
13, repr., as 1883–1890; Manchester
1987, no. 90, repr. 99 fig. 128, as
c. 1895; Paris 1988–1989, no. 304,
repr. (New York only), as "Hacking
to the Race," c. 1895

Selected References
Étienne Charles, "Les mots de De-
gas," *La Renaissance de l'Art Français
et des Industries de Luxe* (April 1918),
3, repr. as "Esquisse d'un tableau de
courses"; Shackelford 1984, 102–
104, repr. fig. 4.9

96

Jockey (study for *Hacking
to the Track*)

c. 1890–1892
charcoal on paper
25 x 31.5 (9¹³⁄₁₆ x 12⅜)
vente stamp lower left: Degas

Ateneum, The Finnish National
Gallery

Provenance
Atelier Degas, Vente III:129.1

97

The Trainers

c. 1892–1894
pastel on cardboard
38.7 x 90.8 (15¼ x 35¾)
signed lower left: Degas
L 597 bis

The Wohl Family

Provenance
Durand-Ruel, Paris; Paul Aubry,
Paris; his sale, Hôtel Drouot, Paris,
10 May 1897, no. 44, repr., as "Les
Entraîneurs"; Knoedler, Paris;
Mrs. Ralph King, Cleveland

Exhibitions
Cleveland 1947, no. 42, repr., as
c. 1883; New York 1968, no. 8, repr.,
as c. 1880; New York 1978, no. 21,
repr., as c. 1880

98

Racehorses in a Landscape

1894
pastel on tracing paper
48 x 64 (18⅞ x 25³⁄₁₆)
signed and dated lower left:
Degas / 94
L 1145

Collection Carmen Thyssen-
Bornemisza on loan to Fundación
colección Thyssen-Bornemisza,
Madrid

Provenance
Durand-Ruel, Paris, acquired from
the artist, 18 August 1894 (stock no.
3116); acquired from Durand-Ruel
by Horace O. Havemeyer, New
York, 30 March 1895 (stock nos.
3116, N.Y. 1376), until 1907; Mrs.
H. O. Havemeyer, New York, 1907–
1929; her daughter, Electra Have-
meyer Webb, New York, 1929–1960;
her daughter, Electra Webb Bost-
wick, from 1960; Andrew Crispo
Gallery, New York; Baron H. H.
Bornemisza, Lugano; sale, Soth-
eby's, London, 26 June 1984, no. 9,
repr., as "Jockeys à l'entraînement"
(not sold); Baron H. H. Thyssen
Bornemisza, Lugano

Exhibitions
The Grolier Club, New York, 1922,
no. 72; Philadelphia 1936, no. 53,
repr., as "Training"; New York
1960, no. 62, repr., as "L'entraîne-

ment"; Tübingen 1984, no. 192, repr., as "Jockeys beim Training"; Paris 1988–1989, no. 306, repr., as "Racehorses in a Landscape"

Selected References
Grappe 1911, 36 repr., as "L'entraînement"; Meier-Graefe 1923, repr. pl. XC, as "Avant le Start"; Havemeyer 1931, 378, repr., as "L'entraînement"; Cabanne 1957, 30, 116, 106 repr., as "Chevaux de courses: l'entraînement"; Louisine Havemeyer, *Sixteen to Sixty: Memoirs of a Collector* (New York, 1961), 257; Sutton 1986, 150–151, 156 repr., as "Race Horses in Training"; Frances Weitzenhoffer, *The Havemeyers: Impressionism Comes to America* (New York, 1986), 102, repr. color pl. 53; Boggs and Maheux 1992, 132, 133 repr., as "Racehorses in a Landscape"; *Splendid Legacy: The Havemeyer Collection* (New York, 1993), 338, 337 repr., as "Racehorses in Training"; Kendall in exh. cat. New York 1993, 113, 236, 235 repr., 239 repr. (detail), as "Racehorses in a Landscape"

99

The Fallen Jockey (study for *Scene from the Steeplechase: The Fallen Jockey*)

c. 1895
charcoal on paper
23 x 31 (9 1/16 x 12 3/16)
vente stamp lower right: Degas

Private collection

Provenance
Atelier Degas, Vente III:353.2; bought from R. Balay, New York, 1950; Baron Louis de Chollet, Fribourg

Exhibitions
Saint Louis 1967, no. 45, repr.; New York 1968, no. 26, repr.

Selected References
Boerlin 1963, 46, 52 repr. fig. 7; Sutton 1986, 139, repr.

100

The Fallen Jockey

c. 1896–1898
oil on canvas
180 x 151 (70 7/8 x 59 7/16)
L 141

Öffentliche Kunstsammlung Basel, Kunstmuseum

Provenance
Deposited by the artist with Durand-Ruel, Paris, 22 February 1913 (as "Cheval emporté," stock no. 10251); Atelier Degas, Vente I:56; bought at that sale by Jos. Hessel; sale, Hôtel Drouot, Paris, 9 June 1928, no. 36, repr.; bought at that sale by Georges Bernheim, Paris; Benatov collection, Paris, by 1955, until 1957; E. and A. Silberman Galleries, New York, by 1959; bought by the museum, 21 March 1963

Exhibitions
Paris 1955, no. 29, as 1866; Paris 1988–1989, no. 351, repr., as c. 1896–1898

Selected References
Boerlin 1963, 45–54, repr. figs. 6, 11 (detail)

101

Jockeys

c. 1895
oil on canvas
26 x 38 (10 1/4 x 14 15/16)
signed lower right
L 896 bis

Private collection, courtesy of Galerie Schmit, Paris

Provenance
A. A. Pope, Farmington, Connecticut; Edgar R. Thom, Bloomfield Hills, Michigan, by 1949; Galerie Schmit, Paris

Exhibitions
New York 1949, no. 77, as "Race Horses"; New York 1968, no. 15

102

Jockeys

c. 1895
oil on panel
14 x 17 (5 1/2 x 6 11/16)
vente stamp lower right: degas
L 1027

Private collection, courtesy of Galerie Schmit, Paris

Provenance
Atelier Degas, Vente I:26; Collection Nunès and Fiquet, Paris; Collection Roger G. Gompel, Paris, by 1924; Galerie Schmit, Paris

Exhibitions
Paris 1924, no. 62; Bern 1951–1952, no. 48; London 1989, no. 10, repr.

103

Racehorses

1895–1900
pastel on tracing paper, laid down on cardboard
55.8 x 64.8 (21 15/16 x 25 1/2)
signed lower right: Degas
L 756 (as c. 1883–1885)

National Gallery of Canada, Ottawa

Provenance
With Ambroise Vollard, Paris; bought from the Vollard estate by the museum in 1950

Exhibitions
(?) Paris 1939, no. 40; Ottawa, National Gallery of Canada, November 1950, *Vollard Collects*, no. 10 repr.; Los Angeles 1958, no. 44 repr., as c. 1883–1885; New York 1968, no. 17, repr., as late 1890s; Paris 1988–1989, no. 353 repr., as 1895–1900

Selected References
Vollard 1914, repr. pl. VIII; Maheux 1988, 67–69, 70 repr.

104

Three Jockeys

c. 1900
pastel on tracing paper, mounted on board
49 x 62 (19 5/16 x 24 7/16)
vente stamp lower left: Degas
L 763

The Metropolitan Museum of Art, Partial and Promised Gift of Mr. and Mrs. Douglas Dillon, 1992

Provenance
Atelier Degas, Vente I:136; bought at that sale by Jacques Seligmann, Paris; Seligmann sale, American Art Association, New York, 27 January 1921, no. 27; bought at that sale by Durand-Ruel, New York; deposited with the Galeries Durand-Ruel, Paris (stock no. 12547), 4 July 1921; acquired by G. and J. Durand-Ruel, New York, 10 September 1924 (stock no. 4675); bought by Hugo Perls, 20 May 1927 (stock no. 12593); Esther Slater Kerrigan collection, New York; Kerrigan collection sale, Parke-Bernet Galleries, New York, 8–10 January 1942, no. 47; bought at that sale by Lee A. Ault, New York; sale, Parke-Bernet Galleries, New York, 24 October 1951, no. 93, consigned by V. Dudensing; bought at that sale by French and Co., New York, for Bryon Foy; Bryon Foy collection sale, Parke-Bernet Galleries, New York, 26 October 1960, no. 75; bought at that sale by Douglas Dillon; partial and promised gift to the Metropolitan Museum of Art

Exhibitions
Maison-Lafitte 1926, no. 88, repr. facing 33 (?); New York 1968, no. 12, repr.; New York 1978, no. 29, repr.; Paris 1988–1989, no. 352, repr.; New York 1993, no. 78

Selected References
Thomson in exh. cat. Manchester 1987, 101, 100 repr.

105

Jockeys

c. 1885–1900
pastel and graphite on paper
76 x 96 (29¹⁵⁄₁₆ x 37¹³⁄₁₆)
vente stamp lower left: Degas
L 939

Private collection

Provenance
Atelier Degas, Vente I:154, as
"Jockeys"; Trotti Collection, Paris;
Winkel and Magnussens, Copen-
hagen; Durand-Ruel, Paris; Étienne
Bignou, Paris; Reid and Lefevre,
London; Private collection, London

Exhibitions
London 1970, no. 12, repr., as
"Avant la course"; Dallas Museum
of Art, 1989, *Impressionist and
Modern Masters in Dallas: Monet to
Mondrian*, no. 30, repr., as "Before
the Race"

106

Jockey

c. 1900
charcoal heightened with pastel;
counterproof on paper
28.9 x 22.5 (11⅜ x 8⅞)
atelier stamp on verso

Private collection, Italy

Provenance
Atelier Degas; Vente III:106.3;
Galerie Durand-Ruel, Paris; Baron
Louis de Chollet, Fribourg; sale,
Christie's, New York, 15 November
1990, no. 105, repr.

Exhibitions
New York 1968, no. 60, repr.

107

Jockey

c. 1900
washed pastel, brown wash, and
transferred pastel on paper
27.9 x 21 (11 x 8¼)
vente stamp lower left: Degas
atelier stamp lower left verso
inscription lower right verso in
graphite by later hand: original
drawing by Degas / # 376 in s
L 1320 bis

National Gallery of Art, Washing-
ton, Gift of Mrs. Jane C. Carey as
an addition to the Addie Burr Clark
Memorial Collection, 1959.12.10

Provenance
Atelier Degas, Vente II:378; Pellet
collection, Paris; Mrs. Jane C.
Carey; her gift to the museum, 1959

108

Jockey

c. 1900
charcoal on paper
31.5 x 22 (12⅜ x 8¹¹⁄₁₆)

Private collection c/o Paul Prouté
S. A.

Provenance
Atelier Degas, Vente IV:259.c;
Paul Prouté, Paris

Exhibitions
Paul Prouté S. A., Paris, 1971,
Dessins Estampes, no. 84, repr.

109

Washerwomen and Horses

c. 1904
charcoal and pastel on tracing paper
with strip added at bottom
84 x 107 (33⅛ x 42⅛)
vente stamp lower left: Degas
L 1418

Musée Cantonal des Beaux-Arts,
Lausanne. Bequest of Henri-
Auguste Widmer, 1936

Provenance
Atelier Degas, Vente I:182; Galerie
Paul Rosenberg, Paris; M. Snayers,
Brussels; sale, Brussels, 4 May 1925,
no. 45 repr.; Dr. A. Widmer, Val-
mont-Territet; his bequest to the
museum, 1936

Exhibitions
Manchester 1907–1908, no. 173 (?);
Bern 1951–1952, no. 69, as c. 1902;
Amsterdam 1952, no. 56; Tübingen
1984, no. 218, 97 repr.; Paris 1984–
1985, no. 16, 126, 119 repr. fig. 100;
Paris 1988–1989, no. 389, repr., as
c. 1904; Martigny 1993, no. 26, repr.;
Zurich 1994–1995, no. 179, repr., as
c. 1904

Selected References
Browse [1949], 411, no. 235a;
Cooper 1953, 14, 26, no. 31, repr.;
René Berger, *Promenade au Musée
Cantonal des Beaux-Arts, Lausanne*
(Lausanne, 1970), 40, 41 repr.;
Catalogue du Musée des Beaux-Arts
(Lausanne, 1971); Terrasse 1981,
no. 669 repr.; Sutton 1986, 303, repr.
pl. 287; Thomson in exh. cat. Man-
chester 1987, 103, 105, 104 repr.;
Catherine Lepdor, Patrick Schaefer,
and Jörg Zutter, *La collection du
Musée cantonal des Beaux-Arts de
Lausanne* (Bern, 1994), 28 repr.

110

Study of a Mustang

1859–1860
reddish brown wax and green clay
24.5 x 12.7 x 35.6 (9⅝ x 5 x 14)
P 48

Virginia Museum of Fine Arts,
Collection of Mr. and Mrs. Paul
Mellon

Provenance
Atelier Degas; the artist's heirs,
1917; Adrien A. Hébrard, Paris;
Nelly Hébrard; sold to Knoedler
and Co., New York, 1955; acquired
by Mr. and Mrs. Paul Mellon, 1956;
their gift to the museum, 1993

Exhibitions
New York 1955, no. 8; Richmond,
Virginia Museum of Fine Arts, 1956
(temporary installation)

Selected References
Rewald 1956, 142, no. VIII (as be-
tween 1865 and 1881); Millard 1976,
5, 9, 20, 59, 97 n. 8, repr. fig. 2 (as
c. 1860–1862)

111

Horse at Trough

early 1860s
red wax
19.7 x 10.5 x 24.1 (7¾ x 4⅛ x 9½)
P 42

Virginia Museum of Fine Arts,
Collection of Mr. and Mrs. Paul
Mellon

Provenance
Atelier Degas; the artist's heirs,
1917; Adrien A. Hébrard, Paris;
Nelly Hébrard; sold to Knoedler
and Co., New York, 1955; acquired
by Mr. and Mrs. Paul Mellon, 1956;
their gift to the museum, 1993

Exhibitions
New York 1955, no. 2, repr.; Rich-
mond, Virginia Museum of Fine
Arts, 1956 (temporary installation)

Selected References
Rewald 1956, 15, no. II (as between
1865 and 1868); Beaulieu 1969, 370,
372; Millard 1976, 5, 6, 20, 97, 100,
repr. fig. 9 (as before 1881); exh. cat.
Manchester 1987, 39; Loyrette 1991,
392 (as 1867–1868)

112

Horse Walking

early 1870s
reddish wax
21.6 x 27 x 8.7 (8½ x 10⅝ x 3⅜)
P 52

Collection of Mr. and Mrs. Paul Mellon, Upperville, Virginia

Provenance
Atelier Degas; the artist's heirs, 1917; Adrien A. Hébrard, Paris; Nelly Hébrard; sold to Knoedler and Co., New York, 1955; acquired by Mr. and Mrs. Paul Mellon, 1956

Exhibitions
New York 1955, no. 10, repr.; Richmond, Virginia Museum of Fine Arts, 1956 (temporary installation); Washington 1991, no no., repr. 188

Selected References
Gsell 1918, 378; Rewald 1956, 142, no. X (as before 1881); Millard 1976, 20, 59, 97 n. 8, repr. fig. 7 (as before 1881); Failing 1995, 59, repr.

113

Thoroughbred Horse Walking

early 1870s
yellow brown wax
12.7 x 21.4 x 4.5 (5 x 8⅜ x 1¾)
P 38

Collection of Mr. and Mrs. Paul Mellon, Upperville, Virginia

Provenance
Atelier Degas; the artist's heirs, 1917; Adrien A. Hébrard, Paris; Nelly Hébrard; sold to Knoedler and Co., New York, 1955; acquired by Mr. and Mrs. Paul Mellon, 1956

Exhibitions
New York 1955, no. 5, repr.; Richmond, Virginia Museum of Fine Arts, 1956 (temporary installation); Washington 1991, no no., repr. 189

Selected References
Rewald 1956, 142, no. V (between 1865 and 1881); Millard 1976, 20, fig. 13 (before 1881); McCarty 1986, 223–224, repr.

114

Horse Walking

early 1870s
red wax
23.5 x 11.4 x 21.6 (9¼ x 4½ x 8½)
P 39

Virginia Museum of Fine Arts, Collection of Mr. and Mrs. Paul Mellon

Provenance
Atelier Degas; the artist's heirs, 1917; Adrien A. Hébrard, Paris; Nelly Hébrard; sold to Knoedler and Co., New York, 1955; acquired by Mr. and Mrs. Paul Mellon, 1956; their gift to the museum, 1993

Exhibitions
New York 1955, no. 4; Richmond, Virginia Museum of Fine Arts, 1956 (temporary installation)

Selected References
Gsell 1918, 378, repr.; Lemoisne 1919, III, repr.; Rewald 1956, 141, no. IV (as before 1881); Beaulieu 1969, 370; Millard 1976, 20, 59, 74, 97 n. 8, fig. 15 (as before 1881); Failing 1995, 56, repr. 56–57

115

Horse with Jockey; Horse Galloping, Turning the Head to the Right, the Feet Not Touching the Ground

mid 1870s
dark brown and reddish brown wax, green clay
29.2 x 33.1 x 10.4 (11½ x 13 x 4⅛)
P 53, 54

Collection of Mr. and Mrs. Paul Mellon, Upperville, Virginia

Provenance
Atelier Degas; the artist's heirs, 1917; Adrien A. Hébrard, Paris; Nelly Hébrard; sold to Knoedler and Co., New York, 1955; acquired by Mr. and Mrs. Paul Mellon, 1956

Exhibitions
New York 1955, nos. 17–18, repr.; Richmond, Virginia Museum of Fine Arts, 1956 (temporary installation); Washington 1991, no no., repr. 192

Selected References
Rewald 1956, 144, nos. XVII and XVIII (as between 1865 and 1881); Beaulieu 1969, 372; Millard 1976, 23 (as between 1881 and 1890)

116

Horse Trotting, the Feet Not Touching the Ground

1880s
red wax
23.2 x 27.5 x 5.6 (9⅛ x 10⅞ x 2¼)
P 51

Collection of Mr. and Mrs. Paul Mellon, Upperville, Virginia

Provenance
Atelier Degas; the artist's heirs, 1917; Adrien A. Hébrard, Paris; Nelly Hébrard; sold to Knoedler and Co., New York, 1955; acquired by Mr. and Mrs. Paul Mellon, 1956

Exhibitions
New York 1955, no. 11, repr.; Richmond, Virginia Museum of Fine Arts, 1956 (temporary installation); Washington 1991, no no., repr. 190

Selected References
Lemoisne 1919, 110, repr.; Fevre 1949, repr. between 112–113; Rewald 1956, 142, no. XI (as c. 1879–1881); Beaulieu 1969, 374; Millard 1976, 23, 99, 100 n. 13 (as 1885–1886)

117

Rearing Horse

1880s
red wax
30.9 x 27.3 x 19.2 (12⅛ x 10¾ x 7½)
P 44

Collection of Mr. and Mrs. Paul
Mellon, Upperville, Virginia

Provenance
Atelier Degas; the artist's heirs,
1917; Adrien A. Hébrard, Paris;
Nelly Hébrard; sold to Knoedler
and Co., New York, 1955; acquired
by Mr. and Mrs. Paul Mellon, 1956

Exhibitions
New York 1955, no. 13, repr.; Rich-
mond, Virginia Museum of Fine
Arts, 1956 (temporary installation);
Washington 1991, no no., repr. 191

Selected References
Lemoisne 1919, 110 repr., 111; Re-
wald 1956, 143, no. XIII (as between
1865 and 1881); Beaulieu 1969, 373
(as c. 1885); Millard 1976, 23, 100
(as late 1880s); exh. cat. Paris 1988–
1889, 462, repr. fig. 260 (as 1888–
1890); Loyrette 1991, 464

118

*Horse Balking (Horse Clearing
an Obstacle)*

1880s
yellow wax
30.5 x 41 x 20.2 (12 x 16⅛ x 8)
P 43

Collection of Mr. and Mrs. Paul
Mellon, Upperville, Virginia

Provenance
Atelier Degas; the artist's heirs,
1917; Adrien A. Hébrard, Paris;
Nelly Hébrard; sold to Knoedler
and Co., New York, 1955; acquired
by Mr. and Mrs. Paul Mellon, 1956

Exhibitions
New York 1955, no. 9, repr.; Rich-
mond, Virginia Museum of Fine
Arts, 1956 (temporary installation);
Washington 1991, no no., repr. 191

Selected References
Rewald 1956, 142, no. IX (as be-
tween 1865 and 1881); Beaulieu 1969,
372; Millard 1976, 21, 23, 59, 100–
102, repr. fig. 66 (as between 1881
and 1890); McCarty 1986, 219, 220,
repr.; Tinterow in exh. cat. Paris
1988–1989, 460–461 (as 1888–
1890); Loyrette 1991, 464; Failing
1995, 59

119

Prancing Horse

1880s
red wax
28.6 x 13.3 x 27.6 (11¼ x 5¼ x 10⅞)
P 40

Virginia Museum of Fine Arts,
Collection of Mr. and Mrs. Paul
Mellon

Provenance
Atelier Degas; the artist's heirs,
1917; Adrien A. Hébrard, Paris;
Nelly Hébrard; sold to Knoedler
and Co., New York, 1955; acquired
by Mr. and Mrs. Paul Mellon, 1956;
their gift to the museum, 1993

Exhibitions
New York 1955, no. 16; Richmond,
Virginia Museum of Fine Arts, 1956
(temporary installation)

Selected References
Rewald 1956, 143, no. XVI (as
between 1865 and 1881); Beaulieu
1969, 372 (as c. 1881–1885); Millard
1976, 22 (as between 1881 and 1890)

120

Horse Galloping on Right Foot

1889/1890
reddish brown wax and cork
34.2 x 46.8 x 22.5 (13½ x 18⅜ x 8⅞)
P 41

Collection of Mr. and Mrs. Paul
Mellon, Upperville, Virginia

Provenance
Atelier Degas; the artist's heirs,
1917; Adrien A. Hébrard, Paris;
Nelly Hébrard; sold to Knoedler
and Co., New York, 1955; acquired
by Mr. and Mrs. Paul Mellon, 1956

Exhibitions
New York 1955, no. 6, repr.; Rich-
mond, Virginia Museum of Fine
Arts, 1956 (temporary installation);
Washington 1991, no no., repr. 190

Selected References
Rewald 1956, 142, no. VI (as be-
tween 1865 and 1881); Beaulieu 1969,
370; Millard 1976, 23 n. 83, 99, 100
n. 13, repr. fig. 60 (as between 1881
and 1890)

121

Horse with Lowered Head

1889/1890
brown wax and cork
18.4 x 27.2 x 7.9 (7¼ x 10¾ x 3⅛)
P 46

Collection of Mr. and Mrs. Paul
Mellon, Upperville, Virginia

Provenance
Atelier Degas; the artist's heirs,
1917; Adrien A. Hébrard, Paris;
Nelly Hébrard; sold to Knoedler
and Co., New York, 1955; acquired
by Mr. and Mrs. Paul Mellon, 1956

Exhibitions
New York 1955, no. 12, repr.; Rich-
mond, Virginia Museum of Fine
Arts, 1956 (temporary installation);
Washington 1991, no no., repr. 189

Selected References
Fevre 1949, repr. between 128–129;
Rewald 1956, 143, no. XII (as be-
tween 1865 and 1881); Beaulieu 1969,
372 (as between 1883 and 1890);
Millard 1976, 23, 99, 100, repr. fig.
63 (as between 1881 and 1890)

122

Draft Horse

late 1880s/early 1890s
dark brown wax
10.2 (4)
P 45

Virginia Museum of Fine Arts,
Collection of Mr. and Mrs. Paul
Mellon

Provenance
Atelier Degas; the artist's heirs,
1917; Adrien A. Hébrard, Paris;
Nelly Hébrard; sold to Knoedler
and Co., New York, 1955; acquired
by Mr. and Mrs. Paul Mellon, 1956;
their gift to the museum, 1993

Exhibitions
New York 1955, no. 7; Richmond,
Virginia Museum of Fine Arts, 1956
(temporary installation)

Selected References
Rewald 1956, 142, no. VII (as be-
tween 1865 and 1881); Beaulieu 1969,
373; Millard 1976, 23 n. 83, 99, repr.
fig. 59 (as c. 1881); McCarty 1986,
221, repr.

123

Horse with Jockey; Horse Galloping on Right Foot, the Back Left Only Touching the Ground

1890s
brown wax and cloth
26.1 x 34.3 x 17.9 (10¼ x 13½ x 7)
P 49, 50

Collection of Mr. and Mrs. Paul Mellon, Upperville, Virginia

Provenance
Atelier Degas; the artist's heirs, 1917; Adrien A. Hébrard, Paris; Nelly Hébrard; sold to Knoedler and Co., New York, 1955; acquired by Mr. and Mrs. Paul Mellon, 1956

Exhibitions
New York 1955, nos. 14–15, repr.; Richmond, Virginia Museum of Fine Arts, 1956 (temporary installation); Washington 1991, no no., repr. 192

Selected References
Rewald 1956, 143, nos. XIV, XV (as between 1865 and 1881); Beaulieu 1969, 370; Millard 1976, 23 n. 83, 38 n. 62, 99, repr. fig. 64 (as between 1881 and 1890)

124

Horse Standing

modeled late 1860s/early 1870s
cast 1919/1921
bronze
29.5 x 18.7 x 18.7 (11⅝ x 7⅜ x 7⅜)
P 47

Norton Simon Art Foundation, Pasadena, California

Provenance
A. A. Hébrard, Paris; the Lefevre Gallery, London; purchased by the Norton Simon Art Foundation, Pasadena, 1977

Exhibitions
London 1976, 47, repr.; Cambridge, Mass., Fogg Art Museum, 1977 (temporary installation)

Selected References
Rewald 1956, III; Campbell 1995, 29, no. 38, repr.

125

Horse Galloping on Right Foot and *Jockey*

modeled 1890s
cast 1919/1921
bronze
24.8 x 33.7 x 18.1 (9¾ x 13¼ x 7⅛)
P 49, 50

Norton Simon Art Foundation, Pasadena, California

Provenance
A. A. Hébrard, Paris; the Lefevre Gallery, London; purchased by the Norton Simon Art Foundation, Pasadena, 1977

Exhibitions
London 1976, nos. 49/50, repr.; Cambridge, Mass., Fogg Art Museum, 1977 (temporary installation)

Selected References
Rewald 1956, XIV, XV; Sutton 1986, 152, 158 repr.; Campbell 1995, 23, no. 25, 28, no. 35, repr.

126

Rearing Horse

modeled 1880s
cast 1919/1921
bronze
24.8 x 33.7 x 18.1 (9¾ x 13¼ x 7⅛)
P 44

Norton Simon Art Foundation, Pasadena, California

Provenance
A. A. Hébrard, Paris; the Lefevre Gallery, London; purchased by the Norton Simon Art Foundation, Pasadena, 1977

Exhibitions
London 1976, no. 44, repr.; Cambridge, Mass., Fogg Art Museum, 1977 (temporary installation)

Selected References
Rewald 1956, XIII; Sutton 1986, 154, 158, 159 repr.; Campbell 1995, 13, no. 4, repr.

127

Study of a Mustang

modeled 1859–1860,
cast 1919/1921
bronze
22.2 (8¾)
inscriptions: on proper right front corner of self-base: Degas; on proper left rear corner of self-base: 21 / B and CIRE / PERDUE / AA HEBRARD
marks: FM: A. A. Hebrard
P 48

National Gallery of Art, Washington, Gift of Mrs. Lessing J. Rosenwald, 1989.28.1

Provenance
Halvorsen Collection; Durand-Ruel, New York, by 1922; Ferargil Galleries, New York, 1925; Mrs. Lessing J. Rosenwald; her gift to the museum, 1989

Exhibitions
New York, Durand-Ruel, 1922, no. 48

Selected References
Rewald 1944, 19, no. VIII (another cast illustrated); Rewald 1956, 142, no. VIII (another cast illustrated); Millard 1976, 5, 20, 59, 97 n. 8, repr. fig. 2 (another cast illustrated); Campbell 1995, 21 (another cast illustrated)

128

Rearing Horse

modeled 1880s
cast 1919/1921
bronze
30.9 (12⅛)
inscriptions: 4 / HER.D and CIRE / PERDUE / AA HEBRARD
marks: FM: A. A. Hebrard
P 44

Collection of Mr. and Mrs. Paul Mellon, Upperville, Virginia

Provenance
the artist's heirs; Hector Brame, Paris; purchased by current owner, May 1964

Selected References
Rewald 1944, 20, no. XIII (another cast illustrated); Rewald 1957, 143, no. XIII (another cast illustrated); Millard 1976, 23, 100; exh. cat. Paris 1988–1989, 462, no. 281 (another cast illustrated); Campbell 1995, 13, no. 4 (another cast illustrated)

Selected Bibliography

Adhémar 1955
Adhémar, Jean. "Before the Degas Bronzes." *Art News* (November 1955), 34–35, 70.

Adhémar and Cachin 1973
Adhémar, Jean and Françoise Cachin. *Edgar Degas. Gravures et monotypes*. Introduction by John Rewald. Paris, 1973.

Alexandre 1908
Alexdandre, Arsène. "Collection de M. le comte Isaac de Camondo." *Les Arts* 83 (November 1908), 22–26, 29, 32.

Balanda and Lorenzo 1987
Balanda, Marie-Josephe de and Annie Lorenzo. *Le cheval vu par les peintres*. Lausanne, 1987.

Barbour 1992
Barbour, Daphne. "Degas's Wax Sculptures from the Inside Out." *Burlington Magazine* 134, 1077 (December 1992), 798–805.

Barbour 1995
Barbour, Daphne. "Degas's Little Dancer: Not Just a Study in the Nude." *Art Journal* (Summer 1995), 28–32.

Barbour and Sturman 1995
Barbour, Daphne and Shelley Sturman. "Degas' Women in Washington: Four Case Studies," 31–38. In *From Marble to Chocolate: The Conservation of Modern Sculpture*. London, 1995.

Bazin 1931
Bazin, Germain. "Degas sculpteur." *L'Amour de l'Art*, 12th year (July 1931), 292–301.

Bazin 1958
Bazin, Germain. *Trésors de l'Impressionisme au Louvre*. Paris, 1958.

Beaulieu 1969
Beaulieu, Michèle. "Les sculptures de Degas: essai de chronologie." *La Revue du Louvre et des Musées de France* 19, no. 6 (1969), 369–380.

Berson 1996
Berson, Ruth. *The New Painting. Impressionism 1874–1886. Documentation*. 2 vols. San Francisco, 1996.

Boerlin 1963
Boerlin, Paul-Henry. "Zum Thema des gestürzten Reiters bei Edgar Degas." *Jahresbericht der Öffentlichen Kunstsammlung Basel* (1963), 45–54.

Boggs 1962
Boggs, Jean Sutherland. *Portraits by Degas*. Berkeley, 1962.

Boggs and Maheux 1992
Boggs, Jean Sutherland and Anne Maheux. *Degas Pastels*. New York, 1992.

Bouret 1965
Bouret, Jean. *Degas*. Daphne Woodward, trans. London, 1965.

Brown 1990
Brown, Marilyn R. "The DeGas-Musson Papers at Tulane University." *Art Bulletin*. 72, no. 1 (March 1990), 118–130.

Brown 1994
Brown, Marilyn R. *Degas and the Business of Art: A Cotton Office in New Orleans*. University Park, Pa., 1994.

Cabanne 1957
Cabanne, Pierre. *Edgar Degas*. Paris, 1957.

Camesca and Cortenova 1986
Camesca, Ettore and Giorgio Cortenova. *Degas sculture*. Milan, 1986.

Campbell 1995
Campbell, Sara. "A Catalogue of Degas' Bronzes." *Apollo* (August 1995), 10–48.

Colinart, Drilhon, and Scherf 1987
Colinart, Sylvie, France Drilhon and Guilhem Scherf, *Sculptures en cire de l'ancienne Egypte à l'art abstrait*, Paris, 1987.

Cooper 1953
Cooper, Douglas. *Pastels by Edgar Degas*. New York, 1953.

Degas inédit 1989
Degas inédit: actes du colloque Degas, Musée d'Orsay 18–21 avril 1988. Paris, 1989.

Distel 1989
Distel, Anne. *Les collectionneurs des Impressionistes: Amateurs et marchands*. Paris, 1989.

Dunlop 1979
Dunlop, Ian. *Degas*. New York, 1979.

Exh. cat. Boston 1984–1985
Edgar Degas: The Painter as Printmaker (selection and catalogue by Sue Welsh Reed and Barbara Stern Shapiro; contributions by Clifford S. Ackley and Roy L. Parkinson; essay by Douglas Druick and Peter Zegers) [exh. cat., Museum of Fine Arts; Philadelphia Museum of Art; Arts Council of Great Britain, Hayward Gallery, London] (Boston, 1984).

Exh. cat. Cambridge, Mass., 1968
Degas monotypes (by Eugenia Parry Janis) [exh. cat., Fogg Art Museum] (Cambridge, Mass., 1968).

Exh. cat. Edinburgh 1979
Degas 1879 (catalogue by Ronald Pickvance) [exh. cat., National Gallery of Scotland] (Edinburgh, 1979).

Exh. cat. London 1989
Edgar Degas 1837–1917 [exh. cat., Browse and Darby] (London, 1989).

Exh. cat. Manchester 1987
The Private Degas (by Richard Thomson) [exh. cat., Whitworth Art Gallery; Fitzwilliam Museum, Cambridge] (Manchester, 1987).

Exh. cat. Martigny 1993
Degas [exh. cat, Fondation Pierre Gianadda] (Martigny, 1993).

Exh. cat. New York 1968
Degas' Racing World (by Ronald Pickvance) [exh. cat., Wildenstein and Co.] (New York, 1968).

Exh. cat. New York 1993
Degas Landscapes (by Richard Kendall) [exh. cat., Metropolitan Museum of Art; Museum of Fine Arts, Houston] (New York, 1993).

Exh. cat. Paris 1924
Exposition Degas [exh. cat., Galeries Georges Petit] (Paris, 1924).

Exh. cat. Paris 1969
Degas: oeuvres du Musée du Louvre [exh. cat., Musée de l'Orangerie] (Paris, 1969).

Exh. cat. Paris 1984–1985
Degas: Forme et l'espace (designed and edited by Maurice Guillaud) [exh. cat., Centre Culturel du Marais] (Paris, 1984).

Exh. cat. Paris 1988–1989
Degas (by Jean Sutherland Boggs, Henri Loyrette, Michael Pantazzi and Gary Tinterow, with essay by Douglas W. Druick and Peter Zegers) [exh. cat., Galeries Nationales du Grand Palais; National Gallery of Canada, Ottawa; Metropolitan Museum of Art, New York] (Paris, 1988).

Exh. cat. Paris 1994–1995
Impressionnisme, les origines 1859–1869 (catalogue by Gary Tinterow and Henri Loyrette) [exh. cat., Grand Palais; Metropolitan Museum of Art, New York] (Paris, 1994).

Exh. cat. Saint Louis 1967
Drawings by Degas (by Jean Sutherland Boggs) [exh. cat., City Art Museum of Saint Louis; Philadelphia Museum of Art; The Minneapolis Society of Fine Arts] (Saint Louis, 1967).

Exh. cat. Washington 1982–1983
Manet and Modern Paris (catalogue by Theodore Reff)[exh. cat., National Gallery of Art] (Washington, 1982).

Failing 1988
Failing, Patricia. "Cast in Bronze: The Degas Sculpture Dilemma." *ARTnews* 87, no. 1 (January 1988), 136–141.

Failing 1995
Failing, Patricia. "Authorship and Physical Evidence: The Creative Process." *Apollo* (August 1995), 55–59.

Fevre 1949
Fevre, Jeanne. *Mon oncle Degas.* Pierre Borel, ed. Geneva, 1949.

Fletcher and Desantis 1989
Fletcher, Shelley and Pia Desantis. "Degas: The Search for His Technique Continues." *Burlington Magazine* 131, no. 1033 (April 1989), 256–265.

Galerie Durand-Ruel 1873
Galerie Durand-Ruel. *Recueil d'estampes gravées à l'eau-forte.* Vol. 6. Paris, 1873.

Geoffroy 1908
Geoffroy, Gustave. "Degas." *L'Art et les artistes* 4, no. 37 (April 1908), 15–23.

Gordon and Forge 1988
Gordon, Robert and Andrew Forge. *Degas.* New York, 1988.

Grappe 1908, 1911, 1913
Grappe, Georges. *Edgar Degas.* L'art et le beau. 3d year, 1. Paris, 1908. Reprint ed., 1911, 1913.

Grappe 1936
Grappe, Georges. *Degas.* Paris, 1936.

Gsell 1918
Gsell, Paul. "Edgar Degas, statuaire." *La Renaissance de l'Art français* (December 1918), 373–378.

Guérin 1931
Guérin, Marcel. *Lettres de Degas.* Paris, 1931.

Halévy 1964
Halévy, Daniel. *My Friend Degas.* Mina Curtiss, ed. and trans. Middletown, Conn., 1964.

Havemeyer 1931
H.O. Havemeyer Collection. Catalogue of Paintings, Prints, Sculpture and Objects of Art. Portland, 1931.

Haverkamp-Begemann 1964
Haverkamp-Begemann, Egbert. *Drawings from the Clark Art Institute.* New Haven and London, 1964.

Herbert 1988
Herbert, Robert. *Impressionism. Art, Leisure and Parisian Society.* New Haven and London, 1988.

Hourticq 1912
Hourticq, Louis. "E. Degas." *Art et Décoration* (October 1912), 97–113.

Huyghe 1931
Huyghe, René. "Degas ou la fiction réaliste." *L'Amour de l'Art,* 12th year (July 1931), 271–282.

Jamot 1914
Jamot, Paul. "La collection Camondo au Musée du Louvre. Les peintures et les dessins." *Gazette des Beaux-Arts* 684 (June 1914), 441–460.

Jamot, *Degas,* 1924
Jamot, Paul. *Degas.* Paris, 1924.

Jamot, "Peintre," 1924
Jamot, Paul. "Degas. Peintre d'assiettes." *Gazette des Beaux-Arts* (May 1924), 295–300.

Johnston 1982
Johnston, William R. *The Nineteenth-Century Paintings in the Walters Art Gallery.* Baltimore, 1982.

Kendall 1987
Kendall, Richard. *Degas by Himself: Drawings, Prints, Paintings, Writings.* London, 1987.

Kendall 1991
Kendall, Richard. "The Most Merciless Draughtsman in the World." *Apollo* 134, no. 353 (July 1991), 29–32.

Kendall, "Sculpture," 1995
Kendall, Richard. "Who Said Anything About Rodin? The Visibility and Contemporary Renown of Degas' Late Sculpture." *Apollo* (August 1995), 72–77.

Kendall, "Waxes," 1995
Kendall, Richard. "Striking a Blow for Sculpture: Degas' Waxes and Bronzes." *Apollo* (August 1995), 3–4.

Kendall 1996
Kendall, Richard. *Degas: Beyond Impressionism.* London, 1996.

Lafond 1918–1919
Lafond, Paul. *Degas.* 2 vols. Paris, 1918–1919.

Lecomte 1892
Lecomte, Georges. *L'art impressionniste d'après la collection privée de M. Durand-Ruel.* Paris, 1892.

Lemoisne 1912
Lemoisne, Paul-André. *Degas.* Paris, 1912.

Lemoisne 1919
Lemoisne, Paul-André. "Les statuettes de Degas." *Art et Décoration* (September–October 1919), 109–117.

Lemoisne 1931
Lemoisne, Paul-André. "A propos de la collection inédite de M. Marcel Guérin." *L'Amour de l'Art,* 12th year (July 1931), 284–291.

Lemoisne 1937
Lemoisne, Paul-André. "Degas." *Beaux-Arts* 75th year, new series, 219 (12 March 1937), A–B.

Lemoisne 1946–1949
Lemoisne, Paul-André. *Degas et son oeuvre.* 4 vols. Paris, [1946–1949]. Reprint ed., New York and London, 1984.

Letters
Edgar Germain Hilaire Degas: Letters. Marcel Guérin, ed. Marguerite Kay, Trans. Oxford, 1947.

Lettres Degas 1945
Lettres de Degas. Marcel Guérin, ed. Paris, 1945.

Leymarie 1947
Leymarie, Jean. *Les Degas au Louvre.* Paris, 1947.

Lipton 1986
Lipton, Eunice. *Looking into Degas. Uneasy Images of Women and Modern Life.* Berkeley and Los Angeles, 1986.

Loyrette 1991
Loyrette, Henri. *Degas.* Paris, 1991.

Luchs 1991
Luchs, Alison. "The Degas Waxes," 178–211. In *Art for the Nation.* Washington, 1991.

Maheux 1988
Maheux, Anne. *Degas Pastels.* Ottawa, 1988.

Manson 1927
Manson, J. B. *The Life and Work of Edgar Degas.* London, 1927.

McCarty 1986
McCarty, John. "A Sculptor's Thoughts on the Degas Waxes," 217–225. In *Essays in Honor of Paul Mellon, Collector and Benefactor,* John Wilmerding, ed. Washington, 1986.

McMullen 1984
McMullen, Roy. *Degas: His Life, Times and Work*. Boston, 1984.

Mathews 1984
Mathews, Nancy Mowll, ed. *Cassatt and Her Circle. Selected Letters*. New York, 1984.

Mauclair 1903
Mauclair, Camille. "Artistes contemporains. Edgar Degas." *Revue de l'art ancien et moderne* (November 1903), 381–398.

Meier-Graefe 1920, 1924
Meier-Graefe, Julius. *Degas*. Munich, 1920. Reprint ed., 1924.

Meier-Graefe 1923
Meier-Graefe, Julius. *Degas*. J. Holroyd-Reece, trans. London, 1923.

Millard 1976
Millard, Charles. *The Sculpture of Edgar Degas*. Princeton, 1976.

Mongan and Sachs 1940
Mongan, Agnes and Paul J. Sachs. *Drawings in the Fogg Museum of Art*. 3 vols. Cambridge, Mass., 1940.

Monnier 1969
Geneviève Monnier, "Les dessins de Degas du Musée du Louvre," *La Revue du Louvre* 19, no. 6 (1969), 359–368.

Monnier 1978
Monnier, Geneviève. "La genèse d'une oeuvre de Degas: 'Sémiramis construisant une ville.'" *La Revue du Louvre et des Musées de France* 28, nos. 5–6 (1978), 407–426.

Moore 1907–1908
Moore, George. "Degas," *Kunst und Kunstler* 3 (1907–1908), 98–108, 138–151.

Moreau-Nelaton 1931
Moreau-Nelaton, Etienne. "Deux heures avec Degas." *L'Amour de l'Art*, 12th year (July 1931), 267–270.

Musée du Louvre 1914, 1922
Musée du Louvre. *Catalogue de la collection Isaac de Camondo*. 1st ed., Paris, 1914. 2d ed., 1922.

Museum Boymans-van Beuningen 1968
Museum Boymans-van Beuningen. *Franse Tekeningen uit de 19e Eeuw. Catalogus van de verzameling in het Museum Boymans-van Beuningen.* Compiled by H. Hoetink. Rotterdam, 1968.

Nicolson 1960
Nicolson, Benedict. "The Recovery of a Degas Race Course Scene." *Burlington Magazine* 102, nos. 682–693 (January-July 1960), 536–537.

Pingeot 1991
Pingeot, Anne. *Degas, sculptures*. Paris, 1991.

Pingeot 1995
Pingeot, Anne. "The Casting of Degas' Sculptures: Completing the Story." *Apollo* (August 1995), 60–63.

Reed and Shapiro 1984
Reed, Sue Welsh and Barbara Stern Shapiro. *Edgar Degas: The Painter as Printmaker*. Boston, 1984.

Reff 1963
Reff, Theodore. "Degas's Copies of Older Art." *Burlington Magazine* 105, no. 723 (June 1963), 241–251.

Reff 1964
Reff, Theodore. "New Light on Degas's Copies." *Burlington Magazine* 106, no. 735 (June 1964), 250–259.

Reff 1965
Reff, Theodore. "The Chronology of Degas's Notebooks." *Burlington Magazine* 107, no. 753 (December 1965), 606–616.

Reff 1967
Reff, Theodore. "An Exhibition of Drawings by Degas." *Art Quarterly* 30 (1967), 252–263.

Reff 1970
Reff, Theodore. "Degas' Sculpture, 1880–1884." *Art Quarterly* (Autumn 1970), 276–298.

Reff 1971
Reff, Theodore. "Further Thoughts on Degas's Copies." *Burlington Magazine* 113, no. 82 (September 1971), 534–543.

Reff 1976
Reff, Theodore. *Degas: The Artist's Mind*. New York, 1976.

Reff 1977
Reff, Theodore. "Degas: A Master among Masters." *Metropolitan Museum of Art Bulletin* 34, no. 4 (Spring 1977).

Reff 1985
Reff, Theodore. *The Notebooks of Edgar Degas*. 2 vols. 2d rev. ed., New York, 1985. 1st ed., London, 1976.

Rewald 1944
Rewald, John. *Degas, Works in Sculpture: A Complete Catalogue*. New York and London, 1944.

Rewald 1946, 1961, 1973
Rewald, John. *The History of Impressionism*. 1st ed., New York, 1946. 3d rev. ed., 1961. 4th rev. ed., 1973.

Rewald 1956
Rewald, John. *Degas Sculpture. The Complete Works*. New York, 1956.

Rewald 1956, 1962, 1978
Rewald, John. *Post-Impressionism: From Van Gogh to Gauguin*. New York, 1956. 2d rev. ed., 1962. 3d rev. ed., 1978.

Rewald, "Van Gogh," 1973
Rewald, John. "Theo Van Gogh, Goupil and the Impressionists." *Gazette des Beaux-Arts* 81 (January 1973), 1–64; (February 1973), 65–108.

Rewald 1986
Rewald, John. *Studies in Post-Impressionism*. Irene Gordon and Frances Weitzenhoffer, ed. New York, 1986.

Rivière 1922–1923
Rivière, Henri. *Les dessins de Degas*, 2 vols. (Paris, 1922–1923). Reprint ed., 1973.

Rouart 1937
Rouart, Ernest. "Degas." *Le Point* (1 February 1937), 5–36.

Rouart 1945
Rouart, Denis. *Degas à la recherche de sa technique*. Paris, 1945.

Rousuck 1968
Rousuck, E.J. "Degas's Racing World." *The Thoroughbred Record* (13 April 1968), 1003–1012.

Shackelford 1984
Shackelford, George. *Degas: The Dancers*. Washington, 1984.

Scharf 1962
Scharf, Aaron. "Painting, Photography, and the Image of Movement." *Burlington Magazine* 104, no. 710 (May 1962), 186–195.

Scharf 1968
Scharf, Aaron. *Art and Photography*. London, 1968.

Sickert 1917
Sickert, Walter. "Degas." *Burlington Magazine* 31, no. 176 (November 1917), 183–192.

Sturman and Barbour 1995
Sturman, Shelley and Daphne Barbour. "The Materials of the Sculptor. Degas' techniques," *Apollo* (August 1995), 49–54.

Sutton 1986
Sutton, Denys. *Edgar Degas: Life and Work*. New York, 1986.

Terrasse 1981
Terrasse, Antoine. *Edgar Degas*. Frankfurt, Berlin, and Vienna, 1981.

Thiébault-Sisson 1921
Thiébault-Sisson, François. "Degas sculpteur par lui-même." *Le Temps*, 23 May 1921, 3. Reprinted in exh. cat. Paris 1984–1985, 177–182.

Tinterow and Norton 1989
Tinterow, Gary and Anne M. P. Norton. "Degas aux expositions impressionistes," 289–351. In *Degas inédit: actes du colloque Degas*. Paris, 1989.

Valéry 1938
Valéry, Paul. *Degas Danse Dessin*.
Paris, 1938.

Valéry 1960
Valéry, Paul. "Degas, Dance, Draw-
ing," 1–102. In *Degas, Manet,
Morisot*. David Paul, trans. New
York, 1960.

Venturi 1939
Venturi, Lionelli. *Les Archives de
l'Impressionisme*. Paris and New
York, 1939.

Vingt dessins [1897]
Degas, vingt dessins, 1861–1896.
Paris, 1896–1898.

Vitali 1963
Vitali, L. "Three Italian Friends of
Degas." *Burlington Magazine* 105
(June 1963), 269ff.

Vollard 1914
Vollard, Ambroise. *Degas: quatre-
vingt-dix-huit reproductions signées
par Degas*. Paris, 1914.

Vollard 1924
Vollard, Ambroise. *Degas*. Paris,
1924.

Vollard 1938
Vollard, Ambroise. *En écoutant
Cézanne, Degas, Renoir*. Paris, 1938.

Walker 1933
Walker, John. "Degas et les maîtres
anciens." *Gazette des Beaux-Arts* 10
(September 1933), 173–185.

Wells 1972
Wells, William. "Who was Degas's
Lyda?" *Apollo* 95, no. 120 (February
1972), 129–134.

Willoch 1980
Willoch, Sigurd. "Edgar Degas i
Nasjonalgalleriet." *Kunst Kultur* 63
(1980), 21–40.

Selected Exhibitions

Paris 1866
Salon de 1866. 84e Exposition officielle. Palais des Champs Elysées, 1 May–20 June

Paris 1868
Salon de 1868. 86e Exposition officielle. Palais des Champs Elysées, 1 May–20 June

London, Summer 1872
Fourth Exhibition of the Society of French Artists. New Bond Street, Summer

London, Winter 1872
Fifth Exhibition of the Society of French Artists. New Bond Street, Winter

London 1873
Sixth Exhibition of the Society of French Artists. 168 New Bond Street, Summer

Paris 1874
Première exposition. Société anonyme des artistes, peintres, sculpteurs, graveurs, etc., Boulevard des Capucines, 15 April–15 May

London 1883
Durand-Ruel, Dowdeswell's Galleries, 133, New Bond Street, Spring/Summer

Paris 1884–1885
Le Sport dans l'Art. Galerie Georges Petit, 14 December 1884–31 January 1885

New York 1886
Special Exhibition. Works in Oil and Pastel by the Impressionists of Paris. American Art Association, 10–28 April; National Academy of Design, 25 May–30 June

London 1905
Pictures by Boudin, Cézanne, Degas, Manet, Monet, Morisot, Pissarro, Renoir, Sisley. Grafton Galleries, January–February

Manchester 1907–1908
Modern French Paintings. Manchester City Art Gallery, Winter

Cambridge, Mass., 1911
A Loan Exhibition of Paintings and Pastels by H. G. E. Degas. Fogg Art Museum, 5–14 April

Paris 1912
Exposition d'art moderne. Manzi, Joyant et Cie., June–July

New York 1913
Armory of the Sixty-Ninth Regiment, 17 February–15 March

New York 1915
Loan Exhibition of Masterpieces by Old and Modern Painters. Knoedler and Co., 6–24 April

Zurich 1917
Französische Kunst des 19. und 20. Jahrhunderts. Kunsthaus Zürich, 5 October–14 November

New York 1918
Exhibition of Paintings and Pastels by Degas. Durand-Ruel Galleries, 9–26 January

Chicago 1922
Exhibition of Drawings by Degas. The Arts Club of Chicago, 19–31 January

New York, Durand-Ruel, 1922
Exhibition of Bronzes by Degas. Durand-Ruel Galleries, 6–27 December

New York, Grolier, 1922
Prints, Drawings, and Bronzes by Degas. The Grolier Club, 26 January–28 February

Paris 1922
Le Sport dans l'Art. Galerie Barbazanges, 17–30 November

Paris 1924
Exposition Degas. Galeries Georges Petit, 12 April–2 May

Maison-Laffitte 1926
Les courses en France. Château Maison-Laffitte

Cambridge, Mass., 1931
Degas. Fogg Art Museum, 9–30 May

Paris 1931
Degas. Portraitiste, Sculpteur. Musée de l'Orangerie, 19 July–1 October

London 1932
Exhibition of French Art, 1200–1900. Royal Academy of Arts, 4 January–5 March

New York 1932
Exhibition of Pastels and Gouaches by Edgar Degas and Camille Pissarro. Durand-Ruel Galleries, 4–25 January 1932

Chicago 1933
A Century of Progress. Art Institute of Chicago, 1 June–1 November

Northampton 1933
Edgar Degas. Smith College Museum of Art, 28 November–18 December

Philadelphia 1936
Degas, 1834–1917. The Pennsylvania Museum of Art [now the Philadelphia Museum of Art], 7 November–7 December

London 1937
Degas, 1834–1917. The Adams Gallery, closed 4 December

New York 1937
Exhibition of Masterpieces by Degas. Durand-Ruel Galleries, 22 March–2 April

Paris 1937
Degas. Musée de l'Orangerie, 1 March–20 May

Cambridge, Mass., 1938
The Horse: Its Significance in Art. Fogg Art Museum, 20 April–21 May

Paris 1938
Degas. Galerie Mouradian-Valloton, closed 12 March

Paris 1939
Degas: peintre du mouvement. Galerie André Weil, 9–30 June

Cleveland 1947
Works by Edgar Degas. The Cleveland Museum of Art, 5 February–9 March

New York 1947
Degas. Durand-Ruel Galleries, 10–29 November

Washington 1947
Loan Exhibition of Drawings and Pastels by Edgar Degas, 1834–1917. Phillips Memorial Gallery, 30 March–30 April

Minneapolis 1948
Degas' Portraits of His Family and Friends. Minneapolis Institute of Arts, 6–28 March

New York 1949
A Loan Exhibition of Degas for the Benefit of the New York Infirmary. Wildenstein & Co., Inc., 7 April– 14 May

London 1950
Degas. The Lefevre Gallery, May–June

Ottawa 1950
Vollard Collects. National Gallery of Canada, November

Toledo 1950
Degas: Paintings, Sculpture, Sketches. Toledo Museum of Art, May

Bern 1951–1952
Degas. Kunstmuseum Bern, 25 November 1951–13 January 1952

Amsterdam 1952
Edgar Degas. Stedelijk Museum, 8 February–24 March

Edinburgh 1952
Degas. Edinburgh Festival Society and Royal Scottish Academy, 17 August–6 September; London, Tate Gallery, 20 September–19 October

New York 1955
Edgar Degas (1834–1917). Original Wax Sculptures. Knoedler and Co., 9 November–3 December

Paris 1955
Degas dans les collections françaises. Gazette des Beaux-Arts, opened 8 June

Fort Worth 1957
Horse and Rider. Fort Worth Art Center, 7 January–3 March

Los Angeles 1958
Edgar Hilaire Germain Degas. Los Angeles County Museum of Art, March

Williamstown 1959
Degas (Exhibit Ten). Sterling and Francine Clark Art Institute, opened 3 October

New York 1960
Degas. Wildenstein & Co., 7 April– 7 May

Paris 1960
Edgar Degas, 1834–1917. Galerie Durand-Ruel, 9 June–1 October

Richmond 1960
Sport and the Horse. Virginia Museum of Fine Arts, 1 April– 15 May

London 1960–1961
The John Hay Whitney Collection. Tate Gallery, 16 December 1960– 29 January 1961

Baltimore 1962
Manet, Degas, Berthe Morisot, and Mary Cassatt. Baltimore Museum of Art, 18 April–3 June

New Orleans 1965
Edgar Degas: His Family and Friends in New Orleans. Isaac Delgado Museum, 2 May–16 June

Washington 1966
French Paintings from the Collection of Mr. and Mrs. Paul Mellon and Mrs. Mellon Bruce. National Gallery of Art, 17 March–1 May

Saint Louis 1967
Drawings by Degas. City Art Museum of Saint Louis, 20 January– 26 February; Philadelphia Museum of Art, 10 March–30 April; The Minneapolis Society of Fine Arts, 18 May–25 June

Amiens 1968
Degas aujourd'hui. Maison de la Culture, 22 February–22 April

Cambridge, Mass., 1968
Degas Monotypes. Fogg Art Museum, Harvard University, 25 April– 14 June

New York 1968
Degas' Racing World. Wildenstein & Co., Inc., 21 March–27 April

Nottingham 1969
Degas: Pastels and Drawings. Nottingham University Art Gallery, 15 January–15 February

Paris 1969
Degas: oeuvres du Musée du Louvre. Musée de l'Orangerie, 27 June– 15 September

London 1970
Edgar Degas. 1834–1917. The Lefevre Gallery, 4 June–4 July

Williamstown 1970
An Exhibition of the Works of Edgar Degas (1834–1917). Sterling and Francine Clark Art Institute, 8 January–22 February

Boston 1974
Edgar Degas: The Reluctant Impressionist. Museum of Fine Arts, 20 June–1 September

Paris 1974–1975
Centenaire de l'Impressionisme. Grand Palais, 21 September–24 November; New York, Metropolitan Museum of Art, 12 December 1974–10 February 1975

Paris 1975
Degas. Galerie Schmit, 15 May– 21 June

London 1976
The Complete Sculptures Of Degas. Lefevre Gallery, 18 November– 21 December

Tokyo 1976–1977
Degas. Seibu Museum of Art, 23 September–3 November; Kyoto City Art Museum, 7 November– 10 December; Fukuoka Art Museum, 18 December 1976– 16 January 1977

New York 1977
Degas in the Metropolitan. Metropolitan Museum of Art, 26 February–4 September

New York 1978
Edgar Degas. Acquavella Galleries, Inc., 1 November–3 December

Richmond 1978
Degas. Virginia Museum of Fine Arts, 22 May–9 July [no catalogue]

Edinburgh 1979
Degas 1879. National Gallery of Scotland for the Edinburgh International Festival, 13 August– 30 September

Washington 1982–1983
Manet and Modern Paris. National Gallery of Art, 5 December 1982– 6 March 1983

London 1983
Edgar Degas, 1834–1917. Artemis Group (David Carritt Limited), 2 November–9 December

Washington 1983
The John Hay Whitney Collection. National Gallery of Art, 29 May– 5 September

Chicago 1984
Degas in the Art Institute of Chicago. The Art Institute of Chicago, 19 July–23 September

Tübingen 1984
Edgar Degas: Pastelle, Ölskizzen, Zeichnungen. Kunsthalle Tübingen, 14 January–25 March; Berlin Nationalgalerie, 5 April–20 May

Boston 1984–1985
Edgar Degas: The Painter as Printmaker. Museum of Fine Arts, 14 November 1984–13 January 1985; Philadelphia Museum of Art, 17 February–14 April; London, Arts Council of Great Britain, Hayward Gallery, 15 May–7 July

Paris 1984–1985
Degas: Forme et l'espace. Centre Culturel du Marais, 14 October 1984–27 January 1985

Rome 1984–1985
Degas e l'Italia. Villa Medici, 1 December 1984–10 February 1985

Washington 1986
The New Painting: Impressionism 1874–1886. National Gallery of Art, 17 January–6 April; San Francisco, Fine Arts Museums, 19 April–6 July

Manchester 1987
The Private Degas. Whitworth Art Gallery, 20 January–28 February/ Cambridge, Fitzwilliam Museum, 17 March–3 May

Williamstown 1987
Degas in the Clark Collection. Sterling and Francine Clark Art Institute, 20 June–25 October

Paris 1988–1989
Degas. Galeries Nationales du
Grand Palais, 9 February–16 May;
Ottawa, National Gallery of Can-
ada, 16 June–28 August; New York,
Metropolitan Museum of Art,
27 September 1988–8 January 1989

London 1989
Edgar Degas 1834–1917. Browse &
Darby, 11 April–13 May

London 1991
*Paintings, Pastels and Drawings by
Edgar Degas.* David Bathurst Ltd.,
12 June–5 July

Washington 1991
Art for the Nation. National Gallery
of Art, 17 March–16 June

Martigny 1993
Degas. Fondation Pierre Gianadda,
19 June–21 November

New York 1993
Degas Landscapes. Metropolitan
Museum of Art, 21 January–3 April;
Houston, Museum of Fine Arts,
24 April–3 July

Miami 1994
*Edgar Degas: The Many Dimensions
of a Master Impressionist.* Center
for the Fine Arts, 2 April–15 May;
Jackson, Mississippi Museum of Art,
30 May–31 July; Dayton Art Insti-
tute, 13 August–9 October

Paris 1994–1995
*Impressionnisme, les origines
1859–1869.* Grand Palais, 19 April–
8 August; New York, Metropolitan
Museum of Art, 19 September 1994–
8 January 1995

Zurich 1994–1995
Degas Portraits. Kunsthaus Zürich,
2 December 1994–3 March 1995;
Tübingen, Kunsthalle, 18 March–
18 June

Credits and Addendum

Every effort has been made to contact the copyright holders for the photographs in this book. Any omissions will be corrected in subsequent editions.

Photographs supplied by the owners except as noted below:

Alinari/Art Resource, NY: Boggs figs. 12, 13, 14. Antikenmuseum Basel and Sammlung Ludwig, photo by Widmer: Boggs fig. 3. Artemis: Boggs fig. 89. Bibliothèque Nationale, Paris: Boggs fig. 34. The Bridgeman Art Library International Ltd., London and New York: Boggs fig. 64. Document Archives Durand-Ruel: Boggs figs. 39, 41, 42, 67, 70, 71, 75, 91, 93. Drouot: Boggs fig. 49. Galerie Schmit, Paris: Boggs figs. 15, 19, 58, 68, 69, 72, 82, 84. Library of Congress: Boggs fig. 77; Barbour and Sturman figs. 12, 14. David A. Loggie: chronology, Degas, *Portrait of M and Mme Paul Valpinçon*. Musée d'Orsay, Album Michelez: chronology, Pichat, *Grand Prix de Paris de 1866*. Musées de la Ville de Paris: chronology, Béraud, *The Races at Longchamps*. Eric Pollitzer: chronology, Manet, *The Races at the Bois de Boulogne*. Réunion des Musées Nationaux: cats. 1, 7, 11, 29, 34, 53, 56, 60; Boggs figs. 8, 21, 23, 24, 25, 26, 48, 52, 53, 63; Barbour and Sturman figs. 4, 6. Tim Thayer: cat. 80. Didier Tragin/Catherine Lancien: chronology, Moreau, *Diomedes Devoured by His Horses*. Elke Walford: chronology, Renoir, *Riding in the Bois de Boulogne*. Bruce M. White: cat. 85

Additional information on the comparative illustrations:

Boggs
fig. 1, Reff Notebook 2, fol. 43
fig. 2, Reff Notebook 3, fol. 28
fig. 4, Reff Notebook 8, fol. 24v
fig. 5, Reff Notebook 8, fol. 77
fig. 6, Reff Notebook 12, fol. 16
fig. 7, Reff Notebook 12, fol. 11
fig. 8, Inv. 4891
fig. 9, Reff Notebook 13, fol. 61
fig. 10, Reff Notebook 13, fol. 118
fig. 11, Reff Notebook 13, fol. 110
fig. 16, L 94
fig. 17, Reff Notebook 18, fol. 7
fig. 20, Reff Notebook 18, fol. 127
fig. 21, L 82
fig. 22, Reff Notebook 18, fol. 15
fig. 23, RF 15503
fig. 24, RF 15528
fig. 25, L 124
fig. 26, RF 15534
fig. 27, P 42
fig. 28, Reff Notebook 18, fol. 165
fig. 29, Reff Notebook 18, fol. 162
fig. 30, L 77
fig. 31, Reff Notebook 14, fol. 79
fig. 36, 1924-6-17-35
fig. 39, Vente IV: 226.b
fig. 40, Reff Notebook 22, fol. 89
fig. 41, Vente IV:238.c
fig. 42, Vente IV:238.a
fig. 43, Vente IV:235.a
fig. 44, Reff Notebook 22, fol. 35
fig. 45, Reff Notebook 18, fol. 13
fig. 46, Reff Notebook 18, fol. 80a
fig. 47, Reff Notebook 18, fol. 113
fig. 48, Inv. 8356
fig. 49, sale, Paris, Hôtel Drouot, 6 May 1976, no. 17
fig. 50, Vente IV:209.a
fig. 52, P 47
fig. 54, Reff Notebook 22, fol. 68
fig. 55, Reff Notebook 22, fol. 79
fig. 56, Vente IV:229.b
fig. 57, Reff Notebook 22, fol. 15

fig. 58, L 157
fig. 59, Vente III:354.2
fig. 60, L 179
fig. 61, Reff Notebook 22, fol. 127
fig. 62, Reff Notebook 22, fol. 123
fig. 63, L 461
fig. 64, L 649
fig. 65, Vente III:178
fig. 66, Vente IV:223.c
fig. 68, Vente IV:235.b
fig. 69, Vente IV:234.c
fig. 70, Vente III:141.2
fig. 71, Vente III:91.2
fig. 72, Vente IV:217.c
fig. 73, L 889
fig. 75, Vente IV:215.a
fig. 76, L 878
fig. 78, L 755
fig. 81, Reff Notebook 37, fol. 197
fig. 82, Vente IV:216.d
fig. 83, L 664
fig. 84, Vente IV:216.c
fig. 85, L 631
fig. 86, L 859
fig. 88, Vente IV:246.b
fig. 89, Vente III:107.3
fig. 90, Vente III:230
fig. 91, Vente IV:235.c
fig. 92, P 44
fig. 93, Vente IV:214.b
fig. 94, L 762

Barbour and Sturman
fig. 2, Bibliothèque Nationale, Notebook 19, fol. 35
fig. 5, sold at auction to a private collector in the 1970s